THE LINKE PHOTOGRAPHERS' GUIDE TO ONLINE MARKETING AND SOCIAL MEDIA

Lindsay Adler and Rosh Sillars

Course Technology PTR
A part of Cengage Learning

COURSE TECHNOLOGY
CENGAGE Learning™

Australia, Brazil, Japan, Korea, Mexico, Singapore, Spain, United Kingdom, United States

COURSE TECHNOLOGY
CENGAGE Learning™

**The Linked Photographers' Guide
to Online Marketing and Social Media**
Lindsay Adler and Rosh Sillars

**Publisher and General Manager,
Course Technology PTR:**
Stacy L. Hiquet

Associate Director of Marketing:
Sarah Panella

Manager of Editorial Services:
Heather Talbot

Marketing Manager:
Jordan Castellani

Acquisitions Editor: ˙
Megan Belanger

Project Editor/Copy Editor:
Karen A. Gill

Interior Layout:
Shawn Morningstar

Cover Designer:
Mike Tanamachi

Indexer:
Kelly Talbot

Proofreader:
Tonya Cupp

For product information and technology assistance, contact us at
Cengage Learning Customer & Sales Support, 1-800-354-9706

For permission to use material from this text or product,
submit all requests online at **cengage.com/permissions.**

Further permissions questions can be e-mailed to
permissionrequest@cengage.com.

All logos and trademarks are the property of their respective owners.

Library of Congress Catalog Card Number: 2009942404

ISBN-13: 978-1-4354-5508-5

ISBN-10: 1-4354-5508-8

Course Technology, a part of Cengage Learning
20 Channel Center Street
Boston, MA 02210
USA

Cengage Learning is a leading provider of customized learning solutions with office locations around the globe, including Singapore, the United Kingdom, Australia, Mexico, Brazil, and Japan. Locate your local office at: **international.cengage.com/region.**

Cengage Learning products are represented in Canada by Nelson Education, Ltd.

For your lifelong learning solutions, visit **courseptr.com.**

Visit our corporate Web site at **cengage.com.**

Printed in United States of America
1 2 3 4 5 6 7 12 11 10

To my wife Shirley, in our tenth year of marriage,
for all her love and support.

—*Rosh*

To my parents, who have supported me
in every way possible.

—*Lindsay*

Acknowledgments

From Lindsay:

Thank you to my parents for supporting me in every way possible. Particularly, thank you to my mother, Kathleen. Mom, you have helped me edit my articles, driven me hundreds of miles to conferences, bought my first equipment, helped me run a business, and always given me moral support. There are few parents who would do what you have both done for me.

Thank you to all of the people who graciously allowed me to interview them and use their work as illustrations of the concepts behind social media.

Thank you Rosh for joining this project—your expertise in social media took this book to an entirely new level.

Thank you to my social network. To my Twitter followers, Facebook fans, blog readers, and anyone interacting with me online—you give me something to write about and a way to put my theories into practice.

I also must thank the professional photographers and photo teachers who have inspired me and given me a helping hand. Thank you to Mary Ann and Joe McDonald, John Harrington, Bruce Strong, and the dozens of others who have given me inspiration.

To my fantastic editor, Karen. Thank you for putting up with all the bumps we encountered along the way. You were fantastic.

Lastly, thank you to my sponsors. Your support allows me to travel and share my passions with others.

From Rosh:

Thank you to Shirley McShane Sillars for contributing her support, ideas, and editing abilities to this book.

To my children, Ava and Kelly, who I love dearly. Thank you for putting up with the hours of Daddy writing on a tight deadline and barking orders not to bother him.

To my father, Malcolm Sillars, for sharing his wisdom; my mother, Patricia Sillars, for her loving caution; and my stepmother, Edith Sillars, who has been there for me when I didn't listen to my mother or father.

To my first photography teacher, Jack Summers, who inspired me to make my art a career.

Thank you to Lindsay Adler for extending this wonderful opportunity to me.

I wish to acknowledge my podcasting partners, Dean La Douceur and Greg Evans. Also, I want to offer a special thank you to my photography representative, April Galici-Pochmara, for igniting the spark that started the social media explosion in my life.

Thank you to my entire social media community. Without all of you, this book would have been impossible to write.

About the Authors

Lindsay Adler is a professional portrait and fashion photographer working in New York and London. Her work has appeared in dozens of publications internationally. She is a regular contributor to publications such as *Popular Photography*, *Shutterbug*, and *Professional Photographer*.

For the past 10 years, Lindsay has owned and operated a studio in upstate New York, and currently she shoots for several international fashion magazines including *Sublime* and *MindFood*. She has received dozens of awards, scholarships, and honors for her work.

Each year Lindsay teaches thousands of photographers internationally through workshops, conferences, and seminars. She loves sharing her passion and knowledge of photography. She does so not only through her workshops but through educational videos, her blog, Twitter, and several other outlets. She teaches on various topics, ranging from Photoshop techniques to fashion photography to nature photography.

Rosh Sillars, a veteran photographer with a background in photojournalism, specializes in people, food, and interior photography. He earned a Bachelor of Fine Arts (BFA) in photography from the College of Creative Studies, Detroit. He owns the creative representation firm The Rosh Group Inc., which serves advertising and corporate clients. He teaches photojournalism at Wayne State University and digital photography at the University of Detroit-Mercy, both in Detroit, Michigan. He also works as a social media consultant for the integrated marketing company Synectics Media. Rosh has worked as a staff and freelance photographer for many media outlets, including daily, weekly, and monthly newspapers as well as local and national magazines. He has won numerous local and national awards for his photography and is a two-term past president of the Michigan chapter of the American Society of Media Photographers.

Rosh is the host of the blog and podcast, "New Media Photographer." He also cohosts podcasts at Prosperous Artists and The Driven Business.

His home studio is Octane Photographic in Ferndale, Michigan. He lives in Ferndale with his wife Shirley and two daughters, Kelly and Ava.

Contents

Part II The Basics of Social Networking

Chapter 6 Your Web Site 63

Chapter 7 Your Blog 85

Part III Essential Social Networks

Chapter 10 Flickr 143

Chapter 11 Twitter 163

Chapter 12 Facebook 191

Chapter 13 LinkedIn 213

Chapter 14 Tumblr 225

Chapter 15 YouTube 243

Part IV Case Studies

Part V Reference

Chapter 18 Tools for Social Networking 327

Introduction

It's no secret that the Internet has changed how people and businesses interact with one another. You can connect with friends or potential clients across the world with the click of a button. This fundamental shift has profoundly influenced the way photographers market themselves and present their work to the outside world. Businesses have changed. Communication has changed.

Photographers have a great deal to gain from social networking. Social networking is not the communication and marketing of the future. It is the communication and marketing of today. Photographers can gain more exposure for their work and build a positive reputation online. They can find new clients and develop a community around their work. They can network with colleagues to learn and share.

Photographers may be familiar with social networking tools like Facebook, Twitter, and blogging but may not know how to put these tools to use for business success. There are endless tools and social networking platforms available to photographers. It's easy to become overwhelmed by the possibilities.

This book acts as a practical guide for photographers to get online and embrace social networking efficiently and effectively. You don't need to know *everything* about social networking—just the platforms and tools that can help you as a photographer.

What You'll Find in This Book

This book explains why social media should be important to you as a photographer and how you can get started in this exciting and rapidly growing world. You'll learn how to use various social networks and social networking tools to build your reputation online, find new clients, network with colleagues, and expand your business. You'll also read case studies to illustrate how photographers are already successfully utilizing social networking for impressive business success.

This book provides a practical guide for photographers to jump into social networking. Although it covers the concepts and theories behind social networking, a majority of the book is devoted to essential knowledge that photographers can utilize for efficient and effective use of their social networking activities.

Part I, "Introduction: Why Social Networking?," covers why social networking is something that photographers should—and must—embrace. Chapter 1, "Social Networking: What Happened?," discusses the development of social networking as a communication tool. In Chapter 2, "Social Networking: How-To," you'll read about how photographers have begun embracing social networking as a means of building their reputation and expanding their business. Chapter 3, "Social Networking: Your Story," explains the basics of utilizing social networking to achieve your business goals, including establishing your brand and sharing your knowledge with others.

Part II, "The Basics of Social Networking," focuses on the essential knowledge and tools of social networking, including the basics of getting started, best practices for ensuring success, and means of analyzing this success. Chapter 4, "The Plan," provides a basic plan of how to get started on the right foot with social networking. Chapter 5, "Personal Branding," is a brief overview of how to determine and establish your personal brand. Chapter 6, "Your Web Site," discusses the appearance and functionality of your Web site. Chapter 7, "Your Blog," explains what to blog, how to blog, and the best ways to drive traffic to your blog. In Chapter 8, "Search Engine Optimization and Analytics," you learn how to optimize your site and blog for search engines (search engine optimization, or SEO) and how to utilize analytics to determine whether your SEO is effective. Finally, in Chapter 9, "AdWords," you discover how paid advertising of AdWords can be an effective tool for achieving search engine success.

Part III, "Essential Social Networks," encompasses Flickr (Chapter 10), Twitter (Chapter 11), Facebook (Chapter 12), LinkedIn (Chapter 13), Tumblr (Chapter 14), and YouTube (Chapter 15), which are applicable and essential tools for any photographer. These chapters provide an overview of each network, method of sign-up, and the most important capabilities offered. The benefits of each platform are explained, as are the best practices. Finally, you'll discover some tips and tricks for uniquely utilizing these networks.

Part IV, "Case Studies," gives some concrete examples of how photographers are already utilizing social networking to build their reputation, find new clients, expand their business, and connect with colleagues. Chapter 16, "Our Stories," covers how social networking has played an essential role in the success of the authors. Chapter 17, "Your Stories," introduces you to the stories of several photographers who have utilized social networking with extreme success. These case studies demonstrate social networking in practice so you can pick up tips from photographers who are already successfully employing these tools.

Part V, "Reference," includes Chapter 18, "Tools for Social Networking." This chapter is an extensive list of social networking tools available to you as a photographer. It includes blogging plug-ins, social bookmarking sites, and tools for Twitter. As an overview of many of the social networking tools not previously covered in other sections of this book, this chapter can act as a guide for their use.

Who This Book Is For

This book is written for photographers who are curious about the power of social media and interested in developing a larger audience for their photography. It appeals to amateur and professional photographers alike. Whether you just want to network online with others who share your passion or you want to expand your clientele using the tools of the Internet, this book is for you. If you are completely new to the concepts of social networking, this book will act as a helpful guide to get you online quickly, efficiently, and effectively. If you are already active on a variety of social networking platforms, this book offers many useful tips and tricks for better utilizing these networks as a photographer.

Part I

Introduction: Why Social Networking?

1

Social Networking: What Happened?

Communication Today

Media is about communication. Business is about relationships. Social media is where communication and relationships converge.

Should you care?

It is important to understand what makes media a social endeavor. Simply put, it is the ability of content providers to interact or engage with one another. This is accomplished every time a reader leaves a written comment about a blog post or a viewer responds to a YouTube video.

Social media is produced in many forms, and it's growing by the day. Some of the standard forms of social media are blogs, forums, microblogs, podcasts, and unique content sharing Web sites such as Digg.com. Even more valuable is the fact that these media channels are open to everyone. There are no traditional barriers of hierarchy or geographic location that impede this form of communication.

This new form of media is changing how we communicate. It is giving people more opportunities to network with like-minded people, grow their businesses, and gain name recognition in their areas of expertise. This is especially true for photographers.

In the past decade, technology has changed the way photographers have created their images. Today, technology is changing how photographers share their creative vision. As artists, we have embraced new ways to express our vision and to

share this vision with others. With recent technological changes, photographers now have easy access to a larger audience. Figure 1.1 includes the icons of several of the major social networks. This list, however, is far from inclusive of the dozens of social networks available today.

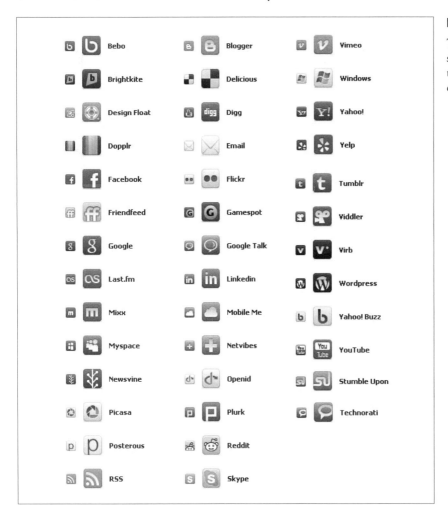

Figure 1.1

There are dozens of different social networks that appeal to different audiences and communities of people.

The Changing Photography Business

It is harder than ever to make a living as a photographer. More people are exploring and embracing the craft of photography because advanced technology has made it easy and accessible. Technology has lowered the barrier of entry into the field. The ability to create "good enough" photography is now as simple as pointing the camera and pressing a button. This has eliminated the need for a professional in the minds of many photography buyers. In addition,

advances in technology and the availability of cheap imagery with online stock photo agencies have decreased the implicit value of the craft in the minds of many. Although the barrier to starting a photography business has been lowered, the climb to a successful photography career has become steeper. Professional photographers need every advantage available today to attract new customers.

What Happened?

It has been said that much of the twentieth century was an anomaly. How did people communicate before then? In most cases, it was by word of mouth. Communication was often slow and had limited reach. People sought information from the people they trusted.

During the twentieth century, mass media took root. Through mass communication, companies became able to deliver a single message across extremely large audiences. People became dependent on these messages and their sources to help form their opinions.

Companies spent large amounts of money delivering their message to the masses. Advertising agencies worked to develop campaigns that would appeal to most people. If they were successful, the client company made money. The money would be collected, and if the company posted a profit, it would invest in more advertising. Thus, the company would grow and the cycle would continue its course.

Something else happened during this time of mass-media growth. Companies discovered that to sell more of their products, they had to create average products. The goal was to create products that would appeal to most people. The mass-media model can be reduced to a numbers game.

The Detroit automotive industry is an excellent example of this way of thinking. After competitors were edged out of the market or bought by larger companies, the American consumer was left with three major car brands. These brands focused on selling in large volume, leading to the production of average cars and trucks.

Consequences of Mass Media

The consequence of mass media and communication is that the individual voice and niche desires don't count. Mass communication is a one-way channel, and the people with the money control the message. If the consumer has a complaint or is being ill served, he is often ignored. It would take the work of a reporter or bad publicity to raise any concern for the firms disseminating these mass-media messages. An individual's voice is easily replaced with another round of mass-media advertising.

The mass-media process has affected photographers in two important ways.

First, they don't teach business and marketing very well in most photography schools and art programs. Most photographers use obvious advertising models by default. They adopt mass marketing techniques and strategies by shotgunning their pitch to prospects and hoping for the best.

Second, mass marketing requires photographers to create average images to sell average products. Imagery that is not too extreme, easy to understand, and clean is desired. Photographers often are hired by enthusiastic art directors for their creative vision, but ultimately they are asked to employ their technical skills to deliver the client or agency's vision.

The need for photographic technicians is fading; photographic vision has become more important.

Benefits of Social Media

Photographic knowledge and expertise are easily available for two reasons. The first reason is that digital cameras are easy to use and provide instant feedback, so images may be improved with the next press of the shutter. The second reason is changing the world. Just like technology has made photography accessible to all, it has brought publishing to the average person.

The Internet gives anyone willing to do so the power to publish their ideas, thoughts, concepts, and imagery to the world from the comfort of their home or office. This is an amazing technological advance that is making a major impact on the mass media model. It is giving the individual her voice back. Once again, individuals matter.

The term *publishing* refers to the distribution of content. Whether you're publishing through a blog or creating your own online magazine, the process is easy and inexpensive. For example, there are many free blog hosting sites that require only an e-mail address to sign up. Once the user starts posting content, he is a publisher ready to reach a niche market. There are also several sites online that allow you to create and publish your own online magazine and include advertising content for revenues. You can become the publisher within minutes. Figure 1.2 shows one such company, Issuu, that gives you a customizable interface for publishing your own online magazine for free.

Free and easy access to publishing platforms has negatively impacted mass media. This hurts publishing as well as the livelihood of many photographers. Requests for original photography have been on a solid down trend for a few years. Even family portrait and wedding photographers are hurting because friends and family can now offer photography services for cheap or for free. People are willing to accept "good enough" when it is free.

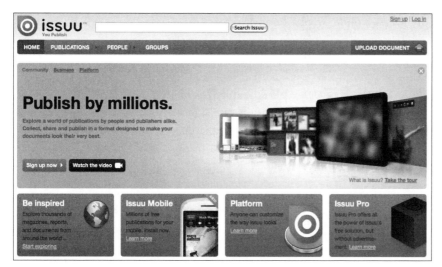

Figure 1.2

Online publishing platforms like Issuu allow you to create and publish your own online magazine, free and with customization.

A photographer's prospects have a voice again, too. Words—both positive and negative—about a photographer spread quickly on the Internet. The consumer is empowered again merely by pressing a button or clicking a mouse. The consumer has a choice.

Today the average person has the opportunity to seek quotes from local, regional, national, and international companies. The result is that pricing for many products and services has become highly competitive. The consumer can order furniture from North Carolina, print post cards in Canada, and process digital prints in Montana, all while living in Texas.

Local retail customers generally do not purchase photography services from other parts of the world. Due to increased Internet access, consumers are comparing local photographers to the best, unique, and most creative photographers around the world. They also compare photography prices and images produced from their personal digital cameras.

We are inundated with thousands of visuals every day. Whether photos on a cereal box or slick TV ads, we see thousands of images that we have become almost immune to. We barely notice these images, yet photographers are tasked with standing out above the visual noise.

The almost-daily influx of blogs and Web sites has increased the need and demand for digital images. In spite of this increase, supply still outpaces demand.

In addition, the ability to publish pictures to microstock photography Web sites has flooded the market with images. Most of the photographs on these sites are high in quality but average in style.

Microstock agencies offer mostly average photography because it's another form of mass media. They charge low usage fees to their clients. These fees often range from 50 cents to 2 dollars. Photographers only receive a fraction of that fee. Consequently, both the agency and the photographer depend on volume to make money. Just like mass media, average photography in the microstock arena appeals to more people and thereby generates additional sales. Photography has become a commodity. On sites like iStockphoto.com, shown in Figure 1.3, many stock images are offered for just $1, and most content is valued at a fraction of the cost just a few years ago.

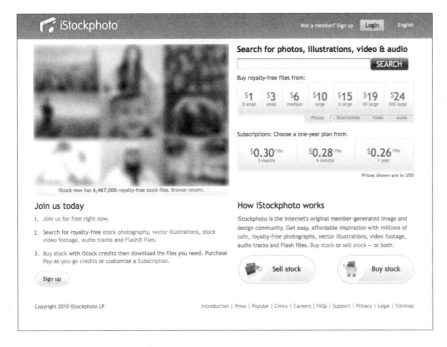

Figure 1.3

Microstock companies like iStockPhoto have helped turn photography into an inexpensive commodity, selling images at extremely low prices.

How Do You Compete?

The answer is to use your new voice, which is louder and has more channels than ever on which to communicate . The world is now your marketplace. But before you use your new voice, the most important thing you can do is employ your eyes and ears.

The world of social media offers great opportunity to gain and share knowledge.

Today's photographer must take advantage of the information offered online. Social media outlets allow both amateur and professional photographers to advance their craft, increase knowledge, and share results.

The goal of today's photographer is to develop a story, style, and brand that removes her from the commodity market. She needs to craft an authentic story and reputation that is worth sharing through word of mouth.

The *personal brand* is a catch phrase in social media circles. It simply means who you are and what you represent in the eyes of others. As a photographer, you can adjust your brand over time with actions, but like your reputation, you must earn it.

You must develop an online brand and reputation. Often a solid following reaffirms your trustworthiness. You no longer sell just your images. You sell your knowledge, your expertise, and yourself.

The Training Wheels

Social media Web sites are the training wheels of photographers' business vehicles of the future. It's the way we will do business. It's better to practice now and enjoy the benefits of social business, marketing, and applications before you're racing to catch up with the pack.

Have you ever said these things or known someone who asked:

"Why do I need e-mail? I can call on the phone."

"I don't need a Web site. I like to present my portfolio in person."

"I'll never switch to digital."

Today, doubters are calling social media "worthless" and "a waste of time." True, it is worthless if you are not concerned about building rapport, trust, and deeper relationships with your prospects and customers. Networking was always an important business tool, and now we have new arenas to network and promote our photography.

Believe it or not, social media is what we need.

You are a salesperson. Like or not, it's a fact. Everything you do is part of the sales and marketing process. Answering the phone, showing your portfolio, interacting with others while on assignment, sending invoices, and following up are ways we leave impressions of ourselves and affect future sales.

Salespeople are always looking for better ways to keep open lines of communication with prospects and clients. What has haunted photographers for years is the knowledge that five minutes after a photographer shows his portfolio to an art buyer, another photographer is walking in the door. The universal sales question has always been: How do I follow up and stay top of mind with prospects and clients without being annoying?

Although social media platforms will come and go, the need to keep in touch on a regular basis will not diminish in value. Whatever the method, you need a way to deliver a deeper understanding of who you are and share insightful knowledge with the people with whom you want to do business. This is what social media has to offer.

Some corporations already are changing their business models to build on the profitable and innovative benefits of collaboration. The tools necessary for such models are the social media platforms we are using today. If you want to engage with modern companies, you need to know how to plug in.

You have a choice. You can engage, or you can be left behind.

The U.S. government has begun to realize the incredible power that social networking has for collaborating and achieving set tasks. In December 2009, the U.S. government under Defense Advanced Research Projects Agency (DARPA) initiated a contest to celebrate the 40th anniversary of the Internet. Participants were challenged to find 10 red weather balloons hidden around the country. The first team to find all the balloons would win $40,000. As shown in Figure 1.4, a team from MIT won the contest in less than nine hours with ingenuity and the power of social media.

Figure 1.4

The U.S. government arranged a contest for people to use social networks to find 10 red weather balloons hidden across the country and offered a $40,000 prize.

The power of collaboration is nearly unlimited; you can coordinate, brainstorm, and work with individuals worldwide on any idea you share a passion.

It's important to note that we wrote this book during a time of deep economic recession in the United States. We've learned that historically, great opportunities are often developed during financial crisis. Please don't misinterpret our enthusiasm for a lack of concern. We understand that there is much to worry about both within and outside our industry.

After each economic meltdown, the boom technology preceding the fall seems to become the new standard. Survivors are the ones who embrace the current technologies with good business sense and innovation. This is certainly true with photography.

For photographers, the 2002 recession was the beginning of the standardization of digital photography and establishing an online presence with a Web site. It's amazing how many photographers quit the business due to the digital revolution and how many others embraced it and flourished.

Some photographers didn't want to learn digital, whereas others couldn't deal with the change in the business model. Digital and interactive media—also known as new media and social media—will become the norm for the next generation of photographers.

Today's youth and future photographers have already embraced social networking as a way of life. Many young photographers have gotten an early start as a result of their embracing blogging, Facebook, Flickr, and other tools that already seemed second nature to them. London fashion photographer Lara Jade began extensively using Flickr and deviantART (social network for artists) at the age of 16. She developed a large following on these networks that eventually contributed to her being signed by a major photo agency in Milan while still only 19. Her popularity and networks expanded along with her career in a symbiotic fashion. She obviously had the talent to back up the growth of her career, but social networking played an integral role to her early success. You can see an overview of her Flickr collection in Figure 1.5. Because the community Lara has developed is so strong, she often gets hundreds of comments on her work when she posts new images. She regularly updates the sites, comments on the work of others, submits her images to groups, and in general is an active member of this online community.

Future photography careers will depend on the innovation of photographers willing to let go of what does not work and focusing on advancements in photography and the display of images.

Figure 1.5

Fashion photographer
Lara Jade has built a
strong community of
followers on both Flickr
and deviantART.

What needs to be let go? It's too early to tell. Social media is not here to replace presentation and marketing methods that work. Many traditional marketing campaigns will continue to work for years to come. Digital marketing should be used to enhance already successful marketing programs.

What needs to be embraced? Focus your attention on the platforms that survive this current technology shift, and don't forget your clients. Pay attention to the networks and technology they engage in. Go to your audience and build relationships wherever they are, and then engage them in your own networks. If you photograph bands, you might consider a presence on MySpace. If you work with architectural firms, you might want to try LinkedIn. If you photograph high school seniors, you will definitely need Facebook. Figure 1.6 shows how you can create a portrait studio page in Facebook and then create a photo album dedicated specifically to the seniors you photograph. If Facebook is an integral part of your client's life, it should be an integral part of your business approach.

Photographers must once again adapt to another business model shift. Social media soon will become standard operating procedure as it loses its cutting-edge status.

Figure 1.6

Go to the network where your audience is.

Does Google Know You?

It is estimated that 80 percent of people with Internet access use searches to educate themselves about products and services. We would suggest the numbers are even higher for photographers.

If you don't have a Web site, you are not in business. Photography buyers depend on online portfolios to research photographers they would like to interview, call for a portfolio review, or hire.

This means the easier it is to find you, the greater the chances a photography buyer will have the opportunity to offer assignments. Online searches have become one of the main avenues for photographers to gain new clients. Understanding the methods to improve your Web site ranking is now mandatory.

The process of actively working to improve search results is called *search engine optimization* (SEO). Your online activity plays a role in how well your Web site ranks in the search engines. This includes the quality of the content you provide, your Web site updates, and your *social media activity*. Figure 1.7 is an example of a good SEO result for the term "people photographer."

Different search engines judge the relevance of your Web pages based on different algorithms or criteria. When it comes to search marketing, the opinion that counts most is Google, which owns about 60 percent of the enormous search market. The other 40 percent is divided among the other search engines, such as Yahoo and Bing.

Google has dominated because it has strived to continuously improve its search results better than any of its competitors.

Google wants its customers to have a quality search experience. One of the goals of public relations is to present your client as an expert. Google's job is to find and present the expert information, if not the expert herself.

The main method Google uses to find the expert is based on the recommendations of the Internet community. The more relevant Web sites that link to another site based on specific key words, the greater the chances that Web site is offering quality information. In other words, the more quality links directed to your Web site, the more important you are to Google.

An important result of social media activity is the number of links that tend to connect people who follow you. These links develop because people want to share your quality information and imagery with the people who follow them.

Google loves data. The more activity and content you offer to the online community, the more data Google has to consume. Even links shared on Twitter (a microblogging platform) resulting in traffic to your Web site can affect how the search engine treats your rank position for various keywords.

Investing in the Long Tail

Chris Anderson of *Wired* magazine wrote an important book called *The Long Tail*. The concept of his book is a reminder that the Web is infinite, and once information is posted, it will remain as content for those in need for a long time.

Chris uses Amazon.com as an example in the book. Brick and mortar stores are limited and depend on the big hits for their survival. Amazon.com doesn't have boundaries and can carry every book in or out of print. If you are interested in a book about butterflies that was written 10 years ago, chances are you would have a tough time finding it at your local chain book store, but Amazon will probably have it. Amazon can carry so many books because it makes more money on individual niche book sales overall than it does on *The New York Times* bestsellers.

Have you ever asked a question within a search engine and found the answer within a forum conducted a few years ago? Chances are that question is not asked very often, but the answer has been waiting for you over the years within that forum. This is an illustration of *The Long Tail*.

Social media activity is akin to investing and watching interest compound your money. In the beginning it may not seem like much, but over time your activity turns into real rewards.

As you share useful information and imagery, you leave a trail on the Internet that leads back to you. Just like investing, if you plan well, your investment will turn into great dividends in the future.

How to Be an Expert in Anything

Everyone is an expert in something. Even if you don't engage with the online communities, social media opens the door and lowers the barrier to sharing your expertise with the world.

With so many experts on the Web, it is important to focus on a unique niche. Don't carve a niche so narrow that you can't develop an audience and following. This may seem like a fine line, but once you start producing content, you will come to find the niche content that is in high demand. For example, just covering techniques in Photoshop is way too broad to really develop any type of following. However, tutorials covering specialized fashion retouching may be in high demand and of high value. For example, the young commercial photographer Joey Lawrence built up a following for his highly specialized and stylistic retouching techniques. Another example is the seasoned photographer Jeff Curto, who has developed his niche around his history of photography podcasts and blog content.

Not every business needs mass media. Business success may be found with an audience of hundreds or thousands rather than millions.

Although it is important to add to the conversation, it is also important to listen and learn. With all the gurus and experts available, it is a great opportunity to take advantage of the knowledge available to you.

Continuous education is the key to becoming an expert. In the beginning you find people whose material you enjoy reading, listening to, or watching. Once you understand the material, you will probably begin to parrot many of the ideas learned through your self-directed training.

Over time, photographers develop their own opinions, interpretations, and skills based on the knowledge they have gathered. Once you are confident, begin to share your expertise. There is nothing wrong with sticking to the standard facts and philosophies of your niche. But an expert continuously builds his knowledge base, tests the ideas, and offers new insight from his experience. This process of learning is not much different from the process of developing your own photographic style and skills. Although you might start off with emulating others, you will eventually develop your own unique skill set and ideas.

While traveling around the country speaking to groups about new and social media, we often ask audiences if they use Google reader or another type of really simple syndication (RSS) reader. It is amazing how few actually take advantage of the technology as a way to aggregate information and educate themselves.

It is not uncommon for people to follow more than 100 blogs, Web sites, and news sources. No one has time to read them all; it is a waste of time to go to each site every day for updates because not every Web site, blog, or podcast is regularly updated. Furthermore, not every post interests every reader. The solution is an RSS reader. A reader allows the Web to come to you. A quick scan of the headlines in your personal reader will give you an overview. If you want more details, click the link to the Web site for the full story. With Google reader, you can also view the content that other people (in your Gmail contacts) are following. As seen in Figure 1.8, one of our contacts is A. J. Chavar. Followers are able to view his feed and even subscribe to certain feeds they find interesting from his content.

So, how does this add to your expertise? Isn't it obvious?

The amount of quality, up-to-date information on the Web is enormous. You can find information on just about anything at most any level of complexity.

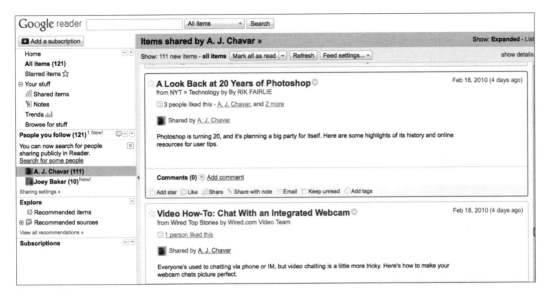

Figure 1.8

Google Reader is a way to bring the Internet to you.

If you wanted to become an expert on butterflies, it wouldn't take long to find the current experts and gurus who would guide you toward the information desired.

Top bloggers, podcasters, and video creators often link to other people they respect using a sidebar list called a *blogroll*. When bloggers link to someone, their reputation is on the line. So, the blogroll is one of the first places I look for additional resources.

It's always good to subscribe to a variety of blogs and opinions. Some expert bloggers offer links to current news and information on a regular basis. Others offer opinion and analysis. Good information, opinion, and analysis will support you in developing your expertise in the subject of your choice.

Use the expert's blog, online interviews, podcasts, or videos as a way to conduct your own extensive research before you purchase his book or invite him to speak to your organization.

Most of the good blogs offer easy methods to subscribe to their RSS feed. But if they don't offer a simple subscription solution, just click on the RSS icon in the URL field to reveal the feed and address. Often it starts with feed://. Then copy and paste the address into your favorite reader. You need to replace the feed:// with http:// for the feed to work properly.

After you have subscribed, study, organize, and apply the content from a variety of experts, teachers, and knowledgeable bloggers. Over time you can become an expert in almost anything!

What Are They Saying About You?

Whether you choose to be a part of the conversation or not, it will go on without you. Some of the online topics include you, your business, and industry.

There are many companies that are not engaging in the social media community, but they are listening and acting upon the wealth of information their target marketing offers.

Other companies are directly engaging their clients through social networking. The business printing company Vistaprint, for example, has integrated Twitter as part of its customer service. If you tweet a problem or even just mention Vistaprint in a tweet, you can be sure to hear from the company via Twitter within the next couple hours. Not only is this service useful for clients, but it is invaluable for the company as building a reputation for caring about and accommodating its clients.

Google Alerts, a free online keyword activity alert system, is an excellent example of a resource on the Web that offers great benefits. Everyone should have an account. It is most important to have an alert for your business and personal name. Figure 1.9 shows what a typical daily Google Alert looks like. You are given a list of links that contains the keywords you specified. You can then click the link to see if the content actually relates to you or your keywords.

Google Web Alert for: Lindsay Adler Photography

Investing Your Time, Extend Your Reach: Professional Photographer ...
Take a moment to read my tips in the pdf as it appear in Professional Photographer Magazine: Invest Your Time, Extend Your Reach by Lindsay Adler ...

Twitter / Lindsay Adler: The first fashion photogra ...
The first fashion photography intensive course taught by me and Lara Jade ... Sign up now! about 2 hours ago from web. lindsayadler. Lindsay Adler ...

Mikimoro Photography (mikimorophoto) on Twitter
~Unknown #quote #photography about 1 hours ago from TweetCaster ... Ahlheim · Jörg · C. Kouloumbris · Mark Allen · Lindsay Adler · Concert Photography ...

Zionc PDF | Download Free Ebook Zionc
óAmanda Zionc / Photo illustration by Nick McCann ... File name: m6293n14.pdf ... óAmanda Zionc / Photos by Lindsay Adler. WoMEn'S CLub outfit. ...

This once a day Google Alert is brought to you by Google.

Figure 1.9

Through Google Alerts, you get a daily e-mail whenever Google comes across a combination of specified search terms, such as "Lindsay Adler Photography."

The Google system sends you an e-mail every time someone writes your name or links to your site in a public location on the Internet and within the social media. It is often a reference to your Web site, blog, or work created. Photographers are often concerned about catching negative information when using the alerts. Most information captured is usually positive or neutral.

You will want to catch negative information so you can put out fires before they get too big, but positive information also can be helpful. People like to be thanked and appreciated. One of the biggest rules in social media is *givers gain*; the more opportunity you have to thank or champion another's work, the greater your results and the stronger the community surrounding you.

When you see an article or image you like, comment on the photo or posting with insightful feedback on the content. The content creator will appreciate you, and you will continue to nurture the community of communication.

Twitter is another excellent source of information about you and your brand. You can set up alerts as saved searches or RSS feeds.

> **Note**
>
> Conversations about your competition and industry are also taking place. Although you may not catch many alerts in the early days of your social networking, being aware of your competition and industry trends can be extremely beneficial.

Social Media Is Helpful

Photographers constantly find themselves in need of information. Common concerns are discovering new location information, finding a good assistant, and determining a quality place to take a client to lunch or to replace broken equipment.

Friends, assistants, and personal guides are helpful, but the social media community is much larger, and the chances of finding quality information that you can trust are much greater.

Dan Lippitt is a fashion photographer. One day he had a concept idea that involved a 1960s-era house. At most, he was hoping to find a house with a few rooms decorated in the distinctive style of that decade.

Dan put a request on his Facebook page. Within hours, he received a lead on an entirely intact house from 1963. It was beyond any expectations he had.

"I can't think of anything more effortless than writing a one- or two-sentence post … and having people respond to you and search you out," he said. "Just a few years ago we would have to place newspaper ads or call on friends or interior designers to accomplish this feat. It would have taken much longer and would have been at much greater expense."

Eventually, Dan sold the spread to a magazine and even recommended the house for a TV show in which he made an appearance.

Although Dan finds Facebook to be a great source for new work, he is impressed with the everyday referrals available to him. It is "free to use … it's the ultimate recommend-a-plumber or recommend-a-hairstylist" platform.

"When I called (the owner of) the sixties house I wasn't some random photographer (calling). I was friend of a friend"—someone [the owner] could trust. "If Jackie (the referrer) says he's cool, he's cool."

Our Future

Like it or not, social media will continue to be part of our everyday lives. The applications we use on the Web and on our phones will become more influential. Nearly every question we ask in our daily lives can be answered in some way using our desktop, laptop, and hand-held devices, which will persist in offering more information and opportunity via the social media.

Social media is communication. Social media is not just the communication tool of the future, it is the communication of now. Many of your clients use social media as their primary form of communication. People now share opinions, news, and information with greater ease and speed than ever before. You can listen to, contribute to, or even ignore the conversations. The bottom line is that social media will affect you, your business, and your industry whether you choose to participate or not.

2

Social Networking: How-To

Become a Social Media Expert

Social media can seem a little overwhelming at first. There are so many options, tools, and catch phrases. But becoming an expert in the core technical knowledge of social media is not that difficult. If you have a name, can think of a catchy handle that represents who you are, and can devise a unique six- to eight-character password, you can become a technical expert, too.

Be Efficient and Effective

The real issue isn't whether you know how to use social media. The most important thing is knowing how to use social media effectively. A large number of people know how to drive a car, but not everyone is qualified to race in the Indy 500. We're not suggesting social media takes the same level of skill as driving a race car, but knowing how to install WordPress, update Facebook pages, and understand what a retweet means doesn't make you an effective user. Knowing the tools isn't enough; there are a variety of "best practices" we will share to help you be efficient and effective.

The secret to success in social media is how you apply the digital tools. Facebook, Twitter, YouTube, Flickr, and LinkedIn have multiple uses depending on your goals and strategy. There are people who make a lot of money using direct mail as a marketing method. Mailing a letter is not complex. You would not hire someone to create and manage a direct-mail marketing campaign based on his ability to lick

a stamp and drive to the post office. Effective skills are required in any campaign, whether it's direct mail or social media.

Participate Actively

To achieve the goal of active participation in social media platforms, you need to build a community of people around your photography. Attracting people who care about your work and who you are offers great benefits. Unlike the mass media model, you don't need 100,000 followers or 1 million fans to find success.

It only takes a few quality people who champion your work to help your career. In the social media world, it's quality, not quantity, that delivers the rewards. An online community of 500 to 2,000 people will offer the success you desire.

However, collecting 1,000 followers is not enough. Your followers must be interested in you and willing to share the good news about your work.

Let's look at how the right kind of followers helped promote a post on the New Media Photographer blog. "189 Business Ideas for Photographers" is a post listing ideas that can help a photographer grow her business. Among the readers of this post are two people who also happen to have accounts with the microblogging platform Twitter. One is a young photographer with fewer than 500 Twitter followers. The other is an Internet marketing specialist with 5,000 followers on Twitter. Both read the post and promote it on Twitter by posting or retweeting a link to the blog.

The tweet posted by the Internet marketing specialist attracts the attention of four additional Twitter users. The total number of followers between the five accounts totaled more than 100,000 people. This means the one tweet yielded the opportunity for at least 100,000 people to see the blog link. In this case, though, only three people took the time to click the link and view the post.

The tweet post earlier in the week by the young photographer with fewer than 500 followers resulted in one of the highest traffic days the site has ever received. Why?

The answer illustrates the value of quality over quantity. First, the photographer's Tweet stated how much she liked the blog post, thus lending it credibility. Her followers obviously value her opinion. Chances are, many of her followers also are young photographers looking for the same information and consider her as someone they can trust. That is one of the main purposes of following someone: being able to utilize someone else's content to build your expertise and knowledge.

It is a common story across the social media community: quality and trust are rewarded. Yet mass media thinking rarely delivers a quality return. Hard marketers are looking for quick results with the least amount of effort. They want an easy way to quantify *return on investment*, commonly referred to as ROI. In the social media world, ROI means different things to different people. One of the most profound meanings is a *return on influence*.

> **Note**
>
> In business people are often looking for *return on investment*—what returns they are getting back for the effort, money, or other resource they invested. In social media, you focus on getting a high return on influence. You aim for all your social networking efforts to help you cultivate influence over your followers and network.

Be Influential

Influence is earned. Once you establish trust, the opportunities will start to develop and multiply.

Avoid selling to your community because they are already sold on you. They like you and want to hear more about what you have to say and what you want to share visually. A big part of your job is to continue to offer what attracted them to you in the first place.

People in unrelated fields generally aren't the best referral sources. Think about the people who give you the most business. What is the common thread, and how can you serve them best?

For example, event planners may be your best source for referrals. The next question is this: how can you become a resource for event planners? Maybe modeling agencies offer you opportunities. What can you do for them?

The next step is to offer your target followers the tools and ammunition to refer you and help you build a larger community who will support your career as a photographer.

Look at Your Community: The Solar System

A helpful concept to work with when building your community is to look at your social media marketing plan as a personal solar system.

In the center is the sun, or your Web site. Closely orbiting your Web site is your blog. Revolving around them are your inner planets, and the far boundaries contain your outer planets, as seen in Figure 2.1.

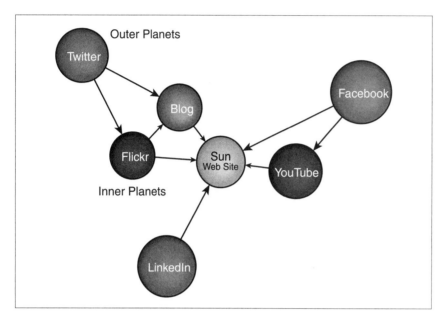

Figure 2.1

When approaching your social media marketing plan, look at the plan as a solar system, with your Web site as the essential center (sun) of the personal system.

Your Web site shows visitors what you do, and your blog tells readers who you are. The Web site is your brochure. It should contain your portfolio as well as sales and e-commerce information. Your blog helps prospects develop a deeper understanding of who you are as a person through your writing, the display of your favorite images, and information about side projects.

Beyond the Web site and the blog orbit the inner planets, which are hybrid sites such as Flickr, which is a photo sharing Web site, and YouTube, which is a video sharing Web site. Photographers use these sites to display their work, but the social aspect of these platforms still allows for community development.

Next are the outer planets generally reserved for community building. Sites like Twitter, Facebook, and LinkedIn are designed to meet new people and develop relationships. Your focus with these sites is to network and attract people into your solar system through meaningful engagement.

Most of your social time is generally spent within the outer planet communities. All planets within your solar system are capable of earning new followers and should be regularly updated and maintained. The ultimate goal is to drive people to the center of your solar system so that they may become familiar with your work, produce sales, and encourage referrals.

Market Yourself

There is a pervasive element developing in the social media realm: people interested in easy money.

These people have come to the wrong place. Whether it's online or offline, there are two types of marketing: hard and soft.

Online hard marketing is paid advertising, such as banner ads, Google's AdWords, and e-mail marketing. Soft marketing has its roots in public relations. It's about content and becoming an expert in your field. People are attracted to experts and seek them out for their knowledge. Most of social marketing is based on this model.

Those looking for a quick buck really need to stick to hard marketing. They should spend time writing e-mail campaigns, creating engaging ads, and using analytics programs to improve returns. Soft marketing means delivering quality content to the people who care, building a community, and rewarding those who refer opportunities.

Mass marketing will always have its place. But it's becoming harder to do because the world is moving toward niche activities and communities. Hard marketing will continue to offer value as part of a marketing plan designed to drive a message. As consumers are given more choices, building brand loyalty will take trust, expertise, and service.

In the world of mass hard marketing, quantity is the key. It means sending your message to as many people as possible and hoping it sticks to enough people to turn a profit. Again, a good media platform and the right message can be very profitable.

In the world of soft marketing, quality is much more powerful than quantity. Building friends and enthusiastic followers is most important. In social marketing, having 100 people who *do* care is better than having 1,000 people who *might* care.

Companies with popular brands and established followings will have an easier time using social marketing to quickly create hard marketing results. Starbucks is a good example. The worldwide coffee chain has brand recognition and fans. Once a social media page is set up in Starbucks's name, its already-established legion of fans will flock to the site, and a new subcommunity will form. Large groups have their challenges and require different strategies.

There are only a few photographers with such a powerful brand. Most photographers need to build a community from scratch. Hard marketing can help attract people to a community, but soft marketing keeps valued clients loyal with the ammunition to refer new business over the long term.

The biggest social media marketing failures often come from mixing the hard marketing and soft marketing platforms. Examples of this are implementing mass-marketing techniques on Twitter or using niche-topic lingo with mass-marketing advertising.

Some photographers just don't understand the value of developing relationships versus advertising. For example, you will see photography lecturers and teachers who use their Twitter accounts only to send updates on their newest speaking engagements. These people will likely not develop many new followers. A person could simply visit a Web site for a list of speaking events. If this person used Twitter to share important tips and information while cultivating a following, she would be much more successful utilizing the power of this networking tool.

Photography and photo lecturer Don Giannatti of www.lighting-essentials.com gets it. Don, or @wizwow on Twitter, teaches light techniques and portrait photography internationally, and photographers are one of his target markets. His Twitter feed is not just a list of the dates and times of his upcoming lectures. In fact, he seldom promotes the lectures. As demonstrated in Figure 2.2, Don's social media efforts focus on giving valuable content in the form of blog posts, sharing interesting links, and carrying on industry-related debates online. His sizable following wants to learn about his expertise and opinions, not his teaching dates.

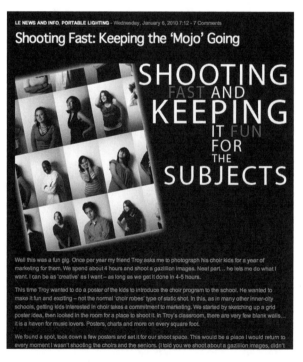

Figure 2.2

Photographer and photography instructor Don Giannatti keeps his blog and Twitter feed consistently updated with photo industry news, technical photography information, and more.

Chase Jarvis, a world-renowned photographer and social media guru, has described the online world of social networking as a giant cocktail party. If you go around and just promote yourself and don't provide anything of interest or value, people won't want to talk or network with you. If you don't seem like a real, genuine, and interesting person, your efforts will fail. Importantly, if you just sit in the corner and don't try to interact, you have lost before you have begun.

Hard marketing is short term and often targeted to the masses. Soft marketing is long term and well suited to niche targets.

Both are valuable. One takes more money and the other takes more time.

Photographers need to make decisions as to how they want to prioritize their marketing budget as well as their time. If not well planned, both can be wasted.

Share and Share Alike

The value of each new social media Web site is not always understood in its infancy—not even by its creators.

Not everyone understands Twitter, and if you asked just a year ago, most people had barely heard of Twitter. Many people have opened an account, tinkered with it a little, and then concluded, "I don't get it; this is stupid." In the early days of Twitter, even the most tech-savvy people didn't know what to do with this user-friendly platform. Some immediately started using it for chatting, whereas others updated each moment of their lives. Even some of the popular social media gurus failed to follow their peers on Twitter because they felt they couldn't keep up with all the tweets. Over time, people started to discover for themselves the best ways to use the Twitter platform.

Tweeters started to share words of wisdom, useful information, and links. Finally, the Twitter community came to an understanding. It's not about chatting. Twitter is a powerful and informative media stream.

This is a common story for many platforms and applications on the Web. It is impossible—and there isn't a need—to know how to use them all.

No one knows what will be the next revolution in communication. It is not necessary to jump on every new, shiny object presented at the Las Vegas Consumer Electronics Show or join every platform presented at SXSW (South by Southwest). It is important to listen to what your target market is talking about and where they may be headed next.

Network Online and Off

Business is about people. Quality networking is an important part of building a rapport and trust with the people you meet online and in person.

Have you ever attended a networking event and bumped into the guy with the stack of business cards in his hand? He's the one darting around the crowded room throwing down cards like a blackjack dealer.

This is not networking. It's handing out business cards quickly.

Why is dealing business cards a waste of time? Relationships are not built on the exchange of cards. If all you do is hand me a card, I have no reason to keep it or to remember you.

It is a far better approach to take time to get to know people. Rather than spend mere seconds with as many people as possible, take the time to get to know two or three people well at each event.

Ask Questions

Learn to ask questions. People love to talk about themselves, so give them more opportunities to do so. The more they talk, the greater the odds of discovering a potential business lead. Also, when you learn more about their interests and goals, there is greater opportunity to appeal to their needs.

Give to Others

Quality networking is the result of living by this motto: givers gain. The goal is not to sell to the people you meet, but to educate them on how to find referrals for you. Few people enjoy a sales pitch. Most people like to be helpful. If you build trust among the people you meet, they will be more inclined to refer you.

Build Trust

The most powerful way to build trust is to do what you say you will do. For example, if you say you will follow up with information on a particular matter, follow up.

People like people who like them. Showing sincere appreciation and interest in what people do can go a long way toward building relationships.

Spend a little extra effort championing, referring, and connecting people. This can be as simple as commenting on a blog post or retweeting information you find valuable.

Note

Retweeting is when you repost the content shared by another Twitter user. When someone shares something you find interesting and want to share with your followers, you can click the Retweet button to post the information again. When retweeting, cite the original source of this information. (Give credit where credit is due.) See more in Chapter 11, "Twitter."

Cater to Your Audience

Online social networking is just like offline networking. Self-promotion is an important part of marketing. We call self-promotion *you* marketing. Presenting your portfolio of images helps to distinguish your work from the competition.

The social media world has little tolerance for self-promotion. Everyone needs to share their story, but ultimately what we call *them* marketing goes a lot further.

Your target audience is *them* marketing. What does your audience want to hear? What are their interests? People like to help people who support and like them. What can you do to make others look better?

If you share activities you are involved with on a particular day, be sure to frame your tweets or blog post in a way that helps your followers. What did I do today that would be of interest to my followers? What information could I share that would be helpful to them and their goals?

For example, don't just share "At a shoot for a jewelry client." Instead, consider listing the model agency used, others on the creative team, info about lighting setup, the location of the studio, or any behind-the-scenes information that would provide insight to your followers.

Act Like Jack

Photographer and social media guru Jack Hollingsworth (see the interview in Chapter 17, "Your Stories") has built a positive reputation in the social media world because he is a connector who spends a lot of time championing others. Within months of launching his Twitter account, Jack became one of the most followed photographers on the microblogging platform. He didn't accomplish this by shouting to the world, "Look at me. I'm a top stock photographer."

He took the time to reach out to his audience. As seen in Figure 2.3, Jack's Twitter feed is not solely self-promoting or just chatting among fellow tweeple. Instead, his Twitter content is a mix of promoting other photographers, sharing valuable links, blogging, taking polls, and more.

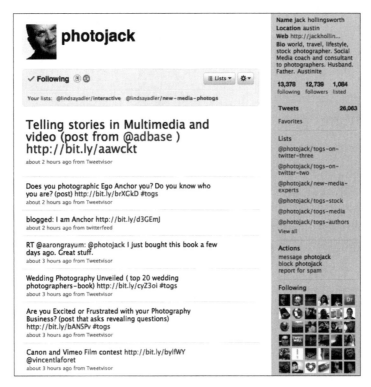

Figure 2.3

Jack Hollingsworth regularly reaches out to his audience to share useful links, take polls, share his musings (through blog posts and tweets), and advance the online conversation among photographers.

Jack has taken his role as connector beyond the virtual realm, organizing *tweetups* (gatherings of Twitter users) and other events to allow the traditional face-to-face networking to grow from online social networking. Although online social networking is a great way to break social barriers and start new connections, it is often valuable to solidify these relationships by one-on-one contact when possible.

You need to champion other people, share information, and support the efforts of others within your target social media community. Don't jump in wondering how you will get yours. Dive in to the social media world and announce that you're there to support others.

3

Social Networking: Your Story

In Part II, "The Basics of Social Networking," you will lay out *your* social media marketing plan. But before you begin that process, you need to think about who you are. What is your niche, what are your goals, and how do you want to present yourself to the world?

Create a Niche

When it comes to your photography, don't say that you can photograph everything. That is a common mistake. Photographers say this sometimes because they don't want to miss an opportunity by narrowing their prospects.

Success, especially in social media, is the result of developing yourself as an expert in your field. If you try to be everything to everyone, your message will be lost in the static of the expanding Internet and the fast pace of the digital world.

Be Memorable

The goal is to be memorable. Many people are intrigued by photographers. We have fascinating jobs that people actually care to hear about. If a guy asks you what you photograph and your answer is *everything,* you risk losing interest. Perhaps if the man finds himself in need of generic photography, he might call you or refer you to someone else in need of an *everything* photographer.

The world is full of "I photograph everything" photographers. Your networking prospects need more help to remember you. Over time, they will meet other generic photographers. Most likely, they will refer the last *everything* photographer they meet.

Be a Specialist

If you are specific and say, for example, that you are a *food* photographer, your name and specialty will live longer in the minds of the people you meet. You may not be in the running for people, architecture, or automotive assignments, but when the opportunity for a food photographer comes along, chances are your name will come up.

Photographers sometimes mention that they specialize in babies, family portraits, weddings, and corporate events. Generally, long lists lead to confusion. Why not narrow the focus to *people* photographer? This is more specific. Depending on your audience, however, this description could be interpreted as a *generic photographer of people*. It is helpful to drill down even deeper, such as presenting yourself as an executive portrait photographer.

What is your strongest photographic discipline? What are you passionate about? Take the answer and narrow it to a tightly focused statement:

- I'm a food photographer specializing in pastries.
- I'm a photojournalistic-style, black-and-white wedding photographer.
- I'm a high-end residential interior photographer.

Defining your niche doesn't have to define your career. Consider it a starting point. You can still accept other assignments you feel comfortable photographing. But when you are networking, present yourself as a specialist.

Take a look at the practices of photography agencies. They never market someone as an everything photographer. They present their artists as experts in a particular area of photography and display portfolios that represent their expertise to make their marketing efforts easier and more focused. Furthermore, if you are a photographer who hopes to sign with an agency, a specialty is essential.

Be Flexible

It is common for additional opportunities to arise outside your niche. A food photographer creating images for a restaurant may be asked to photograph the chef and the interior of the building. The restaurant architect may like your architectural images and ask you to photograph other projects.

It is important to have separate portfolios and resources easily available—especially if you have additional strong talents. For example, the restaurant architect probably will not want to view your food portfolio. In most cases, don't even mention your food photography to the architect. The architect wants to hire a specialist.

This principle also holds true for the online social media world. People remember and prefer specialists. It is much easier to dominate a photography niche that may lead to other opportunities than to attempt to dominate the photography world.

Niches come in many forms. The goal is to separate yourself from the pack. If you limit yourself too much—such as describing yourself as a photographer of Amazon darner dragonflies or ghost orchids—you may find there is little demand for your work.

Some photographers, however, have thrived from their "super-niche." Photographer Mark Moffett has become known as Dr. Bug because of his extreme niche in studying and photographing insects. His work has appeared in *National Geographic* countless times, and he is the go-to person for insect photography. This specialty has also offered him opportunities to create stunning travel and nature images that go far beyond bug photography.

Specializing is a careful balance; you need to define your niche and become an expert without overlimiting yourself.

Develop Your Story

What is your story? Once you decide on a niche, it is time to develop your story. Your story should reflect your passions, and you must enjoy telling it to others.

Your story may incorporate many elements, such as photographers you have studied under, people you have photographed, or places you have traveled. A clear word picture of your photographic style or business practices is also an effective element of a photographer's story.

Some photographers champion a cause, whereas others are known for the specialty products they sell.

No matter the story, it needs to be memorable. Average will not get people's attention. Saying "I'm a people person," "I use professional equipment," or "I have been in business for 20 years" is generic and not memorable enough for people to remember you.

To be remembered online or offline, your story must excite people so much that they want to share it with others. That is how stories spread and how social networking works to build careers. Don't brag about your own story. Instead, be excited and proud of your accomplishments. Encourage people to be excited with you, and they may begin to feel emotionally invested in your career and offer their help to see your career grow.

When telling your story, be sure to consider what makes you different from other people and from other photographers. What excites you as a photographer? Your passions and accomplishments are part of this puzzle.

Beyond your essential backstory, what is the image of yourself you want to portray? What do you want to communicate about yourself? What are your goals for online networking activities? London photographer Felix Kunze set out to define his essence before really diving into social media. He sat down and wrote a list of characteristics he wanted to portray and ideas he wanted people to associate with him. This list included characteristics like "busy metropolitan photographer," "upbeat and thoughtful," and "a touch of mystery." Another goal he set out was to focus always on quality, never mentioning cost.

Write out the story you want to convey about your past, present, and future. Keep these attributes in mind when you participate in social media.

Create Goals

You need to have goals if you want to get the most from social networking. Doing that means identifying your target market, acting as a resource, sharing valuable content, and managing your time.

Identify Your Target Market

You need to identify your target market. This is extremely important. Just as your specialty should not be *everything,* your target market should not be *everyone.*

One of the biggest mistakes photographers make when they get involved in social media is focusing only on information interesting to other photographers. It is fine to develop a comfort level with social networking by beginning your efforts by interacting with other photographers. But remember, this is not necessarily the audience you want to target to grow your career. Unfortunately, thousands of passionate photographers will not pay your bills unless you are selling them a product or service.

Act as a Resource

Recently, a group of Internet marketers met for dinner outside of Detroit to discuss *search engine optimization* (SEO). One of the marketers is a social media consultant. Two others focus on affiliate marketing. The other found her success with *search engine marketing* (SEM) using AdWords.

As the evening progressed, the SEM marketer acknowledged that she liked the idea of using social media but didn't think it was a solution for her target market. The social media expert asked her to explain.

The SEM marketer explained that she sells pianos and that her target market focus is piano teachers. The implication is that piano teachers don't spend much time on Twitter.

The social media consultant offered a solution: create a resource for piano teachers.

The same solution works for photographers. Once you know your target market, create a valuable resource for it and establish yourself as the expert. The resource you create does not have to be related to photography. You are there as the resident photography expert.

For example, as a wedding photographer your target audience is brides (or engaged couples). So how could you use social media to attract brides? Consider creating a blog or other online resource that educates brides on what they should look for in wedding photography. Discuss different products, prices, options, and capabilities. Another approach would be to create a resource educating brides on how to look their best in their wedding pictures. You are the photography expert providing extremely valuable information to your target audience.

Share Valuable Content

You can share the valuable content on this resource from a Twitter feed, a blog, a forum, or interactive community. The size and depth of the resource depends on the amount of energy, content, and time you want to apply to a social media strategy.

If you want to attract architects to your community, you need to find out what interests architects. If your goal is to appeal to chefs, ask what resources chefs are seeking and create it.

Manage Your Time

One of the most common criticisms of social media is that it consumes time.

The truth is, technology is taking more of our time as it transforms the once complex, expensive, or inconvenient into something easy, cheap, and available.

Photography once was a craft that took time and effort to master. Today, millions of people spend their free time capturing digital images and sharing them with the world.

Today's photo processing lab is contained within the personal computer. Photographers spend more time than ever processing and organizing digital images and experimenting with post-processing techniques.

The social media world is following the same path. Traditional media outlets continue to consolidate. As a result, you are now responsible for telling your story. Social media is the new public relations outlet, which takes some time and effort to master.

Learn how to manage your online time wisely. It is possible to develop a plan that takes only an hour a week, or 30 minutes a day. Some of this depends on the platforms you use. Many photographers who successfully utilize social media suggest that an hour a day is more than sufficient to achieve their online goals and expand their business.

Twitter can be an effective tool using only five tweets a day. A photographer can post a photograph with a descriptive paragraph to her blog once a week.

Caution

Beware that Facebook can take up your entire day if you comment on every status update scrolling across your screen.

The key is not how much time you spend but how consistent you are with your content postings and the quality of these postings. Make social media part of your workflow. Start small and as you see results, make adjustments. As your community grows, you will need more time to support it. A large community of the right people can offer great professional and financial rewards.

Be Real

The Internet can be a cold place, and if your goal is to connect with people, you need to portray yourself as a real person. Be personable. Be sincere. Be real.

One of the biggest debates in the social media realm is whether to automate. Purists insist that any kind of automation is bad and goes against the core of what social media is all about.

Hardcore marketers see the value of a target audience but don't have the time or the desire to be social. Instead, they send out automated status updates to multiple accounts and platforms. It is also common for hard marketers to have automatic feeds streaming through their social media platforms.

Unfortunately, such impersonal actions take the *social* out of social media. Imagine sending a robot to a chamber of commerce networking event. Sure, you can program the robot to deliver your message, say how great you are, and share random facts about your work. The robot might even attract attention at first. But over time, the robot's inability to interact in a meaningful way will turn people away.

It is common for an automatic feed to be well followed. If you look a little closer, however, you'll see a large percentage of the followers are other robots. Robots are used to increase followers automatically and quickly in the hope that the large number will become a referral or consumer pool. Unfortunately, robots who follow you don't refer many people or purchase much photography.

It is hard to champion others if you are not around to develop relationships.

Hiring people to maintain your social media program is an option. For the average photographer, that person might be an assistant or a spouse. Be truthful about who is behind the scenes. The goal is to build relationships; representatives can do a better job if they are allowed to show their personality.

For example: Sue from East Coast Studios, Rick from Smith Wedding Photography, or Juan from Cityscapes Gallery may represent a photographer without the photographer being involved within the social media. It is important for a photographer to have confidence in your representative's personality and ability to establish positive relationships with your target market. Your representative just might become more well known than you.

Your brand is your personality. How is your brand being represented? Your branding should be as consistent as the amount of time you spend employing social media. Colors, design, copy, and photographs need to represent you well.

Your logo is not you. Many photographers use their logo or favorite photograph as an avatar in the small one-half inch box provided on the platform profile page. The problem is that logos tend to create an unnecessary barrier between you and your prospects. If the goal of social media activity is to promote the symbol or style of photography in a branding effort, a logo might have some advantage, but for most photographers there are better methods to share your logo and work.

Note

A symbol of you doesn't connect with other people as well as a portrait does.

You need to show the person behind the artwork and the business; people develop a relationship with other people, not with logos. The Internet can be a cold and distant place. Your job is to become a warm and approachable person in this environment. Twitter is about communicating and sharing with others. As seen in Figure 3.1, Trudy Hamilton of TruShots utilizes a photo of herself for her Twitter profile picture instead of her company logo. This lets followers associate her tweets with a real person. A larger corporation, such as Canon, could legitimately use a logo if it were primarily sharing corporate information or press releases with followers.

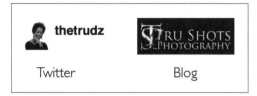

Figure 3.1

Using a personal photo helps people connect with you as an individual.

Part of your branding consistency is deciding what keywords you are going to focus on in your branding campaign. Search engine optimization isn't limited to Web sites. Blogs, Twitter, forums, and Facebook professional pages are indexed by search engines. The more links containing your keywords that lead to the center of your solar system, the more effective your social media campaign.

Consider Multiple Platforms

One of the wonderful benefits of social media is that it has a long shelf life. Internet media is available to interested consumers on their terms. Blogs are written and podcasts are recorded with the knowledge that people will listen over time. Depending on the topic, social media posts will last for years.

It is important to consider multiple platforms for your social media solar system. Blogs are a standard and should be considered a starting point. Many people like to listen while they work and prefer podcasts for this reason.

Platforms offer a variety of features for your audience. The most important social media sites are the ones that your target market prefers.

Consider signing up for every promising new site you encounter. Fill in your information, and make sure you get a representative name or handle. List your home Web site and key social media addresses. Then test the new Web sites, and check in every once in a while.

It is impossible to keep up with all the social networking sites, but if a site takes off and your target market finds it valuable, you are already an established member. Furthermore, having an account with accurate information on a variety of sites helps your searchability and SEO.

Final Establishing Thoughts

Social media is about building trust and your reputation as an expert in your field. Trust is not earned overnight. On the other hand, distrust and a bad reputation can develop quickly.

Not everyone is cut out for the social media marathon. It takes time and effort and is often a lonely game in the beginning. Submitting your first blog post and delivering your first tweet or Facebook status update is usually met with little fanfare. You feel like you are talking to an empty room, but slowly you will fill this room with people who are interested in what you have to say, and they will bring their friends if you consistently provide valuable content. For example, in Figure 3.2, Lindsay Adler tweeted two photos to her followers asking which photo had the preferable retouching effect. She received more than three dozen responses in 30 minutes, helping her to make her creative decision.

Figure 3.2

When you gain enough followers in your social network, you can ask them questions.

Build a Community

As you network and make connections over time, you will gain followers. If you offer quality, insightful, and unique information, people will refer you, share your content, and encourage others to become part of your community.

Some people don't have the patience for social networking. They are sprinters who charge out of the gate, knock on every door, and invite every warm body that says yes into their community. They gain numbers fast and work them hard. In the end, though, they don't find the rewards they thought they would with such large numbers. They don't earn the results.

Once you get past a few plateaus and earn critical mass, you will notice how your following will compound and your calls to action will be answered in greater numbers with positive results.

Note

Social media is about quality, not quantity. Winners earn both quality and quantity. Having a large following of people who trust and care about you is extremely powerful.

Over time the competition will drop out of the race. New people will quickly fill their shoes, but you will have been promoted in the standings, gaining new followers and earning more trust. Time will reward you with more influence. People who trust your opinion will often follow your lead.

As they said in the *Spider-Man* movies, the more power you have, the greater your responsibility. If you earn a large following, the temptation might be to attempt to squeeze every bit of social media *return on influence* (ROI) into fast cash. But that is the quickest way to lose trust and credibility you have worked so hard to earn.

Every social media platform has a different tipping point, or critical mass, in which your influence starts to carry a little weight.

Give First, Get Later

The best method of gaining quality followers is to remember it's about them. Give, give, and give some more. Building relationships with people isn't a quick and easy task; it requires continued effort. It can take months or years to reach your goals, but that is why social media development is a long-term project.

Part II

The Basics of Social Networking

4

The Plan

Name Your Domain

The first step in developing your online marketing solar system is to select a domain name for your Web site. The Web site is your online brochure, so it should be professional. Your domain name should contain some of these elements: your name, business name, location, or specialty. It is important to keep the name simple and easy to remember. It's possible to use all the elements, but doing so would lead to a long, clunky name.

In devising a name, think about your target market and what they are looking for when searching for your service, such as your location and a description of your niche or specialty.

Ask people you know how they would search for your photography niche. What words would they put into Google to find suggestions? Ask the question a few different ways and compare the answers. You should see a clear pattern.

Take advantage of the Google Insights for Search tool at http://www.google.com/insights/search. Narrow your niche to one to three words. Insights for Search displays other options and comparisons that relate to your search terms. For example, `Florida photographer` may receive more traffic than `Wedding photographer`, or vice versa depending on the time of year. As seen in Figure 4.1, Insights allows you to view and compare the number of searches done for different keywords of a period of time (days, weeks, months, years). You can compare different terms

(in this case Florida photographer versus Miami photographer) over a period of time. It is common for Insights to reveal search phrases that you have not even considered as options or ones that are more commonly used

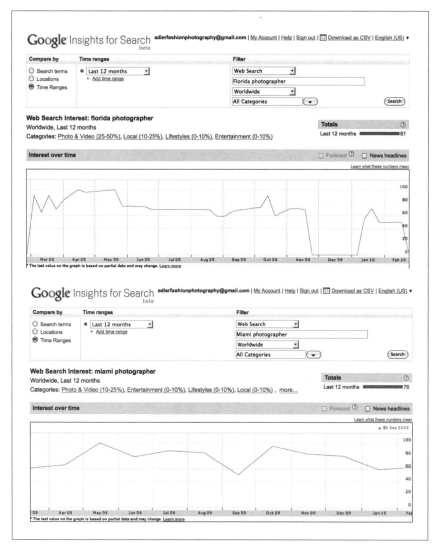

Figure 4.1

Google Insights helps you determine the most common search keywords related to your area of photography.

Consider the type of traffic that certain keywords might generate. Florida photography might offer more traffic than Florida photographer. Unfortunately, people searching for Florida photography might be looking for landscapes rather than the photography services you offer.

Consider how you are going to present your blog. The blog is the foundation of your social media efforts. If your blog is an extension of your Web site, it is recommended that you create a subdomain.

A blog tends to increase traffic through improved search results and returning traffic due to regularly updated content. Keeping your blog attached to your main domain supports your Web site standings within the search engines.

It is common for a subdomain to be titled blog. For example: http://blog.mywebsite.com.

Common blog topics include assignment outtakes, behind-the-scenes at photo shoots, the process of image creation, personal projects, opinions, and reflections on assignments and the photography industry.

There is a misconception that blogging is about opening up your everyday life for the world to view. You have control over how much information you share. Many blogs just talk shop, whereas others detail the emotional life of an aspiring photographer. The saying is true: No one cares what you had for lunch. You don't have to share your family life to open up and offer a deeper understanding of your photographic style, philosophies, and workflow. Photographer John Harrington's blog seen in Figure 4.2 focuses primarily on the business of photography. He is able to share his own experiences and thoughts with other photographers without venturing into the personal realm.

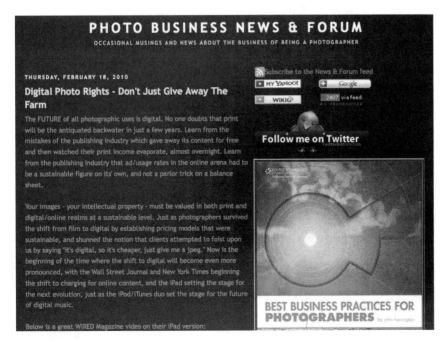

Figure 4.2

Photographer John Harrington's blog focuses on the business of photography and his experiences as a professional photographer in Washington, DC.

Other photographers, on the other hand, might find it relevant and easy to connect with their audience by communicating more personal stories.

If your blog offers information not directly related to your Web site theme or photography, consider using a separate domain to develop a unique brand identity.

Although a separate domain will not directly benefit search rankings, traffic from people interested in learning more about you will offer opportunities. Some photographers have multiple blogs focusing on different niches. Although writing multiple blog posts is a lot of work, the extra traffic provides benefits. Some benefits include name recognition, high-ranking quality links, and nonphotography-related opportunities such as teaching, speaking and writing.

The main focus in all your decisions must be your target market. You have only seconds to share who you are and what you offer as a photographer, so keep things simple. A relevant, high-quality, and easy-to-understand domain can help cut through the noise.

Set Up a Professional E-Mail Address

When you purchase your domain name, you have the opportunity to set up a professional e-mail. Consider using two e-mail options: info@yourwebsite.com and yourname@yourwebsite.com. The info e-mail should be used on your Web site as a method of contacting your company. The e-mail with your name is your professional e-mail.

It is not professional to use Web-based e-mail or e-mails with unrelated titles such as im2sexy89421@gmail.com. However, some photographers can get away with using creative names in their e-mail accounts; it all depends on your personality and target market. Photographers are creative people, and a catchy name can be a benefit. As standard operating procedure, though, limit crazy names and funny nicknames to your personal accounts.

If you have multiple professional e-mail accounts, consider directing them to one central account. It is okay to use a Web-based account as your central location, but make sure you change your "reply to" settings so that returned e-mails display your professional e-mail address.

E-Mail "Signature"

Be sure to set up an e-mail signature—the words and contact information that will appear at the bottom of every e-mail. Your signature should include the following:

- Your name
- Your mobile phone number
- Your Web site address
- Your blog address (if different from your Web site address)

Feel free to include a couple other links if they are particularly relevant to your online brand, such as a link to your Vimeo account (if you produce tutorials or videos) or your Twitter account. Be sure that your signature doesn't become excessive, although everyone has his own style. Photographer Jack Hollingsworth, for example, includes many more links and even samples of his work in his e-mail signature, shown in Figure 4.3.

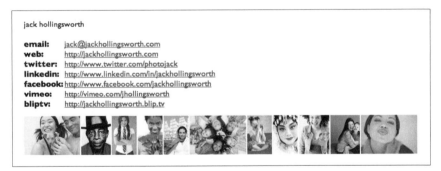

Figure 4.3

Include an e-mail signature at the end of your e-mails with essential contact information.

Prepare a Biography

You need to compose three bios of different lengths for yourself. Each Web site and promotional opportunity has its own space requirements. Ideally, your bio should show your specialties as well as a bit of personality. Most people do not have complete and well-thought-out biographies available. Having one at a moment's notice will give you an advantage. Consider keeping a folder on your desktop with all three biographies, current photographs, and samples of your work that can be quickly delivered when requested.

- **A one-sentence bio.** This should be a concise description of yourself in no more than 140 characters. This is the bio that will appear on Twitter and some of the other social networking sites. Think of this as your tagline. See Figure 4.4.

- **A one-paragraph bio.** This is the slightly longer bio that will appear on most of your social networking sites. Think of this as the elevator pitch for yourself. What interesting things about yourself would you use to promote yourself to a stranger? This bio would appear by your name if you spoke at an event or if someone wanted a snapshot of your experience and expertise.

- **A one-page bio.** This more detailed bio can appear on your blog, on LinkedIn, and in other places where a more complete description of your accomplishments is appropriate.

Name Tru Shots Photo
Location Your Prefrontal Cortex
Web http://www.trusho...
Bio Trudy: photographer, creator of @hiretogs, psychology blogger, book lover, shoe aficionado, and adventurer by both choice and fate.

| 903 | 1,692 | 235 |
| following | followers | listed |

Name Jim Goldstein
Location San Francisco, CA
Web http://jmg-galler...
Bio Web Strategist / Photographer: Capturing the worlds beauty one photo at a time. Photographer of landscapes, nature and anything beautiful

| 2,945 | 4,026 | 539 |
| following | followers | listed |

Figure 4.4

Your one-sentence bio is featured on your Twitter profile and is useful as a tagline for other sites.

Most social networking sites give you the option to personalize your profile by adding a picture or avatar. You should always upload a picture, and ideally you should use the same profile picture across all social networking sites. This helps to establish brand consistency and helps people recognize your virtual presence across the Internet. The repetition of the image will help them connect the dots between you and your work.

If you don't already have a favorite photograph of yourself, you can set up a profile picture shooting session with a fellow photographer. You might consider setting aside an evening with a photographer who has a studio, or a group photo session on a good-weather day. Everyone should take turns photographing one another.

Even if you are a dramatic person, avoid overly dramatic lighting. The photo should make it easy to see your face and show up easily even at small resolutions.

You can wear whatever you like in the photo—not much of it will show—but make sure you look like a professional. For women, avoid tank tops because the way the image crops could give the illusion of being topless (or dressed in risqué clothing). Consider dressing in what you'd wear to events or gatherings. This could help people make the connection between your online identity and who you are in real life.

Be sure your image crops well as a square (see Figure 4.5). The majority of profile pictures in the social media are square formats. If your image doesn't crop well as a square, either the image will become distorted (stretched or compressed when uploaded), or you will have to crop it into an awkward square anyway.

Figure 4.5

Your profile photo should be a clear, well-lit, and preferably square close-up of your face.

Caution

Do not use party pictures, old photographs, or logos for your avatar. Logos and images create a barrier between you and your prospects. You have plenty of room to share your logo and images within most social media sites.

Multiple-Sized Photos

Be sure to have a few different resolutions of your profile image to serve different purposes:

- Full resolution 2 × 3 to include with promotional and print materials
- 200px × 200px to upload on social networking sites like Facebook
- 40px × 40px to upload on social networking sites like Twitter and your Google profile

Also, you should consistently name your image files as such: `yourname_resolution.jpg` (aka `lindsayadler_40x40.jpg`).

Create an Identity Through Branding

Creating an identity is the foundation of branding. Logos and corporate designs transfer an impression about a person or company. All the elements used in visual branding should be well thought out. Test your branding ideas on friends and associates to avoid problems down the road.

Interview a Designer

Your logo is not your brand, but it helps people to identify you and your work. If you already have a business logo, great! If not, there are a few things you need to ask yourself. Who is your target audience, and what are you trying to convey to them?

Your logo should represent all your work. It doesn't need to have a graphics element. In fact, you can create a logo using a color scheme and a particular font or typeface that you want to represent your business. Photographer Melissa Raimondi has both a graphical logo and a typeface for her business identity, as seen in Figure 4.6. Sometimes she utilizes just the graphical crop mark logo to represent her business, and other times she uses the two together. Her logo represents the feminine and artistic touch she adds to each image.

Tip

Design your logo yourself, or hire a professional. You might barter with a graphic designer by offering them headshots or photography services in exchange for your logo.

Figure 4.6

Melissa Raimondi has a graphical logo and a typeface that represent her feminine and artistic approach to photography.

When choosing a logo, consider whether you want one color or a multicolor design. Do not take this lightly. These colors will be used on your Web site as well as your paper communication for a long time.

Suzanne Adelhouser, a graphic designer and owner of Madhouser Design, Inc., suggests a simple logo. You only have three seconds to make a good impression. Will your complex logo get the message across in a timely manner?

Suzanne also suggests considering all the locations and media on which you might use your logo. Think beyond the Web site. Hats, T-shirts, letterhead, cards, and print promotions require higher-resolution graphics.

It is important to have the original artwork created as a high-resolution vector graphic. A vector graphic is a resizable image based on pixel arrays. Images can be resized without loss of quality. This type of file is commonly found in illustration software such as Adobe Illustrator.

Suzanne also recommends considering logos that look good in black and white before color is applied. Also avoid fancy and unreadable fonts, unrelated images, and complicated designs.

Be Alert

Knowing what is being said about you, your company, and industry is an important step in engaging with the social media community. Creating a Google Alerts account is the best first step.

Google sends you an e-mail every time your name or keyword term appears online. This allows you to see who is talking about you positively or negatively or where links to your name or Web sites are showing up. You tell Google what terms to search for and provide different variations on your name or business that might appear. For example, Joseph Smith might appear as Joe, Joey, or Joseph. Figure 4.7 shows a typical daily Google alert e-mail, providing a list of links where the specified terms (Lindsay Adler Photography) have appeared together.

Figure 4.7

Daily Google alerts notify you where your name (or other specified terms) has appeared or been linked to online.

It is important to keep track of your industry as well as your competitors. Knowledge of your industry or niche trends can be helpful in making future business decisions. Your competition can also leave clues to success. What other people say about your competitors can help identify why people hire them or what they do to promote their business.

Businesses often use the Alert system to identify negative information. The most common alert is usually positive. One of the most powerful methods to develop a loyal community is to thank and reward people. The people who say nice things about your work, Web site, or blog should always be acknowledged to the best of your ability.

To set up alerts, go to Alerts.google.com. There will be a box to input an alert term. Under the box will be options related to the type of alerts you want to follow, such as news, videos, or blogs. You may also set up how quickly or often you want to receive the alerts via e-mail.

Domain and Registration Services

Here are a few places where you can purchase domain names. To learn more, see Chapter 6, "Your Web Site."

http://www.godaddy.com

http://www.networksolutions.com

http://www.register.com

http://www.domain.com

Prepare Your Web Site

Your portfolio is the vehicle on which to display your best work. It is a representation of your vision as a photographer. Presenting a professional portfolio is the most important thing you can do as a photographer. Here are a few things you should keep in mind:

■ **Be a ruthless editor.** Most photography buyers would rather see a few incredible images than a lot of mediocre images. Edit down to your strongest work to keep people engaged and intrigued all the way through your portfolio. Unless you are a well-established professional, you want no more than 20 images per section of your portfolio. In fact, 12–15 images per section is ideal. You can divide your portfolio into different sections such as nature, portraits, or travel. Remember, you can still share on the Internet images that don't make the cut. Post them on your blog, on Flickr, or on other social networking sites. Your portfolio should showcase your highest-quality professional work.

■ **Encourage criticism.** Don't be afraid to get other people's opinions about your portfolio. In particular, try to get the opinion of someone whose work you respect or admire. Remember, your portfolio is still your vision, and you don't have to accept other people's opinions. It will, however, help you find your strongest work.

- **Eliminate repetition.** Watch for too much of the same technique or subject in your work. Obviously, if you have established yourself as a successful Grand Canyon photographer, you wouldn't want to edit out images of the Grand Canyon. You want to cut repetition that doesn't define your style. Instead, make it look like you have unlimited powers in your photographic toolbox. For example, in a set of 10 images, you wouldn't necessarily want to have 3 or 4 silhouettes unless this is somehow important to your style of shooting.

- **Determine your audience.** To whom is your portfolio targeted? Is your focus more on commercial work, or portraiture, or do you want to establish yourself as a fine art photographer? Determine your audience or how you want people to perceive you. This will help you decide on the content of your portfolio.

- **Update regularly.** There are far too many photographers who keep their portfolio the same for years. You *must* update your portfolio. Whenever you feel you have created an image that is stronger than other images in your portfolio, add it to the collection. Updating your portfolio shows prospects and clients that you are continuing to create new and interesting work. It also keeps people coming back to your site.

When you select the company or platform for your Web site, keep in mind that you need the ability to easily update your photographs. Some Web site companies allow you to quickly and easily update your images through a content management system for the site. Others will charge you each time you make an update.

Once you have selected your final images, correctly size them for the Internet (800px on the short side or 1200px on the long side is recommended), and add watermarks if you choose. These images will appear in your formal portfolio and throughout a variety of social networking profiles and image galleries.

Use Google

Sign up for a Google e-mail account (Gmail). When you do this you are automatically signed up for all Google accounts. Google offers an extremely powerful suite of applications, most of which are free. These will be great resources for you and your business.

Make sure you fill out your Google profile. This is your way to tell Google who you are in an accurate, consolidated format. Provide your e-mail, biography, Web sites, social networking sites, and links to your photos. You can direct Google to pull photos from your Flickr or Picasa accounts to be associated

with your name. Of course, you need to upload your profile photo. Google even asks you to describe your super power. This is an opportunity to show your wit and personality.

After you set up your profile, whenever people search your name, the bottom of the Google search will show your picture and a link to your profile.

The next step is to sign up for Google Apps. Google offers a variety of applications at no cost that help make your life easier, including Google Calendars (to help organize your schedule and life) and Google Docs (to store, edit, and share documents with other Google users). You often can easily integrate these apps, like Google Calendars, into your smartphone or other planners. As seen in Figure 4.8, you can arrange your month for large events or even plan your daily schedule.

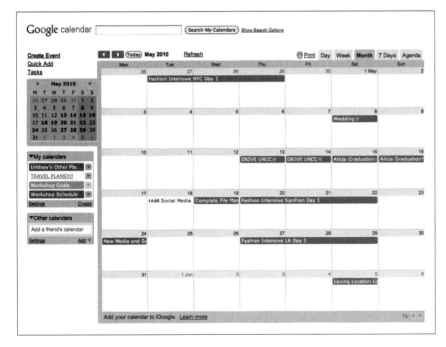

Figure 4.8

Google Calendars is one of the free Google Apps that help make your life easier by allowing you to get organized.

Build Your Solar System

The next chapters offer detailed information about the various platforms available to you to help build your social media solar system. You may change your mind as to which platforms you want to add or subtract, but the information that follows will be a good starting point.

Remember, the Web is continuously shifting and changing. Don't be afraid to try new platforms and let go of platforms that don't fit with your style, workflow, or comfort. Don't keep using social media that is not offering rewards.

Develop Your Community

Once you have your Web site and blog, it is time to reach out to and develop your community.

First, start by establishing your inner planets—or hybrid Web sites. Their main purpose is to display your content. They also offer a social media aspect by allowing people to comment on your creations.

In the long term you will decide on various Web sites, but two good starting points are Flickr.com and YouTube.com.

Flickr allows you to share your images and develop relationships around the images you create. Flickr is easy to use, searchable, and offers multiple options to develop a community around your images. We will explain more in Chapter 10, "Flickr." There are many image-sharing sites, and it is worth taking the time to discover other sites in addition to Flickr to share your photographs.

YouTube is another example of an excellent platform to share your images and ideas via video. Video is one of the most popular forms of communication on the Internet.

Other video-sharing sites considered are Vimeo and Viddler. Each offers unique features worth exploring. Remember that not everyone uses YouTube; additional video sites can help to spread your message.

Take the time to select two to three inner planet platforms that will allow you to display your work with a social media foundation. These sites often allow you and community members to embed your work on other Web sites. These sites also offer direct links for sharing. You can use these links within your outer planets to drive traffic back to your inner planet content.

Next consider your outer planets. These sites are where you spend most of your time engaging with your community. Twitter, Facebook, and LinkedIn are the most popular of these sites.

The biggest sites are not always the best. There are numerous forums and social media-themed sites worth exploring that your target market may hang out in.

Start with the standards, and then explore sites like Blellow or custom Ning communities.

Once you have established your initial solar system, begin to share information. What kind of information do you share? Focus on championing other people, Web sites, and blogs. Offer information that your target market would be interested in discovering. Links to your site are acceptable, but don't overdo it. Post 10 links to highlight other sites for every 1 link that's self-promotional. The ratio may vary depending on your comfort level.

No matter the platform, use your same photographs, your same logo, and a variation of your standard biography. Consistency is important when developing a brand.

Keep your user name or handle consistent. If your name is John Smith, you might have a tougher time. Consider using elements of your Web site title if someone else has already chosen the name you want.

Build Your Brand

Everything you are is your brand; everything you do is marketing. Your brand is your reputation, and it means everything in the online world. As much as the long tail can benefit you over time, it can hurt you when you don't follow through or offer good service.

The Web never forgets your poor choices, but you can bury them. Everyone makes mistakes. You will have your critics. The key is to correct your mistakes quickly and bury poor information with genuine, positive facts.

Every action you take is related to marketing and affects your brand. Not returning e-mails is a poor marketing technique that affects your brand reputation. Sending out jokes on a daily basis also represents who you are. Are your actions the real you?

Observe what other people do in the social media community, but don't feel obligated to follow in their footsteps. Your goal is to attract new clients socially with your genuine personality. If you misrepresent who you are, your new relationships will be in jeopardy with the first personal meeting or transaction.

Passion sells, but you must also be authentic. If you are not comfortable jumping into the social conversation, take the time to read and listen. Start by reading blogs that you find interesting. Listen to podcasts and videos on related subjects you want to talk about.

Next, begin to follow interesting people in the outer planet communities such as Facebook and Twitter. Focus on your target market, but if you are uncomfortable with social media platforms, start with the people you know and find interesting who may not be related to your target.

Develop a daily workflow. Decide in advance how much time you want to invest each day to build your social media community. You may schedule time to work on it once a day or divide it into multiple tasks throughout the week. Consistency is important, but do not overcomment. Start slow and build. Remember: the goal is to build relationships, direct people to your work, and teach your community how to refer you. Before you can start directing people, you need to have your foundation in place.

5

Personal Branding

A Few Words About Personal Branding

Everything you are is your brand. Everything you do and the impression it makes on others is marketing. Your brand is your reputation.

We all know the big brands. The golden arches for McDonald's and the Nike swoosh are known worldwide. The symbol reminds you of your experience—good or bad—with the brand. If you don't have a personal experience with a brand, you most likely have impressions based on advertising or the opinions of people you know or trust.

Note

Your personal brand is not your logo. It's the impression people have about you. A logo is a visual representative of your brand.

The concept of brand impression is true at all levels. Big brands with large budgets use mass marketing to improve our beliefs, impressions, and awareness of their products and services. As a photographer, you do the same thing on a smaller scale with your actions and images.

Your personal appearance, the equipment you use, your handshake, your smile, or how promptly you send a thank-you note all reflect on your reputation.

Some photographers are very approachable, whereas others maintain a professional mystique. Different styles work for different photographers. Everyone is judging and developing opinions about you. As people talk to each other, reputations are built.

In the past, individuals and small business owners had little opportunity to hear or participate in the conversation about their reputation beyond a close circle of associates, friends, and family. Most conversations happened out of hearing range and behind closed doors.

Today, the conversations are online, and you have a chance to influence the reputation of your personal brand like never before. The only cost is acknowledging that you have a brand and taking the time to develop it. In the past, the cost was too high for most photographers. Most people didn't even think about a personal brand and ignored the concept. The growth of social media has made it a hot topic—and for a good reason.

Everyone Is a VIP

In the past, your brand was easy to ignore. People either liked you or they didn't. No big deal. You could show your book to another agency, design firm, or business. If a photographer developed a really bad reputation, he might have to start over in a new market. Now that social media is quickly becoming a part of mainstream society, everyone has a voice. Reputations go beyond local boundaries and make their way around the world. The conversations are often indexed; people have easy access to your reputation with a simple search.

Everyone has a voice with social media. Some voices are louder than others, but the playing field is level. One dissatisfied person may have a small community surrounding him, but it is likely that some of his community members have large followings and are willing to share the news of dissatisfaction.

Everything you do leaves an impression on people. Look at your Web site. Listen to your voice mail message. Analyze how you treat people. It only takes one bad impression to impact future opportunities.

Once you acknowledge the power of your personal brand, understand how everything you do affects your business. Grab the reins and guide your business toward new opportunities.

The best way to develop a reputation online or off is to build your business around your strengths. What are your strengths? Are you a leader, a team player, or a loner? There is nothing wrong with any of these traits. You need to build your brand around who you are.

If you are a leader, share blog posts about who you are and how you lead successful projects or solve problems. If you are a team player, write status updates about how well your team is doing, and acknowledge other team players often. If you are a loner, tweet about your adventures.

Don't be afraid to expand your reputation to a new level as a photographer. Decide your ultimate goal. Once you've defined it, work backward to where you are now. What is the difference between that person and who you are now? What do they do differently? What is your vision? What are your core strengths?

Remember, when you get involved in social media, you have to be who you are. Don't act like someone you're not. If your goal is to be an international fashion photographer, you need to build trusting relationships with people in the international arena. If you wish to be a top wedding photographer, you must build positive relationships with people who refer wedding photographers. In the end, you must make the people who hire you or refer you look good because you followed through and are the person you represented yourself to be.

Create goals and develop good habits. People can only be grateful for someone sending a thank-you card if a card is actually sent.

No matter what you do, be clear about who you are and what your philosophy is. Place it in your biography. Be consistent with what you do and say. Be the person you are or aim to be. It only takes one person to notice that the emperor has no clothes and tarnish a reputation.

Your Personal Brand Statement

Many companies have a mission statement. It is important to keep the company focused. A personal brand statement will help you stay focused while developing a social media presence.

Take the idea of branding seriously. It will support you in becoming a more successful member of the social media community.

6

Your Web Site

Introduction to Web Sites

A Web site is a collection of pages, displayed on the World Wide Web, that is accessible from the same Uniform Resource Locator (URL).

A Web site is essential for most industries, including photography. If your business is not on the Web, you are not in business. You need a location online to send people to "your space" or online brochure. This is the main location where people can find your portfolio, biography, and contact information.

Your Web site needs to be well designed and easy to navigate. It is important to have multiple people proofread your copy and test your site to make sure your online brochure is understandable.

Greg Evans, owner of Synectics Media, a digital marketing agency, suggests you seriously consider a professional Web design company or service. He has seen many projects go awry due to people enlisting the help of a family friend or associate just getting their feet wet in the business.

With "homemade" Web design, even if the initial site is acceptable, the upkeep often becomes unmanageable. Something that started as cheap and easy can become expensive and difficult to maintain. If you're looking for a Web design service, make sure you ask for referrals from people who have successfully used the services of designers they trust. Inquire if they have had any trouble updating their

Web site as well as creating new projects. Ask if the company is easy to work with, if changes are implemented quickly, and if there are additional costs beyond the setup.

Greg reminds us that our Web sites are the front line to the world. A site should be flexible and able to grow with your career.

He also suggests not getting caught up in exciting functions that require plug-ins on the viewer's computer. "Plug-ins are not your friend," he says. Some plug-ins need to be installed on the viewers' computer to add functionality. If people need to work too hard to see your site, chances are they will not bother.

Make sure your images are front and center, easily accessible, and not buried in a gallery three clicks away.

After your site is complete, he says, make sure you test it on different computers, screens, and browsers. You might be surprised at how different it looks.

Considering the Options

Photographers have many options when considering a Web site. Here are some things to keep in mind.

What Are Your Budget Level and Appearance Goals?

Budget is often a factor when deciding how to proceed with your Web site. The following are four options to consider.

- Free ($0)
- Cheap (Under $10 per month)
- Professional (larger budget to invest—several hundred per year)
- Advanced (large budget—several hundred to thousands per year)

How Are You Going to Use the Site?

The price you pay for a Web site can be affected by various options and functionality. What do you hope to achieve with your Web site? Do you plan on selling images from your site? Do you want a blog integrated into your site? It is important to plan ahead and consider whether the following options are in your budget and work toward your goals.

- Portfolio
- Blog

- E-commerce—selling images from your Web site

- Stock photography

- Image archiving

Who Is Your Audience, and What Would Appeal to Them?

There are hundreds of companies that design custom Web sites, and dozens of Web-design companies geared specifically toward photographers. Listed next are some of the options to consider. New companies are sprouting up all the time with exciting new options. We highly recommend that you keep focused on your goals and the needs of your prospects rather than the shiny new objects.

In the early days of Web sites, it was all about having a site. Design was nice, but not necessary. Early sites were boxy in design and displayed basic information with simple graphics.

Today a Web site is so much more and generally goes beyond basic HTML pages. Cascading style sheets (CSS), Flash, and Content Management Systems (CMS) have become standard. With only seconds to impress viewers, design is more important than ever. If your Web site has not been updated to the current styles and technology, it reflects poorly on you as a photographer.

The Blog as a Web Site Trend

In the past, photographers had one Web site for their portfolio work and another site for their blog content. The two were often kept separate and frequently had different page design and branding. Today, the two are merging to the same platform and design. Many photographers have merged their portfolio and their blog. Photographers often integrate their blog into their site design, and even more often they have their portfolios integrated into their blog design as a separate Portfolio tab. As we talk about Web site requirements, keep in mind that you might want to integrate your blog and Web sites as a cohesive unit that represents you as a photographer. WordPress.org is the most common platform for this approach. High-end wedding photographer Jessica Claire has integrated the two into one site, as seen in Figure 6.1. Her Web site, http://www.jessicaclaire.net, includes links to her image galleries, blog postings, updates on her work, and even a Shop page to purchase card templates and other photo products.

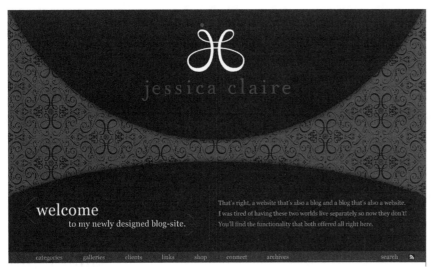

Figure 6.1
Many photographers, including high-end wedding photographer Jessica Claire, have integrated their blog and Web site into a single entity. This site includes blog content as well as portfolio galleries and other essential Web site content.

Web Site Options

Photographers have many options to consider when deciding how to display their work on the Web. Some options are free or low cost, whereas others produce professional results with a hefty price tag. Again, the characteristics of your site depend on the goals and functionality you require. These options may drastically affect price.

Free

The following are some free options for photographers to display their work on the Web. There is no cost for hosting the site, for design, or any other related charges. This is a good place to start if you have an extremely limited budget or if you just want to get your work online quickly.

Flickr

At no cost, you can create a unique URL (http://www.flickr.com/photos/ *yourname)* to send people to view your images. (If you want unlimited image uploads [the free version has image limits], HD video capabilities, and analytics on your images, consider a Pro account, which is $25 per year.) Although you can include your contact information and biography on your Flickr profile, you cannot customize your profile appearance. Flickr is a great first step to getting your images online, but it should not be considered your professional portfolio. Flickr is not the ideal professional Web presence of a photographer, but it is a quick and easy way to get your work online. As seen

in Figure 6.2, the interface is relatively clean and provides a way to share images that you can later integrate into your blog using plug-ins.

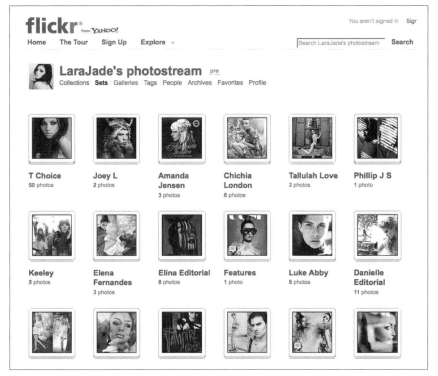

Figure 6.2

Flickr provides a free way to get your images online and share with others. Simply create your unique URL name for Flickr, upload images, and start sharing.

WordPress.com and Other Blogging Platforms

WordPress is a blogging platform that you can use as a Web site. The platform offers a variety of templates to give your professional space a home on the Web with a unique URL. You can create an "about" page for your bio, add your contact information, and integrate your uploaded Flickr images.

Tumblr.com

Tumblr is a unique platform with endless capabilities for customization. It also provides you with a unique URL. Some consider the site a hybrid of traditional blogging and microblogging. Over time people have started using the platform as their main Web site. This is a good option to start building a community, presenting your photos, and designing a customized appearance. On Tumblr you can share images, as seen in Figure 6.3, in the form of a slideshow or single image. You can add captions, behind-the-scenes stories, or any other related media to share on your blog site. Tumblr's main benefit is its ease of use.

Figure 6.3
This figure shows one of the basic, predesigned layouts you can select to represent your site using Tumblr.

Cheap

There are several inexpensive ways to host your Web site online that will allow you more options and capabilities.

The cheapest way to get a Web site online but still on your own domain and with customizable features is through WordPress.org. Using the one-click install of the hosting companies we recommend, you can easily use WordPress.org. You can search the Internet for a Web variety of preexisting free templates or some template available at a low cost. (Many are available for less than $50 as a one-time cost.) Through WordPress, you will have a great CMS, some customization, and an inexpensive solution.

You can search through the WordPress database for plug-ins and widgets to customize your site. There are thousands of useful plug-ins that can be installed and utilized with the click of a button. They will allow you capabilities for Google Analytics, Tweet This buttons, Tumblr feeds, slideshows, and much, much more.

Importance of a Strong CMS

A photographer should not have to worry about upgrading his photographs and the content of his site. Most photographers do not want to have to think about the coding of the site or any of the technical information behind the site. If you don't want to pay or wait for someone every time you want to make a change, definitely consider easy-to-use platforms that allow you to change things on your own.

A photographer should always be updating his Web site. He should share new projects and concepts, keep contact information accurate, and edit photos based on the improving quality of his work.

Ultimately, you need a good CMS to go on the back end of the site so that you can quickly and easily change your content. This is a system that allows you, the photographer and site owner, to control and change content such as blog posts, images, and other material.

Be sure that whatever solution you select—whether WordPress, a custom site, or a photo-oriented Web site—has a good CMS.

Your Domain

To use WordPress, you need to have your own domain name. This is a business investment that you must make right away to secure your home on the Internet. Create one now if you don't already have one.

Your Name

Ideally, you should purchase http://www.*yourname*.com. Buy it if it is still available, even if it is not your business name. You can always forward it on to the domain name you choose to purchase. Try to choose some variation that includes your name (http://www.*yourname*photography.com, http://www.*yourname*photo.com, and more). If your business name is different from your personal name, look to purchase this name as soon as possible.

If you have not already picked a business name, remember three basic things:

1. **Keep it easy to remember.** Your name is often best.

2. **Make it easy to spell.** Do not play off of the word *photo* by spelling *foto* or using letter/numbers 0, O, l, 1.

3. **Keep it short.** Keeping your business name short makes it easier to include on business cards, makes it easier to remember, and ranks it higher for search engine optimization.

Be sure to do a Google search of your business name or proposed domain name and see what comes up. Are there other businesses with similar names? Keep this in mind when choosing a name.

Where to Purchase

If you have found someone to host your domain, this person might sell domain names to you at a discount. Otherwise, two great sites with great customer services are GoDaddy.com and Namecheap.com.

Domain Extensions to Purchase

When you search for your domain name in GoDaddy or Namecheap, you will see that names are available with various extensions. But which ones matter to you? Although .com is the most common domain extension at the end of a Web site, there are a handful of other extensions you should be familiar with. The extension at the end of a domain name helps to indicate the purpose and the content of the Web site. For example, the extension may indicate an educational organization or perhaps a government organization. Following are a the primary extensions to be aware of.

- **.com.** This is a must, so buy it first. .Com implies commercial and is the most widely used extension. People will automatically assume that .com comes at the end of your domain name.

- **.me.** If your domain is your name, consider this because it indicates that a site belongs to you—an individual, not a business.

- **.net.** .Net stands for NETwork and was traditionally designed for Internet service providers (ISPs) and hosting companies. Today, .net is a common alternative to .com if .com is not available. Anyone can register.

- **.info.** This is intended for Web sites that serve as informational resources for a particular topic. If you hope to create a photo resource, you might consider this extension—but not for your main site.

- **.biz.** This is designed for businesses and is commonly used if the traditional .com is not available for a business name.

- **.org.** Non-profit organizations get these.

- **.edu.** This extension is designed and reserved for educational institutions.

- **.gov.** Government institutions get this extension.

If you live outside the United States, you might consider getting the domain name for your country. For example, in England you would get http://www.*yourdomain*.com and http://www.*yourdomain*.co.uk.

Cost

At discount sites recommended in the previous list, you will pay around $10 per domain name per year. Some domains have been given a premium price because they are potentially valuable to large money-making companies. For example, it would cost much more if you tried to purchase a domain such as photomagazines.com (if it were available).

Variations

Consider purchasing variations on your domain name/Web sites. It is relatively inexpensive and might save you a hassle in the future. You can redirect all the variations to your main page. If your name is commonly misspelled, you might consider buying the misspelling just in case. For example, if your business name is Smyth Photography, you might consider purchasing both http://www.smythphotography.com and http://www.smithphotography.com.

Hosting

Once you have your domain name, you need someone to host your Web site. This is the company that gives you information to manage your Web site account, a server to upload your information, and more.

When picking a hosting company, consider the following factors:

- **Cost.** This will likely be per month or per year. You should aim to pay no more than $10 per month, and usually you can find hosting for $7–$8 if you need to host only one domain name.

- **Customer service.** For example, how have others rated the company online? Are there live chat capabilities? Be sure that there is a great deal of availability for help and troubleshooting. Most larger hosting companies offer a free live-chat service.

- **Server speeds.** How quickly is information transferred to and from the hosting server? This plays an important role in how quickly your Web site loads. People are impatient. If your site takes too long to load, people move on and close your site. With most major hosters, server speeds are not an issue.

- **One-click WordPress install.** When selecting a company to host your site, it is best to have a "one-click install" for WordPress.org. In other words, it should be quick and easy to install a WordPress blog. Many large companies offer a one-click option that requires no knowledge of coding or specialized installation.

You might consider Dreamhost.com or Mediatemple.com to host your site. Both of these hosts have strong customer service, low cost, acceptable server speeds, and one-click WordPress install.

Professional

Whether you own a studio or a freelance business, you need to present a serious brand. This is a business investment you should make, but it doesn't have to break your bank. Consider your budget and your goals.

For example, perhaps you need extended capabilities. (You might consider a more advanced content management system on the back end of the Web sites.) Perhaps you want your site to more cohesively reflect your brand and reflect the visual characteristics desirable to your target audience. All of this requires a bit more money and time investment. As you present more images, and often present them large on the site, you will want a hosting company that offers more options, additional customer service, and improved server speed.

You can go one of two routes: premium WordPress themes, or photography-oriented Web site companies.

Premium WordPress.org Themes

WordPress is an open-source personal publishing platform. When you host the WordPress.org templates on your own domain and site, there are hundreds and even thousands of WordPress page templates to choose from. Some are free, whereas others are premium designs that you can purchase. You also can hire a WordPress code designer who can fully customize your site while still maintaining the core benefits of WordPress CMS.

Although various free themes are available, you should consider purchasing higher-end options.

Photography-Oriented Web Site Companies

Two widely used and praised Web site companies are liveBooks and Dripbook. Both are used by some of the big names in photography as a way to display and host their images. And both offer free trials so you can test the appearance and service offerings.

Recommended WordPress Themes

With WordPress.org, you can install customized themes. Some are free, and others are premium sites you pay for. In fact, the following themes exist that were created specifically for photographers.

Free

Photo Based

- Modularity Lite. By GraphPaperPress, this displays a portfolio on the home page. It's a good mix of photos and blog.
- AutoFocus. This is an example of a good-looking home page.
- Viewport. This is all about photography with a home page slider that displays large images.
- Gallery. This is great for photo-a-day bloggers.

Blog Based

- Typebased. By WooThemes, this is popular and simple. It has built-in Flickr integration.
- Meta-Morphosis. By WooThemes, this provides a customizable home page, with good picture integration.
- Fusion. This has a striking home page that's easy to read.

Paid

Photo Based

- Check out GraphPaperPress. It has great customization and minimalist designs for photographers and other visual artists.
- Photocrati WordPress Themes are sleek, photo-centric designs for photographers. The sites look more like Web sites than blogs.
- ProPhoto Wordpress Themes (http://www.prophotoblogs.com) offer elegant blog designs for photographers and have great customer service.

Blog Based

- Check out WooThemes. It has clean back ends with lots of options.

liveBooks

liveBooks is a popular solution for professional photographers, including photographer Chase Jarvis (see Figure 6.4). liveBooks is known for its professional, clean, Flash-based templates geared toward visual artists. The following are features that liveBooks offers:

- Easy content management system (with drag and drop)
- Strong search engine optimization (SEO)
- Integration with Pictage (sell your images to clients)
- Basic templates or complete customization (prices vary)
- Video tutorials and live chat options for support
- Recommended for commercial photographers, photojournalists, and wedding and portrait photographers

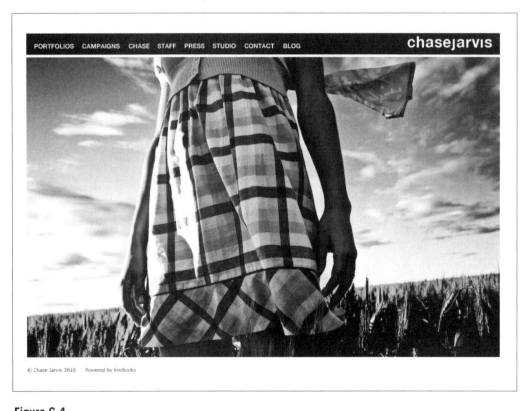

Figure 6.4

Photographer Chase Jarvis uses liveBooks to host his Web site and blog, which receive millions of hits monthly.

Dripbook

Dripbook is a portfolio promotion tool for visual creatives. All portfolios are indexed into a searchable database so buyers can find a desired style and talent. You can export Dripbook portfolios into customizable Flash Web sites (see Figure 6.5). Some of the benefits of Dripbook include these:

- High-resolution image and HD video uploads

- Some SEO

- Dripbook hosting or personal hosting

- Facebook and Twitter integration

- Recommended for fashion and glamour photographers

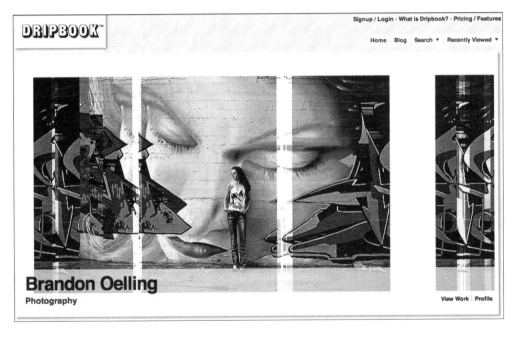

Figure 6.5

Recommended for portrait and fashion photographers, Dripbook offers a relatively clean interface for displaying your images and a good CMS for easy updates.

APhotoFolio

This is a clean and feature-rich Flash Web site and hosting service for professional photographers (see Figure 6.6). It offers unlimited pages, images, galleries, and categories. Photographers control the look of their site with an easy-to-use interface. APhotoFolio offers the following:

- High-resolution image and HD video uploads
- HTML mirror site for SEO
- Unlimited pages, images, galleries, and categories
- Custom logo, color and font support
- Recommended for editorial and commercial photographers

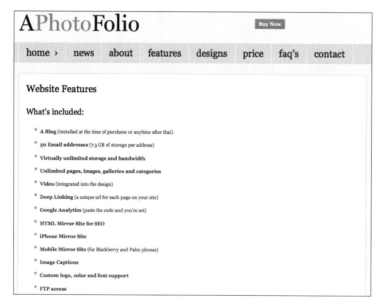

Figure 6.6

APhotoFolio has a variety of custom-designed Web site templates specifically created for commercial and editorial photographers.

PhotoShelter

PhotoShelter is well known for its image delivery system, stock photography functions, and e-commerce solutions for photographers (see Figure 6.7). The back end of this site is specifically designed to appeal to photographers handling the buying and selling of their content online. PhotoShelter is highly customizable and offers the following:

- Customizable galleries and pages
- Custom photography delivery systems and lightbox for viewing images

- SEO support

- E-commerce and FTP distribution

- Searchable capability

- Recommended for editorial, commercial, and stock photographers

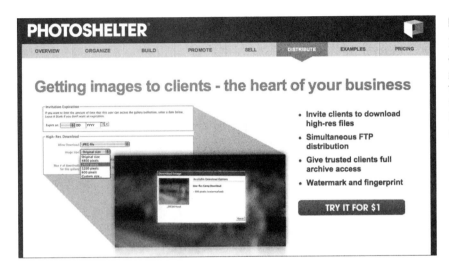

Figure 6.7

PhotoShelter offers customizable Web sites and galleries for photographers, with a sophisticated back end that allows for e-commerce, FTP distribution, and advanced SEO.

Advanced (Studio, Successful Business Owner)

If you have a solid brand, own a high-end studio, or have extra money to invest in a customized Web site, you might consider hiring a Web developer to create a Web site neatly tailored to your needs and brand.

You have a number of options:

- Complete and customized WordPress theme

- High-end options of photo-oriented Web site companies

- Custom-designed Web sites by Web developers/designers

Complete and Customized WordPress Theme

The WordPress.org themes are just a starting place for design. WordPress coders can modify design in about any way you can imagine. In addition, you can add dozens of widgets and plug-ins to give you a stunning site, with expanded capabilities and a design that perfectly expresses your brand. Most importantly, you still maintain the fantastic CMS that WordPress offers to allow you to regularly update and control the content on your site or blog.

You can make your blog or Web site look like pretty much any way you want while still using WordPress.org. You can customize WordPress.org themes to host your images, podcast, e-commerce business, multimedia blog, or any purpose you can imagine as a photographer. In Figure 6.8, you can see how Dave Warner uses a modified WordPress theme to host his extensive LensFlare35 Web site that contains dozens of interviews of today's most influential and forward-thinking photographers. Many only think of WordPress for blogging, but it has far greater functionality when you customize the code and structure.

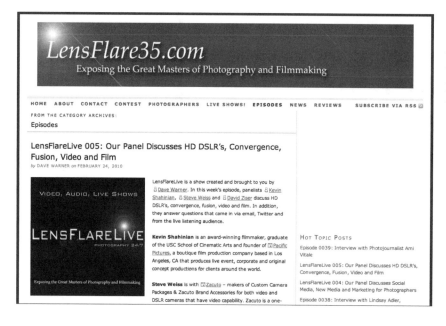

Figure 6.8

Here, photographer Dave Warner uses a modified WordPress theme to host his LensFlare35 interviews with the masters of photography.

Caution

Pick a good coding designer (look for references and previous examples), and don't try to take over the entire process. Tell the designer what you envision, share samples you like, inform him of your requirements, and let him build. Just try to be specific about what you are expecting to accomplish with the site and its features.

You might consider buying a preexisting premium WordPress theme and hiring a designer to modify the code so that it takes on the appearance of your brand.

High-End Options of Photo-Oriented Web Site Companies

There are several companies, including liveBooks, that offer premium services and custom design for higher-paying clientele. They modify appearance and capabilities to fit your demands. With customization, you can break out of templates to better fit the sites to the brand you have established. Always ask for price quotes before you start work, and assume that you will go over budget as you request more changes to be made.

Custom-Designed Web Sites by Web Developers/Designers

If you have a particularly creative vision for your site, or you want something truly one-of-a-kind, you can consider a custom-made site. You can hire a Web designer or graphic designer to create everything you want to accomplish with your Web site. Be sure that the designer has strong examples of previous work and is comfortable with working with image-driven sites.

If you are going out of your way to build a custom site, remember that much of what you want could be accomplished through other Web companies and WordPress. Be sure that they are offering you a capability or appearance you couldn't get elsewhere. This can become expensive, but to represent your work in its best format, it might be invaluable.

Once again, be cautious when hiring a relative, friend, or associate who knows how to build Web sites. Avoid the headache. First, the CMS will most likely be weak, and you have to pay them every time you want a change. Second, their coding and SEO may be weak. Third, they most likely will not have the tools to accomplish everything you want. Many kids and young adults these days know how to make a Web site, but many have not studied design, the proper coding, and site structures.

Aesthetics

Web sites consist of three major page types: home page, topic pages (what appears when you click on a certain topic or category), and article pages. Your branding should stay constant through the different page types, and it should be easy to navigate between them.

Your site needs to be consistently branded and well designed throughout. Even though your home page might seem like your most important page, most often people will be entering your site as a subsequent page through a link. For example, a link might be to a particular gallery or blog post, and their first experience with your site will not be that home page.

Look and Feel

The following are elements to consider when developing a new Web site. Branding, navigation, and image display play a role in your visitors' experience.

Branding

Attempt to keep your brand consistent. Use your company colors, logo, and typeface throughout. Being consistent provides a more pleasant browsing experience for your users. Washington, D.C., photographer John Harrington strives to keep a consistent experience for his users across his Web site. The navigation, color scheme, and overall tone of his site remain consistent while visitors browse its content, as seen in Figure 6.9.

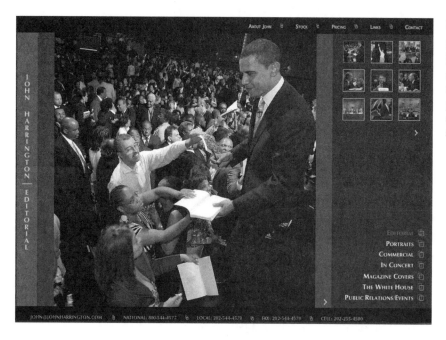

Figure 6.9

Photographer John Harrington is consistent with branding in all realms of his business, from the way he presents himself in person to the themes, colors, and tone of his business cards and Web site.

Simplicity

The simpler your site, the better. If you look at the sites of the most famous photographers in the world, you'll notice that their sites are clean and simple. This applies to colors, navigation bars, image displays, and drop-downs. Simplicity is key because it helps the images and content speak for themselves. If the design is loud, it overpowers the images. If the navigation is confusing, people click away from your site.

Color

Unless you already have established business colors, you should try to keep the background and most key colors relatively neutral. For example, if your business color is lime green, you might only want to make a few key links or titles that color and leave the background black, white, or gray.

How do you display your print portfolio? Even if your cover or case is fancy, the main part of the book should be simple and let the images speak for themselves. This same concept applies to online portfolios.

Tip

Analyze the Web sites of the big-name photographers you admire in your area of photography. What do they have in common? What works and what doesn't work? What do you like best, and how can you integrate these elements into your site?

Navigation

You want to keep your navigation neat and intuitive. Your main navigation tools should run either across the top of the page or along the left or right. Try to keep consistent across your Web sites. Greg Evans of Synectics Media says the general rule is no less than five or no more than nine links per navigation set. The navigation should go no more than one drop-down menu deep. Avoid multiple submenus that pop up under every word. This can become confusing and very quickly become frustrating. The navigation of K&K Wedding Photography (k&kweddings.com) is simple, consistent, and intuitive. As seen in Figure 6.10, the navigation is consistent throughout, and image viewing/navigation is sleek and naturally integrated into the site. Viewers and potential clients aren't distracted by navigation, but instead focus on the images and experience with the site.

Caution

For navigation and other tools on the site, avoid using cute Flash components. For example, don't use sparkling letters or words that follow your mouse (as was common in the early days of the Internet).

Figure 6.10

Navigation should always be simple and should not interfere with your client's experience of your images.

Image Display

As a photographer, your Web site is all about the images. Make sure the images are large and display prominently in the site. Make sure it is easy to navigate through the images, and consider a Click to View Larger option for a more full-screen experience of your images.

Size

Put your images online at the largest size you are comfortable with people accessing. The standard photograph Web site is 400px high and 600px wide. Photographers who generally prefer a larger minimum viewing size should consider images 800px wide. As computers, monitors, and Web browsers improve, it is possible to view images at larger sizes. Some photographers offer 1000px or 1200px wide images.

Don't forget that smartphones are becoming a common source of Internet traffic. Offering a mirror site (copy site designed for smaller screens) is recommended. A number of plug-ins for WordPress can convert your site to a format that is friendly for mobile devices. If you are going with another company for design, ask about capabilities to make your Web site viewable on mobile devices.

Caution

If your Web site is not viewable on mobile devices, you risk losing client interest. For example, perhaps you meet a potential big client at a lunch meeting. This client may be tempted to check out your work immediately after the meeting via smartphone on her ride back home, but if your work isn't easily viewable, she will likely give up and perhaps forget to check your work at all. If you don't have a site that is friendly to mobile devices, be sure to have another place (Flickr or other) to send potential clients to view samples of your work on their phone or handheld device.

Image Navigation

When looking on other Web sites, what type of image navigation appeals to you most? WordPress.org offers various image-viewing plug-ins, with one of the most common being the Next Gen gallery. For other Web sites, SlideShowPro has become a popular company for photographers to display both photos and video. Do you want smaller thumbnails to click, or full-screen scrollthrough of images? These are all considerations for your image's display and page design.

Caution

Be careful how you use music. Music can set the mood for your Web site and appeal to a certain clientele. Calm and romantic music may be great for setting the mood for a high-end wedding boutique. Fast and thumping music might be great for a freelance urban landscape photographer. It must fit your brand and be easy to turn off. If the music is loud and aggressive, it may startle people when it starts on the page, and they may quickly navigate away from it. Most importantly, if you choose to use music for your site, don't infringe on a musician's copyright. Purchase royalty-free music. In most cases, it is safest to avoid music altogether.

Make sure you have a site map. A site map is a Web page listing all the pages within the site. It helps people find what they are looking for on your site. Search engine spiders also use it to find all your content. Site maps are often displayed at the bottom of each page.

Remember: Web browsers (Explorer, Opera, Safari, Firefox) interpret Web pages differently. Test your Web sites on as many computers and browsers as possible before officially launching the site.

Don't get married to your site. Don't build a site and then insist on sticking with its design and layout forever. If your business grows to require new demands, upgrade. If new technology becomes available to make your site function better, upgrade it. Your site is always in beta—a work in progress. Feel free to change anything you need to better display your images, meet your clients' needs, or represent your brand.

Tip

When you first get a Web site, don't start publicizing it until you have content (words and photographs). Even if you don't have the entire look/feel correct, be sure that your images are available to view and that your contact information is easy to find.

Following is a quick checklist of items to consider before you launch your site:

- Make sure all themes, plug-ins, and tools are updated to the latest version.
- Make sure you have a prominent copyright notice on your Web site and on photographs—if desired.
- Confirm that every page has information on how to contact you. Although most traffic enters your site from the front page, some of it lands on internal pages based on search engines.
- Make sure your About page is complete. Have a quality photo of yourself, besides updated, accurate, and easy contact information, such as an e-mail address or phone number.
- Double-check all links to make sure they work.
- Proofread all pages.
- Make sure all your social media connections are displayed and working.
- Test your page speed. Make sure it loads quickly.
- Test your Web site on multiple browsers, monitors, and computers.

Your online brochure is about you and what you do as a photographer. Once it is launched and ready for the world, it is time to work on sharing a deeper understanding of who you are and building stronger connections with a blog.

7

Your Blog

For the ambitious photographer focused on social networking, blogging is no longer an option. It is a necessity. Your blog is the core of your social media experience. It is where you are best able to communicate and share your newest work with the people most interested in what you have to offer. Your blog is where you can post all your updates, links to your other social networking sites, your portfolio, and your images. It is where you develop your niche area of expertise and where you build your reputation.

Before we share why and how to blog and what you might want to blog about, please take a look at Table 7.1, which is a list of terms related to blogging.

Ten Reasons Why You Should Blog

A blog should be the foundation of your social media efforts. It is your home on the Web where all your social media activities lead back to. Here are 10 reasons you should consider blogging.

1. **Build your reputation.** Your blog is a great place to build and establish your reputation. It acts as your home on the Web. This is where you will link to all your social networking sites and create your presence on the Internet. Your blog is where you establish yourself as a talented and knowledgeable photographer. The flexibility of your blog allows you to set your online tone. Are you educational? Artistic? Inspiring? Humorous? Are you a combination of several of these attributes?

Table 7.1 Helpful Blog Terms

Term	Definition
Atom	A popular, feature-rich alternative to basic RSS feeds.
Blog	Short for Web log. Blogs are regularly updated Web pages containing news, personal information, photographs, video, and audio. Blogs usually have themes but can contain any information the author wants to share.
Blogger	The author of a blog.
Blogroll	A list of recommended bloggers.
Body	The main section of a blog post.
Categories	Blog posts that are grouped into lists of related subject matter. A category might be "people photography." A link may be displayed leading the blog reader to all the posts related to people photography.
Comment	A thought or reaction to a blog post. Comments are what make blogging social media. Readers can share their opinions about the content presented in a blog.
Content	Text, audio, or video information presented in a blog.
Headline	The title of your blog post. It is important to think about your headline because a good headline can make or break a blog post.
Microblogging	Like the name suggests, microblogging is a form of blogging in which users (like you) can send brief messages or updates. Examples of microblogging include Twitter and Facebook status updates. These updates can be multimedia and are usually limited by the SMS texting length of 160 characters or the user name length of 140 characters. The tips that follow this table are geared toward full-length blogging, but many are still valid thoughts to consider when microblogging.
Permalink	The unique URL or link to a specific post. Permalinks should be set up as words related to the post for better search engine optimization (SEO).
Photo blog	A blog containing mostly photographs.
Podcast	An audio or video version of a blog post delivered via audio or video rather than text. Podcasts often are available through independent RSS feeds and commonly delivered through services such as Apple iTunes.
RSS	Really simple syndication, or a simple but powerful subscription method employing the XML markup language. It is considered standard for a blog to offer RSS so fans can keep up-to-date via their favorite reader.
RSS aggregator	Software that reads and displays the RSS feed for the subscriber of a feed.
Tags	Similar to categories but more specific. In a blog post related to food photography, the category might be "food" and a tag might be "strawberry." A blog post can be connected to multiple categories and tags. Usually there are more tags than categories.

2. **Express yourself.** Blogging can be cathartic and act as a good way to express yourself. You can share your thoughts, experiences, and goals with other people who might relate to you. You can express yourself through words, photographs, video, poems, and a variety of other mediums. Consider trying a unique form of expression as a way to stand out from other photo bloggers.

3. **Become an "expert."** Through your blog, you can establish your niche market or area of expertise. By sharing information, you can become an "expert" in a certain area of photography. A niche market can be whatever you can imagine, like "Philadelphia's premium fashion and commercial photographer" or "Master of painting with light." Becoming an expert increases your name recognition, gets your work out there, and makes you a go-to person for your peers and possible clients. A good example is Jeff Curto's blog and podcast in Figure 7.1. He addresses specific areas of interest that appeal to the photography community. Whereas others blog about the future of photography and up-and-coming techniques, Curto's approach is a retrospective look at the medium.

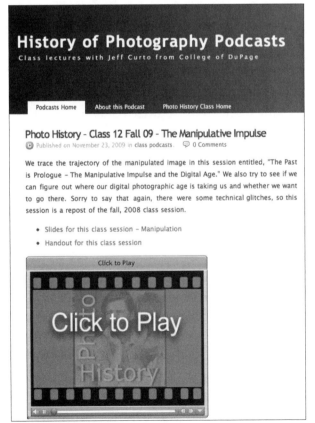

Figure 7.1

Photographer Jeff Curto has established his expertise in the history of photography.

4. **Share your work.** It is sometimes heartbreaking that only a tiny portion of a photographer's work ends up in his portfolio. We have tens of thousands of other images that no one else will get to enjoy. A blog is a great way to share some of the better images that don't make the final cut for the portfolio. You can share your favorite images from a recent trip you took or on a particular photographic technique you enjoy. Either way, a blog is a great home for some of your favorite images—just remember to always add context and additional information about the images for your audience to enjoy and learn.

5. **Improve your SEO.** Blogs are filled with words and content that relate to your area of expertise in photography. Search engines love blogs (due to their high levels of content and keywords) and give them high placement in searches. Blogs are a great way to increase your visibility on search engines.

6. **Build an interest, increase audience.** Blogs are a great way to generate interest in your work. You can get people talking about your photographs and the content of your blog, and this will encourage them to follow you on other social networking sites like Facebook and Twitter. The bigger an audience you can get for your work, the more widely spread your name will be, and the greater your chances for more and bigger clients.

7. **Attract new clients.** People searching the Internet or enjoying your blog might actually hire you after seeing your work through your blog. It might be a corporation looking to use your services or a magazine wanting to run a profile on you. Either way, you have attracted additional clients and helped to build your business.

8. **Show your personality.** It is important to connect with other people on the Internet. Your blog is a great way to show yourself as a real person and help people to connect with you. Although you want to be professional online, you don't want to appear robotic. If all your posts and profiles are cold and factual, there is a chance that you will fail to connect with your audience on a personal level. Your blog is a great place to show your personality, your musings on life, and your goals and aspirations.

9. **Promote yourself.** Although too much shameless self-promotion will drive away your audience, it is completely valid to keep people up-to-date on your upcoming publications, events, awards, and more. It's okay to talk about yourself and your accomplishments if they are timely and they apply to the content of your blog. People are interested in you and what you have to say. It may be relevant to promote an upcoming workshop you are running or an article about your work appearing in a magazine.

10. **Start a conversation.** "Professionalism is more than consumption; it is contribution" (Rovy Bronson). Your blog is your place to start a conversation about photography, photographic techniques, philosophy, news, or whatever you can think of. Get a conversation going, and keep it going. On your blog you can engage with your audience by answering questions, asking them questions, taking polls, and creating an ongoing dialogue. Everybody wins. Your audience gets their questions answered, and you learn more about yourself and photography by answering.

> **Tip**
>
> Technorati is like a highly ranked index of blogs. It attempts to register and index all blogs and blog content. Although Technorati is not as influential as it once was, you still should register your blog on it. Technorati lists all blogs and then ranks them according to various criteria to determine a site's "authority." You should sign up because there's no maintenance required, it's effortless to sign up, and your blog gets indexed better.

Blogging Tips

Following are some blog post suggestions. Some will not apply to you as a photographer, whereas others might inspire you to develop a different approach to blogging.

Make Your Postings Timely

Try to make your blog postings relevant. You might develop a reputation with publishing some of the most up-to-date equipment reviews, critiques of fashion magazines, or timely commentary on any photo subject. If you do, people will come to you as a source of direction and information on what is happening in the world of photography.

Write About Topics That Are Timeless

Write about topics that will be timelessly valuable. People always need to know about apertures and composition, but they might not need to know about a comparison between two types of the newest ETTL flashes available. Write something that people can keep referring to and sending to other photo enthusiasts.

Focus on the Behind-the-Scenes Content

People *love* behind-the-scenes content on photography. For photography and video, it also seems like a magical mystery to those outside the field. People find interviews, videos, photographs, and descriptions of your experiences fascinating to read. Funny stories and anecdotes are always a plus. Remember: people want to see the truth—not some perfect interpretation of what happened. If something didn't go quite right during a shoot, feel free to talk about it. People can learn from the way you overcame an obstacle or will be amused by your experiences.

Ask Questions, Invite Dialogue

Poll your readers, or invite them to ask questions. Get them involved so they feel that they are part of your blog. Give them a reason to keep coming back. Dialogue is the key to the power of social networking; if you encourage this dialogue, it will build the community around your blog.

Offer Opinions

Feel free to be opinionated. People want to hear straightforward opinions about many things related to photography: your experiences with a type of equipment, your opinions of a place, a critique of a photograph. Strong opinions can draw people into your blog and keep them engaged.

Share Your Expertise

Blog on what you know the best. What makes you unique as a photographer? What is your specialty, and what information/knowledge do you have that others might not?

Use Lists

People like lists, as you can see by the format of many of this book's suggestions and to-do lists. Top 10 and Top 100 lists help busy people read information in an easy-to-consume, organized manner. Lists are among the most common type of posts shared on the Internet. Consider making your own lists.

Create a Series

Create a series of articles on a particular topic. This will keep people coming back looking for more. For example, you might have "Natural Lighting Techniques Series: Article 1 in a Five-Part Series."

Things Not to Blog

There are a lot of excellent topics to blog about. It is equally important to recognize the topics that should be limited or not blogged about, like these.

- **Repeated shameless plugs and promotion.** If all you ever do is blog about your pricing, special offers, or upcoming photo classes, people will stop being interested in your blog. The occasional special offer is acceptable, but your blog should consistently provide useful information to your audience, not shameless plugs.

- **Useless information.** If there is no value in what you're saying, don't put it in. The most telling example is reporting what you had for lunch. Talking about your meals has become a bit taboo on Facebook, Twitter, and blogs. Go beyond the obvious. For example, instead of saying, "I'm at the diner eating fish and chips," try this: "I'm eating at a great '50s-era diner that would make a great location for a fashion shoot" and include a photograph to illustrate your point. Be relevant.

- **Whining.** It's okay to critique equipment or experiences or to disagree with someone's opinion. But bitching and moaning won't cut it. Don't complain about how hard you work or how tired you are, or you'll turn off your audience. If you feel strongly about something, feel free to write about it at length. This will help people see that you are a real person with feelings and strong opinions. Just don't rant every time you post; otherwise, people may think that's all you do and may not want to work with you. Use complaints sparingly.

- **Things contrary to your "reputation."** When you figure out your online reputation and voice, try to stick to it. If your blog is focused on photography techniques or the business of photography, don't suddenly blog about the best places to go skiing. It is relevant to blog about the most picturesque places to take a ski vacation because that may still be relevant to your blog.

Ten Great Ways to Drive Traffic to Your Blog

Your blog is of little use to you without an audience to read and pass on your content. Here are some great ways to drive traffic to your blog.

1. **Twitter.** You can let your Twitter followers know when you post something new on your blog, and most likely they will check it out. Be sure to do more than just tweet a link to the post. Instead, include a brief title and description of the blog content. This will make people more interested in reading and make your tweet searchable for keywords in the Twitter search bar. Photographer Chase Jarvis does more than tweet "check out my latest blog post"; he provides his followers with additional details about the content of his post, as in Figure 7.2. This entices readers to click the link and helps the link be search friendly.

From The Blog: Shooting Lights: Not Shooting Lights as in
photographing with strobes, but as in a new SFEAD track f...
http://bit.ly/88EiVD
11:44 AM Nov 20th from twitterfeed

Figure 7.2

Photographer Chase Jarvis regularly updates his blog and shares updates with his Twitter followers.

2. **Links.** You want good incoming and outgoing links. Offer to exchange links with other bloggers; for example, you put them on your blogroll if they put you on theirs. (See the blogroll definition in Table 7.1.) The more incoming links you have, the better. Also, link to other sites. Many sites monitor their incoming links and check to see who is referencing them. In return, they may check out your blog, mention you on their site, or link to you.

3. **Other social networks.** Be sure to have a link to your blog on all your other social networking sites. If people like what they see on Flickr or Facebook, they may be inclined to check out your blog.

4. **Contribute articles and answers forums.** A great way to drive traffic to your blog is to write articles for online or print publications, photo forums, or even local publications. You might consider contributing to online photo publications like DIYPhotography.net. In Figure 7.3, Lindsay Adler has written an article for the online photo magazine *Apogee Photography* to gain exposure and drive traffic to her site.

5. **Guest contributors.** Invite other photographers and bloggers to write guest blog posts for your site. By having them write for your blog, you may get additional traffic if they tell their blog readers to check out your site for a post they wrote. Alternatively, if these guests are big names in the field, search engine searches may direct some readers to you.

Linking Within Your Blog

If you are linking in your blog to other content in your blog, be sure to link using keywords that would make the content more searchable. Consider these examples:

Don't. To see more great photos taken of models in an abandoned warehouse, <u>click here.</u>

Don't. I took many great <u>photos</u> of the models in an abandoned warehouse.

Do. I completed a <u>fashion editorial of photos of models in an abandoned warehouse.</u>

If your links are more descriptive, Google can better identify and index your content.

Apogee Photo Magazine

 Adler Photo Workshops
Fashion, Nature, Photoshop & more

Portraits:
7 Tips on Approaching Strangers for Photographs
by Lindsay Adler

<u>Printer Friendly Page</u>

It can be difficult to get up the courage to approach someone for his or her photograph—especially a stranger. Over the years I have developed a few tricks for positive reactions from my subjects.

Try these tips and I think you'll be pleased with the outcome:

Copyright © Lindsay Adler

Figure 7.3

If you hope to drive traffic to your blog, you might consider writing articles for one of dozens of online publications and forums.

6. **Use Digg, Reddit, and StumbleUpon.** Submit your articles and content to Digg for others to find and share. By submitting to Digg, you are offering up your content for others to review and possibly "Digg" (rate positively) if they like your content. See Figure 7.4. To learn more, see Digg.com in Chapter 18, "Tools for Social Networking."

You might also consider submitting your content to sites like Reddit and StumbleUpon.

Reddit allows users to vote the sites up or down so they will become more or less prominent on the content aggregation site.

StumbleUpon is a "personalized recommendation engine." In other words, the site recommends to you other Web pages and images based on your previous ratings of Web sites. Users can indicate their interests in a variety of categories, and StumbleUpon recommends certain Web sites. You can encourage users to rate your content to share with others.

THE BEST PHOTO + VIDEO LOCATIONS IN THE WORLD
3/04/2010 07:45:00 AM

In the era before blogs really hit the mainstream, it was very unpopular in photography circles to share thoughts, techniques and insights about the craft as well as the industry/trade. It was taboo. Well, the monopoly on information has obviously crumbled and, while it upset a handful of ivory-towered folks in the photo, film and video industries, we've broken out of that paradigm to a new era of more democratized creativity.

Let's consider doing the same thing with photo and video locations around the world.

It occurred to me some time ago that I'm in the remarkably lucky position of getting to shoot in some of the best photo and video locations in the world: the beaches of the South Pacific, the peaks of European Alps, the deserts of the Middle East, the markets of South America, the warehouses in Brooklyn, the streets of Paris and countless others. It's a perk of the job, for sure. It also occurred to me that, it would be really cool to share the privilege of the knowledge of these locations with the world and, perhaps in return, get to learn about dozens, hundreds, even thousands of new locations that I'd never known of otherwise.

I'm admittedly in the very early stages of this idea, but I'd love to see if there's an initial interest from this community such to spark--or help me motivate--a sort of crowd sourced aggregator of cool places to shoot images. If you have an interest, **please take a few seconds and list a location or two you love that you'd like to share in the comments below.** Whether it's beautiful... [click 'continue reading' link below]

266 COMMENTS | POST YOURS >>> CONTINUE READING : FULL POST + COMMENTS

Tweet This! • Share on Facebook • Share Everywhere Else • Email this • Subscribe to this feed

Figure 7.4

Photographer and social media guru Chase Jarvis offers his blog readers a variety of ways to share his work. At the bottom of this image you will see several links providing you the means to share this content with others.

7. **Practice good SEO.** On your blog you can tag all your photos, write brief descriptions of your blog posts, and keyword your posts.

8. **Enter contests.** If you enter and win contests, chances are your name and link to your Web site will appear on the content/association Web site. If the Web site or contest is popular (or through a popular publication), chances are that you will get additional traffic from your entry.

9. **Comment on other blogs.** As an active member of the blogging community, you should try to read the blogs of other people you find inspiring or interesting. This will help you pick up techniques for blogging and start a dialogue with the blogging community. When you see other articles or posts you find interesting, comment on these posts. Be sure to write something insightful that furthers the discussion, and always include a link to your own site. If others see your post and find it valuable, they may check out what other content you provide on your blog.

Note

Backtype is a way to aggregate all your comments on the Web in one place and to see who is talking about you on the Web. When someone mentions your site, you are informed. Backtype basically creates a comment profile for you that tells Google which comments are yours. It is maintenance free (just sign up) and can be helpful to SEO.

10. **Consider Google AdWords.** With Google AdWords, you can pay per click for certain keyword searches. A link to your blog (or Web site) will appear at the top of Google's search page for certain specified keywords. You pay per click and can set a budget and time frame for your ads.

Best Practices for Blogging

When blogging you obviously want to make the most efficient and effective use of your time. If you employ some simple best practices, blogging shouldn't be difficult. The following are some ideas to help you stay on track.

Identify Your Target Audience

It is incredibly useful to figure out your target audience so that you can plan your content, marketing, and best ways to gain readership. Learn what other content they read, what forums they participate in, what blogs and Twitter feeds they follow, and why they would want to read your content. This will help you identify your plan of attack for gaining these people as readers.

Set a Schedule and Stick to It

Whether you blog once a week or on Tuesdays and Thursdays, it doesn't matter. Pick a schedule and stick to it so that your readers know when to expect new content from you. In a perfect world, you would blog something of interest every day.

Plan Ahead

You can't expect to sit down and write a quality blog post off the top of your head and in just one sitting. You should plan different blog posts weeks or months ahead of time. Take the time to brainstorm possible blog posts and even brainstorm with your friends or other photographers.

Keep Blogging in Mind

When you are shooting and in your everyday life, keep blogging in mind. Have a snapshot video or small video camera to capture behind-the-scenes action. If someone asks you an interesting question, be sure to take note of it and perhaps turn it into a blog post.

Tip

To create quick and easy video content, consider using a FlipVideo. It has only one button in addition to the Power button: the Record button. FlipVideo offers a decent quality of video capture (even HD), an easy interface, and an automatic upload to YouTube. You can then embed your YouTube video into your blog for quick and easy behind-the-scenes video content.

Prewrite "Pillar" Articles

Kick off your blog with some top-quality articles that will get your readers excited about upcoming content. Take the time to think of three to five really strong full-length articles you can write as blog posts. These articles should be 500 or more words in length, should include plenty of photos, and should focus on your area of expertise. You can use these articles to later submit to magazines and e-zines.

Encourage Reader Questions

Social networking is about the connections and dialogue that are now possible. Encourage your readers to interact with you. Encourage them to submit relevant questions and answer them. To get readers even more involved, consider offering contests and offer polls once you have a large enough following.

Submit Articles

When you write high-quality articles, don't just keep them on your Web site. Share them with magazines, e-zines, and forums. Share your knowledge beyond your blog, and encourage people to visit your blog for more content on the topic.

Use Analytics

You spend a great deal of time working on your blog and its content. But without analytics, you have no idea how many people are viewing your blog, how they got there, and what content is most popular. Using Google Analytics (see Figure 7.5) or other analytics services will allow you to see all this and more. You can determine how much traffic you get each day, how long people stay on your site, and which keywords or links directed them to your site. See Chapter 8, "Search Engine Optimization and Analytics," for more information.

Figure 7.5

Google Analytics allows you to monitor the performance of your blog or Web site.

Track RSS with FeedBurner

RSS is a secure method in which people may subscribe to your blog updates using an RSS reader such as Google Reader. FeedBurner is a service that offers feed, analytics, optimization, and promotion tools. The service also provides options allowing people to subscribe to your feed via e-mail.

Capture E-Mail Addresses

Make sure you have an e-mail capture program for both blogs and standard Web sites. Offer visitors the opportunity to submit their e-mail address in exchange for something of value such as a newsletter, special offer, or photograph. E-mail addresses are gold, and the opportunity to develop future e-mail campaigns is extremely valuable.

Use Podcasts

Podcasting (audio over the Internet) is another great way to get your message out. Podcasts are easy to host on your blog and distribute via iTunes. Submitting your podcast to iTunes is free. Once you have an Apple account, open the iTunes platform and click on iTunes Store. Select Podcasts, and then Submit Podcast. You need your podcast's RSS feed. If you are using a podcasting service, a feed link should be provided. If you are using FeedBurner, use the FeedBurner feed. You can't change your feed name information once you've submitted it.

Blogging Platforms

There are dozens of blogging platforms. Blogger and WordPress dominate the blogging scene and are generally the best choice for photographers, although many options exist and are created each day.

Blogger

Blogger, which Google owns, is a free blog publishing system with free hosting. Set up your blog, as shown in Figure 7.6, and the site will host all your content for you. This is great if you eventually get a large amount of traffic, because you don't need to worry if your Web-hosting plan can handle the bandwidth. The downside is that you will not be able to have a unique URL that reflects your domain (like *yourdomain*.com/blog). Because it is owned by Google, Blogger will automatically be picked up by your Google profile and is automatically more "Google friendly" than other blogs.

The Blog as a Portfolio

Many photographers no longer differentiate between their Web site and their blog. Many have a portfolio or galleries section as a page on their blog. Rather than keeping the two separate, photographers have integrated the blog and portfolio as a single representation of themselves. Having a separate blog may create a disjointed feeling to the photographer's image. Many of the biggest names in photography have chosen to have their blog integrate seamlessly with their Web site, with both on the same digital platform (WordPress.org, liveBooks, and more).

Figure 7.6

It's quick and easy to sign up on Blogger, especially if you have a preexisting Google account.

WordPress.com

WordPress.com is a free blogging and hosting site. Although you are offered a variety of templates, the ability to customize your blog is relatively limited. WordPress has a strong system of content management (automatically set up for SEO) and does not require that you have your own domain to host. See Figure 7.7.

Figure 7.7

San Diego photographer Stephen Zeller utilizes a WordPress.com theme to host his blogging content. Although it's not as customizable as WordPress.org, a variety of .com templates are available that include free hosting.

WordPress.org

WordPress.org is an open-source blog publishing application that allows you to install WordPress to your own host. Thousands of free templates are available, and many are completely customizable. Because WordPress is open source (all coding is freely available and nothing is proprietary), there are a large number of plug-ins and customization tools. If there is something you want done in WordPress, someone has probably already written code for it.

When you upload WordPress to your server or rented server space (Web host), everything is hosted under your domain. The main benefit of this is a high level of customization and professional presentation. See Figure 7.8.

TypePad

TypePad is a premium blogging platform offering features such as customizable templates, analytics, and e-commerce. TypePad offers a free basic platform, and also a paid personalized platform. Your choice of platform depends on your blogging and micro-blogging requirements and goals.

Note

Most blog platforms can import content from each other. If you need to migrate content from one platform to another, you can easily do so.

Figure 7.8

Washington, D.C., photographer Rachel Fus uses WordPress.org as a platform for both her blog and portfolio. Using a 100 percent GraphPaperPress template, she was able to customize the template to fit her company brand (logo, color scheme, and so on) and blogging needs. GraphPaperPress offers several free and for-purchase templates geared toward photographers. Wordpress.org offers endless possibilities for customization and is hosted on your own server.

Look for Web Hosting with WordPress One-Click Install

When you are searching for a Web host for your domain and Web site, look for a company that offers one-click easy install for WordPress blogs. If not, you will have to manually install the blog on your server. WordPress offers the "5-minute easy install" guide. It is not too hard, but if you are unfamiliar with coding, it will certainly appear overwhelming. Instead, opt for a host that installs in one click.

DreamHost.com is one hosting site that offers this solution.

WordPress.org Plug-Ins

Plug-ins add functionality to a blog. These plug-ins are not the same as the plug-ins we warned you about in Chapter 6, "Your Web Site." Plug-ins are available for many social media platforms. Consider plug-ins that allow the display of social media updates, create site maps, make it easy for visitors to share your content, or add reader polls or analytics.

Following are several recommended plug-ins for WordPress:

- **Sociable.** This plug-in allows you to choose from a large list of social media buttons to display at the bottom of your post so followers can share information with their community.

- **TweetMeme.** This is a popular button to encourage people to tweet your article to the social media platform Twitter. It also offers statistics.

- **Flickr widget.** This widget makes it easy to pull your photographs from Flickr into your blog posts for display.

- **Fotomoto.** This is an e-commerce solution for photographers. The nice thing about the system is that your viewers never leave your blog while they are purchasing an image.

- **Google Analytics.** There are a few good Google Analytics plug-ins. If you use one of the popular, highly downloaded versions, you should be in good shape.

- **All in One SEO Pack.** This plug-in is one of the more popular search engine optimization plug-ins. It is designed to automatically optimize your site for the best SEO.

- **Google Sitemap Generator.** Site maps are important to help search engines find all your pages. This plug-in creates and automatically updates the blog site map.

- **FeedBurner FeedSmith.** If you use FeedBurner to keep track of your RSS subscriptions, you will find FeedSmith to be a handy tool for tracking all the feeds related to your blog. It directs often-uncounted feed subscriptions to the FeedBurner system.

- **Disqus comment system.** New commenting systems are being developed all the time. This is one of the more popular ones that allow followers to sign in to comment via the platform of their choice, such as Twitter.

Your First Blog Post

It is common for new bloggers to write an introductory blog post. There is nothing wrong with such a post, but remember to quickly move forward. Start to think about the topics you might write about 10 posts down the line. Rather than posting, "Hello, my name is Kelly," tell your readers something exciting or interesting right out of the gate, such as how you create dramatic lighting.

Not every photographer enjoys writing. Most photographers prefer to focus their efforts on displaying their images on a pure photography blog. Unfortunately, this method is ineffective when it comes to searches and SEO. Search engines like words and text, so "photo blogs" may be naturally unfriendly to search engines. Make an effort to remedy this problem.

Written descriptions must accompany your photographs, and your blog should have a strong word component. One way to add words is to develop a template for each post using bullet points. Include this with images and blog posts. For example:

Photographer's Name:

Subject:

Art Director:

Location:

Stylist:

Assistant:

The list can be as long or as short as you want it. Having a set list of questions to answer makes it easy to fill in the blanks and offer the search engines what they need to find your Web site. Your list can include technical information, a detailed description of the subject matter, or whatever you envision being the keywords used to find this image or blog post online.

Last Thoughts About Blogging

A blog can be anything you want it to be; however, creativity, quality information, and imagery keep people coming back to photography blogs. It is the rare person who actually cares what you had for breakfast. Find a niche and develop it.

Blogging Success Can Come Quickly

Adam Daniels is a Chicago-based photographer who has been in the business for about five years. In November 2009 he attended a local American Society of Media Photographers (ASMP) event on new media and social media for photographers.

About a week after the event, he began to micro-blog on Twitter and then started a photography blog at http://adamdanielsphotography.blogspot.com. He quickly realized this was an important part of the future of communication.

Daniels hasn't let his personal opinion of his writing skills stop him from keeping a blog. He started by sharing his thoughts on the industry as well as reviews on equipment and photography. He embraces his inner geek, and his followers like it.

About six weeks after the start of his social media campaign, an ad agency in Missouri looking for a food photographer found his blog and contacted him. The job turned out to be the third-largest job of his career.

Since then, Daniels has earned more followers and has received referrals through friends on Twitter.

What advice does he have for a new photography blogger? Don't blog about everything. Keep to a specific topic. If you are a photographer, illustrate your ideas. If you blog about brushing your teeth, set up a creative shot about it.

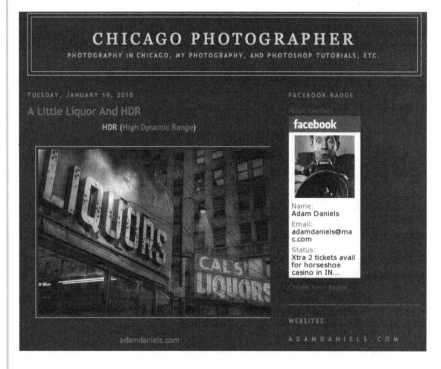

Figure 7.9

Chicago photographer Adam Daniels got one of the biggest photography jobs of his career as a result of his social networking activities. Just six weeks after launching a blog and social networking campaign, he was contacted for a large gig after the client noticed his blog.

8

Search Engine Optimization and Analytics

A Photographer's Guide to Search Engine Optimization

Most people with Internet access—some estimates are as high as 80 percent—use the Web to search for products and services. The percentage of searches for photography may be even greater. Clients searching for photographers want to see samples of their work and rates. These statistics strongly suggest that today's photographer must have a Web presence that is highly ranked with the major search engines. Your income depends on it.

Following are some defined words that will make the topic a little easier to understand.

Algorithm. This is a method of solving a problem using a specific sequence of instructions.

Body. The *body* is the middle section of a Web site defined in the HTML code by the `<body></body>` tags: This is where most of the Web site content is displayed.

Description tag. The *description* is the information displayed under the head tag within search results. This tag is more for visitors. It's your opportunity to encourage searchers to click on the link leading to your Web site. Some search

engines replace your description with other information from your Web site, if they deem it to be more relevant. Google is continuously upgrading the description area of search. For example, future descriptions will display custom information related to inquiries indicating a search for biographies, entertainment, and answers to questions.

Footer. This is the section of the Web page found under the body. Additional text, links, and custom code are often placed here.

Head tag. This is the main tag displayed on top of a Web page. It is important to search engines and to visitors because it tells what the page is about.

Header. The *header* is the top section of a Web site defined in the HTML code by `<head></head>` tags. The head tag contains the title of the page, which is another tool for indexing each page.

Keyword. An important word found in the content on your site and directly related to your site.

Meta tags. These are the equivalent of keywords for your photos, but instead they are the keywords for your Web pages. The creator of a site adds meta tags to a page to help it be indexed. Meta tags should be the most important words for search engines to interpret and index your page.

Search engine. This is a program that searches Web documents for specified keywords and defined criteria and returns a list of documents related to the search terms.

Search engine optimization. Search engine optimization (SEO) is a fancy way of answering the question, "How can you make your Web site more visible and friendly to search engines like Google or Yahoo?" Improving your SEO helps your Web site, blog, and other content appear higher in the organic (unpaid) search results of the search engine. For example, if someone types the keywords `architectural photographer` in a search, good SEO can place your Web site at or near the top of the search results

Spiders. For a search engine to create directories of your pages, it must find all the pages that exist or are newly created. A special piece of proprietary software, called a *spider*, crawls the Web to build these directories. When a spider finds a page, it begins indexing all the words, links, and meta tags there. The information it finds helps the program determine the content and topic of the page, and therefore determine how to display the page in search results.

Search Is Important

Google owns about 60 percent of the search market. The search portal uses a complex algorithm to decide who will find their way to the top of the search results.

All search engines want users to have a successful experience. Google's philosophy is that it wants searchers to find the best matches for their keywords. No one outside of Google knows all the details of its algorithm. One thing is clear, though: Google is looking for the most relevant content produced by people considered to be the experts.

How does Google know if you are an expert? There are many variables in the equation of determining search rankings. One consideration is this: how important do other sites and people feel your site is?

Links are the bonds that hold the Web together. The more links to a specific Web site, the more authoritative the site is considered. Not just any link will do, though. Links need to be related or relevant. For example, a link from an auto repair shop to a food photographer's page is not considered a related link. Too many irrelevant links, and the search engines penalize the Web site or page. The more relevant links to your site, the better. Similarly, there is value for you in linking to other sites. Link to others, and have others link to you.

Google Doesn't Index Web Sites

Google and the other search engines index Web pages, not Web sites. Ultimately, each page is indexed based on its own merits. That is why different pages within a Web site are displayed based on different search terms.

Usually the front page of a Web site is displayed because other Web sites link to the front page first. If a Web page offers more quality information about the site, that page may be displayed first under various search terms.

It is common to see a photographer's contact page as the highest-ranking page for her Web site. Why? On many photography sites, it is the one with the most writing. Google and other search engines don't "read" images. Google can easily index words, text, and other descriptions. Keep this in mind when optimizing your site as a photographer; although your site can be image driven, you must also purposefully incorporate text for SEO.

Think of optimizing your Web site as a newspaper page. Start with the title. Photographers often make the mistake of using this valuable real estate to place their name, studio, or Web site name. Generally, the name of your Web site or business is listed a few times within the body of the site. It is not hard for a search engine spider to figure that out.

Goals of SEO

The goal of SEO isn't to get your name listed high in the search results when your own name is searched. That's easy and less relevant. People placing your name in a search box already have heard of you or know you. They are searching your name, because they are already familiar with you

SEO is about attracting people to your Web site who have no clue who you are but are in need of your service. The title of your Web site shouldn't be who you are; it should be what you *do* and in most cases where you do it—such as your city or state.

Being Google Friendly

Photographers often do not embrace the idea of having writing on the front page of their Web sites. But while the images may be breathtaking, search spiders cannot read the story that your images are telling. Consider writing a short story about what you do. Five hundred words is an optimal length, but any writing using keywords related to your Web site will help drive traffic.

Think about the headlines and first sentences on your Web page. Make sure they are interesting but that they also contain the valuable keywords related to your site. Keywords related to what the Web page is about help the search engines identify the content of the page.

In the past, people would take advantage of the search engines' hunger for keywords by stuffing each page with as many keywords as possible. It worked in the early days, but today you are penalized for that. Search engines are smart and now can tell if you are trying to trick them into giving you a high ranking. Focus on one to three keywords per page. A keyword or group of two or three words should be mentioned three to five times for maximum effect without risking penalties. This is significantly easier to accomplish with a blog or blog post about a particular topic, but it requires care and purposeful word placement on your Web site.

Search involves more than just Google. Although Google is the major player, other search engines affect how people find your Web site. Yahoo and Bing are two search portals in need of your respect. Both are more keyword based than Google and offer different results. These search engines depend more on meta tags than Google does.

As the Internet is maturing, search engines are getting smarter. It is becoming harder to trick the system. Your best solution is to offer quality, updated content. This is a rule for SEO, for becoming an expert, and for best practice of social networking in general. Always offer valuable, relevant content.

> **Tip**
>
> The second-largest search engine is YouTube. Consider having at least one video related to your Web site on YouTube to help drive traffic. Although this will be covered more thoroughly in Chapter 15, "YouTube," the video-driven site is great for developing a following, establishing yourself as an expert, and driving unique visitors to your site.

Think of a daily newspaper's front page. If the headline grabs your attention, you want the content below it to be interesting, relevant, and helpful. It is important to impress the search engines so you attract legitimate visitors, but search engines don't purchase photography. People do. Keep that in mind when writing for your audience.

More Tips for Improving SEO

As stated previously, SEO engines like Google use a "secret formula" to determine your page's rankings. Although we do not have all the answers to SEO, there are some commonly accepted practices that improve your results.

Use a Good Content Management System

You should carefully select the platform for your blog and Web site. Many companies provide you with a Content Management System (CMS) that automatically optimizes your blog or Web site for search engines. If your platform doesn't have SEO in mind, you have to do a lot of legwork yourself. You have to manage meta tags, page titles, and other bits of code to really optimize your content. WordPress already has a great CMS in place. As seen in Figure 8.2, WordPress makes it easy to update your site and has many SEO capabilities built in. Many Web site creators, such as liveBooks, also have CMS geared toward SEO. If you are building your own Web site or want to learn more about the coding and theory behind SEO, check out http://linkedphotographer.com for helpful guides on the topic. To save yourself the headache of learning code, choose a Web or blog company that already takes care of the work for you.

Grader.com

Grader.com is a way for you to gauge your SEO, to monitor improvement, and to compare yourself to your competition. You can have the Web site evaluate the SEO for your blog, Web site, or Twitter account. You can also input the Web site or blog of your competition; the program automatically compares your SEO in an e-mailed analysis.

You are provided information about inbound links to your site, the last time your site was crawled by Google, how many articles have been submitted to Digg, how many times you have been bookmarked on Delicious, and much more. As seen in Figure 8.1, Grader provides your site with a score to analyze your site's performance.

WooRank—http://www.woorank.com—is another Web site designed to evaluate your sites and offer information on how you can better optimize.

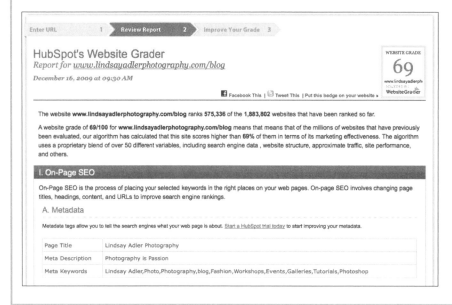

Figure 8.1

This score of 69 percent on Grader.com is above average but still shows several areas for improvement, as indicated in the report that follows the grade.

Caution

If you hire a friend or beginning Web designer to set up your site, CMS might be a huge problem. If this person only knows the design side of Web design, he will not be correctly gearing content for SEO.

> **Note**
>
> A Content Management System is just what it sounds like—the way you handle, or manage, the content—images, text, video, and so on—that you put on your site. Many CMSs integrate SEO into their functions.

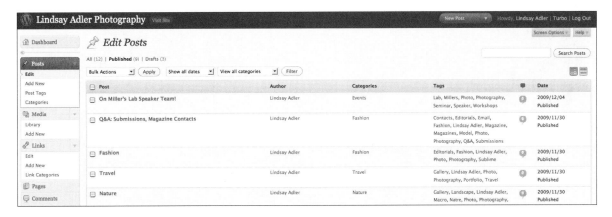

Figure 8.2
With the CMS that WordPress offers, you can easily add new postings, text, photos, and new categories to your blog or Web site.

Use Captions and Alt Tags for Photos

SEO is not an exact science, and no one knows for sure how Google ranks images. At this point in time, Google does not actually "see" the images (it does not scan the images to determine their visual content), although this could be part of image indexing in the future. At the moment, two variables that affect a photograph's SEO are alt tags (your image labels) and the captions accompanying the images. Whenever possible, use both variables to indicate the content of the images. Good image optimization improves the chances of photographs being displayed in traditional search results and image search results.

Captions

If you write captions for your images as part of your workflow process (in Lightroom, Bridge, Aperture, and so on), many social networking platforms automatically detect both your caption and keywords. If not, you should

always attempt to add captions to your images. Captions add context, help identify the content of the images, and should include keywords that apply to the image's content. Don't just list keywords; write a caption that tells the story. Good CMS gives you the opportunity to input captions easily. As seen in Figure 8.3, WordPress captions have an easy-to-understand input screen. You input the caption information, the title of the image, and a general description.

Figure 8.3

Always include captions with your images to help WordPress index your content and improve SEO.

Alt Tags

Alt tags are the only really necessary coding you should be aware of as a photographer. An alt tag is a way to add descriptions to your images within the coding of your site. If you are on a blog interface like WordPress, simply switch to the HTML viewing section of the page. Where an image is, you see `<img src=`, which signifies "image source." Tell the site which image goes in that particular location. Next, add `alt=` and then a description of the image.

For example:

```
<img src="/images/Adler_landscape_waterfall.jpg"
alt="Photograph of fall foliage on a waterfall at Rickett's Glen
in Pennsylvania.">
```

If you don't know coding, be careful of these two things. First, the `<` must come before the `img`, and the `>` must appear after your `alt` tag description. This completes that line of code and holds it together as a single piece.

Also, be sure to use the quote marks (") before and after the image name and before and after the `alt` tag description, as in the example.

If you use a good CMS like WordPress, inserting `alt` tags is automatic. When you add your image, as seen in Figure 8.4, you can simply input your `alt` tag information in the section called Caption. You need no coding or other specialized knowledge.

Figure 8.4

Alt tags are the little tags that pop up when you mouse over an image to help clarify the content of the images in text form.

> **Note**
>
> Consider using keywords in the file name. Ideally, your file name includes your name and some descriptor of the file to increase searchability. For example: `LindsayAdler_Sunset_Oregon.jpg`.

Use Links

Search engines love links. They love when you have links into your site (other people linking to you) and links out of your site (referencing other sites). The more interconnected you are, the better.

Link Out

Your blog or Web site should have links to other sites. You should have a blogroll (list of other sites) of blogs you read, other photographers you respect,

and sites with related content. More importantly, when you are writing blog posts, you should *always* link to other sites. For example, if you reference *The New York Times*, you should have a link to its Web site. If you are referring to the work or blog post of another photographer, you should always link to that site. First, this is good for SEO. Second and more importantly, the person you linked to may be watching who is linking to her site, will check out your site, and may link back to you. Therefore, you will become even more interconnected and important in the eyes of Google. The more you link, the more others will link to you. As you can see in Figure 8.5, Rosh Sillars purposefully describes all the content of his podcast (which could not otherwise be indexed by a search engine). To increase the SEO of this post, he links *all* possible content to related posts or individuals. All links are bold and connect the reader to relevant information.

New Media Photographer Podcast 77

4 [retweet] This week Rosh shares new Web sites, applications and ideas for photographers.

- New Media Photographer: A photographer who publishes to the web.
- Time: 45:30
- Podcast hosted by Rosh Sillars
- This podcast is about new media, social media and digital marketing for the photographer.
- Topics on this week's show: Small random **Twitter** case study, using Wave, **firefox plugin**, campaign for quality links: contact **rosh at rosh. com**, Blogging like **Jack Hollingsworth**, applications, thoughts and ideas for photographers. Social Media may not be for you. What is your plan for 2010? Is 2010 going to be good for social media? Judy Herrmann post on **ASMP blog post.** Photographs helping companies tell their story, **Paula Lerner Multimedia,** become a fan on **Facebook, Lan Bui,** Rosh on Wave Roshian68 at gmail. com
- Podcast network commercials from Dave Warner **Lensflare35** and Jim Goldstein **EXIF and beyond**
- Photography news by Trevor Current: **Ushareimages blog, twitter – @ushareimages.**
- New media photographer comment line link love: none
- Become a fan on **Facebook**
- New Media Photographer Twitter **@newmediaphoto**
- **Tumblr.com** New Media Photographer
- **Friendfeed** – New Media Photographer
- **Itunes New Media Photographer subscription**
- Comment line 206 202 3568
- **Email** New Media Photographer
- **New Media Photographer**
- **Rosh Sillars Photography Portfolios**

Figure 8.5

Here, the bold words indicate links to other sites or related blog posts.

Link In

Having good sites link to you is key to SEO. If sites with a lot of traffic and high ranking (in the view of the search engine) link back to you, your ranking will increase. Furthermore, their links will most likely drive more traffic to your site. Be sure to have *all* of your social networking profiles link back to your site or blog.

Have Profiles and Use Them

The more places you can sign up for online, the better off you are. Get your name and virtual presence all over the Internet. This builds your visibility as a virtual entity and improves SEO. Using your profiles gets you more traffic and more interconnectedness by improving your activity within the online community. Also, you must get a Google profile. A Google profile is a way to tell Google who you are and provide it with accurate information about your online presence. You tell Google your e-mail, Web sites, blog, Facebook page, Twitter account, biography, and more. This helps Google recognize your presence on the Internet and assists with SEO. Figure 8.6 shows the general appearance of your Google profile, including a profile photo, your Flickr (or Picasa) feed, your bio, and contact information.

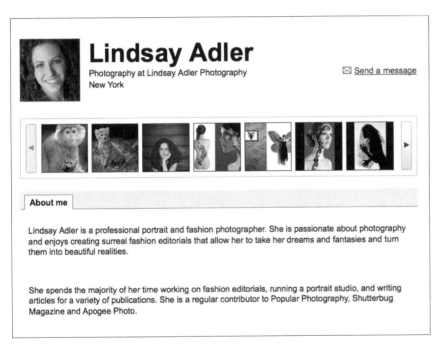

Figure 8.6

Your Google profile is another way for you to let Google identify all the blogs, links, and social networking profiles that should be associated with you and to aggregate your key contact information.

Comment on Your Peers' Content

The act of commenting on other people's work doesn't automatically increase SEO, but becoming more interconnected certainly helps. Each blog has its own method of accepting comments. Some are SEO friendly because they require commenters to submit their URL, thus creating a link back to their site. Be considerate when commenting on someone's blog post. Share your thoughts, ideas, and reactions to their content. Try to add something of value

to the conversation with your post. If you are familiar with a particular topic or want to write a more in-depth response, you might write, "I agree with your statement on X. I've actually written a blog post on the topic," and then provide a link. This can give you an incoming link from another site and encourage additional traffic. Be careful of this approach, though, and be sure you have a good relationship with the person hosting this blog if you are sharing your own links. These comments can be seen as helpful, offensive, or spam. Some blogs provide a comment policy to indicate what content is appropriate. When commenting, it is most important to get your name out there, develop relationships, and share your thoughts. By doing this, others will read your content, link to you, and view you as a respected expert.

Ask the Expert

Blake Discher is a photographer and SEO expert. Although he consults with all types of small businesses, he specializes in helping photographers rank higher in the search engines.

Incoming links are the most important thing, Blake says. Photographers should consider exchanging links with Web sites hosting similar content to their own. In many cases, the most similar Web sites are from other photographers. But this can cause a problem in some photographers' minds.

Blake says a good SEO campaign can take three to six months, depending on the competition for your target keywords. Be careful not to move too quickly. He knows photographers who have worked too aggressively on building links to their Web site and found themselves in the Google penalty box.

Note

It's best to maintain a steady pace. Some clients may add only a couple links every two weeks.

The age of the domain is also important. Google pays attention not only to how long your domain has been registered, but how long it has been registered since inception. Blake recommends that you take the time to find your competition. If the competition is number 1, find out why.

A lot of wedding photographers find themselves on the front page of Google. This is not because they are trying so hard, but because they talk about themselves on their sites. Many editorial and commercial photographers prefer to focus solely on showing their work.

There is an aesthetic balance that needs to be reached between images and words on a Web site for the site to be attractive to both search engines and people.

Blake reminds us of the saying, "Content is king." It is an oversimplification, to be sure, but it is 100 percent accurate. You really need that body copy on your site to tell visitors what it is you do.

In Blake's opinion, SEO is essential for attracting new opportunities for most beginning photographers, but as a photographer moves up the ladder and clients become more sophisticated, search becomes less of a factor in the photographer's career.

Web site load time is a little detail that's becoming more of a factor in site optimization. Recent changes in Google's algorithm were enough to convince Blake to redesign his Web site. By removing all flash imagery, he improved his site's loading speed.

How much is an incoming link worth? It has to be worth something, according to Blake. He has longtime clients who don't pay his current photography rate but still offer value as a customer by giving him a hypertext link under his photographs. Links are especially valuable if they come from a school with an .edu suffix.

The whole SEO game will continue to get harder. Just a few years ago, social media had little influence on searches. Now it's important to have a Twitter presence. Google will continue to refine its search results. What this means, according to Blake, is that photographers need to emphasize their specialty. Blake shares more information on his blog, http://groozi.com.

Google Webmaster Tools

Google Webmaster Tools is a free service to show how Google sees your site. You can determine when Google crawled your site and whether you have any page errors that need to be fixed. You can see basic search statistics to determine which search words have been driving traffic to your site and how people are linking to your site.

You use Google Analytics for determining traffic to your site. You use Google Webmaster Tools to determine how Google sees your site.

Search Google for "Webmaster tools." You can sign up through your Google account. The service is easy to use and free with any Google account. Once you sign in, simply click on the Add a Site button on the home page to add the site you want information about. Then you need to verify that the page belongs to you by uploading certain information to your site. (Upload a special HTML page or a piece of code.) Once verified to access information on the site, simply click on the URL link below Sites. Figure 8.7 shows the overall interface of Webmaster Tools. You can see how people locate your site, any errors that Google encounters finding your page, and other sites linking to your page. You can even see which keywords Google ranks as most significant to your content.

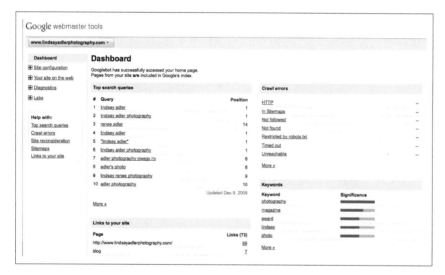

Figure 8.7

Google Webmaster Toolsis an easy way to see how Google views and interprets your site.

Useful Webmaster Tool Tips

Under Settings, be sure to check Include My Site in Google Images Labeler because this assists in getting your images displayed in a Google search.

Under Impressions and Traffic, you can see which search terms drove people to your site. More importantly, you can observe what position your site appeared in the Google search. Why is this useful? If you notice that a particular search word gets you a lot of traffic, but you are not even listed on the first page of search results, you can focus on increasing use of that search word on your page and trying to improve your SEO for that word.

The report also gives you an overview of the anchor text used to link to your site. Anchor text are the words that someone highlights and adds a link to that redirect them to your site. For example, someone might put

- Click here to check out some <u>fascinating fashion photography</u> by Lindsay Adler.

- Click here to see <u>Lindsay Adler's</u> work.

- Click here to see a series of <u>lighting diagrams on fashion photography</u> by Lindsay Adler.

The more descriptive the anchor text, the better the SEO. It shows what and why people are linking to you. This is important for photographers when linking within their own site. You *don't* want to add the link to <u>click here</u> to see more tutorials on fashion photography. Instead, you want to link to the <u>text tutorials on fashion photography</u> because that will index better with Google. As seen in Figure 8.8, Webmaster Tools allows you to see which sites are linking to yours and which pages they are linking to within that site.

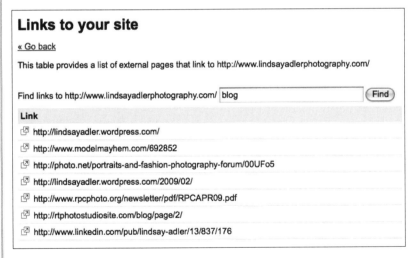

Figure 8.8

In Google Webmaster Tools, you can see which sites are linking to your pages, when this link was added, and the exact URL of the page linking to you.

Analytics (Google Analytics)

Our blogs and Web site are our homes on the Web. They are where we establish our brand and share our work. We spend a great deal of time and money on building these sites and creating their content. Without good data or analytics, we have no way to know how many people are viewing our images and content or how they came to find our sites. Google Analytics is a service owned by Google to help its advertisers benefit from their AdWords advertising system more effectively. Fortunately, Google offers the service free to everyone.

There are dozens of online resources and books written on how to use Google Analytics. Following are the essentials for what you'll want to know as a photographer.

Signing Up

If you have a Google account, you just need to navigate to the Google Analytics page (http://www.google.com/analytics/) and sign up. You can then indicate to Google on which sites you want to run Analytics. Google provides you with a piece of code that you have to insert onto each page you want analyzed. Google provides easy-to-follow instructions for this step. Some Web site companies automatically insert this text for you upon request.

For blogs run by WordPress.org, you can download plug-ins to automatically distribute your Google Analytics code to each page. Simply enter `Analytics` or `SEO` in the WordPress.org site search to find a number of plug-ins to make your site more search engine friendly or allow you to set up Analytics for your site or blog. Four options are listed in Figure 8.9.

Figure 8.9

WordPress.org provides a variety of great plug-ins to automatically integrate Google Analytics into all pages on your site.

Analyzing the Analytics

There are dozens of different screens, menus, and adjustable options to consider when looking at Analytics. It can get overwhelming to look at all the statistics. The following steps help you to keep it simple and are an extremely basic overview of the essentials.

Customize Your Dashboard

Your dashboard is a customizable "home page" for all the information you want to know about your site. By default you are given several pieces of information in the dashboard that may not be necessarily useful in your early analyses. Take the steps listed next to customize your dashboard to show only the data you *need* to know, and remove the rest of the noise. You can and should customize your dashboard to only show essential information, as seen in Figure 8.10.

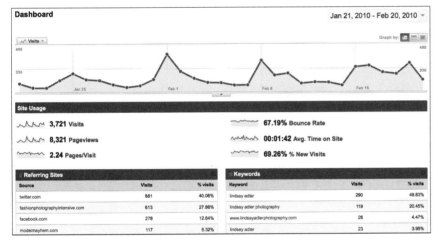

Figure 8.10

Your dashboard should look something like the one here after you customize it.

1. Click on Traffic Sources on the left toolbar of the Analytics. Then click on Referring Sites. This brings up a new graph of information and a title reading Referring Sites. Above the title, click on the button for Add to Dashboard.

2. Click on Keywords and click the same Add to Dashboard button.

3. Click on Content and then on Content by Title. Click the same Add to Dashboard button.

4. Click back to the dashboard by clicking on the icon on the left toolbar of the page.

5. Once you're back on the dashboard page, close out the Visitors Overview panel by clicking the X on the top right of the panel.

6. Do the same for Map Overlay and Content Overview.

7. Now you are left with the Visits graph, Site Usage data, Content by Title, Referring Sites, and Keywords—all valuable pieces of information for you to analyze.

Tip

You can add any information to the dashboard that you desire and remove any that you find less useful. You can also rearrange the different panels to place key information at the top. Once you get more comfortable with Analytics, you might consider including other pieces of data on your main dashboard page.

Let's look at what these different graphs and terms mean and why you should care.

Visits Graph

This graph shows the total unique visitors to your site over time. This graph will show you how many different visitors to your site you have each day and how this number has varied. If you see a sharp jump in visitors on a particular day, it might be of value to determine how and why this value increased. Did you post a new blog article? Did someone mention you in her blog?

A great aspect of this graph is that you can adjust the graphic to show you daily, weekly, and monthly totals. Even more important, you can adjust the time range being displayed on the graph. This allows you to compare your current performance with past performance, to look for trends, and to analyze specific time frames (perhaps the time frame of an ad campaign you ran). If you want to see the cause of the increased visits in a single day, you can adjust the time frame to show you that specific day and then review the data in the "Referring Sites" and "Keywords" sections discussed in a bit.

The Visits graph is great reinforcement for you to watch your visitors grow over time and reaffirm that your social networking efforts are effective. As seen in Figure 8.11, your traffic will not be consistent from day to day, and you should take time to analyze your graph to figure out the sources of peaks (high traffic) and valleys (low traffic) to best utilize your efforts online.

Figure 8.11

Your Visits graph allows you to see the ebb and flow of traffic to your site over any period you specify.

Site Usage

The Site Usage panel provides you with a variety of valuable information. Most important to understand are visits, pages per visit, bounce rate, and average time onsite. As seen in Figure 8.12, Site Usage provides an overview of your site's overall statistics on traffic and viewer interaction.

Site Usage		
3,721 Visits		67.19% Bounce Rate
8,321 Pageviews		00:01:42 Avg. Time on Site
2.24 Pages/Visit		69.26% % New Visits

Figure 8.12

The Site Usage panel provides you with a variety of valuable information, including overall visits, bounce rate, and average time onsite.

Visits

This value represents different visitors each day. If a particular person logs on from the same computer and looks at your site three times in a single day, it counts as a single visit.

Caution

The data provided by Google Analytics is far from perfect. Many factors can throw off your actual values. For example, if a person looks at your blog from two different locations in a single day, this will be represented as two separate visits even though it is from the same person. There are several other factors that affect statistics, so be sure to keep this in mind when analyzing Google's information.

Pages/Visit

This value indicates the average number of pages that users view on your site each time they visit. If a person comes to your page, looks just at the first page and then leaves, your value will be 1. If the user clicks through your content, the value will increase. This number is important in helping you understand if readers are being enticed to read beyond the up-front content. For a blog, people may come to the main page and leave because they just want to read the most recent post. Ideally, however, readers will skip around pages and content.

Bounce Rate

The lower your bounce rate, the better. Bounce rate is the percentage of visitors that enter your Web site on a particular page and do not visit any other pages on your site. They land on your site and bounce out of your site on the first page. This number indicates the *stickiness* of your site. If the bounce rate is high, your site doesn't encourage readers to look around the site further.

Tip

You are aiming for a bounce rate of less than 50 percent. Yes, this may still sound high, but 40 to 60 percent is considered a good starting goal. Anything under 30 percent is extremely good. Chances are a lot of people will navigate to your site and realize that they have already read your content or that you aren't what they are looking for.

Bounce rate can be deceiving on a blog. The front page of your blog contains multiple posts, including your most recent. Many people will enter the blog home page, read the new content, and leave. This will give you a particularly high bounce rate. It is not uncommon for blog bounce rates to be as high as 80 percent.

Exit Rate

This is often confused with bounce rate. Exit rate is the percentage of visitors who leave a particular page compared to the number of visitors the page has in total. The difference with bounce rate is that this does *not* have to be the first page on which a person lands. It helps you to determine on which pages people are leaving your site. (It may help you to find weaknesses in site design and content.)

Average Time Onsite

This value is fairly self-explanatory; obviously, the more time readers spend on your site, the better. How long do your readers stay on your site once you get them there? This number is important for you as a blogger so you can determine how long to make your blog posts. If you read through a blog post and it takes you 5 minutes to read, but your average reader is only on the site 2 minutes, you might want to consider shortening your posts or improving your content quality to encourage readers to read them in their entirety.

Tip

The online attention span for video and slideshows is somewhere between 2:30 and 4 minutes. So, if you have videos or content that take 5–10 minutes to consume, consider breaking the content into parts. People are more likely to watch three 3-minute videos than one 9-minute video.

Traffic Sources Overview

This is a general overview of how people are getting to your site. Referring sites are the hits that were directed to your Web site from another site. This means they might have been directed from another blog that linked to you or one of your social networking sites, such as Twitter. Search Engines indicates the number of times that people reached your site as a result of a search. Direct Traffic is how many people typed in the URL to your site instead of having to be directed there. This information is interesting, but it's not particularly useful because it is so general that it leaves little room for analysis. As seen in Figure 8.13, Traffic Sources is general and doesn't contain detailed information.

■ Referring Sites
806.00 (56.92%)

■ Search Engines
356.00 (25.14%)

■ Direct Traffic
254.00 (17.94%)

Figure 8.13

Traffic to your site can come from search engine results, direct traffic, or referring sites.

Referring Sites

This is one of the most valuable pieces of information in all of Analytics. It tells you how readers get to your site. For example, you can see if people are getting to your site by click-on links on Twitter or Facebook, articles you

wrote, other blogs, search engines, and more. This information is key to helping you understand where your social networking and marketing efforts are most effective and which networks to continue building. The more people you can send to your site, the better; therefore, you want to use referring sites to keep driving up traffic. As Figure 8.14 illustrates, you can determine which other sites drive the most significant traffic to your site and where you should be concentrating your networking efforts.

Referring Sites		
Source	**Visits**	**% visits**
images.google.com	188	23.33%
twitter.com	86	10.67%
lindsayadler.wordpress.com	71	8.81%
stumbleupon.com	55	6.82%
photo.net	48	5.96%
view report		

Figure 8.14
Referring Sites is incredibly helpful to figure out which sites and social networking efforts are driving the most quality traffic to your site.

Tip

If you notice that Twitter and Facebook are directing a lot of traffic to your site, you might consider getting even more active on these social networks. This information shows that the people on these particular networks are interested enough in what you have to say to click and see your Web site or blog.

Keywords

Keywords indicates which search terms readers used that led them to your site. For example, one keyword that gets a lot of visits might be your name. This suggests that people have heard your name elsewhere online or offline and are interested in learning more.

Keywords can tell you how and, more importantly, why people visit your site. For example, if you have many visits from the keywords studio lighting diagrams, you know that this is popular content on your blog you should continue to include. In other words, a lot of people come to your site because they are interested in studio lighting diagrams. You should continue to cover topics that Keywords indicates are extremely popular reasons for visiting your site.

Furthermore, you might want to focus on integrating other keywords into your SEO to drive traffic for other reasons. For example, perhaps you have one hit for Chicago Wedding Photographers in Keywords, but you are trying to expand your wedding photography business. This lets you know that you should concentrate on emphasizing these keywords and topics more on your Web site and blog. As seen in Figure 8.15, Keywords gives you an overview of what keywords direct viewers to find your content.

Visits **356** % of Site Total: 25.14%	Pages/Visit **2.09** Site Avg: 2.08 (0.69%)	Avg. Time on Site **00:02:04** Site Avg: 00:02:15 (-8.47%)	% New Visits **79.21%** Site Avg: 70.55% (12.28%)	Bounce Rate **68.82%** Site Avg: 63.06% (9.13%)	

	Keyword	None	Visits ↓	Pages/Visit	Avg. Time on Site	% New Visits	Bounce Rate
1.	lindsay adler		27	2.37	00:04:30	55.56%	55.56%
2.	lindsay adler blog		16	2.25	00:00:49	12.50%	50.00%
3.	lindsay adler photography		14	2.21	00:02:11	71.43%	64.29%
4.	jack saundercock		11	4.55	00:15:46	72.73%	45.45%
5.	adler photography owego		9	2.00	00:00:26	100.00%	33.33%
6.	fashion photography submissions		7	1.71	00:00:32	28.57%	71.43%
7.	adler photography		5	4.20	00:06:12	20.00%	40.00%
8.	fashion shoot call sheet		5	1.60	00:00:37	20.00%	60.00%
9.	portraiture class		5	1.20	00:00:08	100.00%	80.00%
10.	submitting fashion editorials		5	1.00	00:00:00	20.00%	100.00%

Figure 8.15
From your main dashboard, click on View Report to see more specific statistics about keywords and your site.

Content by Title
This panel tells you what pages of your site are getting the most views. By Title helps show you the information based on the title of the page, not the URL (which you might not easily recognize/remember). Again, this is another way of indicating which pages and topics are most popular and what topics keep people on your site the longest. Clearly, it is useful to know this information. It can help you figure out your most popular content and perhaps carve out your niche.

Tip

If you double-click on any of the panels on your dashboard, you are redirected to a page with more detailed information.

If you are aiming to increase traffic to your site for certain keywords, Google AdWords may be a consideration. You are able to choose keywords, a time frame, and a budget to increase your site's presence related to specific keywords. Ideally, your Web site will come up organically in Google. You can also choose the ad-placement or keyword pay-per-click approach.

Custom Metrics from Google Analytics

Google Analytics is a deep program with endless methods to customize your experience. Google allows you to create customized metrics so you can examine and analyze traffic within this set of criteria. For example, you might want to find out where your "ideal" readers are coming from. You might decide that the best visitors are people who view at least two pages on your site, don't bounce, and spend more than 3 minutes on your site. Google provides you the capabilities to set up these parameters and determine which sites are referring the best visitors.

There is a lot of data available to you; decide in advance what information is important. Once you gain an understanding of one metric and how it represents quality or poor traffic or information about your site, you can begin to explore additional tools. Don't follow every bit of data; you don't need it. There are better things for you to do, such as creating more great content, which is the best SEO of all.

9

AdWords

The Paid Solution

One way to drive traffic to your Web site, especially in the beginning, is to create a search engine marketing (SEM) campaign. All the major search engines offer opportunities to advertise within search results. If done well, the campaign drives traffic and converts it to sales.

The most common system used for SEM is Google's pay-per-click system called AdWords, which you can find at http://AdWords.google.com. These are the text-based ads found alongside the organic search results. If you have good search engine optimization (SEO) skills, running an AdWords campaign will seem natural. In Figure 9.1, you see that Rosh ranks in the number two-highlighted links section for food photographer in Google. These highlighted links are not organically generated rankings from SEO. Instead, they result from use of a Google AdWords campaign.

Traditionally, having the first position within an organic (nonpaid) search leads to more traffic than a paid search. If your Web site is not showing up with your target keyword searches, AdWords is a good option to consider. Some photographers use AdWords even though their SEO efforts have put them on the front page. The additional ad is often considered an affirmation that the photographer is a professional within the community.

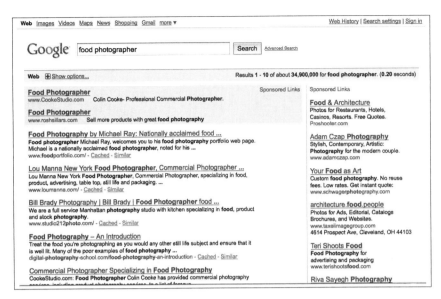

Figure 9.1

When you search for food photographer in Google, Rosh's Web site appears in the second, highlighted, sponsored (paid) links category.

Know the Important Terms

Before going further, you need to be aware of the vocabulary within AdWords. Following are the most important ones you need to get started.

- **Click.** Clicking on an ad, which takes a prospect to a landing page.

- **Click-through rate (CTR).** The percentage of people clicking on an ad compared to the number of impressions.

- **Conversion.** A prospect taking the action you see as valuable on a specific page. A conversion may be performing a transaction, filling out a form, taking a survey, sending an e-mail, or making a phone call.

- **Cost-per-click.** The amount that advertisers pay for each click on their advertisement. In many search engine systems, this price is determined by a bidding system.

- **Impression.** The opportunity for an ad to be viewed. An impression is counted each time an ad is displayed on a search page.

- **Keywords.** Targeted search words for advertising. If you sell cat food, you might target people searching for information on the word cat.

- **Landing page.** The page that prospects are sent to after clicking on an ad. It is beneficial to create specialized and unique landing pages for advertising rather than send prospects to your front page.

- **Nonorganic, paid results.** These search engine results are placed ads.

- **Organic search.** Natural results listed based on the algorithm of a search engine.

- **Pay-per-click (PPC).** An advertising system in which the advertiser is only charged for clicks on the ad. This is in contrast to pay-per-impressions, in which advertisers pay a fee each time the ad is displayed.

- **Pay-per-impression.** Advertisers pay the host (search engine or Web site) whenever an ad appears on a site, regardless of whether the users click on the advertisement.

- **Search engine marketing (SEM).** Internet marketing method using text ads related to search engine results.

Keep Your Ad Relevant

Originally, AdWords was a pure auction system. The highest bidder won the first spot for selected keywords. But in the tradition of Google, the system was changed to offer search customers the best experience possible. It was then that Google created an ad scoring system. Advertisers still bid on advertising space, but if the ad is not relevant to the keywords or landing page assigned to it, the ad receives lower priority. In some cases the ad is not even shown.

In other words, an ad with a lower bid might be placed higher on a search result page than an ad with a higher bid. This happens if the words within an ad are a better match to the keywords being searched. Also, if the landing page of an ad has higher quality information related to the search terms, it is placed higher in the search results.

Google has a search engine ranking system for the results that are paid ads to provide searchers with the most valuable content.

When Google changed its traditional AdWords auction system from ad placement to the ad scoring model, it hurt search results for many photographers. This caused some photographers to abandon the service, because the results dropped off so quickly. The reason the new system does not work for photographers is simple: photographers generally do not have words on their front pages. They have photographs and Flash presentations to impress site visitors.

To keep search ad listings relevant, Google depends on the ad wording to match the wording on the Web page. The advertiser pays a lower rate and earns a higher score if Google deems the ad to be highly relevant. Higher quality ads also are placed in higher positions in search results, even if the advertiser has submitted a lower bid.

The solution is to create a specialized page—called a *landing page*—on your Web site. A landing page should have the following elements: quality SEO; exciting images related to the advertisement; and a call to action encouraging visitors to convert using a form, a phone number, or an e-mail address.

Considerations to Keep in Mind

If you are selling $2 stock photography images using AdWords and the keywords cost $3 per click on average, AdWords may not be the right solution. Obviously, you would have to invest a little money and test the system. Unlike traditional print advertising, which is expensive, AdWords ideas can be tested for only a few dollars.

Advantages of AdWords

In most cases, photographers are selling services that earn hundreds if not thousands of dollars. If a wedding photographer invests $400 per month in search advertising and closes an average of one $2,000 wedding per month, the numbers add up. Traditional print advertising can cost much more with no return on investment (ROI).

Another advantage of AdWords is the ability to test ads and ideas by running multiple ads aimed at the photographer's target market. Over time, the best combination of headlines, body text, and keywords shows up in the statistics. This can be accomplished in a few short weeks with a small investment. The ability to track results quickly is a major advantage to SEM.

Drawbacks of AdWords

The downside to search advertising is that people have become blind to Internet ads. It is harder to get quality traffic from Internet advertising. Plus, click fraud has become a problem. Unscrupulous people click on ads that they host to make additional income. Google seems to be doing all it can to improve performance and protect against fraud. Even with Google's efforts, it still takes some savvy headline writing, testing, and strategy to run an effective campaign.

Campaign Creation

Setting up a campaign is not hard, but learning how to run an effective campaign takes time. If you are not comfortable with the technology, you can hire people to manage your AdWords account. If you are good at SEO, AdWords should be easy.

Open an Account

The first thing you need to do is open an account. If you already have a Google account, you can easily sign in and register a credit card for ad placement payments. Simply search for AdWords in Google, and you will be directed to the sign-in page (see Figure 9.2). Sign in with your Google username and password.

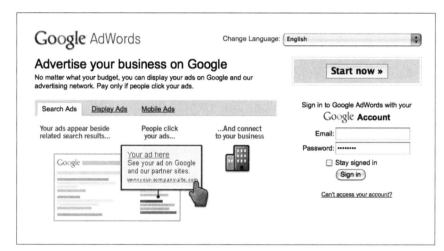

Figure 9.2

If you already have a Gmail account, you effectively already had an (inactive) AdWords account.

Determine Optimum Keywords

Decide on keywords you want to target, perhaps starting with your niche or specialty. An example might be Texas wedding photographer or Houston food photographer. The general rule is that the more general the term, such as photographer, the more competition for space and the more expensive it will be to advertise. In this case, Rosh considered using the keywords food photographer and took advantage of Google Insights to help estimate possible traffic from keywords searches, as seen in Figure 9.3. Google Insights allows you to check the number of searches for various combinations of related keywords.

Another useful tool for selecting keywords is the Keywords tool, which allows you to input your Web site. It suggests possible related keywords and statistics related to those keywords. As seen in Figure 9.4, you are given information about competition for the keyword, the total global monthly searches, and the total local monthly searches for this word. Keywords is discussed in greater detail in Chapter 8, "Search Engine Optimization and Analytics."

Figure 9.3

Google Insights offers a look at the number of searches done for a particular keyword or set of keywords. You can use this information to judge possible traffic flow from certain keywords and compare other combinations of words.

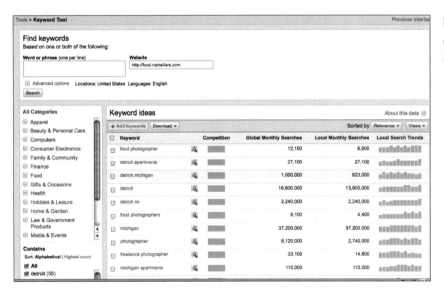

Figure 9.4

Google Keywords suggests keywords to use based on the Web page you input.

Create a Budget

Create a monthly budget. Google ad buys are based on a daily budget. A daily budget of $5 would average $150 dollars a month. Most people set a budget based on cost-per-clicks. In other words, you pay each time someone clicks on your ad and is redirected to your page. In your budget you can set the most you want to pay for each click and how much you are willing to spend each day.

Figure 9.5 shows an old (paused) campaign used to attract students to photo-related courses in London. You can see for this campaign that the highest price per click was $2. These results tell you for a particular day how many times people clicked on your ad, how many times your ad appeared (Impr.), what the average cost-per-click (Avg. CPC) was, and even the average position in which your ad appeared on Google paid results (how far down the page the ad appeared).

		Keyword	Status ⑦	Max. CPC	Clicks	Impr.	CTR ⑦	Avg. CPC ⑦	Cost	Avg. Pos.
☐	●	London Photography Courses	⬚ Campaign paused	$2.00	5	197	2.54%	$1.57	$7.83	7
☐	●	Photo Courses	⬚ Campaign paused	$2.00	4	168	2.38%	$1.58	$6.32	8.1
☐	●	London Studio Photography	⬚ Campaign paused	$2.00	3	216	1.39%	$1.39	$4.16	6.4
☐	‖	Digital Camera	⬚ Campaign paused	$2.00	2	2,404	0.08%	$0.60	$1.21	3.1
☐	●	London Photography	⬚ Campaign paused	$2.00	1	597	0.17%	$1.65	$1.65	7.4
☐	‖	Lightroom	⬚ Campaign paused	$2.00	1	238	0.42%	$0.95	$0.95	3.6
☐	●	London Photo Courses	⬚ Campaign paused	$2.00	1	21	4.76%	$1.97	$1.97	6
☐	●	London Photo Workshops	⬚ Campaign paused	$2.00	1	3	33.33%	$1.99	$1.99	5.7

Figure 9.5

In this AdWord campaign, you can see daily the various statistics provided for each keyword, including the number of clicks, the total ad impressions, the cost per click, and the ad's position on Google.

Set Up Your Campaign

Once you have a target keyword market and budget, it is time to set up a campaign. Select the tab marked Campaign and then select New Campaign. You are taken through a process that includes selecting target keywords, developing your budget, and creating your first ad.

Google offers some excellent tools under the Opportunities tab to help you select keywords, develop a budget, and judge how much traffic and expense to expect from your selections. The tools predict how many views and clicks your ad should receive. Google also offers how-to videos to help you learn the system.

Just like searching for keywords for SEO, using Google's Insights for Search tool is helpful. The Keywords tool is another excellent option. The number of keywords you should select can vary from 10 to more than 100 depending on how you want to manage your campaign.

Some keywords are not searched very often but may be beneficial over time. These are called *long tail keywords*. Individually, they may not offer a lot of traffic, but 100 of them may offer the same traffic as a more commonly searched word for a fraction of the price. This is a more advanced technique that is worthy of consideration.

Your advertising campaign information is represented by four main tabs: Settings, Ads, Keywords, and Networks.

You are allowed to create multiple campaigns and ad groups to separate different campaigns, strategies, and budgets. Doing that doesn't cost extra, so take advantage of the opportunity to keep your campaigns manageable. In the example in Figure 9.6, you see a long series of campaigns targeted at different audiences and therefore different keywords. By separating topics into the campaigns, you can monitor your investments toward each type of audience. Here you can see campaigns geared toward photography courses, fashion photography, and even senior portraits.

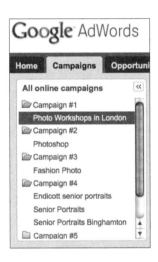

Figure 9.6

You can separate your AdWords investments into different campaigns. These campaigns help you organize and manage your spending geared toward different clients or even different geographic regions.

Under Settings, you have the option to select or adjust your highest bid offer per-click. It is recommended that you start high in the beginning and work your budget down to a more comfortable level after you have established yourself as a serious advertiser.

You can select the geographic regions where you want to focus your advertisements. If you photograph senior portraits, there may not be a need to advertise outside your local area.

Google allows you to place ads solely in Google search results or along with its search network partners. We recommend all search options. You also have the option to advertise on Web pages. You can advertise on all related Web pages that Google deems as fit, or you can hand-select the pages on which to advertise. Consider advertising on Web sites after you have more experience with advanced campaigns.

You can select when the campaign runs, for how long, and how the advertisements will rotate.

Success Determinants

You don't just want to throw some campaigns up there and judge your success based on how much money you are spending. You can review certain statistics to analyze success and even take actions to maximize the impact of your AdWord campaign.

Review Your Ads

Under the Ad tab are your ads. Google is strict about the advertisement landing pages. They need to lead to the Web site where the ad says it is going. Google staff manually approve each ad. A great advantage of Internet advertising is that you can test ads. Your goal is to achieve the highest click-through rate (CTR) possible. The CTR is determined by the number of times an ad is displayed divided by the actual number of clicks. A good CTR is considered as an average about 1 percent of people who are seeing the ad clicking on it. This statistic may vary depending on the subject, competition, and location of the ad.

Analyze the Keyword Statistics

The Keywords tab offers information about the keywords selected for the campaign. Much of the same information is offered for the keywords, such as impressions, CTRs, and costs. One of the most important bits of data is located under Status. This column tells you if your bid qualifies for the front page of a Google search. It also houses an icon that, when you place your cursor over it, displays your keyword score. This score represents how relevant Google considers the keyword in relation to the page the advertisements are sending the prospects. If the score is too low, Google does not show the ad for the selected keyword.

A Google score as low as 4 qualifies for the front page. Tweak your ads' landing pages to increase the score to 10. That's a good goal. It's difficult to achieve a 10, but every number increase in score quality means lower rates and better placement opportunities. In the sample shown in Figure 9.7, the keyword quality score received a 5 out of 10.

Improve Conversions

Your CTR is one of the most important statistics representing how well your advertisements, keywords, and ad placements are doing. But the ultimate indication of how well a campaign is doing is based on conversions.

Figure 9.7

A keyword quality score analyzes how relevant Google considers the advertisement content to the keywords you are associating them with.

Conversions are the actions you want a visitor to take after clicking the ad and landing on your designated page. The action could be filling out a form, e-mailing for more information, or purchasing a product.

Click-through rates are based on the quality of the ad copy, keyword relevance, and ad position. The conversion is based on the quality of the landing page. The landing page is the page people are directed to after clicking on your ad.

Optimize Landing Pages

Landing pages can also be tested and optimized. Under the Reporting tab at the top of the page is Google Web Site Optimizer. By pasting code onto a Web page, Google can test pages as well as elements to improve conversions.

It is amazing how colors, button sizes, photographs, headlines, and many other elements can increase or decrease conversion rates. Web Site Optimizer assists you in developing the ultimate landing page. For the food photographer Google search, Rosh directs the link to the landing page shown in Figure 9.8. The content and layout of a landing page are important.

Use Analytics

Notice under the tab marked Reporting that there is a link to Google Analytics. You should already have an account. The same type of tracking information is available for advertisements, such as which keywords are most effective and offer quality prospects. If a keyword has a bounce rate of 85 percent and an average view time of 3 seconds on the page, those statistics might indicate a problem. If a Web site has a 25 percent bounce rate with an average of 2 minutes on the site, you may want to add more resources to the catalyst that is driving the better results.

Figure 9.8

When searching for food photographer, if you click on Rosh Sillars' link, you are redirected to this clean page created specifically for his food photography services (to help with SEO and its relevancy in the eyes of Google).

Take advantage of the opportunity to test everything. Don't let your opinion get in the way of success. Let your customers tell you what they want to see and purchase.

Internet Advertising

Advertising on the Internet is still maturing, but the opportunity to track with accuracy what works and what doesn't is appealing. If you are having trouble earning traffic through organic search results, consider dedicating a budget to kick-start your social media efforts.

Part III

Essential Social Networks

10

Flickr

Overview

With tens of millions of users and billions of photos, Flickr is the granddaddy of image-sharing sites. It's equal parts photo sharing, image backup, social networking, and image organization.

Flickr is not just a place for amateurs to dump their vacation snapshots. It has a large and rich community of photographers who are serious about the art of photography. If you're looking for advice on a shoot or just want to get your work noticed, the Flickr community is a great ally.

The sheer pervasiveness of Flickr integration in both desktop applications and other social networks makes the service an obvious choice. Think of Flickr as your photography headquarters online—the central place you can store and distribute your photos.

Furthermore, it has several other features, including image analytics and creative licensing for images, that make it even more attractive for photographers.

Sign-Up

Yahoo owns Flickr, which means that you're required to sign up for the site with a Yahoo e-mail account. Don't worry if you don't have one—it's completely free and easy to sign up.

Simply go to Yahoo.com and click on the button that reads Free Mail: Sign Up. Here you'll need to input a little bit of information about yourself: name, birthday, chosen ID, and e-mail address. Remember when signing up for your ID that you want to keep things consistent if you can; try using the user ID you usually use, and keep track of your password.

Tip

You'll want to forward your Yahoo account e-mail to your main e-mail address if you've just signed up for a new account. People on Flickr can send you messages, and you are notified about updates on activity on your work. This Flickr mail appears when you are signed into Flickr and is also sent to your Yahoo e-mail. If you want to receive e-mails about these messages, you need to forward your Yahoo account to your primary e-mail.

After you have your Yahoo account, go to Flickr.com and click on the large Create Your Account button. Sign in using your Yahoo e-mail and password. You can then create your own domain name, like Flickr.com/linkedphotog. Remember to keep this name consistent with your usual user ID. When that's done, you're all set up and ready to start utilizing the site by uploading your first set of images.

Upload a square picture of yourself. Include your Web site, your region, and a short bio. Including information about yourself helps other users connect with you and see what you may have in common. People tend to be suspicious of online profiles, so Susie Florin is going to be trusted a lot more than susie329.

Tip

The first step to getting started is obvious: upload some photos. A good place to start might be uploading your portfolio to a Flickr set titled Portfolio so that other Flickr members can see a sampling of your work.

Capabilities

Once you decide you like Flickr, you can install a desktop application to upload photos directly from your desktop, but for now, let's go through the basic capabilities of Flickr.

Upload Images

You can upload your images to your Flickr *photostream* (your feed of images) to share with others. With a Flickr Pro account, you can upload an unlimited number of images. Flickr is also configured to allow you to perform batch uploading, meaning you can upload a large number of images at a time. For example, if you go on a trip to the American West and photograph a lot of landscape, batch uploading would come in handy because many of the keywords (tags), sets, and licensing permissions would remain the same.

Put Images in Sets and Collections

Flickr allows you to sort and organize your images into sets and collections. A *set* is a way to file your images. You can think of it as an album or filmstrip containing images with similar content or all taken during a certain time frame.

On the right side of the upload page you can select a previous set you created (under Add to Set) or create a new set by clicking on the Create a New Set link.

Although a photo can be in only one set, it can belong to many collections. So even though your picture of Jill's wedding cake can only appear in the Jill's Wedding set, it can belong to both the Weddings and Food collections.

As seen in Figure 10.1, during the image upload process you have the ability to create new sets for your images. Later on you can organize your content into collections if you want to make subcategories or subsequent groupings of your images.

Input Metadata

You can add a variety of metadata to your images including tags (keywords), titles, and captions/description. By adding this information, you improve your search engine optimization, helping more people to find your images. Ideally, you should be adding keywords and other essential metadata to your images during your usual workflow process. Flickr then automatically detects this content and uses it to define your images. For example, the keywords you added in Lightroom or Aperture would appear in the Tags section when uploaded to Flickr.

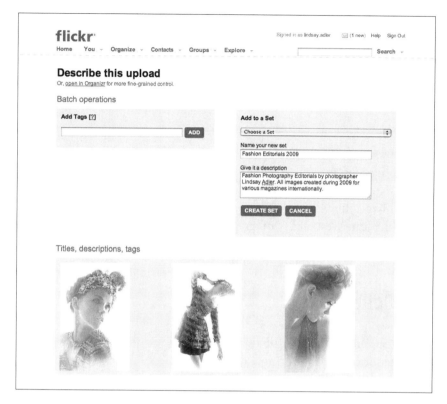

Figure 10.1

Sets in Flickr are similar to albums. When you upload your images, you can either assign images to a preexisting set or create a new set to fit the subject matter.

Add Images to Favorites

When you find images on Flickr that you like, you can add them to your favorites. You can then go back and see all of your favorite images to use for inspiration or to keep track of work you admire. Try to watch who is adding your images to their favorites. These people appreciate your work and would be good people to interact with to help build your online community. If they add your work to their favorites often enough, ask them to write you a testimonial on your profile page.

Add Contacts

If you really enjoy someone's work and artistic style, you can add that person as a contact. Whenever this person adds new images, you will be notified in the Contacts section of your sign-in page. Contacts are not like friends in Facebook. You can add someone as a contact without them adding you back, and vice versa. This is a great way to monitor the work of someone you respect and comment on that person's content. Slowly you will become part of the community around your work and engage other Flickr users.

Comment

You can comment on anyone's photographs, whether praising the work, providing critique, or commenting on the image's content. Because your goal in social networking is to build a community, you should always leave comments that engage the photographer or other users. Try to be insightful. For example, you might draw parallels between a particular image and the work of another photographer, or perhaps you might praise a strong composition. Furthermore, if people comment on your images, be sure to respond. They'll be more likely to comment again in the future if you do.

Join Groups

Flickr has hundreds of groups you can join to help expand your community and interact with people of similar interests. There are groups based upon camera equipment, geographic area, shooting techniques, subject matter, magazines, and pretty much any topic you can think of. If a group that fits your interests does not yet exist, you can create one. Many groups also allow you to submit images to their group pages. This is another way to gain exposure for your work—particularly to an audience that shares similar interests.

Send Messages Through Flickrmail

Flickr has its own mail system that allows you to send private messages to individuals. You can ask questions by adding comments, but photographers often don't notice these. By sending Flickrmail, you are sending a private and direct message to the other Flickr user. Do not overuse this feature or send a Flickr message that can be accomplished more easily through a comment. As a best practice, messages should contain some desire for action on the part of the receiving photographer.

View Image Statistics

Flickr has its own analytics (with Flickr Pro) to allow you to see how many times people view your images, how many comments and favorites your images receive, and how people are finding your images. These statistics allow you to determine your most popular images and perhaps figure out which elements of your photography are strongest. For the purposes of social networking, you can determine what type of images you should post to help build a larger community. The analytics also help you determine how people are finding your images, such as through the different search engines.

Upload Video

Flickr has recently upgraded and incorporated video sharing into its interface. Flickr now offers HD capabilities that permit full-screen views and embedding capabilities. With digital cameras now offering built-in HD video modes, this feature will continue to grow in importance. Right now it is simply value-added.

Profile

Flickr allows you to add a detailed profile section. You can include your bio, your avatar (photo of yourself), links to all your other social networks, and a section for testimonials about your work. You can also include other contact information for others to reach you outside of Flickr. Figure 10.2 is an example of how photographer Lara Jade's Flickr profile appears.

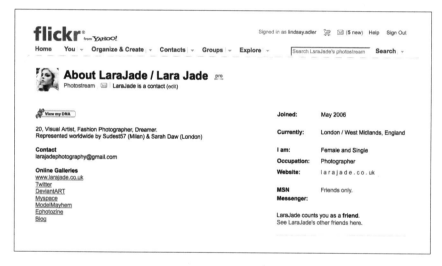

Figure 10.2

Flickr profiles allow you to include essential information including links to other social networks, your bio, and a section for testimonials (not shown, but present below the included content).

Tagging

As in Facebook and MySpace, you have the ability to tag people. By tagging people in a photo, you indicate that they appear within the image. This tagged image then appears in the Profile section of their Flickr account. If you know other Flickr users, tagging people is a good way to build up a network and make you seem more personable. For example, if you tag a photo you took of Mark and someone on Mark's page notices this image, this person might be intrigued and check out your images. Tagging is just another community-building tool.

Benefits

Flickr's slick interface is easy to follow. No matter your level of tech savviness, you'll catch on to using Flickr quickly. The organizational tools and batch commands are extremely well done for a Web site, and you can even use desktop applications to export and upload your Flickr images.

Of course, the largest image-sharing social network is a prime audience and a great community for your work. There are many serious photographers on the site who can give you image critiques or point others to your work. Over the years, a really good community of discussion and appreciation of photography has developed on Flickr. Combine that with the superior search engine optimization (SEO) that Flickr offers, and the site is a huge win for the visibility of your photos online.

SEO

Flickr makes your work extremely searchable. That's mostly thanks to the excellent way Flickr handles metadata. It automatically pulls in all IPTC and Exchangeable Image File Format (EXIF) data, and it allows you to assign tags, titles, and captions. By containing detailed metadata your images will often appear high in Google image searches for particular keywords.

Community of Photo Lovers

When social networking, your goal is to build a strong community around your work. One of the benefits of Flickr is that it has a built-in community of photo enthusiasts. People active on Flickr love images, whether they are photographers, artists, or just lovers of photography. You will already have a built-in audience with a predisposed interest in what you do. Many Flickr users are very active—they post images, comment on your images, create groups, and are generally very engaged.

Flickr Social Networking Integration

Flickr easily integrates with many other sites, programs, and social networks.

WordPress, TypePad, and Blogger (the top three blogging platforms) all have ways of pulling in Flickr photos. You can display a portfolio or just use your images in posts. Flickr can also automatically add a post to your blog when you upload new images. As seen in Figure 10.3, you can find the option to integrate your Flickr activities under Your Account and Extending Flickr.

Metadata

Photograph metadata is information about your image that is embedded in the photo file. There are two types of metadata: IPTC, which is written by you, and EXIF, which the camera automatically generates.

- **IPTC.** This metadata includes the information that you would embed into the file, such as caption, copyright, author, Web site, or tags.

- **EXIF.** This is the metadata your camera embeds, including time of image creation, type of camera/equipment, and camera settings (such as f/stop, exposure compensation, aperture, and so on).

Location data always used to be set after the fact with IPTC data. You can still do that, but with GPS, some location data is recorded automatically with EXIF. With this embedded geographic location called *geotagging*, Flickr can actually plot your image on a map, showing where it was taken—yet another way for people to find your photos.

Copyright information, your name, and at least one way to contact you are a bare minimum for inclusion in IPTC. Captions, titles, and tags (keywords) data are all smart to include, too—and Flickr will pick that information up for you if you input it earlier in your workflow. Put it in once, and you're good to go.

In fact, you can have your major social networks like Twitter and Facebook integrate with Flickr. When you post to Flickr, a post can be added to these networks. If you wanted to, you could use Flickr as the sole place to upload your images and have all the other social networks simply pull in these images from your Flickr account.

Your account

Personal Information Privacy & Permissions Emails & Notifications Extending Flickr

Your printing location To get started printing photos from Flickr, tell us where you are in the world

Account links • Picnik edit
 http://www.picnik.com

Your blogs • Lindsay Adler's Weblog edit
 http://lindsayadler.wordpress.com/
 • Twitter: Lindsay Adler
 http://twitter.com/lindsayadler

Your Facebook account Link your accounts to share your Flickr updates on Facebook.

Figure 10.3

Flickr integrates with a variety of social networks including your blog, Facebook, and Twitter.

Flickr API

Flickr has a sleek design meant to help you manage your images. Flickr's Application Programming Interface (API) furthers this goal. API is a Web developer term for a method to allow the information stored on Flickr servers to be accessible without using the Web site. Put another way: you can do everything you need to do on Flickr without ever going to the site.

On the Flickr Web site at Flickr.com/services, you can find a list of featured third-party Flickr apps, which show you some specific ways that the API information has been integrated into other programs.

The two most practical uses of the API are uploading pictures from your desktop software and your Web site automatically using your Flickr photos.

Uncommon Uses of the Flickr API

WorldInPictures is an application that allows you to find pictures close to any specified location. This might not see regular use, but it can serve as a virtual location scout if you are traveling to a new location.

Retrivr allows you to search for photos on Flickr simply by drawing rough sketches of them.

Google Profiles allow you to pull in Flickr photos. That's a great way to expose your Flickr photos to anyone searching your name on Google.

Flickr Rainbow displays the most recent images uploaded to Flickr that have been tagged with the colors of the rainbow.

Following are some common integrations you might be familiar with:

- Adobe Lightroom has the option to upload your photos directly from Lightroom into Flickr. The plug-in is quite powerful and is available as donationware at `regex.info/blog/lightroom-goodies/flickr`.

- Slideshow Pro, a highly customizable photo slideshow application for Web display, allows you to pick up your photostream and display it through the Slideshow Pro interface. Instead of having to update your Web site each time you want to display new images, now you only have to update a particular photostream on Flickr.

- iPhoto 09 and later has Flickr exporting built into the application. Downloading a plug-in gives you some more control. Connectedflow.com (a British-owned company) has a good one for sale for £12.

- Aperture has a plug-in built by the same company. This is highly recommended if you often use Flickr and Aperture.

- Facebook can post an event to your wall when you upload new Flickr photos. This is quick and easy to set up—and highly recommended to share your images with your Facebook audience. Visit Flickrbits.com to see nearly 200 programs that have utilized the Flickr API.

Art Buyers' Image Search

Many art buyers and publishers look for images on Flickr. Many book covers, DVD covers, travel images and more are discovered on Flickr. Using Flickr gets your work out there and provides an opportunity for these art buyers to see, appreciate and purchase your work.

Best Practices

Flickr is not just a place to upload your images. There are a number of best practices that can help you to make the most use out of this network. By getting a Pro account, using metadata, and building a strong Flickr community, you can really make this social network work for you.

Get a Pro Account

If you are serious about utilizing Flickr, you'll want to get a Pro account. The fee of $25 a year gets you a lot of perks. The best is unlimited storage for your images. (Note that RAW files are not accepted.) You can, in effect, use Flickr as a backup solution for your images. Although this is certainly not recommended, it is useful to have yet another place to keep another copy of your digital files.

With a Pro account, you have no limits to the numbers of sets, collections, or images you can put online. Photographers who actively use Twitter may have thousands of images available on Flickr. In fact, some photographers even have hundreds of thousands of images online.

HD video and analytics are the other perks bestowed on Pro members. HD video is a must if you're serious about motion, although we recommend using Vimeo and YouTube for your video needs. More importantly, it is valuable to have analytics on your images readily available. Being able to know which images and content are most popular is essential when trying to build your name and community within Flickr. It also acts as positive reinforcement, showing you the amount of traffic your images are receiving.

Update Regularly

As in any social network, you should update your profile or content regularly. For Flickr, you should aim to regularly add new images to your photostream. In an ideal situation, you would be adding at least three images per week. Some of the most successful Flickr users add images almost daily. When people add you as a contact, they are informed whenever you upload new content. By uploading new content, you keep people coming back to view and discuss your images.

Use Descriptive Tags

One of the greatest benefits of Flickr is its fantastic SEO. To use this capability, you must utilize metadata and tags (keywords). For example, if you have an image of a barn, don't just tag the image with "barn." You might use "red," "barn," "farm," "farmland," "rural," "NY," "summer," "crops," "agriculture" or any other descriptive terms that apply. This will help people find your content more easily. In fact, Flickr images often rank extremely high in Google image search, which allows more people to discover your images (and thus your brand).

In fact, be sure to add as much detail to the tags, title, and caption as possible. Your title, by default, is your image name (which often is not ideal and should be reworded for SEO purposes). In Figure 10.4, you see an example of the metadata input stage when you are uploading images to Flickr. You want to include as many relevant tags as possible. In this case, "fashion," "editorial," "model," "barn," "farm," "car," "sublime," "black and white," "rural," and several others are possibilities.

Note

Flickr integrates nicely with standard International Press Telecommunications Council (IPTC) metadata. That means if you use a desktop program like Adobe Lightroom or Apple Aperture to tag, title, caption, geotag, or otherwise sort your photos, Flickr picks up that information automatically. Of course, this saves tons of time, and it's great for consistency. Ideally, you should have keywords and metadata added to your images during your regular workflow and have minimal data input required when working in the Flickr interface.

In fact, Flickr can even detect your EXIF (Exchangeable Image File Format) camera data and include that in information it displays. This would include camera (make and model), shutter speed, aperture, flash settings, focal length of lens, and more.

Figure 10.4

Flickr allows you to input a variety of metadata including titles, descriptions (captions), and tags (keywords). To improve your SEO, always use as detailed descriptions and tags as possible.

Build a Community

Building a network on Flickr or any social network takes a lot of work. The more you get out there and interact with your community, the better your reputation and the stronger your community will be. There are several things you can do to get people to notice you and in turn notice your work and start connecting with you.

Add Friends and Contacts

When you find someone whose work is consistently intriguing to you, perhaps Sally Moore, you might consider adding her as a contact. When you view Sally's photostream page, underneath her name is an option to Add Sally Moore as a contact. All of your contact's latest uploads will show up on your home page.

Marking someone as a friend not only adds someone as a contact, but it gives that person access to images you marked as private. Unlike Facebook or MySpace, that person does not need to confirm you as a friend. This is a Twitter-like relationship—you can follow anyone you choose, but people don't need to follow you back. (If this is confusing, it will make more sense once you get to Chapter 11, "Twitter," and Chapter 12, "Facebook.")

Leave Comments

Become an active community member. Start exploring Flickr to find photographs you like enough to leave feedback or react to. Give comments to photographers you know, comment on your favorite subject area, or search random terms.

The Explore section of Flickr (found on the home page when you sign into your account) shows ways to interact with the billions of photos in the Flickr universe. You might search the images that have been rated "most interesting" in the past seven days, search "places" (determined by tags and geotags), or just look for subject-specific words in the Search Bar.

When you find a photo that intrigues you, try to leave constructive or insightful comments. This shows that you take the comments seriously, and you might even start a discussion based on your insights. "This is so cool!" doesn't really help you that much. We're looking for constructive criticism or questions on how the artist did it. If you have suggestions on how to improve an image, be sure to word your comment in a gentle and supportive way, such as, "I like the concept behind this image, but if I were trying the same effect, I would most likely shoot with a wider aperture so the background is less distracting" or a comment worded with similar gentle tones.

Leaving good comments might encourage people to check out your photos—and even comment back to you.

Similar to commenting, you can add notes to a photo. Above every image is a button that says Add Note. This allows you to make a selection on part of the picture and to effectively add a sticky note with a comment on that area. This capability is useful if you are critiquing someone's image. It's most appropriate in groups that are created for users to get feedback.

Add Photos to Your Favorites

Keep track of the images you like—perhaps you can use your Favorites as a reference for inspiration for your own shoots. Important note: when you Favorite an image, the owner gets an e-mail letting him know you're a fan. That makes the Favorite tool valuable for spreading your name—just use it sparingly.

Join Groups

There are thousands of Flickr groups out there, based on every category you can mention. There are groups for pet lovers, Canon equipment users, travel photographers, fashion photographers, photographers who live in Maine, and on and on.

Joining groups is a great way to start an interaction with other photographers who have similar interests. You will be putting yourself in a group that's predisposed to your work because you all share an interest.

Groups are the place to obtain feedback on your work, ask questions of fellow photographers, and organize your work. Many groups also hold competitions featuring the best work of their members.

Many groups have certain rules. For example, a Canon photography group might require that all images be taken with a Canon camera body. Other groups are by invitation only.

Create Your Own Groups

No one says you have to stick with what's out there. If you think of a group that hasn't been organized yet, start it. Perhaps you specialize in underwater portraiture and no group exists. Go create one! You might also create a group for your city (maybe "Professional Photographers of Scranton, Pennsylvania" or "Upstate New York Photo Enthusiasts"). Search the Groups section of the Web site to make sure your proposed group does not already exist.

Tips and Tricks for Photographers

A few characteristics of Flickr are particularly attractive to photographers. For example, Flickr allows you to indicate the specific licensing (copyright status) of your images and even allows you to submit your images to major art buyers or stock photo agencies, such as Getty Images. Following are a few of the key tips and tricks of what you should know about Flickr as a serious photographer.

Submit to Getty Images' Flickr Group

Getty Images, the prestigious stock photo agency, has set up a group on Flickr inviting photographers to submit their work for consideration. Through flickr.com/groups/callforartists, a photographer can submit a series of 10 portfolio images for consideration by Getty. If your images catch Getty's eye, the agency can approach you to include your images in its Flickr collection of images. As seen in Figure 10.5, this collection of images is available to photo buyers through Getty's main page and attracts a large audience of photo buyers.

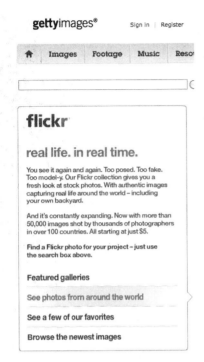

Figure 10.5

If your images catch Getty's eye, the agency may add your images to its Getty Images Flickr collection, which is available to art buyers.

Add and Request Testimonials

Flickr profiles allow users to add testimonials. This is yet another way for a photographer to build and reinforce her reputation. Photographers you have interacted with or whose work particularly inspires you are prime candidates to receive a testimonial from you. If someone has added you to her contacts and frequently comments on your work, you might consider sending that person a Flickr message and asking her if she would be interested in writing a testimonial for you. Again, this just helps your reputation and establishes how others view your work in a positive light.

Protect Your Creative Rights

Lest we sing the praises of Flickr too much, there is one strong argument against using the service. As the world's largest photo community, Flickr is prone to being used by people who do not pay for the images they use. Horror stories include images appearing on brochure covers and Web sites. Eastern Europe and Asia, where copyright laws are less common, seem especially prone to these abuses.

If you make your living by licensing photographs, having them magically appear in prominent marketing materials means lost income. If Flickr is the way the thieves got your image in the first place, you'd be understandably leery about using the site anymore.

Don't be too worried, though. Yes, image theft does happen. Yes, getting money after the fact is unlikely. However, the amount of business you stand to gain by sharing your work far exceeds the risk. Besides, the money these days isn't in licensing images; it's in proving that you can consistently deliver high-quality work.

Sites like Flickr and iStockPhoto have guaranteed an abundance of cheap stock photography for marketing agencies. Millions of amateurs can get lucky and produce the same body of work a few pros used to handle. Nowadays, the money is in making a name for yourself—building yourself as a brand that is synonymous with high-quality photography.

If one of your images gets stolen, by all means fight to get fair compensation. And if you don't get it, be public about it. Share what happened with other Flickr members, on your Web site, with friends. But don't be too angry about it. After all, more people are seeing your work, and that's a good thing.

Minimize Your Risk

Many photographers are wary about uploading images to Flickr because they fear that their images will be stolen and used without their permission or compensation. This fear is not completely unfounded; many photographers have found themselves in this unfortunate situation. Just follow these precautions to minimize the risk of your images being stolen:

- Only upload low-resolution images to Flickr. An image that's 800×800 is more than big enough for the Web and prevents most print designers from printing the image.

- Watermark your images.

- Mark your images as copyrighted.

Employ Licensing

Flickr helps combat piracy by allowing photographers to indicate the usage rights of each image. Licenses can be either a Creative Commons variant or full copyright.

> **Note**
>
> As a simple deterrent, Flickr prevents people from simply right-clicking copyrighted photos and saving them to their computer.

There are two ways of controlling access to your images on Flickr. Permissions allow you to set who can see the photos; licensing determines how the photos can be used.

Licensing depends on Creative Commons, a different sort of copyright standard that has the Internet in mind. You can license your work in any variety of the following options:

- **Attribution.** Others can copy, distribute, display, and perform your copyrighted work—and derivative works based on it—but only if they give you credit.

- **Noncommercial.** Anyone can copy, distribute, display, and perform your work—and derivative works based on it—but they can't make money off of it. We recommend this option!

- **No derivative works.** You let others copy, distribute, display, and perform only verbatim copies of your work; they can't modify it.

- **Share alike.** Others can distribute derivative works only under a license identical to the license that governs your work.

If you have more questions about licensing on Flickr, there is a Licensing Awareness Working group (LAW) that provides various discussion forums and information about Flickr's licensing policies.

To learn more about the Creative Commons options, visit the Creative Commons Web site licensing section at Creativecommons.org/about/license. Figure 10.6 is a visual overview of the main variety of Creative Commons options.

Analyze Results with Flickr Stats

Flickr Stats allows you to analyze information about who interacts with your Flickr images and how. This option, available with the Pro account, lets you see how effectively you are managing your social networking on Flickr.

Figure 10.6

Flickr allows you to indicate the permissions on your images, including the copyright status. You can use each of these different Creative Commons designations to indicate how you allow your images to be used.

Stats allows you to access the following information:

- **View counts.** This gives an overview of the activity on your account, including the views of all your photos today, yesterday, and for all time. It offers a general picture of the activity on your Flickr account.

- **Your most viewed photos and videos.** You can see which images have received the most activity on a given day—the ones with the most views and comments. If you then click on a particular image, you can view its activity over time.

- **Referrers.** This section tells you how people have discovered your images. Did they find you on Flickr? Did they link from searching on Google or Yahoo? Did they find you by clicking on a link from another Web site?

- **Breakdown of your photos and videos.** This is an overview of your presence on the site, including how many photos you have uploaded, how many are geotagged, and how many have received comments.

In this particular graph I did an experiment to see how my participation within the Flickr community would affect the views/interaction with my photostream. For the first several days I did nothing—no additional uploads or interactions. Then I uploaded a few dozen pictures and became extremely active.

I posted two dozen pictures, joined groups, commented on other people's photos, and so on. In Figure 10.7 you can see the statistics on my images during this experiment. As a result of my original activeness within the Flickr community, views of my photostream skyrocketed. Next, I only uploaded photos and did not comment on anyone else's photos or become involved in groups. You will see that my photostream views slowly dropped off. After a few days I stopped my activity altogether. You can see that slowly views of my images dropped off to a low and steady level. What does this show? Others will express interest in you if you express interest in them. You get what you put into social networking.

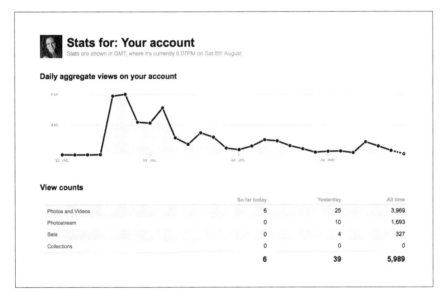

Figure 10.7

Over a period of a few weeks, I drastically varied my activeness within Flickr. This graph shows how the views and interactions with my images were directly proportional to my activities on Flickr. If I was very active, views skyrocketed. If I was inactive, few people continued to interact with my content.

Purchase Photo Products

Several companies that produce photo-related products integrate with Flickr. Companies such as MOO (business cards and stickers), QOOP (posters and calendars), and Blurb (books) allow you to seamlessly integrate with Flickr to purchase your photo products. This can be a good option to save you time and integrate into your workflow.

11

Twitter

Overview

Twitter is a social networking and microblogging tool that allows users to post short messages in real time. These messages can be up to 140 characters in length. The posts, called *tweets*, can be read by anyone who views or follows your profile on Twitter.

A few years ago most people had not heard of Twitter. Yet after its role in major events like the most recent Iranian election protests, Twitter has become a mainstream discussion on news channels and cable shows. It is an important and efficient communication tool, and its power and influence are expanding rapidly.

For those of you completely unfamiliar with Twitter, think of it as a cross between Facebook status updates, instant messenger, blogging, and blogging comments all mixed into one. Some think of it as the water cooler of the Internet—it's where you can meet, network, and communicate with others about the issues of the day.

Twitter is not about chatting. It's a media stream. The core function is to share information with people who have similar interests. What makes Twitter social media is the ability to reply and comment to the content provider.

Note

Microblogging is a term often used to describe Twitter and Facebook status updates. Limited by short message service (SMS) texting length, microblogging was originally used simply to update the question, "What are you doing right now?" As Twitter has evolved, microblogging has become much more in-depth and utilizes a variety of multimedia tools to communicate far beyond basic status updates.

Sign-Up

All you need to sign up for Twitter is an e-mail account, a square profile picture, and a one-sentence (140-character) bio. Then you are ready to start.

Tip

It is quick and easy to customize your Twitter page. Simply go to Settings, Design, Change Background Image to add a customized image to your background. It is a good idea to change your background to give you a little bit more of a personal touch. You can change the background and even the color themes of the page (perhaps change colors to match your logo/business identity).

Make sure you complete your biography. People use biographies to help them decide who is worth following. Share your interests and specialties to help people with similar likes find you. If possible, make your area of expertise within photography clear. As seen in Figure 11.1, your goal is to summarize yourself in an enticing way in just the length of one tweet.

Since the creation of Twitter, there have been hundreds of spin-off applications that integrate with Twitter to achieve a variety of goals. Following are a few of the tools to create a more media-rich experience, help you organize your networking, and analyze the strength of your network. All are completely free.

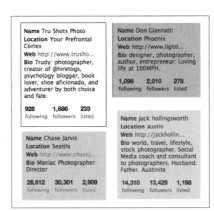

Figure 11.1

Your bio is an important way for people to figure out if you share interests in 140 characters or less. Try to make a bio that is succinct and shows you are worth following.

Photo Tweeting Tool

As a photographer, you must be able to share your images with your followers. Twitter itself does not have the capability to disperse images. Instead, you can sign up for a variety of other free services that integrate with Twitter to share your photography.

The most popular service is TwitPic.com. TwitPic allows you to select an image, caption it, and post it directly to your Twitter account. Also, others can comment on and share your photos. Figure 11.2 shows the TwitPic interface, which allows you to share images with your followers.

Other photo services include TweetPhoto.com, yfrog, ScreenTweet, and many others.

Tip
You also can post your Flickr updates and uploads to Twitter. When you post new images to your Flickr account, you can direct your Twitter followers to the new images.

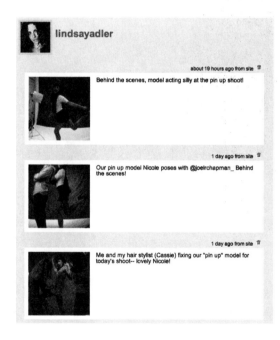

Figure 11.2

As a photographer, a photo tweeting tool is an essential way to share your photo of the day, your behind-the-scenes stories, or other images with your followers.

URL Shortening Tool

Because of Twitter's 140-character limit, it is not practical to write out entire URLs or Web pages into your tweet. You would use up all your characters on the Web page. Instead, there are several free URL shortening services that take the URL you provide and give you a much shorter URL to replace it with. This has two benefits. First, it saves a lot of character length so you can now describe the link and why it's valuable to your followers. Second, the URL shorteners offer a bit of analytics on the link. As seen in Figure 11.3, you can now track how many people click on the link, where these followers are, and how many clicks you accrue over time.

Some popular URL shorteners are tr.im, bit.ly, and Ow.ly. Su.pr is another good option because it is connected to the content sharing site StumbleUpon, giving you the opportunity to drive more traffic. You just need your Twitter sign-in information to sign up.

Figure 11.3

URL shorteners like tr.im convert your full link to a customized (shortened) link that then allows you to collect detailed analytics on the people who view your link.

MrTweet

Your network on Twitter is your most valuable asset. But how do you find people to follow and connect with? MrTweet helps you find people and followers who are relevant to your area of interest.

Simply sign up with MrTweet using your Twitter username, sign in, and you can start receiving recommendations.

Twimailer

When someone follows you on Twitter you automatically receive a quick e-mail saying that their username has followed you. No further information is provided, and there is not a quick and easy way to follow them back. But beyond that, you don't even know if they are worth following back.

Twimailer saves you a step. Go to Twimailer and put in your Twitter information. You are given an e-mail to input into your Twitter account. From then on you will receive significantly more detailed information. As seen in the sample Twimailer e-mail in Figure 11.4, you are provided with the following information:

- Number of Followers, People They Follow
- Last 10 Tweets
- Location and Bio
- Follow Back Button

You now can quickly and easily determine if you are interested in following this individual without having to navigate to her Twitter page.

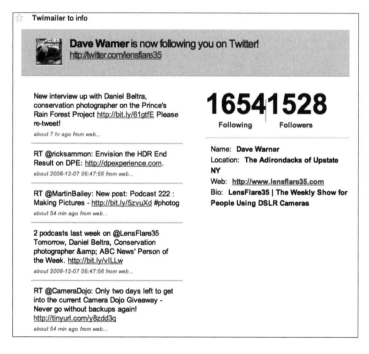

Figure 11.4

Twimailer gives you a quick and easy way to get more information on the people who follow you so that you can make a more informed and quicker decision on whether to follow them back.

Twitter Desktop Client

If you want to really utilize the power of Twitter, you need a desktop client. Twitter.com is limited and doesn't allow you to do a lot of things. There is no way to figure out where you left off reading tweets, you can't manage multiple accounts, you can't automatically shorten URLs, and it is much more difficult to organize the people you follow.

Twitter clients let you know when you have new tweets and when you have been mentioned, and they help you really digest the content that Twitter provides.

There are many different Twitter clients, and each variation appeals to different uses.

- **Tweetie.** This is one of the most popular desktop clients because of its slick interface and ease of use. With Tweetie, you can visually see ongoing conversations, manage multiple accounts, save searches, and post to yfrog. It's extremely clean and easy.

- **TweetDeck.** This is an extremely popular desktop client that runs through Adobe Air and offers dozens of options for ease of use. It allows you to put people in columns (viewing people based on your groupings), automatically recommends people to follow, seamlessly integrates with yfrog, and has an iPhone app.

- **Seesmic.** Similar to TweetDeck, Seesmic offers dozens of options, including excellent Facebook integration. You can save searches, integrate with URL shorteners, and much more. It also offers you an online version so you can have the same desktop experience if you are not at your own computer.

All are free, so download and try them to see what works best for you.

Twitter has a language of its own. Table 11.1 defines some of the terms and lingo that you should familiarize yourself with.

For more Twitter vocabulary definitions, take a look at the Twitter Wiki Dictionary found at http://twictionary.pbworks.com.

Table 11.1 Twitter Vocabulary

Term	Definition
Tweet	A message sent on Twitter
Tweeps/Tweeple	Twitter people who usually follow each other on different social networks
Tweeter	Some who uses Twitter, or a person who tweets
Tweetstream	A person's list of tweets or tweet history
Tweetup	When people from Twitter meet in person, aka Twitter meetup
Twittersphere	The total of all Twitter users
Togs	Short for phoTOGrapher (not Twitter specific, but used often)

Note

There are dozens of Twitter desktop clients that appeal to different types of users. Some other names you might investigate include Nanbu, Twitterific, HootSuite (good for business Twitter accounts), and Brizzly.

Capabilities

Twitter is powerful because it allows you to tap into a large pool of knowledge, opinions, and expertise. Although Twitter can be useful as a way to aggregate the thoughts/movements of the masses, it is also a great two-way communicator. When you first look at someone's profile, the different symbols and lingo can be extremely overwhelming. It is valuable to look at the different capabilities of Twitter before interacting with others.

Twitter Stream (Timeline)

Your Twitter stream is the chronological list of all the tweets of the people you are following. When you look at your Twitter stream, you will see that Twitter has developed its own sort of language and shorthand. At first the symbols and words look foreign, but once you learn a few tools and characters, the shorthand becomes much easier to understand and utilize. Figure 11.5 gives a sample of tweets you might see in your timeline at any one time. They include updates, links to articles, links to photos, musings, comments on the news, and much more.

@username

When @username appears at the beginning of the tweet, it indicates a reply and interaction between two people.

For example, you might see something like this:

> @MaryMay Nice to meet you yesterday! Your photos are fantastic—keep up the good work!

In this message, the person writing the tweet is sending a public message to MaryMay complimenting her work. This tweet will appear on the profile page of the person sending the message. Because this is a message to MaryMay, this will *not* appear to a tweeter's followers. This message will also appear to MaryMay on her Twitter page when she clicks on the @MaryMay button on the right side of the page.

Figure 11.5

Your Twitter timeline shows the list of the tweets of the people you are following.

If *@username* appears in another part of the tweet, this is a mention of that person (and not necessarily a message directed at a particular username). This will appear in the tweeter's profile page, and it will be sent to all of her followers.

For example, you might see something like this:

> Just met up with @MaryMay for coffee; now heading to the local photo gallery.

This message is not a message to MaryMay. Instead, it mentions her within the context of a tweet.

(Hashtags)

Hashtags are like adding keywords to a tweet to help it be identified or be part of a large Twitter discussion. You can tag your tweet for others to find when searching the same topic. This is great for a discussion of a larger topic in a large community. The more people using a tag, the larger the discussion on a particular topic.

You might consider adding a hashtag based on the topic, the location the photo was taken, or other popular hashtags of the day. Figure 11.6 shows how you can search a particular hashtag in the Search Bar, and Twitter will aggregate

all the tweets with this same hashtag, thus showing how that topic is currently being discussed on Twitter. In this case we searched for tweets with both #haiti and #photography to bring up tweets related to photography of Haiti.

Caution

In everyday writing or lingo, we use hashtags to indicate numbers, such as "I was voted #3!" or "What's your mobile #?" Because of the way # is used in Twitter, you should avoid these other uses to shorten your sentences.

Note

Hashtags became widely used and appreciated during some of history's most recent tragedies. For example, during the Mumbai terror attacks, people used the #mumbai tag to create a larger discussion about what was happening during the chaos, therefore acting as a large aggregator of information about the events.

pshannahan **RT @LATimesPhotos Helping hands in #Haiti photos by Carolyn Cole** http://bit.ly/dh2zQl **#photojournalism #photography** #HaitiQuake
about 15 hours ago from web

meslippers **RT @dominique_esser: Haiti Earthquake Aftermath Montage – footage by Khalid Mohtaseb** http://bit.ly/cbjuew **#photography #Haiti**
about 16 hours ago from web

dominique_esser **Haiti Earthquake Aftermath Montage – footage by Khalid Mohtaseb** http://bit.ly/cbjuew **#photography #Haiti**
about 17 hours ago from web

tossedsallard **Haiti art project, a couple of weeks before the earthquake,** http://tinyurl.com/yayejcs **#haiti #photography**
about 23 hours ago from web

simon_cordova **RT @latimesphotos: Helping hands in #Haiti photos by Carolyn Cole** http://bit.ly/dh2zQl **#photojournalism #photography** #HaitiQuake
1 day ago from bit.ly

dataxy **Helping hands in #Haiti photos by Carolyn Cole** http://bit.ly/dh2zQl #photojournalism **#photography** #HaitiQuake (**via** @LATimesPhotos)
1 day ago from Twitterrific

latimesphotos **Helping hands in #Haiti photos by Carolyn Cole** http://bit.ly/dh2zQl #photojournalism **#photography** #HaitiQuake
1 day ago from bit.ly

Figure 11.6

Hashtags are like little keyword tags that can help you aggregate all the tweets on a related topic. Here we have searched #haiti and #photography as hashtags.

Weekly Hashtags

Twitter has already developed a few traditions surrounding hashtags. For example, each Friday is "Follow Friday." This is where you share with your followers who you recommend them to follow. The use of lists has somewhat decreased the importance of this tool, but it still allows you to communicate who you follow that you find interesting or valuable. In your tweet, be sure to include #FF or #FollowFriday to tag your message.

Also, Music Monday is #MM or #MusicMonday when you indicate the music you currently enjoy or recommend.

Twitter has several such tagging traditions. Table 11.2 shows photo-related hashtags.

Remember, every character in Twitter is precious, so people continually shorten tags to the point of abbreviation.

Also, you might consider starting your own hashtags if you think of a useful purpose. Photographers use hashtags for discussions on particular equipment (#5D) or photo events (#WPPI).

Table 11.2 Photo-Related Hashtags

Hashtag	Use
#photography	Used for general photography-related topics.
#photo	Used when your tweet includes a link to a photo. Sometimes also used for photo-related discussion.
#photog	Either used for photography discussion or when talking about a particular photographer.
#photogs	Used when referring to a particular photographer.
#togs	Used when referring to photographers (often when referring to yourself as a photographer).
#camera	Usually used when discussing the technical side of photography and cameras.
#hiretogs	Used to offer your services. Include your specialty in photography, something unique about you, and perhaps a hashtag of your main location (ex: Experienced fashion photographer for portraits, catalog, and editorial #hiretogs #london). People also use #hiretogs to list when they want to hire a photographer.

> ### Tip
>
> On your Twitter home page on the right toolbar, there is a list of Trending Topics. This shows the hashtags and keywords that are most talked about on the Twitter community. To gain followers or participate in the Twitter discussion, you might consider tweeting about these popular topics. The topics change regularly.

Hashtags are a powerful method of gathering information. Twitter streams often contain some of the most current information on a topic. Using a hashtag with a Twitter search can help weed through the noise of this busy media stream.

Retweets

Retweeting (RT) is the equivalent of forwarding an e-mail; you are forwarding/repeating a tweet to your followers. When you retweet, you are passing on useful information to your followers while attributing the source of the content. You don't want to simply cut and paste what someone said; instead, you want to give credit for the idea/information via retweeting.

> RT @MaryMay MJ Camera is offering 40% off of its Epson inks!

You can also click on the Retweet button that appears on the bottom right of each tweet (currently beside the Reply button).

When you click Retweet, the message is shared with all your followers, with the retweet symbol in front of it. The avatar of the person who originally posted the tweet appears in his timeline with this content, and below the tweet is a little message indicating that you were the one to retweet this content to him.

Direct Messages

Direct messages (DMs) are private messages—sent between you and another Twitter user—that are not shown on any profile or timeline.

DMs can only be sent between people following each other on Twitter. If you try to send a DM to a guy you are following but he doesn't follow you back, he will not receive this message.

To send someone a direct message from Twitter, you can simply enter D username. (Note the use of the space—this is a must.) Using Twitter, you can also go to your Direct Messages tab on the toolbar on the right side of your home page. From there, you see the words Send _____ a direct message, and you can select from a list of people who can receive your DM. Furthermore, many Twitter desktop clients provide you with drop-down menu options next to their avatar to send DMs to people.

You can and should use DMs. If you have private information to share, use a DM. Also use a DM if you have information that your followers would not find interesting or relevant. Even if your users don't get an @*username* message, it will appear in your timeline and fill it up with unnecessary content. Instead, use DMs to carry on a conversation between you and one other person if you do not require or want outside input. Figure 11.7 shows the drop interface for sending direct messages. DMs are important for sending contact information that you don't want to have readily available to the public.

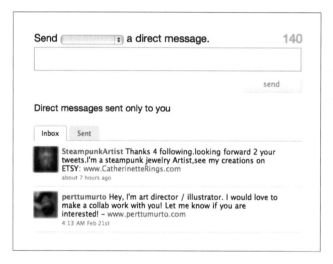

Figure 11.7

Direct messages are private messages, like texts, that are only possible when both people are following each other on Twitter.

Lists

Lists offer a way to organize the people who you follow on Twitter by whatever criteria you choose. They also provide a way to find people of interest if you look at the lists of other people.

When you follow a list, you can view all the content and tweets of all the people on a list without actually having to follow those people. In other words, if you follow a list, everyone on that list does *not* appear in your main Twitter stream. If you find someone with particularly valuable content in a group, you can choose to follow that individual and have his tweets appear in your main stream.

Think of lists like you would groups—you can create groups and categories to separate the people you follow. Then you can check each list to see content on related topics.

Currently, you can create up to 20 lists, each with up to 500 people. You can add a tweet length descriptor to each list to indicate why the people have been grouped.

You can also make a list private if you have a reason for sorting people that you'd rather not make public, although in most cases you would want to share your lists with others. Also, underneath your avatar it lists Followers, Following, and Listed. Listed indicates the number of lists you appear on. This is a good way to gauge how popular your content is and what people consider to be your niche (based on which list you have been placed into). Figure 11.8 illustrates how Jack Hollingsworth has utilized lists to organize the extensive number of people he follows into coherent categories.

Lists are helpful in finding new people to follow, particularly when you're first starting out on Twitter.

@photojack/**new-media-experts**	Following: 136 Followers: 29	
@photojack/**togs-stock**	Following: 171 Followers: 38	
@photojack/**togs-media**	Following: 106 Followers: 8	
@photojack/**togs-authors**	Following: 12 Followers: 9	
@photojack/**togs-websites**	Following: 21 Followers: 25	
@photojack/**togs-technology-partners**	Following: 79 Followers: 9	
@photojack/**togs-workshops**	Following: 46 Followers: 16	
@photojack/**togs-vendors**	Following: 162 Followers: 12	
@photojack/**togs-associations**	Following: 25 Followers: 16	
@photojack/**togs-coaches-consultants**	Following: 31 Followers: 13	
@photojack/**togs-on-twitter-one**	Following: 500 Followers: 132	

Figure 11.8

Lists are a great way to organize people around certain criteria to help you better digest your tweets.

Find a tweeter whose content you particularly enjoy, and then check her lists. Chances are you will find that people provide similar content of interest.

Note

Many desktop clients had a list solution before lists were officially introduced. Many of these applications allowed users to sort people into columns or sections. Lists now offer greater flexibility.

You can make lists for a million different reasons and to serve different purposes. Table 11.3 shows some different reasons you might compile lists.

Table 11.3 Twitter List Topics

List Category	Why It's Valuable
Experts	You follow experts to learn from them and to engage in a discussion of topics of interest. You can follow photography experts, new media experts, or experts in any other field. This will help you to keep informed about the important topics of the day.
Other Photographers	You can make lists of your peers, photographers you admire, and even your competition.
Publications	If you aim to be in certain publications, following them will allow you to keep up on their latest news and alert you to networking opportunities.
Affiliations	A list of your affiliations can keep you up-to-date on industry news and events. This could include affiliations like ASMP (American Society of Media Photographers), PPA (Professional Photographers of America), and so on.
Clients	A good way to keep an eye on what your clients are up to is by making a Twitter list of your clients. You can use this to remind you to build your networks and alert you to photo job opportunities. For example, you might see a corporate event. You can then contact someone and see if the event has a photographer.
Location-Based	Making a list of local people will give you an idea of possible local photo gigs, tweetups in your area, and other things of local interest.

Followers

In many social networks you have friends. In Twitter, you have followers. These people visit your profile page and click the Follow button to indicate that they want to receive your tweets in their Twitter timeline. A key difference between Twitter followers and friends is that you do *not* have to follow people back. It can be a one-sided friendship.

Just like e-mail, Twitter has spam. As in e-mail, you never want to click on a link from someone you don't know or click suspicious links. If you do, you might be directed to inappropriate content, or your computer could download a virus. Use common sense. If you receive spam, simply enter @spam username.

Benefits

Twitter is a fantastic communication tool that stands apart from many other social networks because of its mobility and concise format. It allows you to share information, drive traffic to your site, and communicate or collaborate with anyone willing to engage in conversation with you.

Philosophy of Following

How many people should you follow? Who should you follow? Do you follow everyone who follows you? People have different philosophies of following on Twitter. The next sections detail those.

Follow Everybody

Some people believe that the larger the network you have on Twitter, the better; therefore, you should follow as many people as you can. These tweeple follow everyone they find interesting and everyone in lists made by people they find interesting, and so on. Often the people you follow in turn follow you, which grows your network and the number of people seeing your tweets.

With Twitter lists, which is a relatively new feature, you can now create lists of the people you are actually interested in and weed out all the other masses of followers. Also, you can decide to remove people who don't follow you back or who don't provide valuable content.

The follow-everybody approach appeals to people primarily looking for a large audience to broadcast to.

Follow Selectively

Some people only follow others they find to be particularly interesting or key to their online network. These people want to focus on building a strong network that they actively participate in without the noise of following dozens or hundreds of other people.

For this selective approach, focus on engaging in conversations and debate with people you view as important and valuable resources.

Follow Those Who Follow You

Many people believe that you should follow those who follow you. This allows you to more actively participate in the Twitter community because you will receive their tweets, they will receive yours, and you can participate in a more robust dialogue based on your interests. Again, be careful that you don't follow too many more people than those who follow you, and be sure to engage in thoughtful exchanges.

Whom to Follow

When you first get on Twitter, you should look for photographers you admire and start networking with them. Only follow people you truly are interested in.

Here are some other people to follow:

- **Local people.** Look for other photographers or people of interest in your area. These people can provide potential clients, business contacts, and opportunities for tweetups.

- **Real-life friends.** When you sign into Twitter, you can grant it the ability to find users through your e-mail contact list. Simply click Find People, Find on Other Networks, and then log your primary account. This helps you network with people you already have initiated contact with.

- **New media experts.** If you are really interested in new media and social networking, follow experts in new media to give you updates on the latest tools and tricks.

- **Respected photographers.** Look for the big names in photography, particularly the ones in the field of your interest (fashion, food, nature, and so on). By following these individuals, you can learn about the industry as well as receive good content to tweet from.

- **Your competition.** Following your competition is not snooping. You can engage in a mutually beneficial conversation with them about photography in your area of expertise or geographic region. Also, you can see how they utilize Twitter to drive traffic to their site, network, and get more business.

- **Potential clients.** Following potential clients can give you a heads up on their upcoming events, campaigns, or little facts that will make your cold calls a bit warmer. By following potential clients, you can start to interact with them and get them familiar with your name and services.

 Caution: Some people have activated the ability to screen their followers. In your account settings, you can indicate that you must approve your followers to ensure that you can monitor who can see your tweets. For photographers and people who want to grow their brand or business, this is a bad idea. You want to participate in the larger Twitter community and share your thoughts with as many people as possible.

- **Favorites.** When you favorite a tweet, you are essentially bookmarking the tweet to go back to. This feature is not widely used, but you can utilize it in two main ways. First, you can favorite your own favorite tweets as a way to catalog your "best of" tweets. Second, you can bookmark your favorite tweets to emphasize your interest in a certain person or topic.

Mobility

You can take Twitter anywhere you go that has cell phone coverage or Internet service. You can tweet directly from your phone even if you don't have a 3G smartphone—any phone with text message capabilities will work. This gives you the capability to tweet photos from wherever you are and send updates no matter what you are doing. In the past year, it was big news when U.S. senators began tweeting during the president's speeches. You can tweet during shoots to update people on progress and include videos, photos, and short text updates about your experiences.

With smartphones, you can use built-in Twitter apps to post to Twitter. For other phones, you simply text your messages to 404-04.

You can also receive updates to your mobile device. With a smartphone, you can view a Twitter interface. With other phones, you can select which individuals you'd like to receive on your mobile.

Caution

If you don't have a smartphone, be sure to have an unlimited texting plan before utilizing Twitter on your mobile device. Sending and receiving texts can add up fast!

Brevity

Twitter's brevity factor helps you quickly find and be updated on information. It forces people to be concise and prevents rambling, which makes it a great time-saver and an effective communication tool.

Ability to Stay Informed

If you follow the right people online, you can stay informed and educated about the newest happenings in your field, with minimal effort. People will provide information on new equipment releases, photography seminars, and many other timely nuggets. Consider following industry leaders like PDN for news.

Communication

Twitter is both a mass communicator (depending on your audience) and a one-to-one communicator. You can broadcast general information to share with all the twitterverse or send a target message to an individual.

No Hierarchy

There is no hierarchy in Twitter. If you want to send a message to a photo celebrity, there is nothing stopping you. Although this person might not respond, you have a good chance that a thoughtful comment/message might intrigue them enough to respond to you. Everyone is available for interaction if they are willing.

Ability to Drive Traffic to Your Site

Twitter is a fantastic way to drive people to your site. You can tweet about new blog posts or build a following through Twitter and encourage them to visit your blog or Web site for more content. As seen in Figure 11.9, Twitter can be the primary means of driving traffic to your blog or Web site.

Referring Sites		
Source	**Visits**	**% visits**
twitter.com	881	40.06%
fashionphotographyintensive.com	613	27.88%
facebook.com	278	12.64%
modelmayhem.com	117	5.32%
lensflare35.com	48	2.18%

Figure 11.9

Twitter is an extremely effective way to drive traffic to your Web site or blog.

Reputation and Expertise Building

Just like your blog, Twitter is a great place to build your reputation and expertise. If you continually tweet good information related to photography or related topics, you are likely to gain a following that views you as an expert.

Collaboration/Networking

Twitter is a natural networking tool. You can follow anyone you want and then try to develop a relationship with that person through comments, messages, and DMs. It is easy to familiarize another with your name and thoughts, and that makes for a warmer real-life introduction.

Tip

If you are interested in collecting data or opinions from your followers and other Twitter users, you might consider using a Twitter poll. Two main sites for polling are Polldaddy and Twtpoll. These sites allow you to view a specific number of criteria when asking a question, and then they post this poll to your Twitter account. You might take a poll on the number of photographers using certain stock photo sites, or different marketing approaches your followers find most effective. Get creative and get your questions answered!

Feedback

Because of its ease of two-way communication, Twitter can be a great way for you to obtain feedback on your images or questions. If you post an image, you can seek out critique from photographers or peers you respect. You can also post your ideas and get feedback from other photographers.

Best Practices

When engaging on Twitter, there are some best practices to keep in mind to attract more followers, maintain a professional presence, and make Twitter really work for you. If you follow these best practices, you will not only save time, but you will also form a stronger community on this platform.

Think Before You Tweet

Once you post a tweet, you cannot take it back. You can delete it from your profile, but it has already been received by all your followers and put into their timelines. Don't tweet anything you will regret, and even with computer lingo, check for egregious spelling errors.

Develop Content First

When you first get online, you should find a few people to follow and start engaging in conversation. Right away you should concentrate on providing quality tweets. If you get online and start following tons of people but have no good tweets, chances are people won't follow you back. Develop your content first with a small group of people, and then start expanding your network.

Follow Evangelists

You want to encourage people to talk about you online. You want them to talk about your work and your tweets and spread your name. Although you might not always follow people who follow you, consider following people who mention you. These are the evangelists you want—the people who look at and interact with your work or tweets. You might consider thanking tweeple for linking to your work or mentioning you in a tweet; positive reinforcement encourages them to mention you more and network with you. If you follow them and find their content uninteresting or unrelated, you can always unfollow them later.

Organize Tweetups

If possible, try to organize in-person get-togethers with other photographers, professionals, and clients. By doing this, you strengthen your networking bond and put a "face to the tweeter." Get together to talk about Twitter, photography, your city, or any topic that unites you. Watch for opportunities for tweetups. New York's annual PhotoExpo has a variety of tweetups.

Caution

Be smart about your meetups. Don't meet with complete strangers by yourself. Just like meeting up with anyone online, never go alone, and always meet in a public place. Groups are always safer.

Provide Valuable Content

As with many things in life, you do not receive from Twitter until you give—until you give *a lot* usually. As with your blog, you should find a niche and continue providing valuable information.

Network with Photographers

Don't just focus on reaching new or potential clients—other photographers are a fantastic resource. They provide a wealth of knowledge to keep you up-to-date in the industry, critique work, and even recommend jobs.

Get Organized—Make Lists

Lists are great organizational tools. It is difficult to track the content of hundreds of people you follow. Dividing these people into lists helps you sort the content and make it easier to digest.

Start Conversations

As mentioned before, there is no hierarchy in Twitter. Starting a conversation with anyone is totally acceptable. If you tweet something particularly interesting toward a celebrity in the photo world, it is quite possible this person will tweet you back. Without the hierarchy, it is all about content. Good questions and good tweets get good responses. As Figure 11.10 illustrates, photographers can start conversations and get feedback by asking questions, posting insightful comments, or creating polls of fellow photographers.

Tip

To encourage conversation, retweet someone's content, respond to comments people make, and show an interest. People love to hear about themselves, so to get someone's attention, don't just talk about yourself—talk about them!

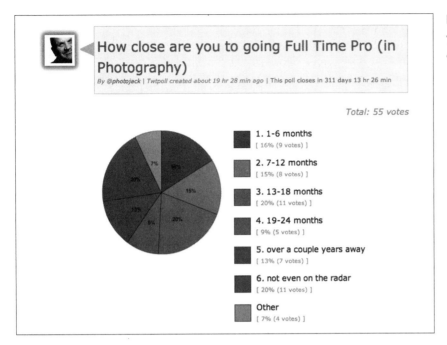

How close are you to going Full Time Pro (in Photography)

By @photojack | Twtpoll created about 19 hr 28 min ago | This poll closes in 311 days 13 hr 26 min

Total: 55 votes

1. 1-6 months
[16% (9 votes)]

2. 7-12 months
[15% (8 votes)]

3. 13-18 months
[20% (11 votes)]

4. 19-24 months
[9% (5 votes)]

5. over a couple years away
[13% (7 votes)]

6. not even on the radar
[20% (11 votes)]

Other
[7% (4 votes)]

Figure 11.10

Taking polls is one way to engage people on Twitter.

Ask Questions

Twitter is all about communication. If you just sit and read your Twitter lists and periodically contribute a valuable tweet, you are far from utilizing the power of Twitter. Instead, ask targeted questions to individuals with a particular expertise; doing so is much more likely to get a response. Once you have a large-enough finding, you might consider asking questions "into the void" of the Internet (just a general question). When your following is large enough, you may get helpful responses and start a good conversation. With a small following, chances are you'll only hear crickets unless your question is particularly provocative.

Find Lists with Listorious and Other List Aggregation Sites

Listorious is a directory of lists that people have added with tags. Simply go to All Tags under the Top Tags column and search for a tag that is descriptive of what you are looking for. You can search for lists based on keyword, which makes it easy to find lists relevant to your interests. Consider submitting your favorite lists to this directory site.

Respond to DMs and Messages

If people ask you a serious or thoughtful question, take the time to respond. Remember, your response is limited to 140 characters, so it will take little of your time but will still help you build a stronger network and become a real person online.

Give Thanks

If someone recommends you to other people, take the 10 seconds to send that person a quick thank-you DM or thoughtful response. Your mom would agree that it's the right thing to do.

Tweet Links

When tweeting links, always include a descriptor of what you are linking to; otherwise, people won't click, and the content won't be searchable. This is true when linking to your blog posting as well.

For example:

> **Don't:** Just posted new content to my blog at tr.im/3asdf9.

> **Do:** Learn great beauty studio lighting techniques in my newest post tr.im/3asdf9.

Also, be aware of the keywords you are including in the description. These are the words that allow others to find your content in the Twitter Search Bar. Try to use language that is a call to action, such as Improve your studio skills by reading my newest blog post instead of Blog posting on studio techniques so that people are more enticed to click and read. Figure 11.11 shows how Don Giannatti didn't just post a link to a book he likes. Instead, he gives the title of the book, a call to action, and a brief review.

Often you want to give as much information as possible. If you post an image, where was it taken? What was it taken of? Where will it be published?

wizwow You can pre-order Nick Onken's Book "Photo Trekking" right now on Amazon. http://bit.ly/a7Jfmi You can & you should. My Review: Terrific
about 9 hours ago from TweetDeck

Figure 11.11

Include as many keywords and descriptions as possible when sharing a link so it becomes more searchable and entices people to click on your content.

Be Personable

If people are following you on Twitter, it is because they find you and your content interesting. They want to see a slice of your life, your opinions, and what you are thinking. Be yourself. Even though you want to be professional online, you really should try to let your personality show through. You cannot please everyone, but if you are genuine, people will find you appealing.

Caution

Don't be an automatic feed. Some Twitter accounts are simply RSS feeds that tweet what new content appears on the tweeter's blog or other site. For example, *The New York Times* has a variety of Twitter accounts that tweet when new content has been posted in a certain category of the paper. Although this approach may be applicable for the newspaper, it is not useful or effective for photographers or individuals. Be a person, and tweet content with emotion and that people can relate to.

Set Up Twitter Alerts

As with Google Alerts, you can set up alerts so you are notified when people are talking about you and your content on Twitter. The most Twitter-friendly companies have utilized Twitter alerts to enhance their customer service.

For example, VistaPrint (an online printing company) sends you a message whenever you mention the company online, good or bad. If you tweet a problem, VistaPrint responds with a solution. If you tweet praise, the company thanks you for it.

Consider setting up Twitter alerts to see who is talking about you, your blog, and your photos. You can improve customer service or just use the tool to expand your network. Visit tweetbeep.com or tweetalarm.com.

Note

You can also set up your BackType account to aggregate your Twitter comments and when people are talking about you on Twitter. Instead of needing a separate alert just for Twitter, you can have BackType aggregate all comments about you, your blog, your Web site, or anything associated with you.

Note

From your Twitter home page, you can also search keywords in the Search Bar. You can then indicate that you want to Save This Search. From now on, these search terms will appear under your Search Bar; by simply clicking on the term, you will be given an automatic Twitter search. Although you do not receive Twitter alerts via e-mail, this is another way to monitor certain terms or URLs.

Comment

As with other social networks, it is always good to get involved with the network by commenting on other people's tweets and photos. If someone tweets a photo, consider offering thoughtful comments on it. (TwitPic and other photo-tweeting sites give you a special place to comment, and the comment is posted to your Twitter page.) Don't try to comment on everything everybody says, but people like to know that their followers are reading and responding to the content they are sharing.

Keep a Steady Stream

Try to keep a steady stream of daily tweets. If you go a week without tweeting, don't suddenly come back and make up for it by tweeting 40 times in one day. To really start building good content, aim for about 5 tweets per day in the beginning. Some people are prolific tweeters—40–60 times per day. Find your tweeting voice and stick to it. The one exception for a lot of tweets is during an interesting event. If you regularly tweet 10 times per day, it is acceptable to exceed this amount if you are at a conference or doing an exciting shoot that people would find interesting.

Tips and Tricks for Photographers

Twitter is a unique social network because it already has a strong community of photographers. Although Facebook and LinkedIn do have some photographers in their networks, Twitter has developed a large and active community of them. You should be aware of a few tips and tricks on how to utilize the platform. This includes photo sharing, photography tips, photo hashtags, and more.

What to Tweet

As discussed earlier, Twitter is considered microblogging. Although this concept doesn't necessarily have bearing on most of your Twitter activities, keep in mind that many of the best practices for Twitter relate to best practices for blogging. Many of the "good things to blog" apply to "good things to tweet."

Behind the scenes. To many, the life of a photographer is exotic and fascinating. There is a great deal of mystery behind fashion and advertising shoots, or really any photo shoot. People love to see and hear behind-the-scenes content. Tweet a real-time photo of the process or updates on your progress.

Good links. If you see links to things you find interesting, chances are your followers will find it interesting, too. These can be links to photo reviews, beautiful images, or anything else you find interesting. The links don't have to be photo related. If your following is primarily other photographers, you wouldn't want to tweet incessantly about sports, but it is completely acceptable to throw in tweets about a sports game you went to or are excited about. Show your personality, which includes referring to interests outside of photography.

Opinions/reviews. Your followers are interested in your opinion. Feel free to give reviews on equipment or photo companies or state your opinions on places you have visited or techniques you have tried. Followers will look to you for your experiences to make educated decisions about their own actions (whether a purchase or trying a technique).

Timely. Try to make your content timely. If there is a new photo exhibition that you visited in your area, or the release of a new camera, be sure to tweet this timely information. This type of content will be valuable to your followers, which might make them look to you for news in the photo world.

Photos. Tweet samples of your work. This can be recent client work, personal work, or anything that shows your vision. Twitter is a great place to share images to get feedback and critique, besides being a place to share images that don't make the cut into your portfolio.

Photo of the Day

Many photographers have taken to the "picture of the day" approach, or 365 project, to motivate them to tweet and take photos. Each day they share one photo they have taken. This technique was made popular by photographer Chase Jarvis, who has developed a large following for his iPhone Photo of the Day. In fact, Jarvis has developed an iPhone app called Best Camera to take and upload these photos to Twitter.

You might also consider highlighting a photo of another photographer each day to show interest in others' work. Ideally, however, you will be uploading your own photos and content.

In Figure 11.12, Don Glanatti shares a link to his photo of the day for his 365 project.

 wizwow 365 iPhone project.2-21-2010 http://post.ly/OzJF
about 12 hours ago from Posterous

Figure 11.12

Many photographers take part in a 365 project where they create and share at least one photo a day, whether with a professional DSLR, iPhone, or even snapshot camera.

Photo Tip of the Day

A lot of photographers and others will follow you looking for your expertise in photography. Consider tweeting at least one tip of the day related to photography. It can be a link to a blog, a tip about Photoshop, an in-camera technique, or anything you can think of. Sometimes photographers online forget their specialty and focus on tweeting about new media and social networking. They lose the reason many people followed them in the first place—because they are photographers!

Photo Hashtags

Consider using photography-related hashtags to help other photographers find you and to aggregate related content. As mentioned earlier in the chapter, there is a range of hashtags that you can utilize to categorize your Twitter content. You might add a hashtag related to a particular camera brand if tweeting an equipment review. You might include a general photo hashtag if you're simply musing about the field of photography. By using hashtags, you make your tweets more search-friendly, which will ultimately help you gain more followers and be better connected.

Testimonials

If your customers praise your work, consider tweeting their testimonials (especially if they are on Twitter). These testimonials can act as a great resource for recommendations and to build your reputation. For example, if someone saw you give a presentation on photography and praised the content you provided, consider retweeting this positive comment. If your clients are on Twitter, consider tweeting them a thank-you after the shoot is complete, and they will often write you a brief testimonial in response.

Specials/Deals

If it applies to you, consider tweeting about the deals or special offers your company has available. For example, for Christmas you might offer a Twitter discount to people who want to buy one of your portrait Christmas card templates off your blog. Get creative, and think of ways to drive traffic to your site through deals.

Caution

Do *not* use Twitter just to promote yourself. People see this as a turn-off and will not follow you. If you primarily tweet about your latest offers or new workshops, it seems like an ongoing Twitter advertisement. Periodically it's okay to let people know about your workshops and specials because your followers want to know this information. It is not, however, okay for this to be your main content on Twitter. Although that information is valuable, it is also boring and gets old fast.

Tweeting Time Advantages

Studies show that the best times to tweet and have your tweets noticed is from 11 a.m. – 12 p.m. and 4 p.m. – 5 p.m. (through the week). At these times more than 50 percent of active Twitter users are reading tweets, but fewer are sending them. So if you have a tweet that you want to get noticed, tweet it then. Another random fact: most retweets happen around 4 p.m., so if you want to be retweeted, keep that in mind!

Simplicity

Don't be fooled by Twitter's simplicity. As with many applications on the Web, the simplest are often the most powerful. Twitter is what you make of it. Its concise format forces you to communicate efficiently and waste no time or words.

12

Facebook

Overview

Facebook currently rates as the most widely used social network in the world with more than 400 million users, and this number is growing daily. In addition to having the largest network, Facebook has some incredibly convenient capabilities that are naturally suited to photographers.

Facebook can be used for both personal and professional communication—as well as for the gray area between the two that is constantly expanding in the digital age. For personal use you can communicate with friends, family, colleagues, and classmates. Professionally, you can promote your business and expand your social networking by building a brand, interacting with clients, and getting connected in the world of the Internet. There are also many ways to improve customer service and encourage word of mouth through many great tools on Facebook.

Facebook began as a site intended for college students, expanded to high school students, and has now grown to include the community at large. People interact with current friends, reconnect with old ones, or connect with new people. The audience is international, from all countries and demographics.

Facebook offers a variety of media, including microblogging, photos, videos, and other apps so you can customize your experience.

> **Note**
>
> The designers of Facebook are constantly modifying the interface and layout. If Facebook follows its trend of previous years, there will be several major changes annually. These changes are intended to improve user experience with the platform, but it may put some figures in this chapter out of date. Just remember that the concepts and tips we supply will remain the same, even if the look of the site varies.

Sign-Up

There are no special requirements for joining Facebook except a valid e-mail address and a minimum age of 13. Before you sign up, be sure to have gathered a few photos of yourself or your work to add to your Facebook albums. This will help entice people to explore and comment on your personal profile. Once you have established your personal profile, you can set up your business page or visual artist page (to be discussed more later).

Getting Connected

Like many other social networking sites, Facebook assists you in getting connected by helping you load your e-mail contacts. You can load contacts from Yahoo, Hotmail, Gmail, and others, and Facebook searches to see if any of these contacts are signed up on Facebook with an account.

After you have used this technique, you can begin searching for people based on their high school or college graduation year, city of residence, name, and other attributes.

When signing up for your account, you first create your personal account. Your business account is a subset of that account, with the same login information. We will discuss this more later.

Capabilities

Facebook offers many ways to communicate with other users and to display information about you and your work. Here is a quick overview of the basic capabilities offered. There are many other add-on applications to Facebook that you can feel free to explore and experiment with.

Personal Profiles

As the name implies, a personal profile is for you as a person. It is not intended for your business representation of yourself; instead, it is intended to present a slice of you and your personality and to help you connect with people you know. Most likely you already have a personal profile page on Facebook. Most people you know probably use Facebook to stay in touch with friends from school, colleagues, family members, and more.

Even though your personal profile is hypothetically personal, you should always keep in mind that anyone could see this content. Even if you have limited who can see your profile through privacy settings, a potential client or boss could come across this information if someone who is your friend on Facebook decides to show that person your profile. Avoid sharing any pictures, content, or language that is contrary to your brand. Chances are that some of your clients will request you as a friend even though you have a business page. Figure 12.1 is an example of a personal profile in which you present information about yourself and updates in your life.

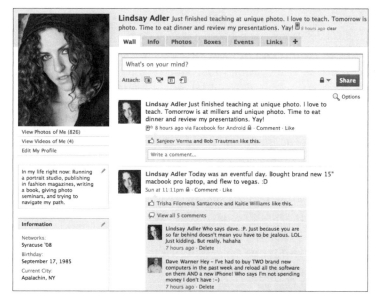

Figure 12.1

A personal profile is intended for you to share photos of yourself, updates about your life, and generally non-business-related content unless (as in this case) you are updating your whereabouts or daily activities.

Tip

You can customize your profile and page's URL. Instead of being an arbitrary name or having a random number applied, the link to your site can be http://www.facebook.com/*yourname* or another appropriate descriptor.

Caution

Your personal profile is not the place to share business updates. Although it is valid to announce a new award or travel plans related to business on your personal page, you should never share updates about discounts or specials. This belongs on your business page. (See the "Business Pages" section of this chapter.)

You can request friendship from anyone on Facebook. You don't have to even know this individual. By adding your coworker Lisa as a friend, you can view her content, but only if she accepts you as a friend first. In other words, friendship on a personal profile is a two-way street. Both individuals must accept the friendship, unlike the "follower" status on Twitter or the "Fan" status on Facebook. (See the "Fans" section of this chapter for a more detailed explanation.)

Business Pages

Business pages are used for your business presence on Facebook. You do not need to set up a separate account to create this type of page. Instead, you can use a business page as an offshoot of your main profile. You can create new pages by clicking on the Ads and Pages button that currently appears on your Facebook home page. As a photographer, you'll want to consider two types of pages: local business page or visual artist page. You should use both of these pages for professional purposes; both are completely public (no privacy settings).

Local Business

A local business page is appropriate for a photographer associated with a particular geographic area. Generally, this applies to photographers who have a studio. A local business page can include your business hours, parking options, business reviews, links to your Web site, and more, as seen in Figure 12.2. People can put comments on your page in reaction to your posts and add their own comments to your wall.

Fans

Your clients or interested Facebook users can become fans of your page. This is like becoming a friend, except you do not have to accept their request, and you might not be able to view their profile content. By becoming fans, people can view your updates in their news feed (discussed in the "News Feed" section later in this chapter) and receive messages that you send out to all your fans.

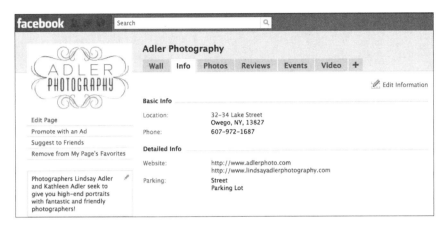

When you create a Facebook page, you can suggest that your friends become fans by clicking the appropriate button on your page's toolbar, as seen in Figure 12.3.

Visual Artist

A visual artist page is configured a bit more to emphasize visuals. There is no place for business-related information, but you do have room for general information. This type of page is more appropriate for a freelancer or perhaps for a fashion photographer, as seen in Figure 12.4. If you are not trying to market directly to a specific geographic area and your business really isn't a local business, a visual artist page is what you want. For this page setup, you can include areas where your fans can discuss your work in a "forum" format.

Multiple Pages

You can create multiple pages for your Facebook presence if that's appropriate. For example, Lindsay Adler owns a portrait studio called Adler Photography in a small town in upstate New York. For this business, she would use a local business page. Adler also is pursuing a career in fashion photography and creates editorials in New York and London. Because her fashion work appeals to a much broader audience and doesn't necessarily appeal to her portrait studio clients, she might use a visual artist page to showcase this type of work.

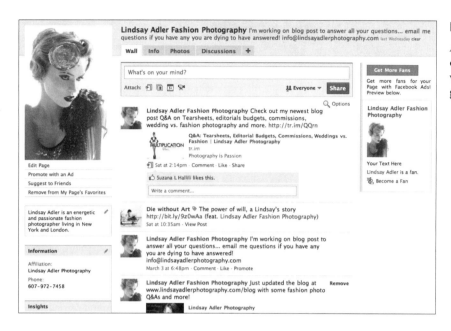

Figure 12.4

A visual artist page is a great option for photographers without a studio or specific geographic region.

Communication

One of the great benefits of Facebook is the multiple means of communication. You can exchange information, get feedback, or just chat with your clients.

Facebook Mail

Facebook allows you to send private messages to other users. When you get new Facebook mail, you will receive an update to inform you of the Facebook message.

Wall

Your wall aggregates and displays all your Facebook-related activities for everyone to see. This is also where you can update your status to let your friends know your current activities and thoughts or to share content. You can treat your Facebook status similarly to a Twitter post in content. These posts appear on your wall.

Your wall is where people can leave you a message publicly or comment on your Facebook activities. Your wall displays when you add a new friend, upload new photos, comment on someone else's page, and more.

To keep your clients or friends up-to-date on your recent accomplishments or online content creation, you might consider sharing links to recent blog posts or other online sites you think will be of interest to your friends.

> **Note**
>
> *Microblogging* is a form of writing brief messages (usually limited to 140–160 characters in length) that can serve as equivalents to extremely short blog posts. Twitter is one form of microblogging. Facebook status updates are another form of microblogging that mobile devices can send and receive.

Commenting

One of the great things about Facebook is the ease of interacting with other users. You can easily leave comments on images, activities, status updates, and more. This is a way to get connected and to further the conversation online. You also have the ability to "like" someone's activities. You simply click the Like button listed under the activity (status update, photo upload, and so on) to indicate your positive reaction to this activity.

Chat

Facebook has its own instant messaging system. When your friends are online, you can have private instant message conversations through the chat mechanism. This is a quick and easy way to have an instant conversation with someone instead of having to communicate through Facebook mail or wall posts.

News Feed

The news feed appears on the home page of Facebook when you have signed in. In short, it is a list of all the recent activities of the people you follow. The news feed is highly customizable. You can indicate which people you are interested in, whether they belong to a specific network or live in a geographic region. You can also indicate what content you want to see—whether you want to see only photos, or status updates, or other specified content. Your news feed helps you keep on top of what is going on with a particular group of individuals.

Photos

Facebook is a particularly friendly platform for photographers. It is easy to upload, tag, and share photos with others. (For an explanation of tagging, see the "Tagging" section that follows a little later.) Although the quality could be improved, it is an amazing platform for sharing images with your clients and exposing potential clients to your work.

Facebook allows you to include an unlimited number of photos (with a limit of 200 per photo album). Because you must upload these images at relatively low resolution, this is not an ideal system for archiving your images. However, it is still an extremely effective way to display and share images.

Photo capabilities include tagging, captions, and albums.

Albums

You should separate your photos into albums so that people viewing your page can easily navigate to the images that interest them. If you are a studio photographer, for example, you might create a separate album for senior portraits, family portraits, baby photos, or other categories, as seen in Figure 12.5. The photos in the figure are images from the Senior Portraits 2009 album.

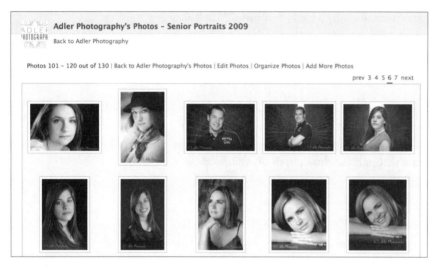

Figure 12.5

When you upload images into Facebook, you should be sure to divide content into albums based on subject.

Tagging

When you post a photo online, you can label, or *tag*, people featured in the photo. This helps to identify who appears in the image. For example, if you have a photo taken at a picnic, you can upload it and then tag each of your friends. The result will be that the people in the image are labeled and the photo then appears on their profile pages. Also, you can include captions with the image to help explain the content.

Tagging is also a fantastic tool for helping more people see your content. People who see the image can comment on the content or navigate back to your Facebook business page with the click of a button.

Be aware, however, that you cannot tag your fans on a business page. Someone you tag must already be one of your Facebook friends. So you might consider adding a person as a friend and then tagging her in an album on your business page. That's yet another reason to keep your personal page as professional and respectable as possible.

The figures that follow demonstrate the process of tagging. After you have uploaded and captioned your image, click on the Tag This Photo button seen in Figure 12.6. The next step is to click on the face of the person you are tagging. If there are multiple people in an image, tag each one individually. Once you have selected their face, begin typing their name in the pop-up screen, as seen in Figure 12.7. Once you have tagged everyone in an image, click the Done Tagging button. All the people you have added will appear listed below the image, as seen in Figure 12.8. If you click on the name, you will be redirected to this person's profile. Now that you have tagged the image, it will appear in all of the subjects' pages. Now everyone can comment on the portrait, as seen in Figure 12.9.

Figure 12.6

Select Tag This Photo to indicate who appears in an image.

Figure 12.7

After clicking Tag This Photo, you can click a person's face, which places a square around her head, and then search through your contact list to add the name and tag for her.

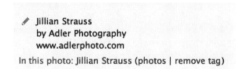

Figure 12.8

The subject's name, Jillian Strauss, will appear beside In This Photo, and you can click on her name to be redirected to her page.

Caution

Even on your business page you only have the ability to tag people who are your friends. In short, if you want to tag a client in a photo, you must first add that person as a friend to your personal page. Some photographers express concern about this because they feel uncomfortable adding young men and women as their friends. Don't worry. Adding people as friends, even if you only casually know them, is a regular activity for most youth. In the worst-case scenario, you can request them simply to tag the photo, and then offer them the option to "unfriend" you once you have completed your tagging.

Figure 12.9

After sharing this image on your Facebook page and tagging the subject, people can add their comments beneath it. In this case, friends, family, and potential clients all offered up praise.

Video

Facebook allows you to upload videos. As a photographer, you might consider uploading video content of behind-the-scenes action of recent shoots. In general, it is better to upload content to video-sharing sites like YouTube or Vimeo and then share a link to that content with your friends via your wall or Facebook mail.

There are two benefits to using the video feature of Facebook. First, you can tag the videos just like you can photos to indicate which of your friends or other Facebook users appear there. After being tagged, this video appears on the pages of all individuals tagged in that content. The second reason is that by using the video features, your videos are always available for people to view under the Video tab of your profile. If you just share a link on your wall, eventually it will be displaced by other updates or links, and therefore not be readily available.

Tip

Some photographers create video slideshows of client images and post these to Facebook where they can then tag their clients. One company that provides this slideshow service is Animoto.

Advertisements

Facebook allows you to create extremely targeted ads. Because most users input a great deal of personal information, you can create ads geared toward your exact target audience. You create a campaign, specify a target audience, and indicate your daily budget. If your focus as a photographer is architectural photography, however, Facebook ads might not work for you. In contrast, if your target audience is brides or high school seniors, Facebook might be the ideal place for your advertising investment.

Successful Photography Facebook Ads, by Jeff Kathrein

Creating and utilizing Facebook ads has quickly become one of the most valuable sources of advertising for our wedding photography services. It now accounts for roughly 80 percent of our inquiries and more than 60 percent of our wedding package bookings.

The ability to market directly to engaged individuals (people who set their relationship status to Engaged) is a huge advantage. For obvious reasons, it is far more effective than our past experiences with marketing. Whether doing expensive and ineffective postcard mailings using dated mailing lists, partnering with local businesses to get the word out about our services, or even paying for wedding magazine ads, none of these provided the accurate and direct marketing abilities that Facebook ads can for us. This has meant fewer dollars spent and an extremely high lead yield.

Here is a short description of how we at K&K Photography have used Facebook ads to our advantage and a step-by-step of what we concentrate on when we create an ad campaign in Facebook Advertising:

1. To create an ad, you must have a Facebook account and a Facebook page. These are relatively easy steps; to save ink, we'll assume you already have set one up.

2. Click on the Advertising link at the bottom of the page or the Ads and Pages link on the left of the home page to get started, and then click Create New Ad.

Tip: We've developed a simple strategy—the Rule of Three: create three different ads, each one slightly different from the other, and divide your ad dollars for the month into thirds so you can run all three consecutively. You will likely find that one of the ads performs better than the rest; this is the ad you should use. Where most people falter here is they don't run the three ads long enough to see a real trend develop with the ads in their campaign. Be patient; watch the ads for at least two weeks.

3. Creating these ads is pretty straightforward, but here are the points to pay particular attention to:

 a. **Title.** Be sure that your title communicates something that makes sense and above all stands out. Don't just be generic and type `Great Wedding Photos` or `Wedding Photography`. You are limited to 25 characters on this, so be concise and word your title potently. You can see a sample of one of our ads in Figure 12.10.

 b. **Body text.** Again, this has to give the potential client a feel for who you are, what you do, and how you do it—and all in 135 characters or less. Again, be concise and set yourself apart.

 c. **Image.** This is the most important part of your ad. It's what people see and glance past when scanning their Facebook page, so it needs to have something about it that grabs their attention. Again, space is limited in these ads. That creates an issue for most photos because you can't see what's in them at 110×80 pixels, so choose an image that still "talks to you" even at that size. Try a different photo for each of your three ads and see which one pulls the most clicks.

Figure 12.10

Your Facebook ads' title and body copy are extremely limited in length, so be catchy and concise.

 d. **Maximum bid.** This number is crucial. It varies from hour to hour, so it's a good idea to monitor the ad for the first few weeks to get a feel for how it fluctuates. For the best use of your ad dollar, you want it to be toward the upper end of the "suggested bid" price. If it's above this, you'll surely get the clicks you want. (We prefer pay-per-click ads to pay-per-impression [how many times the ad is shown]" ads.) If you bid too low, your ad won't be shown as much, and you likely won't use all of your daily limit; therefore, you won't maximize your exposure. So watch the suggested bid amount and set your maximum bid toward the top of the suggested bid range, as seen in Figure 12.11. The figure shows an example of the daily limit and the maximum bid.

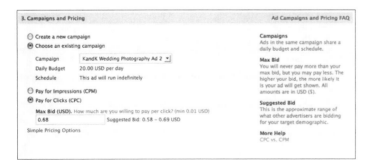

Figure 12.11

When setting up your Facebook campaign, you not only specify the characteristics of your target audience, but also your daily Facebook advertising budget.

Note: For wedding photographers, the key to this tool is marketing your ad to engaged individuals. This means the moment they change their Facebook profile information to Engaged, your ad begins showing on their page's sidebar, assuming they fall within the rest of your ad criteria, explained briefly next.

4. **Additional info.** You will see a dynamic number on the right side of your page, called the Estimated Reach, that changes as you alter the target criteria and specifics of your ad. For instance, if you decide to market your ad to women between the ages of 18 and 35 in the state of New York, your estimated reach number is going to be far less than if you advertise to women that age in the United States. However, if you don't want to offer your services and products to people outside of your home state, be sure to specify your state only. You can even select the cities in your state that you'd like to target. Also, you can toy with the Likes and Interests input fields and try entering info that you hope your ideal client has entered on her profile page, such as Fashion, Style, or even Graduate School. Your ad will then only be targeted to people who have one or all of those tags on their profile page. Be careful not to get too specific, and keep an eye on your Estimated Reach number to the right.

Also, Facebook ads automatically create graphs of both the impressions and clicks that your ads have generated, as seen in Figure 12.12. Use this useful tool to watch trends on a daily, weekly, monthly, or even yearly basis. We have been advertising with Facebook long enough that we have a lot of ad history info to work with. We take note of a spike in the second half of February each year (Valentine's Day engagements) and put more ad dollars into that period to maximize exposure and generate leads during that key time.

Figure 12.12

Facebook provides graphs of the impressions and clicks that your Facebook ads generate over a period of time.

Lastly, remember that this wonderful tool at its best can only bring new potential clients to your doorstep. Don't waste your ad dollars—constantly work and improve on your craft, refine your products and services, and above all be ready to deliver when they do come knocking.

Jeff Kathrein
Owner/Photographer
K&K Photography, LLC
http://www.kandkphotography.com

Other Capabilities

Facebook also has a few other capabilities and options to be aware of.

Events

Facebook allows you to create and join events. For example, if you were host-ing a birthday party, you could create an event, include all the event details (date, time, location, theme), and invite select friends. Others can also invite you to join an event in your area. Your events will appear in this Events tab if the privacy settings for this event are public. The Events tab does not auto-matically show up in your main tabs. You'll have to click the little plus sign on your wall toolbar.

Info

This tab on the Facebook toolbar is where an individual can include basic contact and identifying information about herself. You have complete control over what information you choose to provide. You can show age, phone num-ber, personal interests, college and graduating class, Web site, and much more.

Benefits

Facebook is where your clients are. It doesn't matter if you photograph food or images for corporate annual reports. The companies you work for are made up of people, and you can connect with them on Facebook.

Tip
If you are just learning how to use Facebook, add a friend with similar interests or goals and see how he utilizes the platform. For example, if you are interested in fashion and the newest fashion trends or fashion photography, find a stylist or other fashion photographer who is extremely active on Facebook. This works for any field of photography.

Connection with Your Audience

As stated already, Facebook provides an amazing opportunity to connect with your clients. You can go directly to your target audience. Facebook is the largest social network; it gives you a way to be personable and to create and maintain relationships with clients. Facebook is a great way to show your personality and

take an interest in the lives of your clients. You can comment on their status updates, send messages about the status of their orders, or thank them for their business. For example, if you see that one of your clients got a promotion, you can congratulate her with a message on her wall. This shows you are interested in her life and helps you to maintain a connection. Use your profile's wall or business wall to share exciting updates that might intrigue an audience. Don't just share business-related specials or discounts. If you get an award or are traveling somewhere exciting to photograph, Facebook is a great way to share with your clients and encourage them to maintain an interest in your work.

Insights

Facebook has analytics that allow you to see who is interacting with your Facebook page and how often. You can take a moment to analyze this information. Some of the information provided includes the amount of interaction of different age groups and genders, the geographic location of your fans, and how often they interact with your page.

You can use this information to see if you are reaching your target audience, who makes up the majority of your audience (so you can modify your content), and which of your posts are best received. Figure 12.13 is an example of some of the data points found in Facebook Insights.

Figure 12.13

Page Insights are analytics for your business pages on Facebook. You have access to a variety of key statistics, including demographics of people interacting with your page.

Best Practices and Tips and Tricks

In this chapter we have combined tips and tricks with best practices to provide ways for you to utilize Facebook to expand your business and attract new clients. This list is a best practices guide for Facebook, but from a photographer's point of view. If you take these steps to utilize this platform, you are certain to gain more exposure and find more clients.

Establish Your Brand and Business Presence

Be sure to set up business pages that represent your brand. Whether a local business page or a visual artist page, provide plenty of information and insights into who you are as a business or artist.

Include many samples of your best work. Many people will not take the extra step to visit your Web site to view your images. If you already have them looking at your Facebook page, you should be able to share your best images.

Fill out as much relevant information as possible, including contact information, business site, and business hours if applicable.

Drive Traffic to Your Own Web Site

Facebook is a great way to drive traffic to your Web site or blog. Be sure to include all relevant links to your sites or other social networks in the Info area of your page. If posting links to your blog, be sure the links are intriguing and appeal to your audience so they are tempted to click and view more. Although many people think of Twitter as a great way to drive traffic to a blog, Facebook is also a legitimate source of traffic. More people are active on Facebook than Twitter, and Facebook may have a higher concentration of your target audience.

Interact with Customers

Facebook offers many ways for you to interact with your customers, whether through sending messages, taking polls, chatting, or commenting on photos.

If you are a portrait photographer, whenever you do a shoot, you should post the resulting images to your Facebook page and tag your clients. This provides a way for your clients to share and discuss your work.

If clients post comments on your page, be sure to respond. If people praise your work, be sure to thank them. Use positive reinforcement to encourage more clients to openly praise your work.

Provide Customer Service and Feedback

By having a presence on Facebook, you give clients and potential clients a place to ask you questions. They can send you a message, post to your wall, and communicate with you in a casual way.

You should also invite your clients to post to the Reviews section of your page. Here they can share their testimonials for your work, as seen in the example in Figure 12.14. These testimonials have great value. Testimonials on a Web site feel extremely filtered and contrived. A testimonial on a Facebook page feels genuine and real.

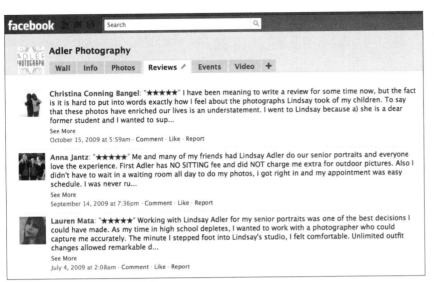

Figure 12.14

Testimonials on Facebook are particularly powerful because they give the impression of genuine praise of your business to potential clients.

Offer a Social Networking Presence

At this point in time, social networking is a buzz word. Just having an established online presence shows that you are a serious business getting ahead of the game. A strong and active online presence will attract young clients because it demonstrates you can relate to and interact with their demographic.

Furthermore, your Facebook presence gives people a place to discuss and compliment your work. If people had a really great experience with you in the past, you might have gotten a nice phone call. Now they can post it on your Facebook page for all your potential clients to see.

Once you set up content on your page, start inviting your personal friends and past clients to become fans.

Draw in New Business

Facebook is a great place to draw in new business by sharing your images and offering incentives. As mentioned before, tagging your images will help get you a lot of exposure. Your business page is also indexed by Google, and may help you in search engine optimization.

You might also consider drawing in new business by offering exclusive Facebook discounts and specials. If you are a portrait photographer, you can create an event for your business page that offers a discount on a session or free prints to clients if they book before a certain date, as seen in the example in Figure 12.15. You can offer an incentive for people to invite their friends to view your Facebook page and more.

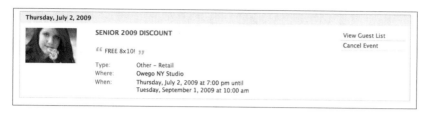

Figure 12.15

Through Facebook events, you can offer time-sensitive specials to your clients, whether they're discounts, free prints, or other incentives.

Establish Client Relationships

You can utilize Facebook to help build and strengthen relationships with your clients. You can also use Facebook as a bit of intel to figure out what's happening in the lives of your clients. For example, you will be notified of your friends' impending birthdays, giving you the opportunity to mail a birthday card (just wishing a happy birthday or offering a birthday discount) or simply leave a friendly message.

You can engage your clients on your page by asking questions and taking polls on topics that interest them. If you photograph bands, you might engage your followers in a conversation about musicians. If you photograph local sports, share updates on these local activities.

When you establish relationships, you encourage word of mouth, which is the best way to get referrals and attract new clients.

Monitor Customer Behavior

Using Insights, you can monitor your client (or potential client) interactions with your pages. You can see how successful your posts are and if you are reaching the correct demographic. Insights are updated daily, and Facebook has even begun issuing weekly e-mails summarizing the Insights for your pages. The graphs created by Insights allow you to view how several variables, such as page interactions and number of fans, change over time.

Use Targeted Advertising

Utilize the strength of Facebook's target advertising to reach your audience. Create a variety of customized ads to target each of your audiences. For example, you might have one ad geared toward brides and another ad targeting high school seniors.

Establish Your Personality

Facebook is a great place to establish yourself as a real person and to help your clients connect with you. People want to be photographed by photographers they trust or can relate to. They want to hire photographers who will provide

a pleasant business experience. You can use your Facebook profile and page to express your personality. You can include updates on your life, thoughts, and experiences, as well as images, to portray who you are.

Privacy

You can adjust the privacy settings of your personal page. Your business or visual artist's page is 100 percent public, and you can't alter that fact. Your personal page, however, has several settings:

- You can make your personal profile completely personal. Only people you accept or add as your friends can view the content on your page.

- You can allow people to see only a limited profile. You indicate which parts of your profile can be viewed by certain friends or the public.

- You can make all information completely public so that others (even those who are not your friends) can view every part of your profile.

As seen in Figure 12.16, Facebook allows you to customize the privacy setting for nearly every aspect of your personal profile. Your choice of privacy completely depends on your preferences, but it is recommended that you keep the content on your personal page professional regardless of the settings. People can also show others the content of your page; anything you write or post can be saved somewhere else in cyberland even after you delete it. Be cautious, and remember that potential clients or bosses can see this content.

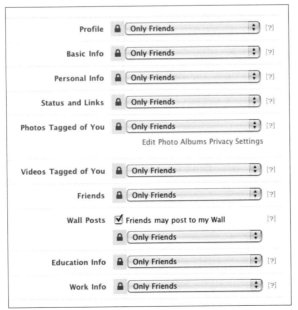

Figure 12.16

Facebook allows users to adjust the privacy settings of their personal profiles to determine who can see particular content.

Tip

There are several other ways to protect your privacy in Facebook. Go online and search `Facebook Privacy Settings` to find a variety of articles that will walk you through the other options available to you.

Facebook Success Story: Lindsay Adler

Facebook can be used for business purposes to increase your exposure and success in fine art photography, fashion photography, travel photography, or any type of photography you are involved in. I have had a personal profile on Facebook for more than six years, and it has kept me in contact with friends and family. But lately I have used Facebook to grow my portrait business in rural upstate New York with a small but expanding studio.

I opened a new studio location in June 2009, and shortly thereafter I created a Facebook business page to increase my exposure. I chose to classify my Adler Photography business page as a local business instead of a visual artist. Doing this gave me more interaction with the fans and allowed me to post information like hours, location, and parking.

I began by putting up my logo, a brief and friendly business description, my business hours, my location, and images of previous clients. I created an album to feature some of my favorite and most recent images so clients could see some of my work and my vision. I made sure I had lots of interesting content on the site, including some business discounts and upcoming events.

Next, I began directing my friends and family to this page to become fans. When you create a new business page under your avatar, there is a link that says Suggest to Friends. This link allows you to invite any of the people in your personal Facebook network to become fans of your business. Businesses do not have "friends"; instead, they have "fans." I immediately began inviting my hundreds of personal friends to the business site, and a good portion of them became fans. People began actively commenting on my content with a great deal of praise, as seen in Figure 12.17.

After I had established a decent-sized network of fans (well over 100), I began putting all of my clients' photos online. A large part of my studio business is senior portraits. In the area where I live, I'd estimate that more than 90 percent of high school seniors have a Facebook presence, with more than 75 percent of the students being regularly active on the site.

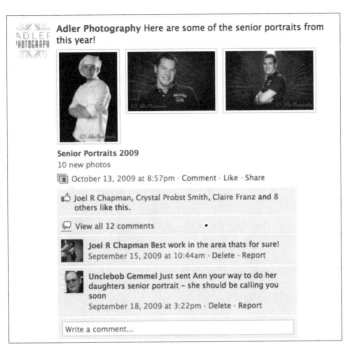

Figure 12.17

After I started sharing my portraits online, I received dozens of comments and praise on my images.

After photographing students, I would add them as a friend (to my personal page) and put their photos on my business site in an album specifically for high school seniors. I would then tag the students, which resulted in the images appearing in the students' personal profiles as well.

Two things to note:

1. My photos had a clearly identifiable copyright watermark so that other people on Facebook could instantly tell who took the photos.

2. I asked the clients at their portrait session if I could put their image on Facebook. This is the only way that they would receive the image as a (small) digital file to show their friends. If they refused, they would not get the file another way.

When these tagged files appeared in the students' profile, they would receive many comments and compliments on the photos, and the images would show up as part of my Senior Portraits Album that the students could click on to view portraits of their friends.

Many photographers who give clients Facebook-sized images charge for this service. This is a terrible idea, because distributing the images for free gets your name out there and gets students talking about your work.

After I started tagging students, my business began to snowball. For one high school, I went from having 20 students booked to more than 60 students booked in a couple weeks' time. Many came in and told me they had looked at my Facebook page at some point in their decision to book me. Others who had gone to other studios first saw the quality of my work through their friends' Facebook pages and then hired me to redo their photos. Furthermore, this Facebook word-of-mouth success did not just apply to students. Many mothers who were on Facebook saw their friends' children's photos and then booked me to take child portraits, family portraits, and more.

In this small rural area, within my first three months of real business, Facebook played a part in getting me more than 30 percent of my business. The number continues at this high level today, and most likely I can track an even higher percentage of my business indirectly to my Facebook activities.

13

LinkedIn

Overview

LinkedIn is based on the principle of six degrees of separation. Who are you connected to through the people you know? Because the Internet transcends time and distance, the six degrees shrink to just a few degrees of separation, thus bringing us closer to colleagues and clients for networking.

LinkedIn is social networking focused on professional and business connections. It maintains a serious and professional interface, which allows you to essentially establish your online business representation of yourself. LinkedIn has more than 60 million members, with representatives in more than 170 different industries, including photography, fashion, and magazines.

Through LinkedIn, you can make connections with other industry professionals to learn information, get additional business, receive recommendations, or be introduced to other industry professionals. Some refer to LinkedIn as the "Facebook of Professionals."

Sign-Up

Signing up with LinkedIn is completely free, and you can tie in your other social networks to the site. There are no requirements or background checks. Just sign up with the e-mail of your choice.

Once you sign up, you can allow LinkedIn to scan your e-mail directory and suggest people who you know and might want to connect with. This information is only utilized to help you make connections; don't hesitate to use this helpful feature. After you have started making connections, LinkedIn starts recommending people you might know based on your profile information and current contacts. In fact, LinkedIn claims that the average person who signs up already knows 15–20 people on its network.

When you sign up, fill out your profile (including an upload of a profile photo) as completely as possible to increase searchability.

Capabilities

LinkedIn argues that its Web site is not just for making connections; it's for getting things accomplished efficiently and with the right people. Your connections are important because they can help gear you toward the correct team of people you need to reach your goals. For example, perhaps a photographer wants to speak with an editor at a magazine she hopes to shoot for. The photographer can search the editor's profile and see if the two have any common connections. The photographer can then ask that common connection to introduce or recommend her to the editor. As in the offline business, recommendations are always a strong way to get jobs and make new contacts. As the saying goes, "It's not what you know, but who you know."

The following sections explain the LinkedIn terms you should be familiar with so you can understand the capabilities for the program.

Connections

People you add as "friends" are referred to as "connections." You can only add people as connections if you know them: a former colleague, classmate, and so on. When you add this person to your connection, all their connections are added to your network. Although you are not directly connected with them, you can ask your connection to introduce you in a virtual way.

Tip

To have someone introduce you to her contact via LinkedIn, simply ask her to click the Forward This Profile to a Connection button that is visible to her on your page.

Profile

Your profile section allows you to add a variety of information about yourself. You can include your current and past employment, formal education, bio, resume, Web sites, recommendations, and specialties. You should include a more detailed bio for your Summary section, including your experience and content that might appear in a cover letter and narrative resume. Be sure that your profile image is professional and well lit so that you are easy to identify. Figure 13.1 shows how a basic profile appears to people viewing your LinkedIn page. Your LinkedIn profile is a great summary and overview of your business accomplishments.

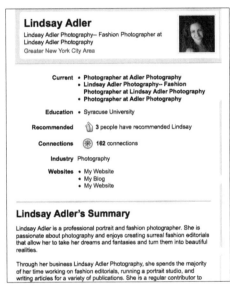

Figure 13.1

At a glance, your profile includes your employment, education, key links (Web site, blog, and so on), and any recommendations you have received.

Inbox

You can send and receive messages from your first-level connections on LinkedIn. Your Inbox holds the e-mails of people who have requested to add you as a connection or people who have requested a recommendation. Through your Inbox, you can separate out the action items. Click on the Action item's button that appears underneath the Inbox details on your home page. If you ask questions in the Answer section of LinkedIn, the responses are sent to your Inbox. As seen in Figure 13.2, if you are active on LinkedIn, your Inbox can quickly be filled with requests for connections and recommendations. Figure 13.3 illustrates the way that LinkedIn processes messages. Instead of LinkedIn just sending you a message, you are given the person's photo, contact information, and a little flowchart diagramming how you are connected with a particular individual.

Note

An *action item* is something in your Inbox that is not just a notification, but instead requires or requests some action on your part.

	From	Subject		Status	Date ▾
☐	Rachel Fus	Rachel Fus wants to stay in touch on LinkedIn	⚑	Pending	2/19/2010
☐	Kevin Krawczuk	Join my network on LinkedIn	⚑	Pending	2/15/2010
☐	Max Nepstad	Join my network on LinkedIn	⚑	Pending	2/10/2010
☐	Patrick Shaughnessy	FW: Photography	⚑	Pending	2/08/2010
☐	PRASANNA KULKARNI	Join my network on LinkedIn	⚑	Pending	1/28/2010
☐	Sarah-Jane Adams	Sarah-Jane Adams has recommended you on LinkedIn	⚑	Pending	1/18/2010
☐	Focal Point -	Join my network on LinkedIn	⚑	Pending	1/12/2010
☐	Tony Frontera	Join my network on LinkedIn	⚑	Pending	1/11/2010
☐	Mahmudur Rahman	I would like to add you on my network	⚑	Pending	1/09/2010
☐	jiankun xie	Join my network on LinkedIn	⚑	Pending	1/07/2010
☐	Emily Taradash	Emily Taradash wants to stay in touch on LinkedIn	⚑	Pending	12/27/2009
☐	shravan karra	Join my network on LinkedIn	⚑	Pending	12/24/2009
☐	Jade Stoner	Join my network on LinkedIn	⚑	Pending	12/23/2009

Figure 13.2

Your LinkedIn Inbox contains messages from your connections, requests to be added as a connection, recommendation updates and requests, and pretty much any actionable activity on LinkedIn.

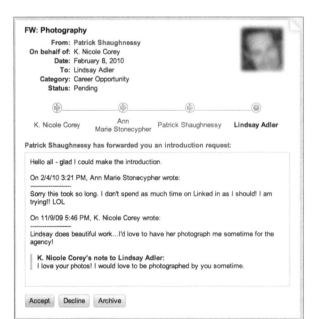

Figure 13.3

LinkedIn processes messages by allowing you to see how you are connected to the person sending the message.

Groups

LinkedIn has groups for everything you can imagine, including dozens of groups related to photography. As with all social networking, joining groups is a good way to expand your network by interacting with others on the site. Photo-related groups include Adobe Photoshop Group, Photography Industry Professionals, Canon Digital Photography, Professional Photographers of America (PPA), and dozens more. When you join a group, everyone in that group automatically becomes a connection, so joining PPA, for example, adds 1,800 LinkedIn members to your network. When you add a group, you can allow members to send you messages and arrange for daily or weekly digest e-mails of the group's activities. Membership in a group is not usually automatic; it often requires approval from the group's manager. The timeline for acceptance to a group varies greatly. Figure 13.4 shows the discussion board of a Fashion Photography Professionals group that helps to answer questions that would be pertinent specifically to the group members, not all photographers in general. Groups provide a good forum to connect more directly with people in your field or your target clients.

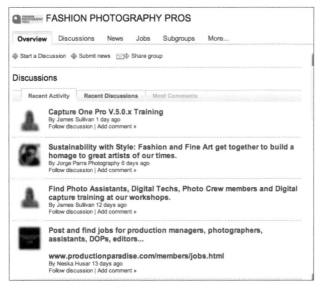

Figure 13.4

Within a group, you can ask questions and start a discussion on leading industry debates—in this case within the field of fashion photography.

To find groups related to your industry or region (or any other criteria you can think of), simply click on Groups on the left toolbar, go to Group Directory, and then click Search.

Groups allow you to start a discussion, submit relevant news, and share with others you think would be interested in joining. You can even create your own group.

Profile Completion Status

While you are filling in your profile status, a percentage bar appears beneath your photo to indicate whether you have taken advantage of the different capabilities and profile bars of the site. The more thoroughly you have completed your status, the easier it is for others to find your profile via search engines. Furthermore, it is a best practice to have your profile as complete as possible so that people have more information to identify you by.

Contacts

LinkedIn conveniently creates a virtual contact list of all your connections, giving you an alphabetical list of their names, e-mail addresses, and links to their profiles. You can also sort through the contacts based on the companies they work for, industries they work in, or cities where they are located. This could be helpful if you were looking to build a strong community in a particular location or trying to find a connection within a particular company.

Applications

LinkedIn offers a variety of business-oriented, purposeful applications that you can integrate with your profile. You can have polls, a suggested reading list, and apps that allow you to integrate LinkedIn with your other social networks, including your blog. To learn about more apps, simply click the Apps button on your toolbar, which is to the left of your home page.

Twitter

You can connect your LinkedIn account to Twitter so that your tweets show up on your LinkedIn profile page. You can indicate that all tweets show up in your status, or only those tweets with the hashtag (#) be included. If you are less active on your LinkedIn account, this can be a good way to provide some more insights and up-to-date content about yourself. If you do this, however, be aware that anything you tweet (no matter how personal or frivolous) will temporarily appear on your business profile. Be sure the content you are tweeting would be appropriate for viewing by business colleagues and other professionals.

Status Updates

Just like on Facebook, Twitter, and MySpace, you can update your status to let your connections know what you are up to. Your updates should be more business oriented. Consider sharing new concepts, business links, and (once in a while) an accomplishment of your own. The more you focus and champion other people, the more luck you will have building quality relationships.

Events

You can search as well as create events to share with your connections. If you are holding a photo lighting workshop, you can create and share the event with others. You can also search keywords (photography) to see what other photographic events are happening by area. As seen in Figure 13.5, professional photography organizations like ASMP and ASPP post their meetings and workshops on LinkedIn events. You can find workshops, seminars, meetups, award ceremonies, and other key events going on in your field, all searchable by zip code.

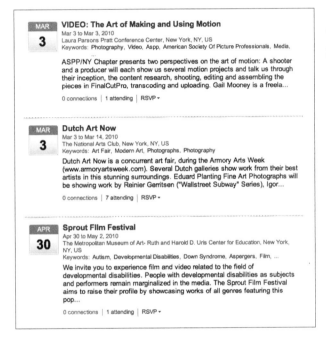

Figure 13.5

Through LinkedIn, you can look up events in your geographic region related to photography.

Recommendations

You can request recommendations from people you know or who you have worked with in the past. You can treat this as a formal letter of recommendation, or you can ask for a simple paragraph testimonial. Both are beneficial. Some job applications in the Jobs section require applicants to have recommendations. One method to encourage others to give you a recommendation is to recommend them. If you have good relationships and experiences with people in your community, let everyone know. Don't expect or demand that people return the favor, but the more you give the more you will receive.

Search

LinkedIn's customizable Search Bar is a powerful networking tool. You can search for people based on their name, place of employment, industry, and interests. Use LinkedIn's search tool to find employees within a target company or organization. Within your search results, you will discover how many degrees away you are from company individuals. Even better, LinkedIn lists the people you know who are already connected with the employees.

LinkedIn shares additional important information to help build your network and keep you informed. The site displays key statistics about the companies you are targeting (when available). It also lists new and former employees as well as promotion and status changes within a company.

Jobs

Employers can post a variety of job openings—full-time, part-time, and even one-time gigs. In the Jobs section, you can search any keyword and see what job listings have been posted. Job searches may be refined to companies, job function, and location, among other options. Many of the top corporations list jobs on LinkedIn.

Benefits

The benefits of LinkedIn include more than networking capabilities. As with many of the social networking sites, the ability to increase traffic to your Web site can be an added benefit. LinkedIn is fondly regarded by the search engines and often lists your profile high in the search results when people search for you.

Traffic to Your Site

One of the ways you can improve the search engine optimization (SEO) of your business site is to have quality incoming links. Traffic from social media and networking sites does play a role in your search engine rankings. You can send traffic to your site from LinkedIn and improve the SEO of the site through your links there.

SEO

One of LinkedIn's best features is its amazing SEO. When you complete your profile, it generally ranks high in a Google or Yahoo search of your name, which is beneficial. First, it gets relevant content about you listed high in a search result of your name. Second, because of LinkedIn's sleek and simple interface, it allows people to quickly find and digest information they need about you.

Analytics

LinkedIn tells you how many times your profile has been viewed in the past week and what industries those people represented. You can also see how often your profile appeared in searches in a similar timeframe.

People You May Know

After you've signed into your LinkedIn profile, you see suggestions of People You May Know in the top-right portion of the screen. As with Facebook, LinkedIn guesses people you may already know based on your profile information and other connections you have made. This makes life a lot easier because you don't have to go looking for connections—LinkedIn brings them to you. If you click Invite beside a person's name, you are prompted to indicate how you know this person. This gives you more credibility and encourages this person to add you as a friend. It is always better to include a personal note to encourage the person to add you.

No Spam Contacts

Not just anyone can contact you. You must have some type of link (graduated from the same school, had a similar place of employment, and so on) to invite someone to connect with you. This requirement is good because it helps maintain more formal relationships than on other social networks, thus keeping the business atmosphere.

Best Practices

The following are some ideas that will help you get more out of your LinkedIn account. If you only use the platform as an Internet business card, your results can be limited. Make sure you take advantage of the various methods that LinkedIn offers to connect with professional people.

Customize Your URL

As with other social networks, you can customize your URL to reflect your name or business name. As soon as you set up your account, be sure to visit Account Settings to customize your URL to something like this: http://www.linkedin.com/in/*yourname*. If your name is not available, consider a using a variation. Try switching your first and last name, adding a middle initial, or using a nickname.

Complete Your Profile

Fill out every part of your profile. The more complete the profile, the more information it provides to people and the better results that appear in search engines. Skimping on your profile is avoiding opportunity.

Connect

Try to connect with as many past and present clients as possible. This helps you maintain relationships with current clients and brings you to the minds of past clients who might remember you for future business. As with any other business, foster relationships.

Arrange Meetups

One of the greatest strengths of online social networking is its ability to enhance your real-life networking. Set up events or arrange physical meetups with your connections or others online with similar interests. This is the best way to make and maintain relationships.

Use Answers

The LinkedIn Answers feature allows you to ask questions and answer questions of other users. Answers lets you ask questions about any subject within your industry or about LinkedIn. More importantly, you can use Answers to establish yourself as an expert on certain topics or industries. After a set period of time, a person who posted a question is prompted to select the person who gave the best answer, and that person receives an "expertise point" that is visible on his profile page. With enough expertise points and activity in Answers, you can gain credibility in certain subject areas like photography. Don't be sparing with your answers or offer replies unrelated to the original content. Figure 13.6 shows one person whose answer was insufficiently short and another who had a more thoughtful response.

Take Advantage of Recommendations

Seek out recommendations, and offer to give recommendations to others in return. As with real life, having recommendations is extremely important for your credibility and for others to consider working with you. If someone on LinkedIn is considering contacting you for work, he might be encouraged if one of his connections has already given you a favorable recommendation. Recommendations can be short testimonials, or they can be treated like formal business letters of recommendation. Figure 13.7 illustrates a few quick

recommendations that may help a future client feel more comfortable with your services or in taking the first steps to contact you. The more recommendations you have and the stronger they are, the better.

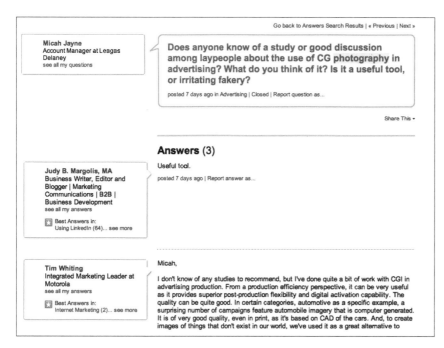

Figure 13.6

If you are going to reply to people's posts, write thoughtful and helpful answers that establish your expertise in the field.

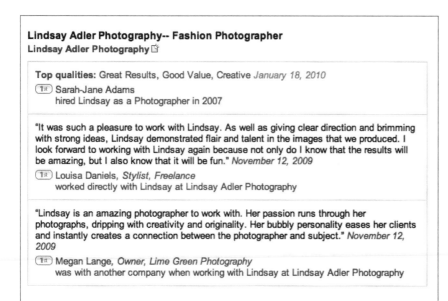

Figure 13.7

If possible, get recommendations from several former clients and employers to establish your credibility in this business network.

Join Groups

Join as many groups as are relevant to your career, region, and interests. When you join a group, the members of the group are automatically added to your extended network. Be sure to participate in the groups. Some groups have thousands of members, and every time you comment means a new opportunity for a prospect to find you.

Consider starting a group. The founder or owner of a group is listed for every new person to connect. You also can add your Web site or post links to a group to share relevant content, improving the opportunity to drive more traffic.

Monitor Events and Awards

You can search events posted on LinkedIn to see if there are opportunities to meet up with colleagues or potential clients.

Tips and Tricks for Photographers

LinkedIn's simple and streamlined interface is great for quickly finding information and connecting to people, yet it does not really lend itself to benefit people in the visual community. In general, as a photographer you should approach LinkedIn the same way that other small business professionals would approach the site—with the goal to make connections and establish a reputation. As a photographer, try to keep in mind the type of people present on LinkedIn who could be potential clients: local businesses, magazine editors, art directors, and more. LinkedIn also can be particularly good for targeting corporate clients. Corporations have a large presence on this business network.

Find a niche and develop it. Determine where your clients are, and go to them.

Tip

As we travel the country listening to stories about the benefits of social media for photographers, LinkedIn seems to be the most valuable platform for advertising, corporate, and architectural photographers. Many of the ideal clients for these photographers have an active LinkedIn presence and network. A portrait photographer aimed at local brides might not likely find his target market on LinkedIn, but an advertising photographer might be able to find contacts at an advertising agency or other corporation.

14

Tumblr

Overview

Tumblr is a blogging platform known for its extreme ease of use and excellent integration with multimedia and social networks. With the click of a button, Tumblr allows users to post text, images, videos, links, quotes, and audio to their blogs, called *tumblelogs*. As in Twitter, Tumblr users can "follow" other users to read their posts and content.

Tumblr is a great way to easily aggregate content you find on the Internet, as well as contribute your own as short-form blog posts. Furthermore, it easily integrates with a variety of other social networking sites, including your personalized blog.

With a streamlined and consistent interface, Tumblr is easy to navigate and utilize. Its browser bookmarklet gives a one-click pop-up menu that allows you to select your content, describe it, and share it with others.

Many people who "don't have time to blog" use Tumblr as an easy blogging solution, and others use it to create a useful resource of online content. If you aren't ready to launch a full-on blog, consider starting with Tumblr to make the transition easier and to start aggregating content to blog about. This will not only help you get into the habit of blogging regularly, but help you start building a community. You will gain experience and followers.

Tumblr as Main Blog

Fashion photographer and retoucher Georgina Robinson uses Tumblr instead of a blog, as seen in Figure 14.1. "I have had a blog before… everything from LiveJournal [and] WordPress to blogspot," says Robinson. "But I always found it hard to connect with people. Tumblr has a good community with other creative people like myself sharing similar things, so I find it a good way to find new artists and build a community." In addition to enjoying the community, she finds it quick and easy to share information, including showcasing her work. She frequently uploads images that inspire her as a way to catalog them, share her visual style, and interact with a community that has similar passions to her.

Figure 14.1

Fashion photographer and retoucher Georgina Robinson uses Tumblr instead of a blog because she finds it easier to share content and enjoy the creative community she has begun to build on Tumblr.

Sign-Up

Signing up on Tumblr is just as easy as most other social networks; you just need a name, password, profile, photo, and bio.

Once you've signed up, be sure to select your customized URL with your name or business name. You can always change your custom URL by going to Customize, Info, URL. If you intend to use Tumblr as your main blogging platform, you can also add your own custom domain (http://www.*yourdomain*.com)

as the URL for your tumblelog. Tumblr offers you easy, step-by-step directions for setting up Tumblr as your main blog page with a unique URL. When you create a new tumblelog, you automatically are assigned a custom Tumblr URL, such as fashionmags4photogs.tumblr.com, as seen in Figure 14.2.

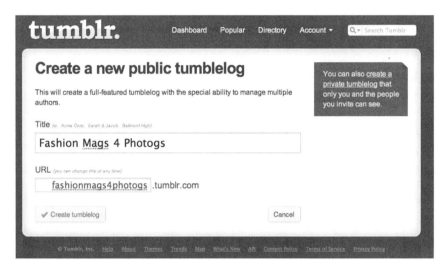

Figure 14.2

When you create a new tumblelog, you can create a customized Tumblr URL (http://www.*yourblogname*.tumblr.com).

As with other social networking sites, you can import your contacts from Gmail, Yahoo and other e-mail services to figure out who you already know on Tumblr. To get used to how others use Twitter, import and follow these contacts.

As soon as you sign up, you need to install the Tumblr bookmarklet on any of the browsers that you use. Thankfully, this is extremely easy to do. On your main Tumblr page, simply click on Goodies, and then drag the Share on Tumblr button onto your browser's toolbar. From now on whenever you want to use Tumblr, all you have to do is find content you like, click on the Share on Tumblr button, write your description, and click Create Post! That's all there is to it!

Capabilities

Don't be fooled by Tumblr's simplicity. The site is able to handle RSS feeds, audio, and video integration. Your social media updates can also be included in your Tumblr stream. The platform offers the convenience of multiple users and tumblelogs.

Social Bookmarking Services

Social bookmarking is a way for people to organize, share, search, and manage their bookmarks. With social bookmarking sites, you bookmark your pages with a single click and add a description of the bookmark; don't add unnecessary clutter to the bookmarks of your browser. You can access these searchable bookmarks from anywhere. You can add keywords to help the search process, or you can simply search your descriptions and titles. Whenever you find something interesting or perhaps something you want to go back and look at on the Internet, you can click on a bookmarklet you add to your browser toolbar.

You can share your bookmarking lists with others and have these lists feed into your other social networking sites like Twitter.

By far the most popular social bookmarking site is Delicious.com (originally released as Del.ic.ious). You have probably already seen the logo included on many Web sites. Others utilize sites like Digg, Publish2, and Diigo. Delicious, as seen in Figure 14.3, allows you to bookmark pages, comment on others' bookmarks, categorize your links, and more. The links are then searchable by keywords and by popularity.

Figure 14.3

Delicious is one of the most popular social bookmarking sites; it allows you to comment on links, categorize your bookmarks, and search items by popularity.

Media: Text, Photos, Quotes, Links, Chat, Audio, Video

The great thing about Tumblr is that it can easily post any type of media you can imagine directly to your tumblelog. If you find a YouTube video you want to share, Tumblr is smart enough to realize that the content you want to share on a particular page is a video, and it grabs the video to post. It does the same with photos, links, and more. For audio posts you don't need to just link to music. Instead, you can call in to the Tumblr phone box to leave an audio post, or you can post your own prerecorded comment. Tumblr is incredibly multimedia friendly, so take advantage of that capability. Figure 14.4 shows the Tumblr dashboard (control panel), which allows you to select all the different media you can upload to the site.

Figure 14.4

The symbols on the Tumblr dashboard (like a control panel) symbolize all the different media types that can easily integrate with Tumblr, including text, photos, quotes, links, chat, audio, and video.

Tip

At first it does not seem apparent why a photographer might want to post a chat to share. Chats are usually informal and often associated with Internet shorthand. As a photographer creating resources, consider interviewing other photographers through chat services like Skype or Google Wave. You might interview another photographer about a particular technique she uses, or about the way she approaches marketing. This chat can be an interview that you can then share as unique content to your followers.

Dashboard

Your Tumblr dashboard is the timeline showing the content that you and the people you follow have posted. It also alerts you to any of the interactions that your followers have had with this content (if they comment, add it as a favorite, and so on).

Multiple Tumblelogs

With Tumblr you can create multiple tumblelogs tied to your same account. This allows you to group your tumbles into categories, especially if you have varying interests (one log for sports teams you follow, another log for photographers you admire, and so on). When you click on your Tumblr bookmarklet, you are given the choice of which of your blogs you want this content to appear in. You can only choose one at a time, although you can go back and repost to another blog if necessary.

Reasons to Tumble

You can create your tumblelogs to become resources about certain photographic topics, or you can use them as just a general log of what you find interesting online. Following are great reasons to consider using separate tumblelogs.

- **Inspiration.** You can create a tumblelog just for images and photographers you find inspiring. Whenever you find a photo you like or a Web page of an impressive photographer, simply click on your bookmarklet to have it instantly added. You can add quotes, videos, photos, or links to anything that inspires you.

- **Photography tools/techniques.** As a photographer, you should always be learning and trying new things. You can have a tumblelog dedicated just to new techniques and tools that you hope to use.

- **Resources.** Multiple tumblelogs are particularly useful for people hoping to make an online resource. For example, you might make a log of all the photography workshops and conferences in your area, nation, or world-wide. This becomes a resource for anyone looking to attend or speak at these locations. You might also make a resource of advertising agencies, photo agencies, or any business resources that could appeal to aspiring or established professionals. You could even create a tumblelog that highlights all the places you would recommend for photographers to shoot at. Get creative. Make a resource, and build your reputation as an expert.

- **Blogging, microblogging.** Tumblr allows you to quickly and easily set up a blog to share your recent images, musings, behind-the-scenes photos, audio files, and pretty much any content you would share on a "normal" blog. Because of Tumblr's interface, you can share your content with extreme ease—just a few clicks. If you don't have a blog already, Tumblr could be an easy way to start sharing content. You can create a unique URL or buy a domain name to redirect to this page.

Multiusers

Tumblr allows multiple users to contribute to a single tumblelog. It also allows guest contributions to your tumblelog. There are lots of reasons why you would want multiple people contributing to a single tumblelog. For example, you might invite many photographers to contribute to a single blog geared toward highlighting useful photography services (printing, retouching, or whatever you want). The more minds to contribute, the more varied and numerous the content. You can invite others to join your tumblelog or take submissions from guest contributors.

To enable capabilities for submission through Tumblr, go to Customize, Advanced, Enable Audience Submissions.

> **Tip**
>
> You can now access Tumblr directly from your iPhone. Other smartphone apps are available as well.

Social Networking Integration: Twitter, Facebook, Blogs

Tumblr makes it quick and easy to integrate with other social networking sites. You can send Tumblr content to other sites or pull content into your tumblelog from other social networking sites. It works both ways.

Go to Customize, Services, and then you can set up a few pieces of information to enable you to share your posts on Facebook or direct your posts to Twitter.

Integration of RSS Feeds

Tumblr is a great way to aggregate and manage the RSS feeds you create or the RSS feeds you follow. Tumblr can pull in and display any RSS feed you give it. It can pull blogs (WordPress, Blogger, and the like), Delicious, Digg, Twitter, Vox, YouTube, Vimeo, or anything else that has an RSS feed and has regularly updated content. You might consider using Tumblr as a way to aggregate all your activity on the Web. You could have your tumblelog import your tweets, your YouTube videos, anything you add to Delicious, and more.

Now all your activities are not just disparately spread out on the Internet; you can gather them in one place to review and share with your followers. For another approach, you can pull in feeds to your favorite blogs and Web sites for this content to appear in your tumblelog. This makes it easy to share with others and use the content from these sources.

To pull RSS feeds into your tumblelog, go to Customize, Services, Automatically Import My. Here you are provided with a variety of options to import your RSS and the way this feed should be displayed (as a link, as text, as photos).

What Is RSS?

RSS stands for really simple syndication. Think of RSS as a way to aggregate and standardize your Web page or blog in an extremely simplified, standardized form. An RSS feed is an Internet document that includes some or all of the post text and related metadata (such as author and date posted). People can subscribe to a feed by clicking on the RSS logo or wherever a Web site has Subscribe to Feed. The user then receives notification of all content updates on the blog or site and a streamlined way to read the feeds. RSS feeds are pure data; there is no design or style added like there is on a Web site. When you subscribe to feeds, you can group feeds into topics.

FeedBurner, as mentioned earlier in the book, is a tool for bloggers and podcasters to manage their RSS feed promotion and subscriptions.

Followers

Just like on Twitter, people can follow your tumblelog. You don't have to add someone as a friend to see their content or for them to follow yours. Instead, when people view your tumblelog, they can simply click Follow to receive your content on their dashboard timeline.

Like Feature

You have the ability to "like" any content you find on Tumblr. Simply click the heart-shaped button on the upper right of each post. Once you "like" a post, you can access this post for later review from your dashboard/home page by clicking on the Liked X Posts button.

Customization

Tumblr allows customization of the look and feel of your tumblelog. Tumblr emphasizes sleekness and ease of use, but at the same time endless templates and methods of customization. You can download from its hundreds of templates, find more online, or tweak your HTML code. You can add widgets, change fonts and colors, and more.

To adjust the basic appearance (including layout and color scheme), go to Customize, Theme to find a variety of presupported created themes. You will also see the option to browse more themes or use custom HTML (for those with more coding experience or who know someone who can code). Figure 14.5 shows an overview of the Themes section, where you can browse hundreds of customized themes.

There are even Tumblr designers who can customize a specialty template just for your use, although there are many suitable designs already offered for free.

Figure 14.5

Tumblr's extremely customizable site offers hundreds of themes to uniquely display your blog.

Timed Posts

Suppose you find *a lot* of posts you want to share at one time, but you don't want to bombard people with content. This is more important if you have your Tumblr posts automatically tweeted. You can queue your posts so they are published at certain times of day or spread apart by certain time intervals.

> **Note**
>
> Tumblr uses a formula to rate the popularity of different tumblelogs. Tumblr rates a mix of the number of followers you have, how often your posts are reblogged, and how many times people have "liked" your content. Tumblarity is popular on Tumblr; it can help you find other people to follow on Tumblr when you create an account.

Photo and Photo Sets

Photo sets are Tumblr's built-in solution to image galleries. Photo sets are a clean and simplistic way to display sets of images. The end display is elegant, and the upload process is extremely easy. As seen in Figure 14.6, simply select your image from your computer and input your caption information.

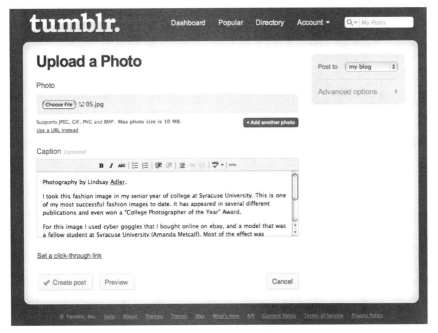

Figure 14.6

Uploading photos as individual images or as albums (called *sets*) is extremely easy in Tumblr and requires just two easy steps.

Benefits

Tumblr is well known for being easy to set up and use. Its ability to integrate with other sites and its searchability are excellent reasons to try this blogging platform.

Ease of Use

Tumblr is about as easy as it gets for blogging. Ease is its number-one benefit! You can add your own content in the form of videos, text, or photos, or you can simply share what you've found online. You are able to quickly and easily share information with others and to create an archive of things you find interesting.

Integration with Other Sites

Tumblr integrates with a number of sites. As described previously, you can pull in content from any site with an RSS feed, and you can export your content to other sites like Twitter and Facebook. Tumblr can act as a place to gather all your content creation on the Web or as a way to export interesting things you find to your other social networks.

Searchability

Have you ever seen a photo you loved online and later tried to go back and find it for inspiration, without luck? For many people, if they didn't bookmark a page or image, they can't locate that content again. Tumblr allows you to archive any content you like in a blog-post form that you can easily go back and reference later. It keeps everything you've found interesting right at your fingertips in a few clicks without having to dedicate a permanent bookmark.

Best Practices

As with all other social networking activities, there are a few best practices you should utilize to get the most use out of your time on Tumblr. Be sure to use the bookmarklet to capture unique content for your followers. And ensure that people can find your information through your tags and descriptions. If you adopt some of the following tools and concepts, you will become a sought-after resource for your community.

Use the Bookmarklet

Adding the bookmarklet to your browser toolbar makes Tumblr use seamless with your Internet searching activities. You don't need to navigate away from the page you are on or even take more than 30 seconds to get your Tumblr posting ready. After navigating to Goodies, simply click on the part of the page for adding a bookmarklet, and you will be asked to drag and drop the bookmark onto your browser toolbar, as seen in Figure 14.7. After you have dragged it there, you will always have a link that you can click on quickly to share on Tumblr. Any time you navigate to a page, photo, or other media of

interest that you want to add to your tumblelog, simply click the bookmarklet, and a pop-up screen will appear. This pop-up screen allows you to enter text describing the link and even select an image or audio to include with the link, as seen in Figure 14.8. After you click on Create Post, your content is automatically added to your tumblelog and integrated with the design, as seen in Figure 14.9.

Figure 14.7

By adding the Tumblr bookmarklet to your browser toolbar, you can include photos, audio, text, and links in your tumblelog with the click of a button.

Figure 14.8

When you click Share on Tumblr, you are presented with a pop-up menu allowing you to select photos and links and add descriptions to the content you are sharing.

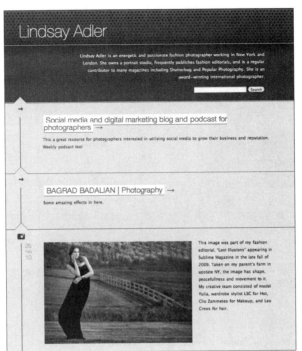

Figure 14.9
After you have described your content and selected the appropriate links, simply click Create Post and the content will automatically be integrated into the custom design of your tumblelog.

Provide Unique Content

If you really want to use Tumblr to its fullest capacity, consider providing unique content just like you would on any other blog. You can add your own text, quotes, and photos with just a few clicks. Your Tumblr followers can then share this information, or you can feed this information into your own blog.

Create Resources

As discussed before, you can and should create resources that you think others would find useful. Remember to utilize your niche to figure out a good resource. If you are a fashion photographer, you might consider making a tumblelog of fashion magazines you enjoy or want to work for. If you are a sports photographer, you might create a tumblelog of tips and tricks for sports photographers, including equipment and shooting techniques. Use your niche and take it to the next level—make your tumblelog a great source for relevant information. Figure 14.10 shows a Tumblr resource listing fashion magazines. This resource helps aspiring fashion photographers find and target possible magazines for their editorial submissions.

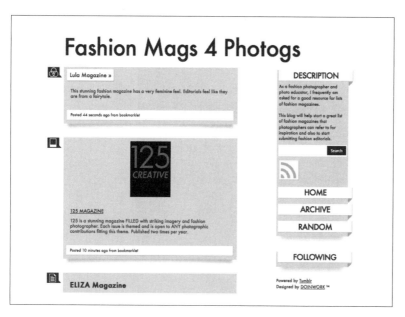

Figure 14.10

Tumblr is great for creating resources that aggregate information and valuable content.

Integrate with Your Blog

You can choose to have your tumblelog act as your main blog by putting all content on this site, including your photos, links, tear sheets, and more. Most photographers use Tumblr to follow new and interesting content and to easily link to content they have discovered. If you are regularly updating your tumblelog with valuable content, you should include a small widget of the tumblelog on your blog page. This shows your blog readers what you find interesting and entices them to read up more on your Tumblr content.

The site http://www.tumblr.com/docs/apps provides a list of other third-party apps that allow you to integrate with your blog and other social networks. WordPress also has a Tumblr plug-in for easy integration. Figure 14.11 shows the beta of the Linked Photographer site, with the right column of Cool Links being fed directly from the Linked Photographer Tumblr page. If you find and share an interesting social media link on your Tumblr page, it could feed directly into your blog or Web page.

Allow Search Engine Indexing

You want to be sure that Google and other search engines can index your tumblelog. If you're tumbling your own content, it improves SEO. Go to Customize, Advanced, Allow Search Engines to Index Tumblelog.

While you are there, consider checking the Not Safe for Work button if your blog includes a lot of nude or erotic photography.

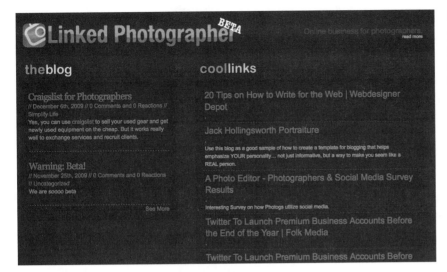

Figure 14.11

You can integrate Tumblr into any WordPress.org template to pull content directly into your blog.

Follow Other Photographers

As with all social networking sites, you are trying to reach out to your peers and potential clients. Find other photographers with similar interests to you and follow their content. They can help you find interesting resources and provide examples of how to utilize Tumblr as a photographer. Interact with their work, and offer guest contributions to their tumblelogs where appropriate.

Add Visuals to Nonvisual Content

Even if you are posting a link, quote, or something else nonvisual, add a photo to it. Most likely your followers are visual people—that's why they followed you in the first place. A link by itself appears cold and boring. Try choosing a photo from that page (whether a company logo, photo of the author, or chart) to make it more descriptive. If you post a quote, show a photo related to the quote content or a portrait of the author.

When you're posting a link with your bookmarklet, be sure that the title and description are accurate and helpful. From there, click on the Photo tab to select an image on that linked page that helps readers identify the content. You are automatically given a choice of content based on the images detected on the page. Your post is still displayed as a link, but you have a visual to make the link more engaging and easier to understand.

Personalize Your Descriptions

When you post content to Tumblr, you must add something of your own. You can add your thoughts, your opinions, why you found the content interesting, and so on. Post descriptions with your links, and make sure your description shows your personality. The title is not usually enough to tell people why the link is relevant, why you found it interesting, and why you would want to share it with others.

Reblog

If you find other good content on Tumblr, feel free to click the Reblog button to repost this information in your tumblelog to share with others. By reblogging, you are sharing the information with your followers but still attributing its original source.

Include useful descriptions when you reblog. Your description should include basic content, the original creator, and why you feel it's important. Descriptions should be between 1 and 5 sentences in length.

Add Tags

When you click on one of your posts, you have the option to edit the post. You can add better descriptions, create a custom URL, and add tags. Tags are the keywords to your posts; they are extremely useful for the Tumblr Search Bar. Tags indicate the topic of the post to the search engine. Ideally, try to use at least three descriptive tags.

Tips and Trick for Photographers

The following are tips for a better Tumblr experience. The way you integrate RSS, handle photographs, and manage some of the options available allow you to create a better tumblelog.

Integrate Lifestream for WordPress.org

Look up the Lifestream widget to integrate your Tumblr feed into your personal WordPress blog. You can bring in the content from Tumblr with photos, links, and appearances similar to that of Tumblr but still have the functionality of your personal blog (for WordPress.org only).

Post Photos

Post periodic photos with behind-the-scenes content or your favorite images. Tell how or where the image was taken, and remember to provide information that your followers would find useful. Don't just post an image with a title; offer better and more valuable content.

Search Tumblarity Directories

You can search directories of a variety of tags to follow people in your area of interest. When you click on the directory link on the top of the Tumblr.com main page, you are taken to one of a variety of random pages based on individual tags. Examples of common page themes are fashion, photography, and automotive tumblelogs. If you want to find a specific theme, click on the page tag name next to the word `Directory`. A listing of all the tagged pages available are displayed for you to choose from. Your tumblelog can be listed on a themed page if your followers recommend you. You can also purchase a position on one of the pages. You can also recommend your favorite blogs to the Tumblr community.

Control the Image Resolution

You can control the resolution of your images on Tumblr. If you want to ensure that your followers do not have access to your high-resolution images, turn off their ability to access these files. Go to Customize, Advanced, Enable High-Res Photos and make sure the Enable button is clicked off.

Manage RSS Feeds with FeedBurner

Claim and manage the RSS feed from your Tumblr account with FeedBurner. This option is available under Customize, Service, FeedBurner. Once you claim your feed through FeedBurner, you can keep track of your tumblelog subscribers.

Use Analytics

As always, utilize analytics to gauge the performance of your site. Because Tumblr allows you to modify its HTML, you can insert Google Analytics into the code and get feedback on your traffic sources, daily visits, keywords, and more. If you are using Tumblr just as a resource to plug into your blog, this is less essential; however, if your tumblelog is your main log, this is a must-do.

.

15

YouTube

Overview

YouTube is a user-generated video-sharing Web site. What does this mean? Well, it means that anyone can create and upload videos to share with anyone who has access to the Internet.

But YouTube is really much more than this. It is its own social network that allows you to create a profile, create channels of viewer content, comment on videos, rate videos, and even send messages to fellow YouTube users. This is what makes it social media.

YouTube is integrated with many types of video-capturing devices and video-editing software, making it quick and easy to create and upload videos.

Although YouTube began as a phenomenon reaching primarily younger audiences, now it is widely used in all age brackets. It is by far the most widely viewed video-sharing network that is renowned for its viral videos and endless amounts of content.

Note

A *viral video* is a video passed quickly from person to person.

Sign-Up

At the moment you can use any address to sign into a YouTube account, but in the future new users will be required to have a Gmail (Google) e-mail account. You should have a Google account anyway, because you can use it for a Gmail account (e-mail), Google Analytics, AdWords, and more. Figure 15.1 shows how signing up for a YouTube account involves signing into your Google account.

Figure 15.1

Google owns YouTube, so your YouTube account sign-in is as simple as using your preexisting Gmail account.

You can view content with or without a YouTube account.

Capabilities

YouTube videos are flexible and customizable. The site offers many options, such as the ability to embed video on your Web site or blog, customize channels, and add privacy controls. YouTube is 100 percent social media because people can comment on your works and subscribe to your updates.

Creating a Customized Channel

When you sign up for YouTube, create a customized channel. You can adjust the page layout, the color scheme, and the information on display to distinguish yourself from the default YouTube channel settings. You can use your custom channel to share videos with your followers and give them a channel to subscribe to (see "Subscribing to Channels"). By creating a customized channel, you are given your own YouTube URL. Figure 15.2 shows the customized YouTube page of photographer Chase Jarvis. The customization gives his page a unique look to stand out from other YouTube content. A personalized channel, as seen here, is home to all your video content, subscribers, channel descriptions, and more.

Embedding Video

To embed a video is to make the actual YouTube video and YouTube player appear in another Web site. The section on the YouTube page that says Embed allows you to copy the HTML code for this video. To put it on your blog, for example, navigate to the HTML code section of editing the blog and paste the code you copied. When you publish this code in your blog, viewers can see the actual YouTube video. This is often a better way for blogs and Web sites to share video content because it keeps viewers on your site. If you provide a

Figure 15.2

When using YouTube, create a personalized channel to upload and host all your video content.

link, users are navigated to YouTube, where they may forget about your site and start searching the Web. When you embed the content into your blog, you also can get better analytics on who is viewing your content. Figure 15.3 is an example of the box that appears in the upper-right corner of the screen when you're viewing a video. You are given a brief description of the channel, a URL of the video, and the HTML code to embed the video.

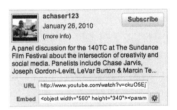

Figure 15.3

YouTube allows you to easily embed video content into your Web page or blog by copying and pasting a few lines of HTML code.

Subscribing to Channels

When you find a YouTube content provider you like, you can subscribe to its channel through YouTube. This way whenever the provider shares new content, you are automatically notified of the update. A good way to get people to view your content is to encourage subscriptions to your YouTube page. This way when you put up new content, you already have a built-in audience interested in what you have to share. Figure 15.4 shows how you can view the subscribers to your channel.

Selecting a Customized URL

The URL is the Web site address, which is the address you would paste in an e-mail, blog, or microblog if you wanted people to click on the link to be redirected to YouTube. As seen in Figure 15.5, you can give your channel any name that will then be added after YouTube.com.

Figure 15.4

YouTube viewers can subscribe to your channel to get automatic notifications when you upload new content.

Figure 15.5

When you sign up for a personalized channel, you can select a customized URL for your page.

Controlling Privacy

If you want to utilize YouTube for both public and private use, you may want to take advantage of the different privacy controls of YouTube. You can indicate that you only want to share videos with friends so that the broader public cannot access this content. If you use the privacy controls, don't embed videos onto your blog or Web site. It may seem obvious, but just because you can see the private video on your site does not mean others can, too.

Responding to Videos

If you want to share your feelings about content with other users, you can always take the traditional social media route—you can comment on other videos and send messages to other users. YouTube has a unique feature that

allows you to respond to content with your own video content. You can upload the content from an external video recorder or record right through your Webcam.

Benefits

Sharing videos is one of the most popular pastimes on the Internet. YouTube is the most popular service on the Web, offering huge benefits to video creators. YouTube videos are easy to share with its global audience. Photographers can easily demonstrate their teaching abilities, show behind the scenes, or share portfolios with subscribers. Plus, the analytics available for YouTube videos help make you a better content creator.

3G+ Integration

Because YouTube has become so mainstream as a video-sharing Web site, it has a couple of inherent benefits. First, YouTube has been integrated into portable media. As more people use smartphones to access the Internet, this feature will continue to become more important. Second, YouTube allows you to integrate with other social networks beyond just your ability to embed video content. If you visit My Account, Account Settings, Activity Sharing, you can set up YouTube to automatically post to Facebook, Twitter, or Google Reader when you do certain activities like upload a new video or add a video to your favorites.

Audience Share

Although it began as a phenomenon reaching primarily younger audiences (18–24), now YouTube is widely used in all age brackets. Many of the other popular video services are High Definition (HD) video sites. As nice as HD is, it can be slow depending on your viewers' connection and equipment. YouTube is also much more open to the types of video (especially commercial and promotional) you can share on its platform. If you want your video content to be seen and develop a following, put it on YouTube.

Learning Tool

YouTube provides a great visual learning resource. Besides getting your name out there, it allows you to search the social network for a plethora of videos on other photographic topics. Need to learn about basic studio lighting? You can find dozens of videos. This may also be useful if you search a photographic topic and find no valuable or well-produced resources. This shows there is a

good opportunity for you to create content! Registered users can upload any video content that they own the copyright to—from music videos to video blogs, to skits, to slideshows, to tutorials. If it can be put into video content, you can find it on YouTube. Figure 15.6 shows a behind-the-scenes video post by photographer Chase Jarvis. Posts like these are extremely popular because they give nonphotographers insights into the life of a high-end photographer and give photographers industry secrets and advice.

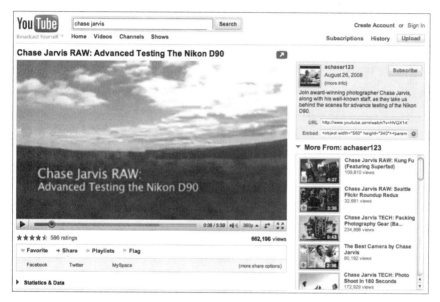

Figure 15.6

In this behind-the-scenes video, photographer Chase Jarvis tests a new Nikon camera. He shares his knowledge and one-of-a-kind experiences with his followers.

Social Networking Integration and Embedding

YouTube makes it extremely easy to embed video into another Web site. On the right side of most YouTube configurations, you see where you can subscribe to a video, go to a URL, or embed code. As seen in Figure 15.7, you can also click the Share tab to share on Twitter, Facebook, or other social networking sites.

Figure 15.7

YouTube allows you to quickly and easily share video content with others through e-mail, Facebook, Twitter, StumbleUpon, and other networking sites through the Share tab beneath each video.

Analytics

YouTube analytics are found under Insights, and they go beyond telling how many people have viewed your videos. Their tools display where people are viewing your video from, the demographics of who is watching your video, and regional results. One of the most valuable statistics offered is "hotspots." YouTube shows you how well you keep your audience's attention second by second. This is extremely valuable information to help you create better videos in the future. Figure 15.8 is an example of the Insights page for all videos of Adler Photo Workshops.

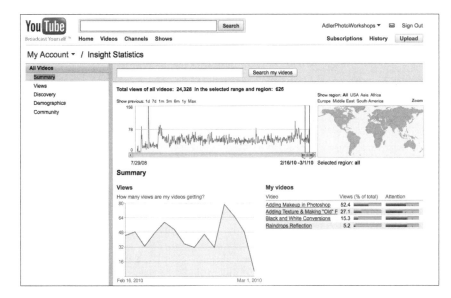

Figure 15.8

The Insights section of YouTube provides relatively detailed analytics about page views, where your views are coming from, and other valuable information.

YouTube as "the Standard"

YouTube is the most popular video-sharing Web site. It has been integrated with a number of cameras, video software packages, and Web sites.

There are two main divisions of YouTube use: personal and professional. You can use the network to host personal photos or video blogs, or you can create professional content geared at a specific audience.

In Chapter 18 we discuss the video sharing site Vimeo. There are several differences between Vimeo and YouTube. Vimeo is an HD video sharing site, and YouTube offers both high- and low-resolution options. The Vimeo

versus YouTube debate is usually over quality verse quantity. YouTube is more open about the types of videos it accepts, such as promotional videos. Vimeo is more for the creative video producers wishing to share their art.

The central benefit of YouTube compared to other social networking sites is the size of the audience. If you want to get noticed or have a viral campaign, YouTube is where you should be.

Best Practices

As a photographer, you might be curious about what type of content you can contribute to YouTube. The content to upload really depends on the type of photography you focus on, but approach it as you would blogging.

If you refer to Chapter 7, "Your Blog," under "Blogging Tips," you'll remember some possible content you can provide. What would your target audience find interesting? What makes you different?

Content possibilities include these:

- Behind-the-scenes content at your most recent shoot
- How-to photographic or Photoshop tutorials
- Slideshow set to (royalty-free) music
- Video blog talking about a recent photo experience

Many photographers feel overwhelmed by the idea of creating video content. They feel that now they have to worry about sound, movement, and video editing in addition to visuals.

It is unnecessary to start off as a master of video. In fact, a good way to start is simply to record yourself talking through your Webcam. You can show a photo, discuss technically how you created it, describe how the image makes you feel, tell where and when you captured the image, and any other relevant information. The entire process of creating the video and uploading it onto YouTube for millions of potential viewers to see would only take a few minutes of your time.

In Chapter 18, "Tools for Social Networking," you will find a list of video-editing software to get you on your feet in the YouTube realm.

Create Interesting or Valuable Content

As with any online or blogging content you create, your content should be interesting, entertaining, or valuable to your target audience. Obviously, you must first identify your potential target audience. What makes you unique?

What would your audience find interesting or helpful that you could share with them? When they find the content interesting, be sure to provide a link or direct them to your Web site or blog.

One of the best ways to gain a following is to consistently contribute content to YouTube. When viewers really like your content, they subscribe to it so they are notified whenever you add new videos. This is one way you can focus on building a reputation—a reputation for valuable content and great photography.

Label and Tag Your Videos

Many photographers know that they need to add keywords and metatags to improve their search engine optimization (SEO). Treat videos in a similar fashion—always label and tag them appropriately. This makes them more easily searchable on YouTube and Google.

Create Your Own Channel

If you plan to host content on YouTube, create and customize your own channel. There are various options for including descriptive content and adjusting the channel's appearance. If people view a video you created and really like your content, they often subscribe to your videos so that they are informed whenever you introduce new content. Similarly, be sure to fully fill out your profile/account information with details about yourself. Don't just be a channel; be a person your viewers can relate to and connect with.

Interact with Other Users

As in other social networks, to encourage more views and visibility, attempt to interact more with other users. You can do this through comments on other videos, interacting with groups, adding people as friends, and sending messages to other users. As seen in Figure 15.9, your Inbox serves as a way to communicate with other users through YouTube e-mail and allows you to review new comments from viewers.

Produce in HD

If you can produce in High Definition (HD), consider publishing in HD. It is of much higher quality for viewing your images than standard low resolution, which means viewers can see your tutorials better. Note that not all computers can handle HD well. Consider your audience before presenting in HD.

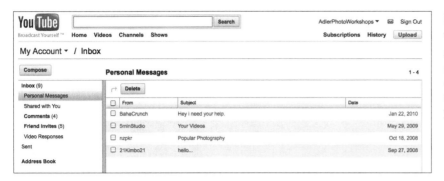

Figure 15.9

YouTube has its own mail system that allows you to exchange messages with other YouTube users and to review new comments to your videos.

Tips and Tricks for Photographers

The following are tips that will be helpful when you're creating videos for YouTube. The type of content you create can make a difference in how well it is received. The way you handle your audio, capture video, and edit can influence its success.

Tips for YouTube

Some people get paid for the content they produce for YouTube through the YouTube Partnership Program. When you as a photographer have enough good content and enough subscribers, you can apply to become a partner (http://www.youtube.com/partner), as seen in Figure 15.10.

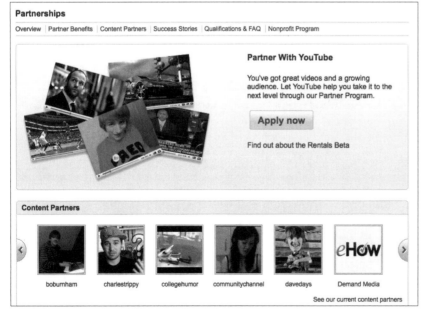

Figure 15.10

If you are accepted to the YouTube partnership program, Google compensates you for the production of content on your page by placing targeted ads on your channel. You can earn thousands of dollars per month based on your Internet following.

Google gets permission to put advertising on and around the video. The user splits the advertising revenue with Google/YouTube. The program aims to encourage users to make more quality content and to increase ad revenue.

Some successful YouTube content creators make money in the six-figure range. Although this is not the purpose of YouTube for most photographers, it is one approach that you may take. If you build a strong enough following and consistently provide quality content, you could find yourself making a few thousands dollars a month from the partnership program. This is no easy task, but if you are able to be unique and attract the required option, this is certainly a possibility to keep in mind.

Tips for Content

The "Best Practices" section of this chapter suggested several possibilities for YouTube content related to photographers, but attempt to think outside of the box.

Although how-to photography tutorials are valuable, there are tens of thousands of photography-related tutorials online. Try to think about what makes you different and what unique knowledge you have to offer. When you describe the video (with keyword and description), try to be as specific as possible to allow people and search engines to easily find your videos.

Besides behind-the-scenes videos, tutorials, and slideshows, you might consider guides for your clients. You could provide a posing and clothing video to help them make the most of their session. You could even create a "Bride's Guide to Photography with *X Studio*" to explain how you approach weddings and how you can work together to make beautiful images. Get creative. Figure out what your peers and your clients would find useful in your content.

Furthermore, if you have a specific target audience, try to think of content that they would want to pass on (send a link to, tweet about, and so on) to others. If your video is funny or extremely relevant, your video could become widely circulated.

If your content is strong enough, it may be picked up by other sites like Metacafe, 5 Minute Videos, and more, where you will reach an entirely new audience. This spreads your name further and increases your visibility to potential clients.

Tips for Music

As photographers, we are acutely aware of copyright laws and infringements. You wouldn't want someone to use your images without compensating you; likewise, you wouldn't use someone's music without compensating them.

All slideshows or videos should have some kind of audio to them. No matter how beautiful your images are, people won't watch a silent slideshow.

AudioSwap is YouTube's own library of royalty-free videos. Once you upload a video to YouTube, you can choose from dozens of songs that you can apply to the background. This is a quick, easy, and free way to add audio to your videos. The downside? You cannot edit or alter the music to fade in and out, pause for sound effects, or match it to the length of the video. Still, it's free and decent-quality music to add to your videos with little effort.

Here are a few rules to keep in mind when adding video. If you use someone else's music, you are not allowed to use more than 30 seconds of any particular song without compensating the owners. The safer way to go is to either purchase royalty-free music or utilize YouTube's new AudioSwap option.

You can find royalty-free music in other locations on the Web. If you are looking for a single song, there are dozens of Web sites (search `royalty free music`) that sell individual songs, and iTunes offers a variety of royalty-free tracks and CDs for purchase.

If you are part of the partnership program with YouTube, you can use full tracks from all the big-name artists for free. How this works is that an advertisement for this song will pop up in the bottom of the video screen. If viewers click on it, YouTube directs them to purchase the song from iTunes. It's yet another advantage of being a partner.

Tips for Software

The pros in the video industry use the editing software Final Cut Pro, but it is extremely costly and complex for those just experimenting with video.

Many computers come with editing software that is sufficient for creating YouTube tutorials. Apple's iMovie is more than capable of editing most video content for YouTube, and there are hundreds of online tutorials that teach the program. Through iMovie and many other software programs, you have the option to export directly to YouTube.

Tips for Video Capture

Nowadays, many point-and-shoot cameras and newly released DSLRs (Digital Single Lens Reflex) come with video capabilities. If you have no video capture devices, you can use your Webcam to capture quick videos of you speaking. Another alternative is to purchase an inexpensive and easy-to-handle video camera.

A FlpVideo, for example, has two buttons: a Power button and a Record button. Once you have recorded, the small video camera has a built-in USB hub to connect directly to your computer. After you download the camera's software, it's just a few clicks to automatically upload content to your YouTube account. If you are overwhelmed by video, this might be a quick and easy solution for you.

Tips for Screencasting

Screencasting is when you record everything on your computer screen. This is a cheap way to teach computer techniques and share them with others. Various screencasting tools are listed in Chapter 18; most software downloads cost less than $50. When recording actions on your screen, be sure to move your mouse more slowly than you would normally.

Tips for Video Editing

Most photographers were not trained in video (whether recording video, editing video, presenting video, or something else). Because new DSLRs offer HD video capability, this knowledge will become more and more important. Here are a few tips for producing your first videos.

1. Aim for videos between 2 and 5 minutes in length. On average, people have an online video attention span of about 3.5 to 4 minutes. Don't go over 5 minutes; even the most interesting online content doesn't hold viewer interest that long.

2. If you are speaking, speak slowly and clearly. If you add background music to your video when speaking, make sure the music is subtle and doesn't interfere with your words.

3. If you add background music, have it fade in. If it is a loud song and starts immediately at 100 percent volume, people may be startled and immediately switch off your video.

4. Develop a relatively consistent title and ending screen. If you become more advanced, you could have a short video clip as the intro, but for most videos a simple title screen is fine. The title screen should have your logo, your name, and some way to contact you, whether by Web site or e-mail address.

5. Keep your video description specific and easy to understand. It helps people become more intrigued and performs better on searches.

There is a lot more to know about creating video, but on forums like YouTube, you don't need the highest quality editing. Just remember to apply the same concepts required for good photography: aim for good lighting and framing, and keep the editing simple.

Tip

Animoto is a program that allows you to upload your images and automatically creates a slideshow video (with music) of your photos. Animoto can automatically upload to a variety of social networks, including Facebook and YouTube. It's a quick and easy way to create video content to put on your YouTube channel, particularly when you are first getting online.

Future of Photography and Video

Many camera manufacturers now offer HD video capabilities with their DSLRs. Without getting into the technical aspects of it, DSLR video allows for visual effects and portability that had been virtually impossible before. Photographers can now have high-quality video capabilities at their fingertips.

Those who learn to utilize the new video functions in their cameras in the most creative ways will become valuable image makers. Plus, video will offer new client and promotional opportunities for your business.

If you really want to learn more about video, many community colleges offer night classes on beginning video.

Part IV

Case Studies

16

Our Stories

We wanted to share some photographer interviews and case studies of those who have used social media to enhance their careers and gain new business. We are aware that these stories only scratch the surface of all the success stories out there.

In this chapter we tell you how we discovered social media and how we learned to use these new communication tools. Neither of us was immediately "social media stars." Building a community online takes a lot of time and effort; we share the steps we took to get where we are today.

Social networking is not easy. In the beginning we both made mistakes, wasted time, and even missed out on opportunities. This chapter is intended to tell you our stories and share our advice to save *you* time and mistakes.

In Chapter 17, "Your Stories," we share what many of you in the photography community have told us about your successes with social media.

Case Study: Lindsay Adler

Social networking is undoubtedly a key part of my success as a professional photographer. Not only did a variety of networks play an essential role in my exposure, but they continue to play a role in my business growth and even profitability. I will take you through the process of how I became involved in social networking, how it helped me grow, and how I utilize it today.

The benefits of embracing online publishing, new media, and social networking have had a bit of a snowball effect. The more work I put up and the more active I become, the more people interact with my work. This in turn helps get my work more exposure through word of mouth, retweeting of links, and sharing of my content with others. When my work gets noticed and shared in a blog or in an international magazine, it drives additional traffic to my site, thereby increasing my exposure and bringing forth even more opportunities to be noticed.

Many of the different social networking platforms work together to build a strong community around your work. I developed my Facebook network to build contacts of portrait clients and my local community, as well as develop a fan base for my fashion work. From there, I used my blog to provide interesting content and insights of behind-the-scenes work, tips and tricks, and more. Then I used Twitter to drive traffic to my blog. First I'll start by covering "the big three" in my social networking life: Facebook, my blog, and Twitter. Then I'll cover the other tools I've come to find essential to my networking activities.

Social networking has become an essential part of my communication tools and workflow. When I am at an exciting shoot, I film behind-the-scenes videos and photos. I also take notes on the lighting setup and exposure settings. When I do a portrait shoot, I put the photos on Facebook and tag my client. When I find something interesting online, I tweet it to my followers. When someone asks me an intriguing question or when there is a new development in my life, I share it on my blog. When I finish a new editorial shoot, I size the photos for display on Facebook, Twitter, and my blog. When I need advice, I ask the question to my followers on Twitter and friends on Facebook.

Today I am involved in a plethora of social networks, each serving a role in building my brand and expanding my reputation.

The Big Three

There are three social networks that really form the pillars of my online activities. These are Facebook, my blog, and Twitter. Without these networks, I would not be able to achieve my networking goals.

Facebook

I was introduced to social networking through Facebook in high school and college. It became an invaluable tool for my personal life. I could organize events, send quick messages to friends, get copies of photos taken by others, and stay connected with colleagues and classmates. Years later I began to utilize Facebook as a powerful business tool that quickly ignited my more extensive use of social media for expanding my brand.

When I was playing with social media through Facebook, I realized that many young people love posting photos of themselves online. It helps to solidify memories and share their experiences with others. While running my own portrait studio business, my teenage clients began asking for copies of their images so they could post them on Facebook or MySpace.

My first instinct was to shout "No!" at this idea. I originally had no desire to allow teen clients to have a digital copy of their image to pass around, free or otherwise. As more and more clients began to ask, however, it suddenly clicked how I could use Facebook as an amazing marketing tool.

I created a Facebook account for my business, Adler Photography. After each photo shoot I posted digital copies of the final, purchased images on Facebook—free of charge. The results were astounding. Because I tagged the images with the name of the client, the photos appeared on that person's personal profile for all her friends or family to see. People commented, visited my Facebook site, visited my personal site, and spread the word to their other friends online. For high school seniors, word spread quickly. In fact, when I opened a new studio location in 2009, more than one-third of all my business was traced directly to Facebook. I had more business than I could even handle. Figure 16.1 is a view of my Adler Photography local business page on Facebook.

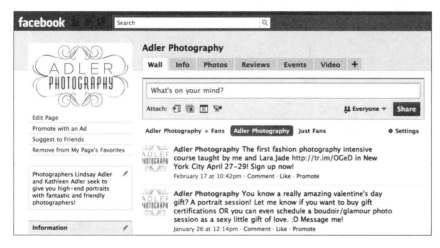

Figure 16.1

When I opened a portrait studio, I created a Facebook page for it. I shared updates with clients, tagged them in photos, and built strong relationships.

A similar approach was effective for mothers with children, brides, and more. Facebook had me hooked, and I could see the power in building a strong network. Just like in the old days, I was getting a majority of my business through word of mouth, except now word of mouth was online.

Today I use Facebook for my fashion and portrait photography. Whenever I do a portrait, I post that person's photo to my Adler Photography Facebook page. This has become an incredibly important tool for my portrait business.

I also have a visual artist page on Facebook for my fashion photography ("Lindsay Adler Fashion Photography"), and I post behind-the-scenes content and updates on this easy-to-update page. Because the audience for my Adler Photography portrait business is often quite different from the audience for my fashion photography, I have separated the two entities into different pages. Whenever I do a new fashion shoot, I post updates, behind the scenes, and final images to my Lindsay Adler Fashion Photography visual page, as seen in Figure 16.2. I use my personal profile to put photos of myself and updates on my life to share with people who have an interest in my personal life.

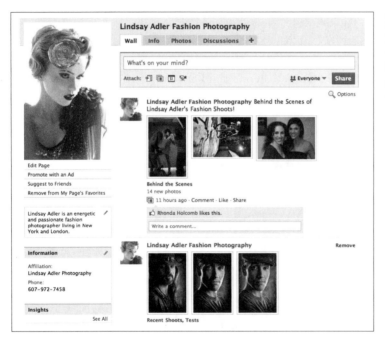

Figure 16.2

I use my fashion photography visual artist page to share behind-the-scenes content of my fashion shoots, as well as updates and recent work.

Blog

The next important social networking tool in my development as a photographer has been my blog. My blog is where I establish myself as an expert and as a go-to person for quality fashion and beauty imagery. It's my home on the Web. I share everything important in my art and career here. I post updates on my upcoming workshops, my musing about the world, tutorials, image portfolios, behind-the-scenes photos and videos, recent publications, and advice for other photographers. Everything of note appears on my blog.

After college I attempted to build a career in fashion photography. I was regularly shooting tests to build my portfolio, and I started shooting editorials to submit to fashion magazines. Although my work was sufficiently strong and creative, I was having a hard time getting published. I would regularly publish in midsized online magazines, yet I couldn't get the attention of print publications. I would e-mail and call different magazines trying to get them to look at my work, but I had little luck. During this time I started a blog for fun and to create a record of my experiences.

Eventually I started taking behind-the-scenes videos and photos to share on my blog, and I started posting each finished shoot on my blog. Within weeks of creating the blog, I received an e-mail from a large Australian fashion and lifestyle magazine. The magazine had seen the images from my blog and was interested in publishing them. After reading the behind-the-scenes info, the magazine was also interested in doing an interview with me about the creative process to share on its widely read blog. I then created a visual artist page on Facebook for my fashion photography, and I posted behind-the-scenes content and updates there. This content also went onto my blog, often with lighting diagrams, behind-the-scenes stories, and descriptions of my retouching effects.

Getting my work into a midsized international publication was an exciting step. From there my fashion editorials were published in a London-based fashion magazine that saw my work on my blog, and then a handful of other publications. The publications just kept growing from my blogging experience. Figure 16.3 is a sample shot of my blog, with a customizable theme by Graph Paper Press.

Twitter

After the success with Facebook and my blog, I decided to try my hand at Twitter. I signed up for an account, taking the advice of a fellow photographer who had embraced Twitter some months before. I followed my photographer friend and watched how he used Twitter as a tool. I was amazed. He was sharing interesting links, asking questions of his followers, and getting great feedback! It seemed like he could ask any question and get some kind of input from his followers—truly a great asset for visual artists! I began sharing some images of my recent editorial shoots on Twitter. Within a few weeks, a Miami-based fashion magazine contacted me. The editors had seen a photo I had shared on Twitter (through TwitPic) and were interested in running the entire editorial in their publication. The power of Twitter was immediately apparent. I was hooked!

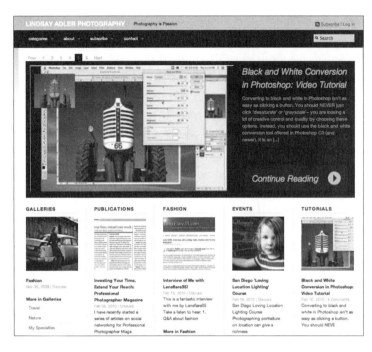

Figure 16.3

My blog is where I establish myself as an expert. I share tutorials, tearsheets of publications, behind-the-scenes photos and videos, lighting diagrams, and updates on my speaking engagements.

As I built a larger network, I was able to reach out to my community for help, advice, and collaboration. When you establish a community based on sharing ideas or a common passion, it becomes a source of productivity, inspiration, and even troubleshooting.

When I was buying a new computer, I tweeted that I needed help deciding what hardware upgrades I needed; within minutes I had more than a dozen responses. When I wanted to find a studio to shoot at in distant city, I tweeted my requirements; I got several instant responses. When I wanted to teach seminars in new locations, I tweeted to see who would be interested in classes in different cities; people responded. When I needed help solving a glitch on my blog, I tweeted; a WordPress designer helped me free of charge. The list goes on and on about small as well as significant ways I have utilized my community for advice and troubleshooting.

I soon realized that the more I gave to the online community through sharing links and creating valuable content, the more I received from my followers. There are many ways I have chosen to give and share online. I give to photographers by sharing lighting diagrams, providing insights into my business experiences, and creating video tutorials. I also give by sharing useful links or by retweeting useful content. Even more importantly, I give by interacting. When someone asks me a question via e-mail, Twitter, Facebook, or another

network, I attempt to answer the question, regardless of content, quickly and succinctly. If the question is in depth, I often compose a blog post or video post to answer the question and share with other followers who might have the same question. This gives me their trust, their respect as an expert, and their willingness to give back.

From Twitter I've formed relationships with stylists, illustrators, retouchers, and other professionals who are essential to my career. I've formed bonds with other photographers, including the people who would later be integral to this book.

I use Twitter as a tool to share information, learn, ask questions, and drive traffic to my blog. When I am at a shoot, I tweet behind-the-scenes photos and updates. When I find interesting and valuable links, I share them with my followers. When I update my blog or Flickr, I ask my followers to check these updates. Twitter is a great tool for joining the greater online conversation about any topic and for driving traffic to your blog.

Other Essential Networks

Although Facebook, my blog, and Twitter are where I expend a majority of my networking efforts, there are a number of others tools and platforms that I utilize every day. Without these different tools I would not be nearly as efficient or successful online.

Tumblr

I gather interesting content I find online into specialized tumblelogs (Tumblr blogs). I have one tumblelog where I gather Web sites and events for photography seminars, conferences, and workshops. I have another tumblelog where I gather photographers and creatives who have work that inspires me and deserves recognition. I also have a tumblelog where I gather fashion photography magazines that I can consider for magazine editorial submissions in the future. In Figure 16.4, I have used Tumblr to gather links related to new media, social networking, and photographers. I can integrate this tumblelog into my blog or Web site.

ModelMayhem

I use this site to find hair stylists, makeup artists, wardrobe stylists, and models for my fashion and beauty shoots. I can post casting calls to describe the shoot concept and see if anyone is interested within a certain geographic area. A majority of the fashion shoots I did in my first year as a fashion photographer consisted 100 percent of artists I have contact with via this network. Figure 16.5 is a shot of my ModelMayhem profile.

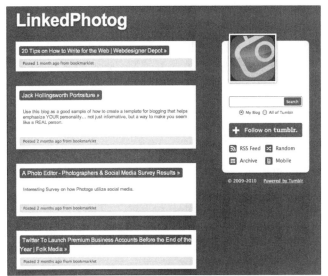

Figure 16.4

I primarily use Tumblr as a way to gather resources for myself and other photographers.

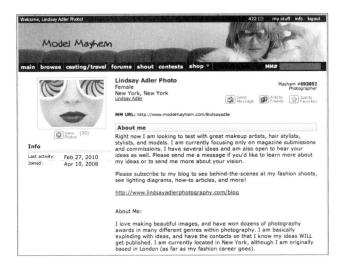

Figure 16.5

I use Model Mayhem to find models for my fashion test shoots and also models for photo and lighting demonstrations. It is a great resource to find hair stylists, makeup artists, models, and wardrobe stylists when trying to organize your first fashion shoots.

deviantART

This is an online community of artists. I post my work here to get feedback from other artists. I utilize this site primarily to find inspiration from other artists and discover textures and patterns to utilize in my images.

LinkedIn

I am only mildly active on this site, but I do ensure that my profile is always up-to-date. I utilize this platform's community forums and groups to share ideas with like-minded professionals and to ask for advice. Based on the specialized groups of professionals, I can ask questions and read up on industry updates.

I often connect with former clients via LinkedIn, but I primarily use the site's forums to answer questions and interact within the photo community. My LinkedIn profile, seen in Figure 16.6, also provides me with a place to request and display testimonials from previous clients.

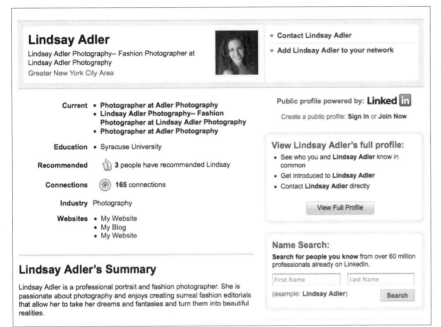

Figure 16.6

I maintain a LinkedIn profile to act as my business profile and online resume.

Vimeo

I upload all of my behind-the-scenes videos, video tutorials, interviews, and other video content to Vimeo because I really like its player's sleek interface. I can then easily embed this content into my blog. I prefer Vimeo's interface to YouTube; it also has a more creative and artistic community within its network. Although Vimeo does have a platform that allows you to create personalized channels, as seen in Figure 16.7, I typically don't try to attract clients to my channel but instead to the video embedded in my blog.

YouTube

Although I already upload my video content to Vimeo and actually prefer its interface, YouTube has a significantly larger community and shows up higher in search engine results. I have a community of followers on YouTube that subscribe to my channel and are notified each time I post a new video. Through YouTube, my content has been passed around the Internet to dozens of other sites, thus getting my name and work out there for others to share.

Figure 16.7

I use Vimeo to host all my tutorial and behind-the-scenes videos.

Every day I find that a different Web site has shared a link to one of my many tutorials. Figure 16.8 shows my personalized YouTube channel for all of my education video content.

Figure 16.8

Many YouTubers subscribe to my content and are notified when I post a new video.

Flickr

Whenever I create fashion editorials (or other work I am proud to share), I post them to Flickr, shown in Figure 16.9. Although these photos might already appear on other social networking sites, Flickr has great search engine optimization (SEO), which means that the images appear high in search engine results of related terms. This is an important way for people to find my work—and visit my site or become familiar with my skill set. I also can have Flickr feed into my blog to show my most recent uploads.

Figure 16.9

I find Flickr most useful for helping improve the SEO of my images on Google.

Other Sites

I have accounts on dozens of other sites, like StumbleUpon, SoundCloud, Digg, Delicious, and several more, but these are just tools that I periodically utilize and are not essential networks.

Social Media Tips

1. **Show a general interest in others, and they will show interest in you.** Comment on other people's photos, blogs, and status updates. They will become familiar with your name and your work and help to build your community.

2. **Portray enthusiasm and personality in your online activities.** Don't just be a robot sharing links and boring posts. Instead, develop an online voice that allows people to better connect with your personality.

3. **Don't use your social media activities to directly promote yourself.** If you just tweet about your services or workshops, people will be turned off. Instead, share your expertise, artwork, and advice. This will serve the cause of promoting yourself as an expert without being a boring egoist.

4. **Become an expert.** Find something you can become the go-to person for, whether that is lighting, retouching, portrait techniques, food photography, or something else. When you develop a following as an expert, people look to you for advice and spread your work to others.

5. **Be patient.** You won't have a huge following overnight. As with all relationships, you have to grow and nurture them.

Essential Sites

- **Web site and blog.** http://www.lindsayadlerphotography.com
- **Twitter.** @lindsayadler
- **Facebook.** Facebook.com/lindsayadler1
- **Flickr.** Flickr.com/lindsayadler
- **LinkedIn.** linkedin.com/in/lindsayadler

Case Study: Rosh Sillars

My social networking developed as a natural extension of my offline business networking.

When I graduated from high school, I walked away with awards in both photography and marketing. I stood at a crossroads of career paths. Ultimately, I chose to follow my interest in art and enrolled at the College of Creative Studies in Detroit. I graduated in 1993 with a bachelor's degree in photography.

While in college, I photographed freelance assignments and ran the darkroom for my local newspaper, *The Grosse Pointe News*. Eventually I was hired as the staff photographer. I caught the news business bug right away; 20 years later that love for the media still flows through my veins. Working in the news business taught me the power and the responsibility of taking pictures accessible to thousands of readers. I still take that responsibility seriously in the online world.

After college I continued to freelance for local papers. Meanwhile, an opportunity opened at a major automotive photography studio. I wouldn't be assisting the photographers; rather, I'd be learning the business under the wings of the photographers' representatives.

Although I wasn't extremely successful at this endeavor, I learned a great deal about the industry and what was necessary to build a career in photography. More than anything else, I learned that business is about relationships. I had to learn how to build them.

Even while working as a news and advertising photographer, my interest in marketing remained strong. Over the years, I've worked at building small businesses related to photography, on the Web, and in publishing. In most cases, those efforts were supported through networking.

As a child, I spent many hours programming my computers. As a young man, I started a photography career in the news media. All my life I've had the desire to share everything I've learned with anyone willing to listen to me. These elements came together to form a perfect storm that led me to the Internet and later, the social Web.

In many ways the Internet always has been a social realm. My first experiences online were in CompuServe chat rooms. A few years later, Netscape gave me the opportunity to explore the new World Wide Web.

In the mid-1990s, America Online (AOL) helped make Internet socializing a mainstream pursuit. In 1997 I met my first customer, Janice, through social communications. Janice worked for a small design firm. Later she moved to a promotional products marketing company. Today that relationship remains strong; some years that relationship contributed as much as 15 percent to my company's overall revenue.

In 1996, I parted ways with the automotive studio. I was still finding commercial photography opportunities—not in my skill set at the time—through networking. I brought on board some excellent commercial photographers and started my own representation firm, The Rosh Group Inc. (My Rosh Group portfolio is presented in Figure 16.10.) My goal: if I'm not comfortable doing the work, at least I can earn a percentage of the fee. I built my company on a foundation of networking. We managed to earn a solid client list of midlevel businesses and agencies.

I created my first Web site, rosh.com, in 1998. I used it to display Rosh Group Inc. portfolios. I was lucky to get the domain name. A few months later, a large Russian financial firm named the Rosh Group bought Rosh.net, and all the other variations of the name were quickly snapped up.

We tried to be as cutting edge as possible with the site by developing a searchable online image catalog. One of my priorities beyond displaying photographs was to share some of my business ideas. By the end of 1999, I started publishing audio-over-the-Internet business segments—what we now call podcasts.

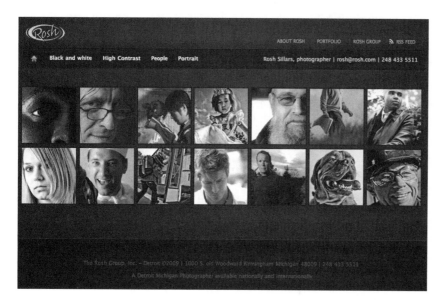

Figure 16.10

I started The Rosh Group Inc. as a photographer's representative agency built on networking and providing a variety of photographic services to midlevel businesses and agencies.

In 2000, my friend Andrew Morlan and I created *Citynet Magazine*, which published in print and online. This venture evolved into the support and publishing of multiple, glossy magazines. The work with glossies eventually faded, but they led to many opportunities in the Detroit media market that kept me busy from 2003 through 2008.

The increase in the magazine business meant my photography became more commercial in scope. To avoid a conflict of interest, I handed over all the representation duties to my company representatives.

During that time, I focused on developing Web sites for my business and learning SEO strategies. The effort paid off: I was ranking at the top of my keyword targets and consequently earning photography opportunities. Figure 16.11 shows my number-2 ranking for interior photographer.

My representative, April Galici-Pochmara, attended a seminar on podcasting in March 2007 and suggested we give it a try.

A few years earlier my friend, Chris Marshall, had contacted me about podcasting. He knew I dabbled with online audio for my Web site tips and presentations. I wasn't able to help him with the new technology. But he piqued my interest in the new opportunities developing with the release of Apple's iPod. By the time I decided to get back into audio over the Internet—now called podcasting—the technology had changed considerably. My friend learned the new technology. His podcast, Collected Comics Library, now had more than 1,000 subscribers and offered me great inspiration.

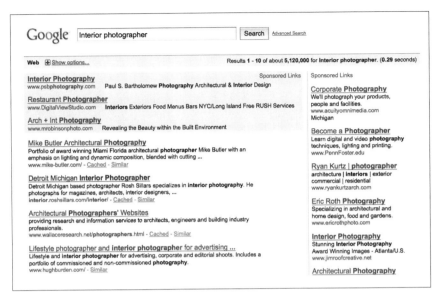

Figure 16.11

My site ranks near the top of many of my keyword targets, which leads to more earning opportunities and business leads. Among these keywords, I consistently rank in the top results of "interior photographer" in Google.

After April suggested the podcast idea, I called my good friend, Dean LaDouceur, and pitched the idea. Within days, we founded the Prosperous Artists Web site and podcast. I threw myself into it, learning about XML (the foundation markup language for really simple syndication, or RSS). I built Flash audio players for the site and bought equipment to record our shows. The Web site was fairly basic. We had little idea whether anyone was listening until the site became a blog in November 2007.

At the same time, I started getting really excited about RSS. It is a simple technology, but in it I saw a huge marketing potential. I almost quit photography that summer to pursue my ideas.

About a year later I spoke about social media for the local chapter of the American Society of Media Photographers (ASMP). It went over well. Ben Colman, one of ASMP's national directors, happened to attend the event and encouraged me to take my talk on the road.

After a few failed starts on other photography and marketing-related podcasts, in the summer of 2008 I founded the New Media Photographer blog and podcast. (The blog is represented in Figure 16.12, and the podcast is displayed through iTunes in Figure 16.13.) This one felt right. My second regular podcast was born. I developed a following in my little niche and never looked back. The blog and podcast cover digital photography, marketing online, business of photography, SEO, and all the major social networks.

Figure 16.12

The New Media Photographer blog provides useful content and analysis of social media, new media, and digital marketing for photographers.

I have two missions with New Media Photographer: educate other photographers with what I know, and attract attention to my photography for more opportunities. The resulting traffic and links support my SEO efforts. This leads to more photography opportunities, including bids on national accounts.

Figure 16.13

The New Media Photographer podcast is a weekly podcast that shares updates in the world of new media and photography, interviews with photographers successfully using new media tools, and tips and tricks for utilizing the social networking tools available.

Within six months and with the help of Susan Carr, Richard Kelly, and Todd Joyce, among others at ASMP national, I was traveling the country sharing what I had learned about the power of social media.

In June 2007, I started playing with a cool new site called Twitter. Many of us didn't know what to do with it. Although I wrote about it often on my blogs, I didn't get the power of the media stream until I spoke at a Michigan Podcamp in November 2008. It was an informal conference of podcasters and bloggers, who were tweeting and sharing online the story of the event. Once the concept clicked, Twitter quickly became my most successful social media platform outside of my blogs and podcasts.

I support people on Twitter, and they champion me in return. Twitter has given me opportunities to speak, write magazine articles, photograph, and coauthor this book about social media for photographers.

Facebook helps me connect with old friends, family, and business associates. I don't use it much for business, but relationships have become stronger through the use of this platform.

LinkedIn is an extremely powerful—and underused—social media Web site. I've started working more with this platform to take advantage of the opportunities to connect with more business people.

Podcasts are the foundation of much of my learning. New photography techniques, marketing, and business ideas help me upgrade the quality of my photography and business. Studiolighting.net, C.C. Chapman's "Managing the Gray," and Mitch Joel's "Six Pixels of Separation" are some of the first podcasts I listened to regularly. I still listen to podcasts for their educational value, most often when I'm working on images in post-production.

I share my outtakes, my 365 project (photographing and posting an image a day), and casual images on Flickr. I strongly believe in protecting my copyright, but I also want people to use my photography to share ideas and educate others. There is a catch, of course, because I license my photographs under the relatively new Creative Commons program, an unofficial licensing system that offers various use options to the general public.

I license my work for noncommercial use; a link must be directed to my Web site to satisfy the license requirements. I find there is value in sharing my secondary images in this manner rather than having them hidden on a hard drive or CD.

Today I teach at two universities. I use social media as a way to keep in touch with and engage my students. One of the biggest complaints from my students always has been that they don't get enough individual feedback on their images. Blogs, and especially Flickr.com, have made it easier for me to keep student images organized and make comments. I also encourage other students to comment on their classmates' photographs.

Video will be a big part of my future. People love watching good videos and multimedia programs. YouTube and similar sites will continue to grow. As a photographer and visual artist, I've made a commitment to develop my visual skills beyond still photography.

In 2009, the Detroit photography market sank to its lowest point ever in what had been an eight-year decline. Many photographers went out of business or left town seeking work elsewhere. Although I had a rough year, social media, SEO, and offline and online networking kept my business afloat.

In the spring of 2009, I approached one of my photography clients, Synectics Media, an Internet marketing company. I really liked the owner, Greg Evans. Greg and I started working on some Internet projects and discovered we shared similar ideas and goals.

I met with Greg and suggested that his company needed a social media consultant for his clients. He agreed. Since then, we have been working as a team to grow and develop his company. In the fall of 2009, we started my third regular podcast—"The Driven Business"—which is an integrated marketing podcast. "The Driven Business" focuses on using the best online and offline marketing concepts (seen in Figure 16.14).

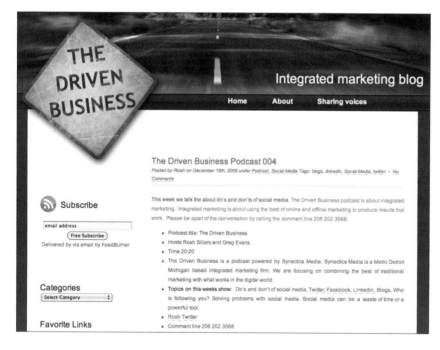

Figure 16.14

"The Driven Business" podcast, in collaboration with Synectics Media, is a business-oriented (not photography-specific) podcast focusing on using the best online and offline marketing concepts available.

I use my experience with Synectics' clients to share real-world examples with the New Media Photographer community.

I recognize that the business of photography has changed. I am fortunate to have some wonderful clients and new opportunities to stretch my marketing muscles. Multimedia creation will play a large role in my future with Synectics Media. The Rosh Group likely will become a visual production company. We will take advantage of new technology and opportunities for photographers to create new styles of creative imagery for the entertainment industry, media outlets, and corporations. I look forward to the future.

Social Media Tips

1. **Create a social media plan.** If you don't have a focus within the social media world, you will wander in circles. Define your target, and then take actions that lead you to the communities in which they reside.

2. **Don't take the social out of social media by automating your content.** Relationships are vital to a healthy photography business. Placing your online networking on autopilot is not how you develop relationships.

3. **Avoid the time-wasting elements of social media, such as endless games.** Playing endless games and checking and responding to the non-stop status updates of your community will drain your time. Facebook is notorious for its games. Gaming itself is not bad, but if your purpose is to network and find new clients, games are not the best use of your time.

4. **Keep doing what works.** Let go of what does not work. Don't feel you have to participate in all the popular social media platforms. If you are not receiving monetary, educational, or inspirational return, let it go.

Essential Sites

- **Web site.** http://www.roshsillars.com
- **Blog.** http://www.newmediaphotographer.com
- **Twitter.** @newmediaphoto
- **Facebook.** http://www.facebook.com/Newmediaphotographer
- **Flickr.** http://www.flickr.com/groups/newmediaphotographer
- **LinkedIn.** http://www.linkedin.com/in/roshsillars

17

Your Stories

There are thousands of photographers successfully utilizing social networking on a daily basis. Some are masters of blogging, others of podcasts, and others of Facebook. These photographers have found which tools and platforms are best suited to their audience and business goals.

In this chapter we will share the stories of several photographers effectively utilizing social networking to grow their business and establish their reputation. These photographers have found their niche and built a strong community around their work.

We will explore the tools and practices that have proven most effective and profitable for these photographers' businesses. The photographers have shared the story of how they became successful in social networking and provided invaluable tips to help you be efficient and successful in your social networking endeavors. Some are famous commercial photographers, others are boutique local wedding photographers, still others are nature photographers, but all have something valuable to share in their experiences.

Chase Jarvis

Web Site. http://www.chasejarvis.com/

Blog. http://blog.chasejarvis.com/blog/

Twitter. @chasejarvis

YouTube. http://www.youtube.com/user/achaser123

Vimeo. http://vimeo.com/chasejarvis

Facebook. http://www.facebook.com/chase.jarvis1

Chase Jarvis is a lifestyle, sports, and urban and popular photographer with major clients such as Nike, Adidas, and automotive companies. In addition to his high-end commercial work, he engages in many fine art projects around the Seattle area. His commercial work is bold and creative, as seen on his Web site in Figure 17.1.

Figure 17.1

Chase Jarvis's Web site and blog, powered by liveBooks.

In both the photography and art world, Jarvis's name is synonymous with the success and growth of new media and social networking. As he sees it, the new media system of distributing artwork has changed the business for everyone.

"Historically, to share your work with a large number of people, you needed to shoot an ad campaign for a large magazine. Now you can just hit Publish and share with an unlimited number of people," says Jarvis. Now that your work can reach people worldwide, you can share your vision and potentially gain more clients. Although in the past photography had been a closed industry (lots of trade secrets), Jarvis urges people to be transparent and share their knowledge. Doing so helps them gain recognition as an expert and develop a strong online community.

Jarvis started sharing his content on YouTube in 2005. He was absolutely shocked at the tens of thousands of views his videos would receive, thus indicating a clear demand and hunger for the content he had to offer. Today he is active on a variety of social networks.

"Your blog is the core. It's the big tanker. Facebook is the middle of three children with photos and videos and two-way discussions. Twitter is the little speedboat that buzzes around and points to other media," explains Jarvis. "You can set up all the social networks you need in 15 minutes and then get started." He is active on his blog, Facebook, Twitter, YouTube, Vimeo, and iTunes (podcasts).

Jarvis urges photographers who are new to social media to have patience. Social networking is just like any other business marketing or networking effort. "The reality is you have to take a long-term view of this stuff," says Jarvis. "You can't expect to be everybody's favorite or have easy conversations with everyone. You have to earn people's trust, be a good persona, and invest time as a long-term endeavor."

You have to engage with people and participate in the community. If you don't, it's like going to a cocktail party and standing in the corner facing the wall. It's hard for people to gravitate toward you if you don't engage by going to their blog or commenting on their work. This is the largest cocktail party in the world going on 24/7 worldwide.

—Chase Jarvis

"All this social media stuff means nothing without the content," says Jarvis. "Make the things you want to make, and share as frequently as possible."

Jarvis describes social media as a giant cocktail party, and many have adopted this description as an apt way to portray new media and social networking.

Jarvis goes on, "Put your work online to share, and your networking will invariably grow. People will be compelled to share interesting stuff with their friends. As the network grows, you will be able to get good feedback and thus start the conversation. At some point you will have a dedicated audience really paying attention to what you are saying and [who] can sustain you. Create, share, and sustain."

While Jarvis focuses on providing valuable content to his followers, he focuses on what interests and inspires him. "If you appeal to everybody, you will appeal to nobody. To be successful at my rates, I need to impress 18 people each year," says Jarvis. "I need 18 clients, and when I have 3 million monthly page views on my blog, that means I can do whatever I want because I have to appeal to such a tiny fraction of my audience."

As a result, Jarvis advocates working on creative, self-funded projects. His projects reflect his passions and often create a buzz around his work, attracting new clients to his photographic talents. One such project he has pursued, seen

in Figure 17.2, is his "Songs for Eating and Drinking" project, where he brings together musicians, artists, and other creatives at dinner get-togethers to engage in interesting conversation and performances. Jarvis records and photographs this work and, like many of his other personal projects, it has created substantial buzz and interest.

Figure 17.2
Jarvis's "Songs for Eating and Drinking" is a personal multimedia project he is passionate about.

Jarvis was asked to shoot a campaign for the Nikon D90, the first DSLR camera with video capabilities. Jarvis always keeps new media and social networking in the forefront of his mind, so he asked Nikon to lend a camera to his staff to record the process of the campaign and other behind-the-scenes video. When the camera was finally launched, the still campaign was successful, but the video piece clearly stole the show. Everyone was talking about its capabilities, passing the video around online, and creating a huge noise within the online photo community. Jarvis was aware of the hunger people have for storytelling and communication online, and this video piece told a great story about the product and the photographer.

Jarvis continues to share a great deal of behind-the-scenes video, photos, and posts on his blog. When he was hired to shoot a campaign for SanDisk, as seen in Figure 17.3, he took new media to another level by broadcasting the shoot and creative process live to his huge community of followers. He tweeted the process, shared video, and updated his blog regularly.

Figure 17.3

For the SanDisk campaign, Jarvis invited his followers behind the scenes to experience the shoot and the product along with him.

"The situation was a perfect synergy between community and commercialism," says Jarvis. Because his followers were often professional and aspiring photographers, he was able to directly reach out to the same audience that SanDisk was targeting. The live record of the event was so popular that he continues to pursue this process of live broadcasting of events and shoots.

Jarvis integrates social networking activities into his daily workflow. Whenever something is shared under his name (on Facebook, Twitter, or another network), he is the one writing the content even though he has a team of six employees. When the iPhone came onto the scene, Jarvis embraced it as the "new Polaroid" to share candid images of the world around him without technicalities and production getting in the way. He was able to share these images with Twitter followers as well as create a visual diary. He began shooting regularly, and he eventually compiled nearly 15,000 images. With these images he published a book called *The Best Camera Is the One That's with You*, pictured in Figure 17.4. Through his work, he illustrates that you can create beautiful images with any equipment. With the success of his book, he launched an iPhone app (Best Camera) that allows you to make basic changes to images and share them online. Millions of people have embraced Best Camera as a tool for their social networking activities.

Figure 17.4

In 2009 Jarvis published *The Best Camera Is the One That's with You*, a book of iPhone images he had taken, thus illustrating that powerful imagery can be created with whatever camera is available to you.

Jarvis has a few essential tips for how to approach social networking:

- Be transparent. Show what goes on behind the scenes of the creative process.

- Exude a sense of personality. If you have no personality, it is hard to connect with others. Your online activities are an extension of yourself and your brand.

- Be patient and invest time in social networking. Success won't come overnight.

- Give to others and expect nothing in return. You want others to follow you because you are a good artist who has something to say.

- Take a look at yourself, your work, and your goals to decide how to approach social media. What message do you want to send to the world? What are you trying to portray about yourself and achieve with online activities? How do you justify your time on Facebook, writing blog posts, and so on? Assess your goals to focus your efforts.

- Don't try to please everybody. Be yourself.

- Check out Jarvis's iPhone app Best Camera to easily adjust and share images. The best camera is the one that's with you.

Jeff Curto

Web Site. http://jeffcurto.com/
Blog. http://www.cameraposition.com/
Blog 2. http://photohistory.jeffcurto.com/

Twitter. @jeffcurto
Flickr. http://www.flickr.com/photos/jeffcurto
Facebook. http://www.facebook.com/curtoj

Jeff Curto is a professional photographer and teacher of photography at College of DuPage. At present, his work is generally fine art photography collected by private collectors and museums. You can see an example of his work in Figure 17.5.

In 2005 Curto began a podcast called "History of Photography" to accompany a class he was teaching, but by making it available on iTunes, he quickly gained a large following. Today each class podcast has more than 10,000 downloads. Due to the success of this podcast effort, he followed up with a more personal photography podcast called "Camera Position," seen in Figure 17.6, that currently garners about 15,000 downloads per episode. These numbers are regularly growing and offer Curto a large audience to share his knowledge, expertise, and ideas.

With the success of his podcasts, Curto has built a successful blog to construct a stronger community around his listeners. His social networking activities on Facebook and Twitter have grown naturally from his involvement with the communities put together around his podcasts.

Figure 17.5

Image by Jeff Curto.

Finding a photography niche within the podcasts has been important to Curto's success. "I noticed that most podcasts had to do with technical issues in photography and that most of the tech podcasts that dealt with Photoshop and digital cameras were very well done and comprehensive. I therefore thought I'd deal instead with the more creative aspects of photography." As always in social media, you want to further the conversation, not duplicate content that already exists. "The more you give away, the more will come back to you," says Curto, who seeks to use a friendly approach backed up with real-world experience to make his content attractive.

Figure 17.6

Jeff Curto has built a large following through his Web site and podcast.

Curto's new-media efforts have helped him establish an international reputation as a photographer and photo educator. "Based on the success of the podcasts, I've been invited by PDN to do presentations on podcasting at PhotoPlus Expo. More than 20 new collectors of my work have discovered me through my podcasts. Podcast listeners have learned about and participated in my Italy photography workshops. Spreading the word about my expertise as a photographer, teacher, and podcaster has helped me move myself forward with things that I want to pursue in my career."

Curto feels that podcasts allow him to communicate his ideas clearly and easily to a large audience in his own voice. He is able to start conversations and further communication.

Curto has a few points of advice for making the most out of podcasting and your blog:

- For podcasts, consider asking your podcast listeners to post comments in the iTunes store. This moves the podcast up in the store's hierarchy and helps you get more listeners.

- Set up your blog to automatically post to Facebook and Twitter when you add new content. This saves time so you don't have to worry about each network independently. Facebook helps you to build a community that is interested in what you have to say, and Twitter is a great way to drive additional traffic to your site.

- Your blog puts a human face to your business more so than a Web site. A Web site is your business card, whereas the blog is a chat over coffee.

All social media are about storytelling and listening—telling your story with your voice and listening to other people's stories. Conversation is the new online currency; we want to communicate with each other, and these tools are allowing that to happen.

—Jeff Curto

Lara Jade

Web Site. http://larajade.co.uk/
Blog. http://larajadephoto.blogspot.com/
Twitter. @LaraJade_

deviantART. http://larafairie.deviantart.com/
Flickr. http://www.flickr.com/photos/larajade

Lara Jade is a young fashion and portrait photographer focusing on creating fantasy moments, child memories, and raw emotions through her work. Figures 17.7 and 17.8 show her style. Although she's only in her early 20s, she has already amassed an extremely large following through social networking, which has helped her grow her career and gain innumerable essential contacts.

Figure 17.7
Image by Lara Jade.

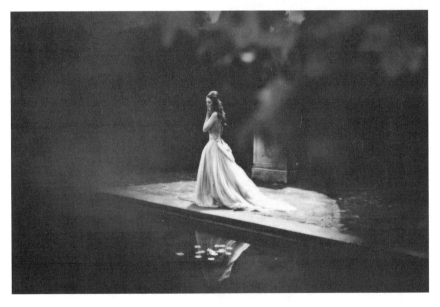

Figure 17.8
Image by Lara Jade.

Jade began social networking several years ago on the artist networking site deviantART. She browsed the work of hundreds of artists for inspiration and quickly developed a large following on the site.

Jade is active on Facebook, Twitter, deviantART, Flickr, and her blog, and she has tens of thousands of followers across the various platforms.

As a fashion photographer, Jade has found Twitter to be especially appealing as a way to tweet behind-the-scenes photos from her iPhone during her shoots. She often shares these same images on her Facebook page, seen in Figure 17.9.

She does not budget specific time for social networking but includes it as a seamless part of her daily activities. She updates Twitter a few times each day and tries to update all of her social networks with new images after each new fashion shoot.

Social networking has always been my tool to get my work to the world. It has taught me how to improve and has opened doors in ways I could never have imagined. I have met some extremely inspiring people—people that I have become good friends with and people that have supported me and watched me grow from the start. I am grateful that social networking has given me so much.

—Lara Jade

New media and social networking have changed the direction of Jade's life. First, while still a teenager, the prestigious Italian artist agency Sudest57 was directed to her images from a photographer who had seen her work on deviantART. After seeing the images online, this agency signed her as a photographer, and she now works with large clients in Italy and abroad.

With her work on Flickr and deviantART, Jade has also been discovered by a variety of art buyers. From those two Web sites alone she has been featured on book covers and in international magazines, and she has had work purchased by major companies like Touchstone and BBC.

Figure 17.9

At press time, Jade had more than 11,000 fans on Facebook and an enormous following on her other networking sites, including deviantART, Flickr, and Twitter.

As a fashion photographer, Jade attributes the social networking sites Flickr, ModelMayhem, and deviantART to her success. These sites allow Jade to connect with like-minded creatives and readily share her images.

Her early success stemmed from sharing self-portraits, which people easily gravitated toward. Although Jade continues to create stunning self-portraits, her work as a fashion photographer has grown, and her massive social network has multiplied exponentially with her work. Her various sites receive many thousands of hits per day in combination, and cumulatively they have received tens of millions of views.

Although online social networking is a great tool, Jade believes that it is important to develop real-life personal relationships with clients and colleagues. "I've found it's always better to know clients and other creatives personally; you can only do this by seeing them, speaking to them, and knowing what makes them tick."

Jade's social networking activities have been extremely successful. She has a few key pieces of advice for expanding and leveraging your online communities:

- Update all your social networking sites and Web site regularly to keep people interested and involved. Always share your newest work and updates on life.

- Build an audience by following people and engaging in conversations. If you follow people, they will often follow you. If you comment on people's work, they often return the favor.

- Put your work in places where art buyers (or potential clients) will find it easily. For example, add your work to groups on Flickr that represent what you do. As a fashion photographer, add your work to a fashion photography group. This is where art buyers might go to find an appropriate fashion picture for a book or magazine.

- Familiarize yourself with copyright laws. Although you want to get your work out to as many people as possible, you want to minimize the ability to steal your work. Upload photos at a relatively small resolution, and disable the download capabilities on sites like Flickr and deviantART.

Jack Hollingsworth

Web Site. http://jackhollingsworth.com/
Twitter. @photojack
Vimeo. http://vimeo.com/jhollingsworth

Jack Hollingsworth describes himself as a world photographer, with specialties in travel, lifestyle, portraiture, and stock photography. Figures 17.10 through 17.12 are examples of his work.

Hollingsworth got his first taste of social media in 2007. "I was primarily introduced to social media through SXSW interactive. It was like a deer-in-the-headlights experience for me. I had seven full days of goose bumps and sleepless nights. I knew, right then and there, that without a doubt I had found a

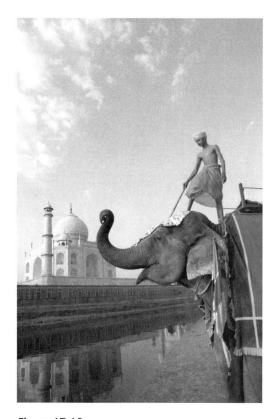

Figure 17.10
Image by Jack Hollingsworth.

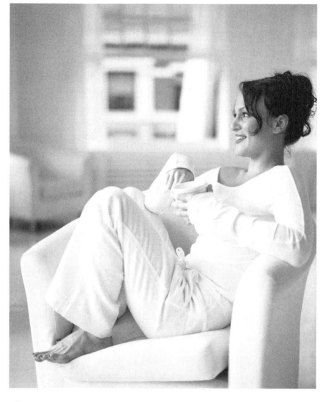

Figure 17.11
Image by Jack Hollingsworth.

Figure 17.12

Image by Jack Hollingsworth.

new home, a new purpose, a new platform to be heard and tell my photo-graphic story. Social media was it. And the last three years haven't lessened one bit my passion and love for all things social media. It's a photographer's dream come true!" Hollingsworth's interactions with Twitter, seen in Figure 17.13, have been a central focus in his embracing of social media.

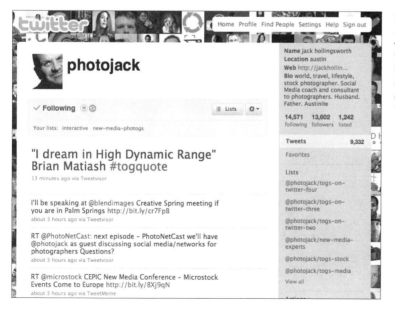

Figure 17.13

Jack Hollingsworth is most active on Twitter, where he focuses on sharing important knowledge and links with other photographers and "giving more than you get."

Hollingsworth feels that the essential networks for photographers are Twitter, Facebook, Flickr, YouTube, and LinkedIn (in that order). He feels it's wise to approach these networks one at a time, giving yourself about a month or so to really become familiar with the capabilities of each network. You should also tackle your blog to build your personal brand. His blog posts start with the phrase "I am" and conclude with musings about his life, job, and photography. One sample blog post, "I Am Great," is pictured in Figure 17.14.

Figure 17.14
Hollingsworth's portraiture blog is a series of short posts and images that reveal something about him.

At the time of this book, Hollingsworth had more than 10,000 followers and an extremely engaging community following him. "I was introduced to Twitter and caught the bug. I've never looked back," says Hollingsworth, who spends a minimum of 1 hour per day on Twitter alone. "My mission has always been clear: to help photographers turn followers, friends, and fans into customers, clients, and brand evangelists for your products and services."

Hollingsworth is a prolific tweeter; he engages with the Twitter community on- and offline. His 2009 tweetup (Twitter meetup) at PhotoPlus Expo in New York was the largest gathering of Twitter photographers in the world to date. Several companies hosted the event, and the space was so full it was standing-room only! For Hollingsworth it is important, when possible, to put a face with the Twitter name and form real-life connections.

Hollingsworth feels that social media is essential to the success of *any* photographer.

Social media is not about return on investment (ROI), but instead return on influence. Your goal is to be more influential through more followers and evangelists.

If you ask Hollingsworth about the opportunities that social media have offered him, he could talk for a while. Here are some of the significant opportunities and changes in his career thus far:

- Social media has generated work in paid consulting on social media and other topics.

- Because of his following and large, active network, social media has landed him several fantastic equipment sponsorships.

- Social media has been essential to strong collaboration and has expanded his pool of freelance help.

- He has been asked to speak at multiple industry events and many major conferences for photographers and new media specialists, including at PhotoPlus in New York.

- Social media has generated paid writing gigs.

- His online activities and networking have increased awareness of his stock photography brand, thus generating more business and potential leads.

- He has joint-ventured with several online product marketers.

- He will be launching 2–3 new products and services related to photography, supported in part by the enthusiasm of his followers and the large online social network he has harnessed.

Hollingsworth has a few tips to keep in mind when growing your social networks:

- Learn one social media tool/network at a time. Give yourself a month to learn the ins and outs of each platform, and then move on to the next one.

- Listen before talking, and give more than you get. Focus on others more than yourself. Limit your signal-to-noise ratio to 5 to 1—5 parts signal (content) to 1 part noise (self-promotion).

- Celebrate the work and success of other photographers.

- The objectives of networking on- and offline are the same: to connect, to engage, to converse, and to be transparent.

A photographer with marginal technical skills but high aptitudes in social media will most definitely do better than a technical photographer with little to no experience in social/new media. If you are a pro photographer and not actively participating in social media, chances are good you may not be around in a couple of years—it's that serious. And for those of us active in social media—it's that exciting.

—Jack Hollingsworth

David Hobby

Blog. http://strobist.blogspot.com/
Twitter. @strobist
Flickr. http://www.flickr.com/photos/davidhobby/

David Hobby is a 20-year newspaper shooter and the creator of the incredibly popular photography blog "Strobist."

"Strobist" bills itself as the "world's most popular free resource for learning how to use off-camera Flash," but it has grown into a massively popular blog covering equipment reviews, interviews, lighting diagrams, and much more. With a following of millions, "Strobist" has become a premier photography-themed blog. Hobby attributes the success of the blog to its information-rich format and word-of-mouth about the quality of this content.

Hobby spends most of his day on the blog, seen in Figure 17.15, and it has become the focus of his photographic career. When he isn't working on the blog he is shooting. Because his blog is so highly trafficked, a majority of his work as a photographer can be traced directly back to his blog. Blogging is the direct source of most of his business, whether it is a photo campaign for a social media site or a cover shoot for a popular magazine.

Figure 17.15

Hobby's blog has become his primary employment due to its large following.

Besides blogging, Hobby effectively utilizes Twitter to drive additional traffic to "Strobist" and to "share oddball stuff" or other photo-related content that isn't necessarily appropriate content for his site.

For Hobby, blogging is the essential new-media activity for photographers.

More than anything else [blogging] galvanizes search engine optimization for you as a shooter. It also gives potential clients a way to see who you are beyond your portfolio.

—David Hobby

Hobby provides these quick words of advice:

- Use Google Reader to RSS everything to save time when monitoring blogs, news streams, and other online content. Similarly, use FeedBurner to broadcast your own blog using full feeds to influence readers.

- Study people who use social media successfully, and learn from them. Blog high-quality posts regularly, and interact with other bloggers.

Don Giannatti

Web Site. http://dongiannatti.com/
Blog. http://www.lighting-essentials.com/
Twitter. @wizwow
Flickr. http://www.flickr.com/photos/wizwow

Image by Megan Abshire

Don Giannatti spent most of his career as a generalist photographer covering everything from product to fashion photography. He even worked as a creative director of his own ad agency, giving him a unique perspective of advertising photography from both photo-producer and photo-buyer points of view. He currently teaches workshops on photography across the country, sharing his wealth of knowledge. You can see some of his work in Figures 17.16 and 17.17.

He is active on a variety of social networks, including Twitter, LinkedIn, Facebook, Posterous, and Flickr. Giannatti posts hundreds of images to his Flickr account, seen in Figure 17.18. His blog, "Lighting Essentials," gets the majority of his social networking attention. Through his blog, seen in Figure 17.19, he regularly shares content about the business of photography, location lighting, working with models, and more.

Figure 17.16
Image by Don Giannatti.

Figure 17.17
Image by Don Giannatti.

Figure 17.18

Giannatti uses Flickr to
share images from his
recent personal shoots
as well as images from his
popular workshop series.

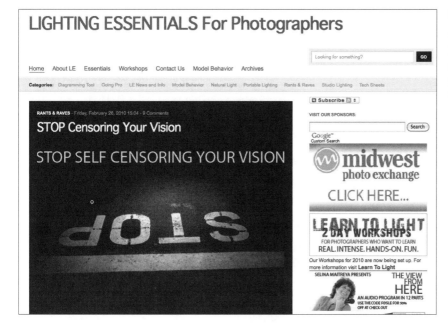

Figure 17.19

Giannatti's blog, "Lighting
Essentials," provides a series
of valuable content for his
followers, including lighting
tutorials and business advice.

Giannatti can list dozens of jobs resulting directly from social networking
efforts. He can trace jobs for big corporations to his blog, and at least a half a
dozen clients to Flickr. Regular Twitter posts maintain interest in his photo-
graphic workshops. His social media efforts keep him engaged with the photo
community and make his work readily available to view by potential clients.

For Giannatti, if photographers have a desire to be social and connected, social networks are the place to be. "If a photographer has a genuine desire to express his point of view, pen his creative mind to others, and share… then social media is a great place to do that."

By engaging in these conversations, Giannatti is able to meet people he would have never met otherwise, and find invaluable sources of inspiration, knowledge, and insights.

Giannatti suggests the following when you begin social networking:

- Take an internal audit of yourself. Are you interested in participating in social media, and are you willing to commit the time required? What do you have to offer? Create a blog and start posting about your experiences and your work, and put up photos to discuss. Keep topics relevant, and add something to the conversation.

- Put up your profile on LinkedIn, and become familiar with Facebook.

- Don't share when you have nothing to offer.

The key to social networking is to stay relevant. I am intrigued by the conversations and strive to keep my posts interesting and informative.

—Don Giannatti

John Harrington

Web Site. http://johnharrington.com/
Blog. http://photobusinessforum.blogspot.com/

Twitter. @johnhharrington
YouTube. http://www.youtube.com/user/johnhharrington

John Harrington is an editorial, commercial, and corporate photographer based in Washington, D.C. Figures 17.20 and 17.22 portray a couple of his images. As the author of *Best Business Practices for Photographers* (Figure 17.21), he also travels and speaks at many large photo conferences.

Harrington is most active on Facebook and Twitter, but he generally focuses on getting his work and updates to the widest audience possible. By having his work and content readily available on social networks, he has been able to keep in the forefront of the minds of his clients. When they see his work, they are reminded of his style and capabilities, and as a result he books more shoots. As an author, he uses his blog to "pay it forward" by sharing new updates and tips of business practices for photographers. While this helps promote the book, it also benefits the collective community and helps him become part of the conversation at large.

The ability to put images and videos online means a more immersive and insightful experience for those I am interacting with.

—John Harrington

Figure 17.21

John Harrington is author of *Best Business Practices for Photographers.*

Figure 17.20

Image by John Harrington.

He regularly includes his views on important changes in the industry or his musings on specific topics.

Harrington generally limits his social networking activities to one hour per day. He finds Facebook his most effective tool.

Figure 17.22

Image by John Harrington.

Make a contribution, and don't just go out and shill and sell yourself. Let people come to you because you have something to offer and they like what you are doing.

—John Harrington

Jim Goldstein

Web Site. http://jmg-galleries.com/

Blog. http://www.jmg-galleries.com/blog/

Twitter. @jimgoldstein

Facebook. http://www.facebook.com/
jimgoldstein

Flickr. http://www.flickr.com/photos/
jimgoldstein

Jim Goldstein is a professional landscape, nature, and travel photographer who has always had an interest in new technologies. His work is diverse and striking. Goldstein embraces the Internet as a way to share his imagery, as seen on his Web site in Figure 17.23. Before picking up photography, he ran a dot-com company geared toward photographers and artists. Today his passion again combines photography and the Internet through social networking.

Figure 17.23

Jim Goldstein's Web site is his home on the Web to share images and other content.

Jim is active on "almost every social media site" but is most active on his blog and Twitter. Goldstein feels that Twitter is a communications channel that allows for easy conversations and relationship building, all essential to business networking. "My blog provides me [with] an arena to self-publish and easily distribute content to others. Twitter has provided endless opportunity for me to make myself available to others and for me to approach others who were previously out of reach."

Goldstein doesn't budget a specific amount of time to social media each day; rather, he gets involved when he has something of value to share. New media modes of communication have become integral to the way he communicates with others.

There are many examples of how using social media has led to photography jobs for Goldstein. After his images from a San Francisco event (adults racing tricycles) were posted online, they were found and licensed by *Penthouse Magazine*. After his success and hearing about the success of others, Goldstein began researching and polling other photo professionals about their social media uses. He has since completed this poll with the help of photographer Taylor Davidson and has been sharing his results online and with the broader photo community. He will discuss his results at PhotoPlus Expo in New York. His poll was even used in the PhotoShelter e-book on social media for photographers.

Take time to listen before you engage people. By listening to what is happening in social media, you will be able to pick up on proper etiquette and gauge how people utilize each network for business or personal use.

—Jim Goldstein

Trudy Hamilton of TruShots

Web Site. http://trushots.com/
Blog. http://blog.trushots.com/

Twitter. @thetrudz
Flickr. http://www.flickr.com/photos/thetrudz

Trudy Hamilton is a portrait and lifestyle photographer often shooting on location to utilize the environment to convey something about her subjects. You can see one of her images in Figure 17.24.

Although she began social networking on MySpace, she eventually migrated to Facebook to engage in a more personal platform. Since 2008, Hamilton has become active in social media and maintained a blog, become active on Twitter, and utilized the network of ModelMayhem.

Twitter is her social network of choice for its concise format, ease of use, and informative nature. She is a prolific tweeter—sharing dozens of tweets with her followers daily. Twitter and other social networking activities, however, have not devoured her time and efforts. Instead, she estimates she spends 2–3 hours a day communicating with others online; it is a streamlined part of her daily activities.

Figure 17.24
Image by Trudy Hamilton.

To her, Twitter is essential for photographers. Hamilton explains, "There are so many benefits, including information on tutorials and training, access to peer review, camaraderie with those who understand the passions and challenges of photography, improving an online presence, adding to their brands, and even contact with potential clients."

One of the most important benefits of social networking for Trudy is the ability to learn and share, although she can also trace several ways in which social networks have helped her business grow. As examples, she has gotten wedding clients through social networks and reconnected with old friends and clients who later hired her for shoots.

> *The key is providing valuable information to other users while still being myself. We are people first and photographers second. Being a real person is something that users like.*
>
> —Trudy Hamilton

Hamilton has a couple of tips to be effective in social networking:

- Be yourself and engage with others. Don't try to sell yourself and work too hard—just be yourself and provide interesting information.

- View social networking as a tool for developing as a business, photographer, and person. With this view in mind, you can make the most out of the experience.

Thorsten Overgaard

Web Site. http://overgaard.dk/
Blog. http://aphotocontributor.typepad.com/
Twitter. @overgaard

Thorsten Overgaard describes himself as photographing "people, places, and buildings with atmosphere and a touch of personality." You can see a couple of his images in Figures 17.25 and 17.26. He works for companies such as Associated Press, Getty Images, and WireImage, producing content that gets consumed by media worldwide. He also teaches photography through seminars and workshops.

Figure 17.25
Image by Thorsten Overgaard.

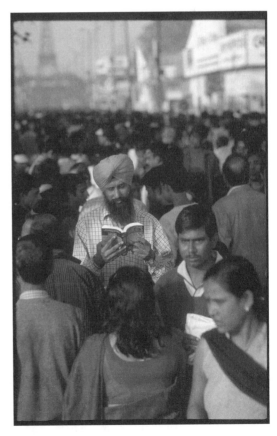

Figure 17.26
Image by Thorsten Overgaard.

Social networking has become an essential part of the way Overgaard operates. In short, Overgaard urges photographers to share their images so that others will hire them to produce the same quality work.

His Web site and blog are essential networks that he attempts to integrate into his daily workflow. He resizes and formats anything he shoots for clients so he can upload it directly to his blog, Web site, or Facebook. He also uses a weekly newsletter to keep people up-to-date on his activities, to illustrate the diversity of his talents, and to keep himself in the forefront of people's minds (and in the minds of potential clients). Overgaard uses Facebook as a way to network with people he meets on his journey. For example, at a fashion week he may take dozens of behind-the-scenes photos not used in other publications. To share them with others (models, stylists, and so on), he uploads them to Facebook, adds people as friends, and tags them in photos. "People respond with warp speed whenever they're tagged in a photo," says Overgaard. You can quickly distribute your photos and reach a large audience, as more people will see the photos, tag themselves, or comment.

> *Social networking is an ongoing and growing life cycle: I produce, post, and share what I do for a living and… what I feel is interesting to do in life. It has value for others. They consume it as just aesthetic entertainment or inspirational and educational fodder for them as photographers and artists, or it inspires them to do whatever they're doing today. It builds a personal brand, which in turn gives me a larger audience, interest [in] working with me, understanding for the fact that I don't work for free, interest in meeting me at seminars, and [interest in] reading my book when it comes.*
>
> —Thorsten Overgaard

"I don't invite people to share my images or site to make money on them; I invite them because I have something to share," says Overgaard. "But I feel I will eventually be able to convert recommendations into commissions." Overgaard regularly generates business for one-on-one photography tutoring and shooting assignments from his online activities, whether tutoring a millionaire oil baron in photography or getting jobs speaking at seminars worldwide.

Overgaard also uses a newsletter to keep his clients and followers up-to-date on his activities and accomplishments. A sample newsletter from February 2010 is shown in Figure 17.27.

Overgaard provides the following pieces of advice for social networking:

- Share your images; people love photographs.
- Be an active part of your camera brand community (whether Canon, Leica, and so on) to receive advice or inspiration or to network with colleagues.

Chapter 17 ■ Your Stories 305

- Use AddThis.com buttons on your Web site and blog to make it easier for people to share your content with others.

- Create content that maintains relevancy and value over time.

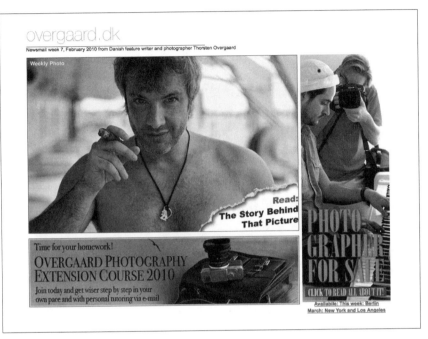

Figure 17.27

Overgaard's weekly newsletter to his followers and e-mail subscribers provides summary updates on his activities and new endeavors.

Seshu Badrinath

Web Site. http://seshu.net/, http://seshuportraits.com/
Facebook Page. http://www.facebook.com/seshuphotography
Facebook Profile. http://www.facebook.com/seshu

Twitter. @picseshu
Twitter. @openshade

Seshu Badrinath is a portrait photographer specializing in multicultural wedding photography, as visible on his Web site in Figure 17.28. He began his social networking through Facebook as an easy entry point and has expanded to Twitter, Flickr, and Tumblr as his main tools of communication.

Twitter allows him the ability to establish a personal brand to attach to the business brand. Being authentic in online social networking and in the real world is extremely important to Badrinath, and he often tries to engage people on- and offline.

For Seshu, "new media" perhaps might just become the "media" of the future.

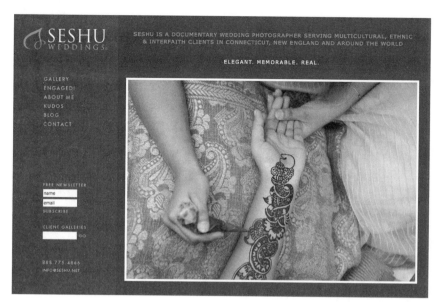

Figure 17.28

As a high-end wedding photographer focusing on multicultural weddings, Badrinath is careful to carry his visual brand throughout his Web sites and networks.

Badrinath has used Twitter and other new media outlets to engage in several successful marketing campaigns. For example, his "Phases + Faces: The Kids of Connecticut" was a campaign to photograph 200 kids to benefit the Connecticut Children's Medical Center. As he completed the sessions, he shared them via Twitter and looked for others online interested in collaborating. He has completed or is working on several free shooting projects like this, which have drummed up a lot of business and buzz about his services by utilizing social media.

Isn't it a curious coincidence that we are experiencing the rise in social networking as traditional media outlets falter and in fact are starting to disappear?

—Seshu Badrinath

Badrinath has picked up several useful hints on how to be effective in social networking:

- Don't just plug your own links on social networks; dig up other resources and content that your friends and followers will find useful. They will look to you as an expert.

- When you do share your own link, be sure to include a concise description of the link content to entice your friends and followers to click.

- Remember that the attention span online is nearly nonexistent. You need to say something useful or funny to catch people's attention. If you don't, you will be ignored.

- Listen to the conversations going on online before chiming in. Contribute when you have something of value to contribute.

David Mielcarek

Web Site. http://www.davidmielcarek.com/ **Twitter.** @davidmielcarek
Blog. http://cinematicbydavidm.blogspot.com/
Facebook. http://www.facebook.com/david.mielcarek

David Mielcarek is a contemporary wedding photographer with a unique style of shooting modern couples (Figure 17.29). He employs social media, including using a WordPress.org theme for his Web site seen in Figure 17.30.

Figure 17.29

Image by Mielcarek.

Mielcarek started his social networking efforts on Facebook as an extension of his wedding photography business. He was impressed by how easily someone could build up a network. After photographing a wedding, he could easily tag the bridal party in the photos—thus sharing his work and getting it out to a much larger audience.

After Facebook, Mielcarek embraced Twitter. Although skeptical of the system at first, he now embraces Twitter as an incredible networking tool. He has booked weddings as a result of Twitter, having followed people who ended up needing a photographer. Through social networking, he recently connected with a New York design company in need of photography. After their online interactions, he was brought on board as a photographer to be featured on their Web site. It's all about networking and timing.

Figure 17.30

Mielcarek's Web site is unique and eye-catching, intended to mimic his unique style of photography.

Twitter has saved Mielcarek money and helped him make decisions. He has heard about deals on software or received advice on other purchases or business decisions.

Because building relationships with potential clients and colleagues is so important, Mielcarek advises the following:

With millions of users worldwide, whatever is going on, chances are someone will mention it on Twitter. You could say it's the closest humanity ever came to the idea of having a collective mind!

—David Mielcarek

- Build and cultivate relationships with people. Nurture and cherish them.

- Remain positive. If you appear negative or bitter, you will lose followers.

- Show genuine interest and enthusiasm in your work and toward other people.

- Social networking is not about the number of friends or followers you have. Befriend people you actually want to connect with, and build meaningful relationships.

- To start on Twitter, tweet information or content you find valuable twice a day to become consistent.

- Be active. Leave comments on fellow photographers' blogs and Facebook pages. This will get them familiar with your name and ideas.

Jeff and Ana Kathrein from K&K Photography

Web Site. http://kandkphotography.com/
Blog. http://blog.kandkphotography.com/
Twitter. @kandkphoto

Jeff and Ana Kathrein of K&K Photography run a boutique wedding and portrait studio in central Florida. Although the husband and wife team use a wide range of social networking tools, they focus their efforts primarily on their blog, Twitter, and Facebook. Their Web site is elegant, as you can see in Figure 17.31. It provides links to their blog and other social networking profiles.

Figure 17.31

K&K Wedding Photography has an elegant Web site with a high-end feel. They maintain their brand throughout Twitter, their blog, and especially through Facebook.

Their social networking efforts began on Facebook after a fellow photographer recommended they try it and start networking with their clients. They joined Facebook and began tagging their clients in the photos from their wedding and engagement sessions. "This way their friends would see them in the photos. They would love them and hopefully say something like, 'Wow! Jane looks great! I want K&K for *our* wedding!'" says Jeff. "And so it went."

Jeff and Ana Kathrein developed a Facebook page for their business and eventually a Twitter account to begin networking with clients. They encouraged their clients to start forming relationships with them online. "We began offering a discount to our brides/grooms when they followed us on both Facebook and Twitter. Many of them didn't have Twitter accounts, so they had to create them," said Jeff. "It was a gamble on our part, as they didn't have to use it ever again, but we have found that many of them do and it's been a useful way to keep in touch with past and current clients in a very informal way. It lets them see that we're still busy, that our work is constantly improving, and we are hoping to continue to get repeat business from past clients through this."

Although social networking and social media are key to their business growth and marketing, Jeff estimates they spend an average of only about an hour or so each day on social networking activities.

Their Facebook marketing has been so successful that they provide clients with "Facebook file" images for them to post and tag. "As soon as our clients receive their disc, we see them update their profile photos almost one-for-one with their new images," Jeff explains. "We also tag them in our copies of the images, and the result is lots of their friends and family see them in great photos and want to book us for a shoot. We booked three shoots in one evening as a direct result of this style of marketing."

We have a $20 daily limit, and we pay per click, the average click costing us around $0.75. This gives us about 35 clicks per day, which tends to generate approximately 40–60 actual service inquiries per month, 25 or so of which are generally qualified leads. Last year, roughly 55 percent of our brides came from Facebook ads, and this year is approximately the same. This has been a huge opportunity for us, being experienced and talented photographers in a new geographic area with a new local market.

—Jeff and Ana Kathrein

K&K Photography has embraced Facebook's ad capabilities to set up a customized ad campaign geared at brides. This campaign has been overwhelmingly successful.

Their numbers and their ROI talked about in the quotation are significant for any business investment.

Facebook is their primary focus, but they also devote time to their blogging efforts. They share their final and favorite images from recent portrait and wedding shoots and share updates on their studio's publicity, press coverage, and publications.

K&K Photography has found the following tips to be particularly pertinent for photographers engaging in social media:

- Know what you are selling and to whom before really concentrating on social media.

- Read up on the most efficient and effective methods of using social media to save time and effort.

- Recognize the social media that isn't working for you and stop wasting time with it. Conversely, recognize what is working and strengthen it.

David Warner of LensFlare35

Web Site. http://www.davidwarnerstudio.com/

Web Site. http://www.lensflare35.com/

Flickr. http://flickr.com/people/davidwarnerstudio

Twitter. @lensflare35

David Warner is a landscape and people photographer who has worked in many realms of photography, whether as a newspaper photojournalist or a wedding photographer. Today he focuses his efforts primarily on landscapes, as seen on his Web site in Figure 17.32. He resides in the Adirondack region of New York.

Figure 17.32

David Warner focuses on landscape photography, although he has extensive experience in newspaper photojournalism and portraiture.

Although Warner joined Facebook, MySpace, and other social networks early on, he admits he didn't utilize them to their full potential. "I just didn't get it," he reflects. "But in 2009 I decided to go full bore on social media and to really get involved in Twitter." Slowly he began adopting other social networks including Facebook and Flickr. Currently, his social media activities help support his primary focus: photography-related podcasting.

According to Warner, "I love doing podcasting about photography and have developed a series of shows where I interview top photographers and film-makers from around the world." He started his podcast in May 2009, and as of January 2010 he has more than 12,000 monthly listeners. His podcast site, LensFlare35.com (Figure 17.33), continues to grow steadily in popularity. He is regularly approached by advertisers and businesses wanting to get involved with his projects.

Figure 17.33

"LensFlare35" is Warner's podcast dedicated to interviewing the "top photographers and filmmakers from around the world." He has expanded to produce several podcasts weekly.

Warner uses social media to drive traffic to his Web site, to network, to gather and share information, and to collaborate. Besides focusing on podcasting, he is most active on Twitter. "I'm able to talk about what I'm doing in real time and to tell people about the cool shows I'm working on, images I've taken, and things I'm doing," says Warner. "I also get a chance to see what *they're* up to, what the trends are, who's doing what, and the new techniques and equipment that are being developed. I get to pass that information on to my followers as well, which provides value to them too."

Warner devotes more time daily to social networking than most photographers, from 4 to 6 hours each day, because of the focus of his job. "I have an online show. It requires *a lot* of time and participation in numerous networks,"

Warner explains. "Most of the time I have TweetDeck open on my desktop on one computer, and then on the other computer I'll have Facebook open as well. I try to write at least one blog entry for either the www.lensflare35.com or the www.davidwarnerstudio.com site each day. So, that constitutes about 2–4 blog entries plus two podcasts and sometimes three each week!"

Warner uses his personal blog to share his photographic work with others. It has helped him get exposure for his portraiture and other personal projects and has led to additional photo employment.

"The more active you can be online, the better for your business goals and exposure of your work," says Warner.

Warner provides these tidbits of advice for those new to social networking:

- Use your blog as a way to reach out to your client base and find a way to share who you are, what you do, and why you do it. For example, when you post images from a recent photo session, explain why you did things a certain way and how these things were done.

- Use Flickr. Google indexes the images and the meta tags you put on them. Putting your images on Flickr will help people find your work.

- Share and gather useful information. People will then look to you as a source of good information and expertise.

> *Google is the big dog out there when it comes to search, and they not only are crawling your Web site and blog, but looking at Twitter and Flickr. So, the more you post, the more you talk, the more people mention you, the easier it is for people to find you. Once they do, you have the opportunity to turn them into paying customers.*
>
> —David Warner

Trevor Current

Web Site and Blog. http://currentphotographer.com
Twitter. @trevorcurrent

Trevor Current is a professional designer and photographer with a focus on creating consumer packaging, print ads, collateral, and tradeshow exhibits for major companies, including Sony Electronics. He enjoys all types of photography, including landscape and portraiture, although his job focuses primarily on commercial photography. He has long been involved in product and personal brand identity development; thus, social networking is a natural extension of his knowledge.

Current is active on many social networks and actively maintains a blog and weekly podcast. He has always believed in sharing knowledge and valuable information with others. His blog, one of his social networking activities, puts this belief into practice (see Figure 17.34). He uses Twitter and podcasting to interact with others online as well as drive traffic to his site. He not only creates his own podcasts, but also contributes photography news to other podcasts, including "New Media Photographer."

Figure 17.34

Trevor Current's Web site includes a range of useful information for fellow photographers, such as updates on social media and the photo business.

Blogging is an important part of his social networking activities. "I like the idea of combining my experience in design and photography with my education background to provide a resource for beginner through professional photographers to learn and grow their skills," says Current. His blog shares shooting tips and techniques, business and marketing tips for photographers, and more. In fact, Current has recently started a project calling for photographers to provide behind-the-scenes videos of their photo shoots. He plans to aggregate and share this content through his blog site.

Current feels that blogging is an essential part of social networking activities, although most photographers aren't using it to its full potential.

Current is active on Twitter, but he doesn't focus only on finding clients. He feels it is an essential platform for networking and collaborating with your colleagues. Through Twitter he has formed relationships with other photographers in a variety of photo and new media projects, and thus has driven traffic to his site. "Twitter is a great place to meet other photographers and exchange ideas and learn from each other," says Current.

Photographers should definitely be blogging, but not about photography. They should be writing [and] creating audio and video content that their customers would be interested in. If you are a wedding photographer, blog about wedding planning, tips for hiring a photographer, recommendations for reception halls, etc. A couple would be much more interested in information that [would] help them plan a wedding as opposed to what ISO setting you used in a particular shot. Behind-the-scenes video from some of your wedding shoots would also be a great addition to your blog. It [would] help to give potential clients a feel of how you work and if the fit would be right.

—Trevor Current

"If you are a commercial photographer, it might be a good idea to follow some local art directors and creative directors since most likely they would be hiring you. If you photograph interiors, follow interior designers. If you photograph buildings and homes, then follow architects. Interacting with them on Twitter is a great way to open up the door for a possible meeting that could lead to some work."

For Current, Facebook is also a key network even though he isn't a portrait photographer. "Everyone is on Facebook, and you need to be where the people are," explains Current. He is on Facebook with a personal and business page and utilizes it as an effective way to network and build strong relationships with his clients and potential clients.

Current feels the following tips will help photographers in their social networking endeavors:

- Be real. Don't put up a persona that's not who you really are. People will see right through it.

- Don't just self-promote. Provide valuable information.

- Networking is networking whether online or in person; the same principles apply. Be good, and good will come back to you.

- Be consistent in your message. Listen and contribute regularly, and even daily if possible.

Paul Bartholomew

Web Site. http://www.psbphotography.com

Web Site. http://www.psbphoto.com

Blog. http://www.psbphoto.com/blog

Twitter. @psbphotography

Paul Bartholomew has used a variety of online practices to encourage strong search engine optimization for his Web site. He is a Philadelphia-based architectural and interior design photographer who also works in the New Jersey and New York markets.

Bartholomew has found that good search engine optimization (SEO) helps drive traffic to his two Web sites.

SEO is not a matter of doing a few big things, Bartholomew explains. It's a lot of little things, tweaks, and a lot of patience. Also, he makes sure his sites are full of rich content with plenty of pages that link to his main page.

Social media further supports his SEO efforts. Bartholomew says he designed his blog to be a news page to highlight his latest work and to serve as a resource for his clients. A recent example of this, he says, was a post on how his clients could get published in magazines. Clients say they like to follow his career and enjoy reading his insights on the industry.

In Bartholomew's holistic approach to social media, the blog, SEO, and other social media sites such as Twitter are all intertwined. Each plays a role in working toward the goal of driving traffic to his Web sites and developing and keeping clients. Bartholomew admits he doesn't spend a lot of time watching his site analytics.

People like information that can help them out in their own careers.

—Paul Bartholomew

It's important to offer your clients a little extra, says Bartholomew, who believes this brings them back for more business. Always provide good content, and let people know you have a blog. Photographers should place their blog links in their e-mail signatures.

Beginning bloggers should be consistent with their posts, Bartholomew says. Set goals, such as posting once a week, and stick with them. Don't take on too much. If you overload yourself, you will not enjoy blogging. If you don't enjoy it, you will not keep up with it.

Bartholomew shares a few tips on how not to get overwhelmed by social media:

- Avoid getting involved with too many types of social media at once unless you feel it's a realistic goal. The idea is to make social media enjoyable and beneficial to you professionally and personally. If it's not enjoyable, it will become a burden to maintain.

- A blog is a great place for sharing news about your work. Other sites, such as Twitter, Facebook, and LinkedIn, will help announce your updates and create a following.

- Look into new forms of social media as they are introduced. You don't have to get involved with everything that's out there, but get acquainted to see where they may lead. Social media is evolving quickly.

Frank Doorhof

Web Site. http://www.doorhof.nl/
Blog. http://www.doorhof.nl/blog/
Location. Emmeloord, the Netherlands

Frank Doorhof has been taking pictures most of his life. In 2001, he put down the still camera and picked up a video camera. In 2004, he returned to still photography full time, focusing his attention on photographing models, fashion, and glamour. He's also been teaching workshops worldwide since 2008.

Although Doorhof's blog, Twitter, and online forums have worked well for him, he says MySpace has not been effective. He uses Twitter to tweet about what he is doing in the studio and to answer online questions. Social media has helped him find success for both his photography and his seminars.

I've unfollowed many people for the simple reason that I was getting bored with their continuous posts about when they sold another picture or that I really had to look and buy.

—Frank Doorhof

One of Doorhof's most striking social media moments came within days of opening his Twitter account. He received a message from a band asking if he wanted to photograph them. Because he loves music, he didn't hesitate to say yes to this opportunity. Two weeks later, he shot the session in the Netherlands. He strongly believes that social media, if used properly, is the best commercial tool you have as a photographer. Share, but don't force your message, he advises. Make sure you balance your efforts, and avoid taking a purely commercial approach.

If handled properly, social networks will give you useful feedback and help your business.

David Sanger

Web Site. http://www.davidsanger.com/
Twitter. @davidsanger

David Sanger is a travel photographer, early adopter, and technology enthusiast. He built a searchable database for his photography that contains 70,000 pages. David Sanger was surprised at how effective Google was at indexing his images. By the end of 2006, business was booming with four-figure sales. This alerted him to the power of individual distribution and the Internet.

Although the stock industry has gone through an incredible transformation— no one knows where it will end up—Sanger says he continues to sell his images through Getty, Alamy, and his own Web site (see Figure 17.35).

Figure 17.35

David Sanger, travel photographer, displays his social media connection options prominently on his blog.

After experiencing the potential of individual distribution, Sanger has been exploring social media to see how he can use it to increase awareness of his work. People all over the world are linking to his sites. He sees the value—and the vast opportunity—in this new world.

Sanger estimates that approximately 10,000 people like and link to his site and images. The big question is this: how can you monetize the links rather than worry about who is stealing your images?

He believes the real market is direct to consumer, much like the direction of the music business. This is where social media comes in: it eliminates the middle man.

Social media is a valuable way for some photographers to reclaim their voices.

Sanger has gained a following with his blog. His readers tend to be in the travel industry, photographers, and photo buyers. He enjoys keeping in touch through his blog by supporting, teaching, and encouraging his community.

For someone just starting out, he suggests establishing yourself on Facebook and Twitter. Then watch, listen, and learn. Tune in like you would a radio station. Discover the information you find interesting and follow. He says you can't explain Twitter. You have to experience it.

Stock, perhaps, has been a temporary phenomenon that lasted about 15 years.

—David Sanger

The following are a few social media tips from David Sanger:

- Don't be afraid to put your work out there.

- Be clear about who you are and what you do.

- Keep current with technology.

Social Media for a Cause

David Sanger also shared with us a story about how a San Francisco photojournalist used new media and social networking to help the people in Haiti after a devastating earthquake.

Lane Hartwell wanted to do more than send a check or text after the earthquake in Haiti. She had heard about HP's print-on-demand magazine project called MagCloud and decided to give it a shot.

The idea was to see if showing real-life images of the people of Haiti could be educational and evoke a feeling of hope rather than despair. Photographers Chet Gordon, Lindsay Stark, and Mary Ellen Mark all shared their images with the project.

Two days later, with the support of friends and fellow photographers, Hartwell tweeted to the world that the 40-page color magazine, called *Onè Respe*, was available, with proceeds going to the American Red Cross. You can see this project at http://www.davidsanger.com/blog/photographers-work-for-haiti-relief.

Bloggers and traditional media helped spread the word to get the necessary funds raised for this endeavor. To learn more, visit David Sanger's blog.

Paul Manoian

Web Site. http://www.paulmanoian.com/
Twitter. @paulmanoian

Many people know Paul Manoian as an active Twitter user with more than 10,000 followers. Although opportunities come his way through Twitter, Facebook has been his most successful social media platform.

Facebook is a fantastic networking tool that lets Manoian keep in touch with family, friends, and close associates. He personally knows many of the people who follow him on Facebook, but that is not true of his Twitter followers. Direct referrals from friends of friends have been most beneficial to his business.

Manoian, primarily a portrait photographer (see Figure 17.36), says he finds contests to be an effective strategy in social media to drive prospects to his sites. He also gives people photos to share on Facebook. The free picture usually has a frame around it containing his name.

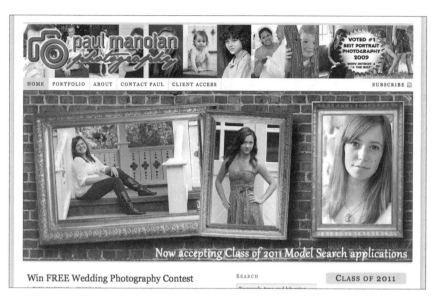

Figure 17.36

Paul Manoian specializes in portrait photography.

If you want traffic and people seeing your material, Manoian says you need to engage with those who follow you. He finds that by giving an image to clients to post themselves, he gets more attention than if he were to post the image on his own fan page and tag it. He also suggests you make sure your clients are not blocking your messages. Finally, remember to comment on their posts.

Don't sell on your personal Facebook account. If you want to sell on Facebook, use a business fan page.

—Paul Manoian

Jeff White

Web Site. http://www.jwhitephoto.com

SEO strategies really work.

Jeff White is a people, fashion, and portrait photographer. He also does a good business selling cityscapes of Detroit.

White also happens to be one of Rosh's studio mates at Octane Photographic in Ferndale, Michigan. Through our conversations on SEO, he has moved his Web site search rankings from nowhere on the radar to one of the top sites in Detroit.

White's SEO successes have led to many new opportunities in the photography business. One of his specialties is actor head shots. He has redesigned his site and optimized some of his pages with top search engine positioning to attract actors.

White believes in the importance of taking a hands-on approach. He designs his sites using iWeb. He is happy with the results and gets great feedback. It is not hard, he says, just time consuming.

"People will link to your site if you have a nice site to view," says White, who benefits from good Web links. Sites with heavy traffic, including local governments and agencies, continue to refer people to his Web portfolio.

I didn't think optimization would be so powerful. You can be the best photographer in the world, but if people can't find you, it is hard to make a living.

—Jeff White

Joseph Cristina

Web Site. http://alluremm.com/
Blog. http://alluremm.com/blog
Twitter. @alluremm

Joseph Cristina is a West Palm Beach-based professional photographer. He specializes in people, modeling, and boudoir photography.

Cristina has been involved online socially for a long time. He ran an early Internet bulletin board system (BBS) before the days of AOL or the World Wide Web.

Today he is active with many social networking platforms, including MySpace, Twitter, YouTube, Flickr, and his personal blog. He spends most of his time writing on his blog and tweeting on Twitter.

"Twitter is my favorite place to share with other like-minded photographers, potential clients, and vendors," Cristina says.

Here's how Cristina got involved on Twitter:

"I remember it like it was yesterday, and it was over a year ago now," he says. "I was on the way to California on a business trip, and before I left I downloaded a bunch of podcasts to listen to on the long flight. One of the podcasts was

by this interesting guy with a unique voice. [There was] a ton of great information and ideas regarding the new media photographer. After listening to 10 or more podcasts, I was hooked. As soon as my plane touched down back in Florida, I immediately got a Twitter account and continued to move my business from the usual advertising model to a more social media model and have never looked back."

The idea that we are going to simply tell someone that we are the best at photography is history.

—Joseph Cristina

Cristina says he believes conventional advertising methods are just about dead.

There is no right or wrong network, he says; there are only the networks that are best suited to your market demographic. These networks will assist you in obtaining new clients or keeping in contact with established ones.

"I would suggest at least one hour a day, minimum, be put into social media networking," Cristina says. "If you have a blog, try to post something of interest at least once a week."

Cristina recommends that you jump in to social media and keep track of the results:

- When opening a new business, join as many social media networks as possible and find where your clients and target demographic are.

- Stay focused. Follow your site's analytics to gain a better understanding of your clients, where they are coming from, and what interests them.

Lan Bui

Web Site. http://thebuibrothers.com/
Twitter. @thebuibrothers

Lan and Vu Bui, also known as the Bui Brothers, started taking pictures as a hobby. They tried taking their hobby to the next level—in a poor way, according to Lan Bui—by becoming mall (studio) photographers. Mall photography jobs are not good photography jobs, says Bui.

Later, the Bui Brothers found other jobs outside of photography, but it wasn't what they wanted to be doing.

In the early days, they used Flickr, the online photography social network, to show their images. Soon they started attending Flickr meetups. Over time, people started to hire them for small jobs. These small jobs ignited the idea to start their own business.

Within a few months of each other, the brothers quit their jobs and began to build the Bui Brothers brand.

Around the same time, the Buis became interested in video blogging. They joined the Yahoo video blogging group, which had only a few hundred members at the time. The group eventually peaked at 3,500 members. (This was before YouTube.com and the ability to easily upload and view online video.) Their biggest concern at the time was how people could download their videos from the Web using a dial-up modem.

If someone else says you're cool, that adds credibility.

—Lan Bui

The Buis started by documenting their lives and soon developed a following. To them, this new way to connect with people was the future.

Lan and Vu took their video production skills and incorporated them into their photography. They shared what they were doing, how they photographed, and who they were as people. At the time, there were not many good how-to photography videos online. They had found their niche.

It wasn't long before the Buis realized that by taking people behind the scenes on their assignments, they were also promoting their own work. As Lan and Vu shared what it was like to work on a fashion assignment or what went on behind the scenes at a wedding shoot, people got to know them. Prospects had already made a connection with them before their first meeting.

The Buis don't have online portfolios. Lan Bui says a portfolio only shows their *work*, but people aren't hiring them strictly for their work. They're hiring the Buis for the event experience and their personalities. The brothers let their enthusiastic clients tell the story through video testimonials.

Lan Bui says he never carries a portfolio either. He's been using his smartphone to show his work and is excited about the prospects of interactive presentations using the new Apple iPad.

These days, the Buis also offer video production to their clients. Lan Bui says what social media platform you use depends on the type of video project you want to make. For episodic content, the best place to is blip.tv. If your project is high-end film style, Vimeo is the best bet. Use YouTube for everything else.

Lan shares a few social media tips for video and general networking:

- Find someone in your business who can be the spokesperson for your business, and make that person part of your company.

- Get involved now. Don't wait.

- Set a time limit for when you are going to publish your first video.

Part V

Reference

18

Tools for Social Networking

Social media is more than Facebook and Twitter. Any site that encourages people to share content and allows others to comment on it or forward it to their followers is a social media platform.

This section is about the Web sites and applications available to support your social media and marketing efforts. As extensive as the list within this chapter is, we are only scratching the surface of what is available on the Internet. New Web sites and applications debut every day. We have included the most popular sites; feel free to add your favorites, those not listed here, or new discoveries at the Linked Photographer Web site (http://linkedphotog.com/).

Following is a list of helpful tech definitions, blogging, and microblogging platforms.

API. Application Programming Interface, or an interface (a program that allows the user to interact with the system) implemented by a software program to enable interaction with other software. Open APIs mean that outside developers can create applications to interact with the original program.

Beta. A beta version of an online tool, application, or software is the first version, or a work in progress, released outside of the development community.

Blellow. This is a niche social media community for freelancers, found at http://www.blellow.com. The platform allows you 300 characters per post and the ability to attach photos. It's designed for freelancers to share and collaborate by joining groups and earn kudos for providing the best answer to a question. Post a question by clicking on the designated box, which colors your post pink.

Blogger. Found at http://www.blogger.com, this is one of the most popular blogging platforms on the Web. It is easy to use and hosts many popular blogs, such as John Harrington's "Photo Business News & Forum." The system is owned by Google and offers many search engine optimization tools.

Blogging. People often think of blogging as outside of social media. Reader comments and interaction with the blog writer are what make it a part of the social media realm. Newer platforms, such as Facebook and Twitter, have decreased the blog writer-reader interaction. But blogging is still an important part of developing a community. Having a blog, which has better search engine optimization than a static Web site, helps prospects find you. Blogs still are major contributors to the conversations in the social media world.

ExpressionEngine. Found at http://expressionengine.com/, this is an advanced technical blogging platform. Its Content Management System (CMS) is flexible, highly customizable, and advantageous. This platform is ideal if you need development flexibility. We recommend it for advanced bloggers with coding experience.

FMyLife. Spill the beans and let the world know the bad things happening in your life at http://www.fmylife.com. It's funny, sad, and sometimes a little over the top.

Jaiku. Start a conversation at http://www.jaiku.com. This microblogging platform, which has a simple interface, is similar to Twitter. Jaiku allows you to follow a channel or a topic, much as you would follow a hashtag on Twitter. Twitter is the most popular microblogging system, but if you are looking to expand your audience, Jaiku is another option.

LiveJournal. Found at http://www.livejournal.com, this site, which was designed for and is most popular with young people, enables you to share your life. Developed in 1999, it is one of the earliest blogging platforms and one of the most social. When you sign up, you are asked to share your interests. Upgrade options are available.

Mashup. Content derived from multiple sources.

Microblogging. Share thoughts, ideas, information, news, and links just as you would with a blog. The difference in that microblogging has a per-post character limit. On Twitter, for example, posts cannot exceed 140 characters.

Microblogging platforms have become powerful streams of information. In many cases, the freshest, most up-to-date content online is posted on microblogs. Be aware that some users abuse the system by disseminating incorrect information. The great thing about this system, like all media streams, is that if you don't like the information, you can unfollow or change the channel of that selected provider.

Movable Type. Found at http://www.movabletype.com/, this is an open-source platform designed to be self-hosted. It is flexible and integrates easily with other social media tools. The platform has innovative tools for the advanced or professional blogger.

Open Diary. Found at http://www.opendiary.com, this site enables you to share your story. The platform, developed in 1998, includes the option to comment on diary entries. It is the inspiration for the blog commenting system in place today. Diary bloggers have the option to make their blogs public or private.

Open source. This means the program's code is available for use by other programmers.

Plurk. At http://www.plurk.com, you'll find a microblog with a different angle. The timeline is displayed horizontally rather than vertically, as it is on Twitter and Jaiku. Post messages with qualifiers such as "feels," "thinks," and "loves."

Posterous. If you don't want to deal with a Content Management System (CMS), Posterous (http://posterous.com/) allows you to easily e-mail blog posts from your computer or phone. This system has become popular with phone photographers. You can even e-mail the Posterous team to set up your blog for you at post@posterous.com.

RSS. Really simple syndication is a technology that creates a secure subscription-based feed system for news, blogs, audio, or video. Blog owners should make feed subscriptions easily available to site fans.

Tumblr. A simple but powerful blogging system, found at http://www.tumblr.com. This is a short-form blog designed to be customizable and easy to use. Many consider it a cross between blogging and Twitter. Text, photos, and videos are easy to add with the user-friendly icon-based dashboard.

Twitter. Twitter (http://www.twitter.com) is not for chatting. It's a powerful microblog media stream and a standard social media platform. Follow people who share interesting information, and if they find you interesting, they'll follow back.

TypePad. Found at http://www.typepad.com, this is a customizable blogging platform that offers more features with an upgrade. Many professional bloggers, such as Seth Godin, and organizations use TypePad. It also has a good support system for your blogging questions.

Viral. The method in which information is shared on the Web. It's derived from the concept of a virus spreading from person to person.

Vox. The focus is on fun and ease of use at Vox (http://www.vox.com). Many of the top social media Web sites integrate with this system, which allows you to import images from Flickr or YouTube directly into your post. Whether you want to share with the world or a few close friends, Vox has excellent privacy controls.

WordPress. Found at both http://www.wordpress.com and http://www.wordpress.org, this is the most popular blogging platform. It is easy to use, customizable, and has a large number of templates and plug-ins designed for the WordPress system. You can host your blog on the WordPress servers at WordPress.com or, for more flexibility, host it on your server with the download found at WordPress.org. You can also find additional templates and plug-ins at the .org site.

Yammer. Let's do business at http://www.yammer.com, which is designed to be the microblog for business. Anyone can start a Yammer account and invite associates to join in the conversation. Yammer is a tool designed to make companies and organizations more productive through the exchange of short, frequent answers to one simple question: "What are you working on?"

Social Networking

These Web sites are designed as general-purpose networking sites. They are personal, customizable addresses on the Web. Many sites allow status updates, photographs, video, and full blog posts. Depending on the site, additional functions may be added with widgets and plug-ins.

Bebo. The motto at http://www.bebo.com/ is "Blog early, blog often." People in the United Kingdom have adopted this social site more readily than others around the world. It has many of the standard features of general social networking sites and is used by a younger audience.

Buzz. Buzz can be found at http://www.google.com/buzz. Google has connected this social media networking tool to Gmail, its e-mail service. It has many of FriendFeed's attributes: It serves as an aggregator as well as a place to share original content and information.

Facebook. Your social address on the Internet. Facebook (http://www.facebook.com) is the number-one social media site in the world and is especially popular among retail photographers. Facebook makes it easy to keep up with family, friends, associates, and clients through regular status updates and its photo tagging system.

FriendFeed. This is a networking feed aggregator and updater. What does this mean? If you are active on many social networking sites, FriendFeed (http://www.friendfeed.com) gathers all the content and displays it on your FriendFeed profile. Updates made to FriendFeed can be displayed on other social networking sites as well. This is one way to put all your social networking activities in one easy-to-manage place. Photographers can use FriendFeed as their main blog or interface for social networking. Facebook recently acquired FriendFeed; look for possible changes in FriendFeed or the integration of the two networks.

Hi5. Social media designed for young people. Hi5 (http://www.hi5.com) is one of the most popular general social media networking sites in the world. It has not made much of a splash in the United States, but it does have quite a following in Central America.

LinkedIn. You will be amazed to find how closely connected you are to the people you want to know. LinkedIn (http://www.linkedin.com) is designed for professionals; it is based on the concept of six degrees of separation. Business is about referrals and networking. LinkedIn allows you to see who knows whom and creates the opportunity to ask for referrals and introductions to people you want to know. A small network of 50 people can be the foundation to building a network of thousands of connections.

ModelMayhem. The site at http://www.modelmayhem.com/ is a fashionable place to be. It's a social networking site for making connections in the world of fashion, glamour, and photography.

Create a profile, upload samples of your work, and then connect with models, hair stylists, wardrobe stylists, makeup artists, and more. This site is immeasurably useful for photographers trying to organize their first fashion/glamour shoot.

MySpace. Musicians helped MySpace (http://www.myspace.com) become one of the first popular social networking sites. Then it became popular with teens who wanted to connect with their friends. Although fading, it is still popular among musicians, entertainers, and young people.

Ning. Create your own community at http://www.ning.com. If you find a niche that needs filling, Ning is the best choice. It is a customizable platform that has the tools to build a community around a business, campaign, hobby, or cause.

Orkut. This is the most popular social networking site in South America. Named after its creator at Google, Orkut (http://www.orkut.com) is designed to help people find old friends as well as make new connections. Users can evaluate people using adjectives such as trustworthy, cool, or sexy.

Plaxo. A smart address book that helps you stay in touch with your contacts. Plaxo (http://www.plaxo.com) automatically updates your contacts with all your feeds and new information.

Link Shorteners

Link-shortening tools condense long URLs into a more manageable size for sharing and publication on microblogging platforms. TinyURL was the first to be adopted on a large scale.

Over the past few years, link-shortening services have added analytics so users can track activity. These services have been helpful in social media. The ability to manage links and test headlines, topics, and the platforms that drive traffic helps make social networking more effective.

Bit.ly. This is the most popular link shortener, found at http://bit.ly/. Its association with Twitter has helped it surpass TinyURL as the shortener of choice. One of the major reasons is its link-management system. Bit.ly gives you the option to send your links from its platform to both Facebook and Twitter. Bit.ly also offers valuable information about clicks, referrals, locations, and tracking conversations involving your link.

Su.pr. The su.pr link shortener (http://su.pr/) is a valuable resource. This application is directly related to StumbleUpon, the content-sharing platform. If you click on the su.pr link, you are directed to the intended page, where you will find a menu bar across the top of the page. This bar gives viewers the opportunity to Stumble (share) the page or review it. This is a great opportunity for the page to earn more traffic.

TinyURL. Because TinyURL (http://tinyurl.com/) is one of the oldest shortening applications, it is considered the most stable. This is especially important to consider when embedding long-term content on a blog or Web site. New link shorteners, even customized ones, are being created on a regular basis.

Other popular link-shortening systems within the social media world are related to specific companies or applications, such as ow.ly (http://ow.ly/), which is part of the HootSuite Twitter management system. Both Google (http://goo.gl/) and Facebook (http://www.facebook.com/) have link shorteners. Link shorteners will continue to offer a useful function; it does not appear their need will diminish any time soon.

Social Media Readers

Readers are an excellent way to keep track of large amounts of information in an organized manner. Some readers focus on one type of content source, such as RSS or Twitter feeds, whereas others import content from multiple sources under your direction.

Feedly. Enhance your Google reader presentation. Feedly (http://feedly.com/) sits on top of Google's RSS reader, creating a magazine-reading experience. It has a clean look and a functionality that some people prefer.

Google Reader. Create your own online newspaper at http://reader.google.com. Google's version of the RSS reader is one of the most popular. You can organize your feeds and share information with people who connect with you through the service. You also can share your favorite posts or news stories through Buzz, Google's new social media service.

Netvibes. A customizable Internet portal or starting page. The site is perfect for news and information junkies. Netvibes (http://www.netvibes.com/#General) is organized into tabs, each containing user-defined modules. Built-in Netvibes modules include an RSS feed reader, calendar, local weather, bookmarks, to-do lists, notes, search and e-mail.

Pageflakes. An Internet portal designed for customizing your personal interests, Pageflakes (http://www.pageflakes.com) is organized by user-selected modules called Flakes. Each Flake contains a user-designated RSS feed, calendar, notes, Web search, weather, social media updates from sites such as Facebook and Flickr, e-mail, and other custom-created modules.

RSS readers. There are millions of Web sites and blogs online that contain an incredible amount of information. It can be frustrating to keep up with all the Web sites you enjoy reading. It's also true that not every site is updated on a regular basis. An RSS reader lets the Web come to you rather than wasting time searching the Web. A quick glance at your reader will let you know which sites have posted updates. Click on a headline that piques your interest to read more information or click to the Web site.

Content Sharing

Internet communities are designed for sharing content or information based on common interests. Content-sharing sites provide information using different methods. Some are based on themed groups and tagging, whereas others focus on the opinion of the community. These sites are a great place to find information and links to share as well as to promote your own photographs, videos, and blog posts.

Delicious. No one can see the bookmarks in your browser. Delicious (http://delicious.com/) is a nonhierarchical social bookmarking system that allows users to tag and share their bookmarks online so people with similar interests can find them via the Web.

Digg. Found at http://digg.com/, Digg is a social news Web site designed to share content from anywhere on the Internet. People submit links and stories while others rate the stories with a thumbs up or a thumbs down. The voting function is the core of the site. The more people who vote for or "Digg" a story, the higher up it moves in the rankings. A high ranking can drive significant traffic.

Mixx. A popular social media option for news sites. Mixx (http://www.mixx.com/) is a user-driven content-sharing site that has people rate and discuss the quality of submitted text, images, or video. Users can search shared articles based on interest.

Reddit. News aggregation is the foundation of this content-sharing site that exists at http://www.reddit.com/. Users may rate the posted links up or down, causing them to become more or less prominent on the Reddit home page.

StumbleUpon. This is a content-sharing site located at http://www.stumbleupon.com. When people find interesting information, stories, audio, or video, they can *Stumble it* using buttons in their browser toolbar or buttons provided on Web pages. Once content is *Stumbled*, the system allows those who follow the Stumbler to see and rate the quality of the submission. The site can generate a lot of site traffic. Some traffic is good and some is poor. It all depends on the quality and interest of the people following the person submitting the link.

Events

Most social networking is done online. Once people start to connect and build relationships, they often want to meet in person. Following is a list of tools and resources to help facilitate or find events in your area.

Craigslist. This site, at http://www.craigslist.org, hosts community event listings.

Eventbrite. This service, at http://www.eventbrite.com, helps businesses and organizations manage events. One of the foundation features is the ticket sales system. It is easy to set up and use.

Eventful. Find, share, and promote events online at http://eventful.com. The site is useful for discovering local event locations and show times.

Facebook Groups. Facebook offers a good option for organizing groups at facebook.com/groups/create.php. Groups are different from pages. Groups offer more administration controls and can operate as a closed environment. Pages are unlimited but open to everyone.

Meetup.com. Networking offline can benefit your business. Meetup.com (http://www.meetup.com) is designed to help people facilitate events related to common interests. Anyone can create an event. This is a valuable promotion and networking tool.

Qlubb. Found at http://www.qlubb.com, this is a Web site designed to help groups organize.

Video Sharing

Video is an excellent way to explain complex information, demonstrate concepts, or entertain people. Video-sharing sites are considered social media because people can subscribe to them, comment on content, or share their uploads with the community. Great videos often become viral and are shared with thousands if not millions of people. Online video continues to grow in popularity. Viewership is expected to increase in the next five years.

Viddler. This site at http://www.viddler.com/ is an interactive Internet video platform. Users can upload, share, tag, and comment on videos. Viewers can create user groups related to common interest in types of videos. The service is free but offers an upgrade. Videos uploaded via the free service have advertising automatically overlaying the video.

Vimeo. Vimeo (http://www.vimeo.com/) is a high-definition video-sharing social network. Although it does not have the audience of YouTube, many photographers prefer its more artistic and professional community. Furthermore, many prefer the Vimeo video-player interface because it is more sleek and customizable than other video players, such as YouTube.

YouTube. Share your vision with the world. YouTube (http://www.youtube.com) is the most popular video site and the second most popular search engine in the world. People can't seem to get enough video.

Live Casting

Justin.tv. The original Justin.tv was a single channel featuring the founder, Justin Kan, who broadcasted his life 24/7. When Justin discontinued broadcasting, Justin.tv (http://www.justin.tv) relaunched as its current form: a network of thousands of individual channels. The site allows users to produce and watch live streaming video. User accounts are called channels. User live video streams are called broadcasts.

Stickam. A live community, Stickam (http://www.stickam.com) is a social networking Web site that features image, audio, and video submitted by users. Live streaming video chat is a popular feature of the service. The site also allows users to embed their streaming Webcam feeds into other Web sites via a Flash player. Pay-per-view may also be set up through the system.

Ustream.tv. Share your thoughts with the world. Ustream (http://www.ustream.tv) is a popular live video streaming platform. Multiple channels of live streaming content are available 24 hours a day. Off-air (previously recorded) content is searchable, providing interesting videos, topics, and people to follow.

Community Answers, Opinions, and Reviews

Community answers. If you have a question about almost any subject, answer sites such as Yahoo Answers are an excellent resource. These sites also can be a source of traffic if you answer questions and leave links with relevant information to your site. Other sites to consider are

WikiAnswers and Askville. (Google stopped taking new questions, but you can still find answers to old questions.)

http://answers.google.com

http://answers.yahoo.com

http://askville.amazon.com

http://wiki.answers.com

epinions. Go to http://www.epinions.com/ to find ratings from the social community on movies, books, electronics, and products. Share your thoughts or seek information on the latest equipment.

Yelp. The site at http://www.yelp.com features customer-written reviews on salons, restaurants, and other businesses. Yelp is fast becoming the number-one business-review location online. Yelp also has popular applications for smartphones.

Collaboration

Collaboration is the future of business. Social media tools are the foundation for how we will communicate internally with coworkers and externally with our customers and prospects. There are many sites and resources online that support businesses collaborating with employees, associates, and customers. One of the most highly recommended sites is 37 Signals Basecamp. We have a large list of other worthwhile tools that will help you work more efficiently with your associates.

Some tools are designed to share files. Other tools allow you to work with and comment on the same document. Still others are purely for communication. Each platform solves collaboration issues in its own way. Many of the platforms combine different services. Test them to see which service helps make you more productive using social media tools.

Basecamp. Get things done at http://basecamphq.com, where you'll find a popular project management and collaboration tool. Chicago-based 37 Signals offers a suite of productivity tools for business.

Bubbl.us. Found at http://bubbl.us, this is a free, Web-based application for collaborative brainstorming. Create maps that you can share with associates or embed on Web pages.

Cubetree. Go to http://www.cubetree.com for this free collaboration tool. The platform supports wikis, blogs, and social networking such as groups and feeds.

Docstoc. Share professional documents at http://www.docstoc.com/. Upload, store, embed, and sell them, too.

Dropbox. Dropbox, located on the Web at http://www.dropbox.com/, is like a collaborative virtual hard drive that allows you to drag and drop shared items to and from your computer.

drop.io. Found at http://drop.io, this is a powerful system for sharing files, collaborating, and presenting in real time via the Web, e-mail, or phone.

EditGrid. This Web-based spreadsheet (http://www.editgrid.com/) offers many of the functions of Microsoft Excel. The difference is that you can collaborate and work on the spreadsheet with others online.

Edmodo. Good for photography teachers, Edmodo (http://www.edmodo.com) is like a private Twitter. Students and teachers can use this service free.

GoToMeeting. Web conferencing tool at http://www.gotomeeting.com that allows you to share any application on your computer in real time. The system enables you to host online meetings with as many as 15 people.

GroupTweet. GroupTweet (http://www.grouptweet.com) is designed for Twitter users to communicate and collaborate privately.

Mikogo. A simple Mac and Windows desktop sharing software, Mikogo (http://www.mikogo.com) can be used for Web conferences, presentations, and collaboration from different locations. The platform is free for personal and business use.

Officemedium. Centralize and streamline your business at http://www.officemedium.com/. Features include file sharing, contact management, social collaboration, and event planning.

ooVoo. Easy-to-use, free, two-way video chat service found at http://www.oovoo.com that's capable of a six-way text chat. The service can also be used to record and send short video messages. Upgrades are available.

Palbee. Found at http://www.palbee.com/index.aspx, this is a free video conferencing service with multiple options. Users can conduct video meetings or record presentations to be stored online for later viewing.

ReviewBasics. Upload a photo or document and invite people to add their thoughts and opinions at ReviewBasics (http://www.reviewbasics.com). This free service is good for people collaborating using different types of content, including videos.

SAP StreamWork. A free and easy-to-set-up collaboration platform found at http://www.sapstreamwork.com. Invite associates and share business information, make decisions, and assign actions to complete tasks.

ScreenCastle. Record a screencast directly from your browser at http://screencastle.com/.

Skype. Talk with friends, family, and associates all over the world through Skype at http://www.skype.com. Skype software allows people to make audio and video calls over the Internet to other people using its software for free. Skype also may be used to call landlines and cell phones for a low fee. Also use the software for text chatting and conference calls.

Socialtext. Social networking solutions for your business can be found at http://www.socialtext.com. The site supports social networking, microblogging, wikis, and blogs.

Spicebird. Spicebird (http://www.spicebird.com/) is a collaborative open-source platform. It provides integrated access to e-mail, contacts, calendars, and instant messaging in one application.

Stixy. Stixy (http://www.stixy.com) is your online bulletin board or whiteboard. It effectively uses drag-and-drop widgets to help you collaborate with friends, family, and business associates.

Twiddla. This site (http://www.twiddla.com) works well for online meetings. Groups can use the tool to mark up and comment on Web pages and images.

Vyew. You can find a free and upgradeable collaboration platform at http://vyew.com. You can use it for Webinars, online conferences, and instruction. It has many features, such as searchable forums, private chat, polls, and voice notation. No installation is required.

Wave. Google Wave (http://wave.google.com) is the first real-time collaboration tool with live messaging. Wave holds promise but is still in the development stage.

WizeHive. WizeHive, at http://www.wizehive.com/, is a collaborative workspace for business. Manage projects, track activity, and share files.

Wridea. Wridea (http://wridea.com) is a brainstorming tool and an easy place to share ideas with associates. The tool organizes your ideas onto different pages and allows other users to comment. The service offers unlimited storage.

Writeboard. Another offering from 37 Signals, Writeboard (http://writeboard.com) is free, collaborative writing software. You can use it to write, edit, and track changes by reviewing previous versions.

Zoho. This site (http://www.zoho.com) has a large suite of collaborative and productivity applications, tools, and gadgets for business.

Photography Sharing and Editing

Sharing photographs is one of the most popular activities on the Web. Facebook holds the trophy for most images hosted online; it's reported that there are more than 20 billion images stored on the popular platform. There is a variety of hosting and editing sites available online. We have listed some of the most popular services. Test them to find the platform that works best for your needs.

Citrify. Edit the photographs in your browser with http://www.citrify.com. This is an easy-to-use editing system that includes most of the basic editing tools plus special effects and portrait touch-up applications.

deviantART. This Web site (http://www.deviantart.com) is intended to be an online community for artists. You can create a profile to showcase your work, maintain a blog, get feedback on your work, buy and sell artwork, and interact with other artists in a variety of forums. Photographers will find this to be a great place to start a community of art appreciation and critiques with other photo/art lovers.

Dropico. Dropico (http://www.dropico.com) allows people to drag and drop pictures from one social media service to another in a single working environment.

FlauntR. Everything is in one location. FlauntR (http://www.flauntR.com) is a combination of photography editing, printing, storage, and sharing service.

Flickr. One of the most popular photography and video storage and sharing Web sites, Flickr (http://www.flickr.com) is a true social media site because viewers also can comment on photos. Images can be shared around the Web through groups and tools. The site has a strong community and is most popular among pros and advanced amateurs.

FotoFlexer. FotoFlexer (http://www.fotoflexer.com) is an advanced online photo editor. As with many editing sites, this one can pull images from your favorite social media locations. The editor has layer, morphing, distortion, and retouching features.

Fotomoto. Sell your photographs online without visitors having to leave your Web site or blog by going to http://www.fotomoto.com/.

Gimp.org. If you are familiar with and use open-source projects such as OpenOffice, Gimp (http://www.gimp.org/) might be a good option for you. It's a free photograph editor and manipulator desktop application that has a number of advanced features, such as lens correction, layers, and channel mixers. Images can be saved in different file formats, including PSD.

Imagekind. Sell your art online at http://www.imagekind.com/. It's a free creative community that provides a print-on-demand marketplace for digital artists, photographers, and painters to sell their work.

ImageShack. ImageShack (http://imageshack.us) is a popular image hosting site.

Imgur. Imgur (http://imgur.com) is an easy-to-use image sharing system. It allows you to upload a picture, manipulate it, and share it on your blog or via e-mail.

Photobucket. One of the largest photo-sharing sites online can be found at http://photobucket.com. It has surpassed Flickr in the number of images hosted. This is because Photobucket is aimed at a younger crowd and is designed for social media. The site offers many of the same free services as Flickr, but the majority of users upload pictures of friends and family. Serious hobbyists, semi-pro, and professional photographers use other community sites.

Photoshelter. This (http://www.photoshelter.com/) is a professional storage, delivery, and e-commerce site for photographers. Professionals can create stock collections and presentation galleries and share lightboxes with clients. This is a commercial site, but it's highly recommended for professional and advanced amateur photographers.

Photoshop.com. Did you know Photoshop is online at http://www.photoshop.com? It's not the full version, but you'll find an easy-to-use photo editor from Adobe. It has many of the standard editing applications found elsewhere and allows you to pull in images from your favorite social media sites, such as Flickr and Facebook.

Photosynth. This tool (http://photosynth.net) allows you to take multiple photos of the same scene or object and automatically stitch them together into one big interactive 3D image that you can share on the Web.

Picasa. Google is in the photography-sharing game, and this is their site (http://picasa. google.com). Picasa works well with the blogging platform Blogspot. It is better known for its organizing and image sharing functions, but it is also a fine basic desktop photo editor.

Picnik. Picnik (http://www.picnik.com) is the tool integrated into Flickr.com. It is an easy-to-use basic editing tool. There are three upgrade versions available that include features such as layering, unlimited history, more effects, and additional fonts.

Picture2Life. This site (http://www.picture2life.com) allows you to edit photos, build collages, and create GIF animations.

Pixavid. This site (http://www.pixavid.com/) is a free photo-sharing service that allows you to upload a picture and share it on social networking sites such as Facebook, Digg, Reddit, Twitter, StumbleUpon, or your blog.

Seadragon. Share your images in full resolution with this zooming viewer at http://www. seadragon.com/ using Photosynth technology.

Smugmug. Many professionals and amateur photographers use this photo-storing and sharing service, located at http://www.smugmug.com. Pro users can sell their images, create watermarks, and use their own domain.

Video Editing

Animoto. This service (http://animoto.com/) automatically produces original video pieces from your uploaded photos, video clips, and music.

EditorOne. You can find a full-featured, timeline-based video editor at http://editorone. ideum.com. It's good for educational mashups.

JayCut. Look no further than http://jaycut.com/ for this Flash-based editing tool. You can drag and rearrange uploaded clips and time the growing number of available transitions between clips. You can also export movies to DVD or social media sites such as Facebook. JayCut has upgrades coming in 2010 that will be worth following.

Jing. Easily create simple desktop movies up to 5 minutes in length by surfing to http://www.jingproject.com. The application is slick and easy to use. The application works in conjunction with Screencast (a movie storage service) and is designed to be used mostly as a collaborative and communication tool.

Kaltura. Looking for open-source video-editing software? Check out http://corp. kaltura.com/. It has a free 10MB trial offer before upgrades are necessary.

Motionbox. This (http://www.motionbox.com) is a video-sharing site that also has a mixer to make new videos from existing ones.

Onetruemedia. Tell your story with photos, videos, and music using the effects and transitions at http://www.onetruemedia.com/.

Photobucket. This service (http://photobucket.com/) is mostly known for its photography hosting, but it also offers video remixing.

Shwup. Shwup (http://www.shwup.com) is an online editor for simple family- and friend-type projects.

YouTube. This (http://www.youtube.com) is primarily a video-sharing service; it also features an audio swap service, which allows users to replace a video's existing audio with a selection from YouTube's catalog of royalty-free music.

Audio Editing

Aviary Myna. Aviary is known for its photo editing, but it also has an audio editor called Myna (http://aviary.com/tools/myna). This is designed to remix music tracks and audio clips. You can apply sound effects and record your own voice and instruments.

Jamglue. This site (http://www.jamglue.com/) allows users to upload music in multitrack format to remix.

Soundation. Soundation (http://www.soundation.com/) is a powerful Web-based sequencer that enables amateurs and pros to make music, ring tones, and audio clips directly from the Internet without downloading software.

Online Productivity

Like the abundance of collaboration tools online, there are also numerous applications to help you become a more productive person. Many of the tools are designed for organization, planning, and saving time.

Clipmarks. This (http://www.clipmarks.com) is a place where people can share or find clips of text, images, and video topics.

Evernote. A popular application for saving information of interest in one location, Evernote (http://www.evernote.com) can be used via e-mail, browser, or mobile application. Some features include the ability to leave voice notes and to create searchable text through converting scanned notes, documents, and business cards.

Instapaper. Save a blog post or Web site article for later reading with the click of a button at http://www.instapaper.com/.

Jott. You can find voice-to-text capability at http://jott.com/. Use your phone to send a reminder to your e-mail account or post to Twitter.

Pixelpipe. Upload photo, video, and audio files and distribute the content across many social networks, FTP, photo hosts, and blogs by using http://pixelpipe.com/.

Remember the Milk. This (http://www.rememberthemilk.com) is a popular online organizational tool with to-do lists and reminders. It is also available for the Apple and Google smartphones.

Ta-Da List. This is an easy to-do list tool. Make lists for yourself or share them with others at http://tadalist.com.

Task.fm. Outsource your memory at http://task.fm. It's a personal, Web-based assistant designed to send you e-mails or phone messages to help you stay on task.

TeuxDeux. Go to http://www.TeuxDeux.com for a simple, clean, browser-based to-do application.

Todoist. This (http://todoist.com) is an easy-to-use task and to-do list organizer. The application is available online and for smartphones.

Toodledo. Toodledo (http://www.toodledo.com/) is a single place where all your to-dos are stored and easily accessible. It has hot lists and e-mail reminders to help you complete your tasks on time.

TripIt. If you're looking for a travel organizer designed to manage, organize, and share travel plans, look no further than http://www.tripit.com/.

Zoho Notebook. This notebook was designed to store and share text, images, and video. Find it at http://notebook.zoho.com.

Brand Tracking

One of the biggest criticisms of social media for marketing and public relations is its limited ability to track results. Link shorteners have been helpful in providing analytics for site traffic, but more is needed.

There are many methods and tools available for site metrics. Different tools measure a variety of actions, including keeping track of your community and your competitors. This is a new area; tools are being developed regularly.

Addict-o-matic. This (http://addictomatic.com) is a useful search engine that aggregates RSS feeds so that you can see your name, brand, or any topic you want to follow across many of the top online search and social networking platforms.

Alexa. Compare site traffic reports and rankings at http://www.alexa.com.

Boardreader. At http://boardreader.com/ is this search engine for forums and online bulletin boards.

Compete. This site (http://www.compete.com) analyzes and compares your competitors' site traffic reports.

FeedBlitz. RSS feed management, e-mail marketing, and social media services are all part of FeedBlitz, found at http://www.feedblitz.com.

Google Trends. This site (http://www.google.com/trends) tracks and displays trends in Google searches and news stories.

Hashtags. Track Twitter hashtags in real time at http://hashtags.org.

HowSociable. Here (http://www.howsociable.com) you'll find a simple, free, brand-measuring tool. The site checks the visibility of your brand across 22 Web metrics and displays a score.

Omgili Charts. If you want to measure and compare the current buzz of any single or multiple terms with a graph display, check out http://omgili.com.

Quantcast. Use http://www.quantcast.com to track traffic and statistics on large, high-traffic Web sites. Compare multiple Web sites within one chart.

Radian6. Gear up for advanced social media listening at http://www.radian6.com. This platform is often used by communication professionals and large brands. It is not inexpensive, but it's worth the price to listen, measure, and engage with your online community.

Social Mention. At http://socialmention.com, you'll find a good, free social media search engine tool that measures data across multiple platforms. It analyzes positive or negative comments and offers a social media score.

Trendpedia. Trendpedia (http://www.trendpedia.com/) is a blog search and trend-following platform. The site also creates charts and discussions around multiple topics.

TweetBeep. At http://tweetbeep.com/, you can keep track of conversations that mention you, your products, your services, and your company with hourly updates. You can keep track of who's tweeting your Web site or blog, even if that person is using a URL shortener.

TweetMeme. View the most popular Twitter threads at http://tweetmeme.com.

TweetScan. Search Twitter with keywords by going to http://www.tweetscan.com.

Twilert. Twitter application that allows you to receive e-mail updates of tweets containing your name, product or service. Just surf to http://www.twilert.com/.

Twitter Search. Search keywords on Twitter by seeking out http://www.search.com/search?q=twitter. The system self-refreshes, which allows you to keep up in almost real time.

Blog Search Tools

BlogPulse. Developed by Nielsen, BlogPulse (http://www.blogpulse.com) searches posts based on keywords and displays current trends.

Google Blog Search. Google's index of blog posts is located at http:// blogsearch.google.com. The advanced search tab allows you to search based on additional criteria.

Icerocket. Looking for a Google blog search tool that also offers additional information about post dates and frequency? Check out http://www.icerocket.com.

Technorati. This (http://www.technorati.com) is a search engine for blogs. It rates the reputation and relevance of blogs based on topics and inbound links.

Search Data

Google Insights. Compare search volume patterns across specific regions, categories, and time frames at http://www.google.com/insights/search/#.

Google Keyword Tool. Generate keyword ideas for related keywords and search volumes at https://adwords.google.com/select/KeywordToolExternal.

Yahoo Keyword Tool. If you'd like to view search volumes for keywords and phrases for the previous month's search data, check out Yahoo's advertiser section at http://advertising.yahoo.com/.

Analytics Tracking

It is highly recommended that every site contain simple code to allow tracking of incoming traffic and the effectiveness of marketing efforts.

Clicky. Clicky, at http://getclicky.com/, offers free analytics with powerful information including social media tracking integration.

FeedBurner. Want to keep track of your RSS feed subscriptions? Try http://feedburner.google.com.

Google Analytics. Go to http://www.google.com/analytics for this powerful information and data tracking tool for Web sites and blogs offered free by Google.

Swix. This site (http://www.swixhq.com) analyzes blog traffic, subscribers, Facebook fans, Twitter followers, YouTube subscribers, and more.

TubeMogul. At http://www.tubemogul.com/, you'll find a free service that provides a single point for uploading video to the top-sharing sites. It also has powerful analytics on who is watching, what is being viewed, and using what method.

Woopra. Go to http://www.woopra.com for a real-time, comprehensive, and easy-to-use Web-tracking and analysis application.

Feed Aggregator

Flock. Flock (http://www.flock.com/) is a Web browser focused on social media. It integrates with dozens of services and helps make it easy to stay connected.

Fuser. Receive all your e-mails and communicate through social media from one location by browsing to https://www.fuser.com.

Ping.fm. Update all your social networks by connecting the most popular networks to one service at http://ping.fm/.

TweetDeck. This (http://www.tweetdeck.com/) real-time application helps organize your tweets and Facebook, MySpace, and LinkedIn status updates. You can group information based on search terms and time frame.

Twhirl. Twhirl, at http://www.twhirl.org/, is a desktop Twitter client. It allows users to cross-post tweets to other sites, post images to TwitPic, and search tweets.

Yahoo Pipes. Surf to http://pipes.yahoo.com for a feed aggregator, mashup, and manipulator. Set up pipes for news alerts and custom Web feeds created from multiple sources.

E-Mail Marketing

E-mail marketing is an important part of online marketing. Collecting clients' and prospects' e-mails should be a company's priority in its marketing efforts. Consider these e-mail marketing companies for their ease of use and options: Constant Contact (http://www.constantcontact.com), iContact (http://www.icontact.com), Vertical Response (http://www.verticalresponse.com), and MailChimp (http://www.mailchimp.com).

Business Networking

Business is about connecting with people. Fortunately, there is a variety of business networking sites on the Internet. We've listed a few of them here.

BizTools. BizTools (http://www.biztools.com) is a global social network of entrepreneurs. The focus is on idea strategies, management, and general business advice.

E.Factor. Being a global community for entrepreneurs is what E.Factor (http://www.efactor.com/) prides itself on. E.Factor helps you build your business, find financing, save money, and network.

Fast Pitch. Get the word out about your business via http://www.fastpitchnetworking.com/. Fast Pitch is a worldwide social platform for business networking professionals to market their business, blogs, and events.

Get Satisfaction. At http://getsatisfaction.com, you'll find a customer-service support system that helps customers resolve issues on their own or with the help of other customers and staff within an online community.

JASEzone. This (http://www.jasezone.com/) is a professional community to connect with potential clients and business partners.

Jigsaw. Jigsaw (http://www.jigsaw.com/) is a prospecting tool that sales professionals and marketers use to find fresh sales leads and business contact information.

Ryze. This free social networking Web site (http://ryze.com/) is designed to link business professionals and entrepreneurs.

Spoke. Find business contacts, information for salespeople, marketers, and recruiters at http://www.spoke.com/. It's a good resource for sales-lead generation and business list building.

XING. At http://www.xing.com, you'll discover a social software platform with more than 8 million members—many of them in Europe.

Ziggs. Ziggs (http://www.ziggs.com/) is a one-stop source for building your brand, marketing yourself on the Web, and simplifying communications with associates, business partners, and prospects.

Business Tools

Amiando. Sell tickets online and create professional registration forms for events via http://www.amiando.com/.

E-Junkie. E-Junkie (http://www.e-junkie.com/) is a shopping cart application with buy-it-now buttons that can be displayed on any Web site for the purpose of selling downloads and products. It can be used with PayPal, Google Checkout, and Authorize.Net.

Flowtown. This site (http://www.flowtown.com) is designed to determine social network activity based on e-mail addresses. This is helpful for expanding your social media network to people you already know and trust.

FreshBooks. Find an easy-to-use online invoicing and time-tracking system at http://www.freshbooks.com/.

Grader. Grader, at http://www.grader.com, is a suite of grading tools and support services to help measure the success of multiple platforms, such as Web sites, blogs, Facebook, and Twitter accounts.

Highrise. Highrise (http://highrisehq.com/), a system to track communication and conversations with customers and prospects, also integrates with 37 Signals Basecamp.

Lovely Charts. Locate an easy-to-use drag-and-drop online diagramming tool at http://www.lovelycharts.com.

Mint. Mint (http://www.mint.com) is free and powerful personal finance management software. It's designed to assist you in managing your money, planning your finances, and keeping a budget.

NeedASig. A free, e-mail signature generator located at http://www.needasig.com/. Select from more than 1,500 different styles.

SalesForce. You can find a popular, full-featured customer relationship management system at http://www.salesforce.com.

Scribd. Publish your information, documents, or e-book online through http://www.scribd.com. Scribd is designed to make publishing easy with its ipaper technology. Publications can be offered for a fee or for free. Full publications may be embedded on other sites for sale, promotion, or educational purposes.

SlideShare. Share your presentations at http://www.slideshare.net, which is a Web site full of information from some of the world's top presenters. Embed presentations on your Web site or blog, or sync presentations with music using the service.

Voki. Voki (http://www.voki.com/) is a free service that allows you to create personalized speaking avatars for your blog, profile, and e-mail messages.

Other Services of Interest

Blip.fm. Create your own online music station programmed by you and your friends by entering http://blip.fm in your Web browser.

OpenID. This (http://openid.net) safe and easy single location sign-on solution is supported by many Web applications, blogs, and networking sites.

Pandora. Pandora (http://www.pandora.com/#/) is an online radio station that learns what you like and then plays it back, along with similar-sounding music.

SpringWidgets. Find or create widgets for your Web site, blog, or for social media by surfing to http://www.springwidgets.com/.

Widgetbox. Widgetbox (http://www.widgetbox.com) is similar to SpringWidgets in that it allows you to find or create widgets.

Wikipedia. A wiki is a collaborative Web site to which multiple authors contribute information for a common goal. Wikipedia (http://www.wikipedia.org) is an online encyclopedia updated regularly by independent editors. The Web publication is monitored for accuracy, particularly with regard to popular topics. Topics outside of the mainstream are not updated as often. Most information online should be verified through multiple sources.

Wufoo. Create contact, survey, and payment forms at http://wufoo.com/. The system automatically builds a database for the forms to make collecting and understanding data easy.

Zoomerang. Create and analyze online surveys at http://www.zoomerang.com/ to improve your sales and marketing efforts.

Index